EVILBYDESIGN

EVIL BY DESIGN

The Creation and Marketing of the Femme Fatale

Elizabeth K. Menon

UNIVERSITY OF ILLINOIS PRESS

URBANA AND CHICAGO

Library of Congress Cataloging-in-Publication Data
Menon, Elizabeth Kolbinger. Evil by design :
the creation and marketing of the femme fatale /
Elizabeth K. Menon.
p. cm.
Includes bibliographical references and index.
ISBN-13: 978-0-252-03083-3 (cloth : alk. paper)
ISBN-10: 0-252-03083-4 (cloth : alk. paper)
ISBN-13: 978-0-252-07323-6 (pbk. : alk. paper)
ISBN-10: 0-252-07323-1 (pbk. : alk. paper)
1. Femmes fatales. 2. Women in popular culture—
France—History—19th century.
I. Title.
HQ1122.M46 2006
305.40944'09034—dc22 2005028934

To my parents and Barbus
(who helped me start),

to Kelly and Briscoe
(who helped me finish),

and to Milo
(who was there in between)

Contents

Acknowledgments

The early years of my research were generously supported by Minnesota State University Faculty Research Grants, in 1996 and 1998. Robert Finkler, chair of the art department, and Dr. Jane Earley, dean of the School of Liberal Arts, deserve special thanks for recognizing the value of my project and encouraging me to pursue it further. In Paris, where much of the research took place, I benefited greatly from the collections of the Bibliothèque Nationale, Bibliothèque Nationale Cabinet des Estampes, Bibliothèque de la Ville de Paris, Bibliothèque de l'Arsenal, Bibliothèque des Arts Décoratifs, the Archives Nationales, Archives de la Seine, Musée Montmartre, Musée d'Histoire Naturelle, and the Jardin des Plantes. I particularly wish to thank Cédric Crémière, who generously shared his knowledge about the use of fetal medical specimens, and also provided me with photographic access to the Musée Dupuytren collection, which was closed while I was conducting my research. Important collections outside of Paris include the Musée de l'Absinthe in Pontarlier, the Association Symbolique Mossa in Malakoff, and the Musée des Beaux-Arts and the Musée Jules Chéret in Nice. I am grateful to the staffs of those institutions.

In the United States, the New York Public Library, University of Minnesota, Notre Dame University, and Northwestern University offered unique collections that rounded out the picture initially formed by my research in European collections. It would not have been possible to complete the documentation for this book were it not for the Department of Interlibrary Loan at the University of Minnesota

Libraries and the Department of Interlibrary Loan at Purdue University Libraries, both of which were instrumental in locating and reproducing materials.

Art dealers who provided much-needed photographs include Hazlitt, Gooden, and Fox in London, Paul Prouté and Galerie Elstir in Paris, Eric Carlson in New York, and Christie's Images Ltd. I am also indebted to the private collectors who so kindly allowed their works to be illustrated in this book.

A number of scholars provided essential observations at the various stages of this manuscript. Gabriel P. Weisberg, of the University of Minnesota, and Yvonne M. L. Weisberg have been guiding forces throughout the preparation of this book, graciously providing feedback on countless drafts, as well as providing assistance with French translations. The current thematic structure was first suggested to me by Petra T. D. Chu of Seton Hall University. Laurinda Dixon, of Syracuse University, gave valuable advice on the content and structure of chapter 2, "Decadent Addictions." I presented that material in an earlier form at a panel she chaired at the College Art Association annual conference.

Other valuable suggestions came from colleagues who attended presentations at numerous conferences where I was fortunate to share the specific aspects of my research as it was evolving. I would especially like to acknowledge the feedback I received after the following conference presentations: "Women on the Fringe: Performers and Prostitutes in Montmartre," conference on Montmartre sponsored by the University of Minnesota and the Minneapolis Institute of Arts (1999); "Master-Slave Narratives in Popular French Illustration," Interdisciplinary Nineteenth-Century Studies Conference, Paris–Nanterre (2000); "Guilt or Gold: Alchemy and Prostitution in Nineteenth-Century Paris," International Congress, "Art and Alchemy," University of Aarhus, Aarhus, Denmark (2001); "Man-made Paradise: Zola's Au Bonheur des dames, Shopping, and Popular Illustration," Southeastern College Art Conference, Columbia, South Carolina (2001); "Topographical Pleasures of Paris: French National Identity According to 'La Vie Parisienne,'" International Conference in European Studies, "Manifestations of National Identity in Modern Europe," University of Minnesota, Minneapolis (2001); "Evil by Design: The Creation and Marketing of the Femme-Fatale in Nineteenth-Century France," at the conference entitled "Decorum and Decadence: Virgins to Femmes Fatales in Art," Martin D'Arcy Museum of Art, cosponsored by the Department of Fine Arts and the Women's Studies Program, Loyola University, Chicago (2002); and "Mapping the Pleasures of Paris," Sixth International Conference on Urban History, "Power, Knowledge and Society in the City," Edinburgh, UK (2002).

I am eternally indebted to the skills of Elizabeth Allen and Janet Whitmore, both of whom helped place my complex thoughts into readable English in different stages of this manuscript's production. I am grateful to Ian West at First Editions Translations, Ltd., Cambridge, England, for his careful translation of nineteenth-century French, and to Sally Heavens, Project Manager–Editorial, at the same organization. At Purdue University, my colleague Tim Fuller assisted by photographing works in private and university collections. In addition, the two anonymous reviewers for

the University of Illinois Press provided valuable suggestions for improvement of the final manuscript as well as encouraging recognition of the work. As we all need thoughtful editors and book designers, I gratefully recognize the work of the staff of the University of Illinois Press, especially Joan Catapano, associate director and editor in chief; Carol Betts, associate editor; and Paula Newcomb, designer.

Early versions of parts of this book were published previously. Parts of chapters 1 and 8 appeared as "Les Filles d'Eve in Word and Image," in *Writing and Seeing: Essays on Word and Image,* ed. Rui Carvalho Homem and Maria de Fátima Lambert, Internationale Forschungen zur Allgemeinen und Vergleichenden Literaturwissenschaft 95 (Amsterdam: Rodopi, 2005), 157–73; a portion of chapter 2 appeared in "Images of Pleasure and Vice: Women on the Fringe," in *Montmartre and the Making of Mass Culture,* edited by Gabriel P. Weisberg (New Brunswick, N.J.: Rutgers University Press, 2001), 37–71; a version of chapter 3 appeared in "Decadent Addictions: Women Drinking and Smoking in Fin-de-Siècle Cafés and Cabarets" in *In Sickness and in Health: Disease as Metaphor in Art and Popular Wisdom,* edited by Laurinda S. Dixon, with the assistance of Gabriel P. Weisberg (Newark: University of Delaware Press, 2004, 101–24); part of chapter 4 appeared in Elizabeth Menon, "Images of Pleasure and Vice: Women of the Fringe," in *Montmartre and the Making of Mass Culture,* ed. Gabriel P. Weisberg (New Brunswick, N.J.: Rutgers University Press, 2001), 37–71; and a portion of chapter 7 appeared in my "Anatomy of a Motif: The Fetus in Late Nineteenth-Century Graphic Art," *Nineteenth-Century Art Worldwide, A Journal of Nineteenth-Century Visual Culture* 3, no. 1 (Spring 2004) (online, http://www.19thc-ArtWorldwide.org/spring_04/articles/meno.html). Much earlier versions of my work pertaining to this book appear as "Henry Somm: Impressionist, Japoniste, or Symbolist?" *Master Drawings* 33, no. 1 (Spring 1995): 3–29; "Fashion, Commercial Culture, and the Femme-Fatale: Development of a Feminine Icon in the French Popular Press," in *Analecta: The Yearbook of Phenomenological Research,* vol. 53, *The Reincarnating Mind or the Ontopoetic Outburst in Creative Virtualities,* edited by Anna-Teresa Tymieniecka (Dordrecht, Neth.: Kluwer, 1998), 363–79; and "Guilt or Gold: Alchemy and Prostitution in Nineteenth-Century Paris," in *Art and Alchemy,* edited by Jakob Wamberg (Copenhagen: Museum Tusculanum Press), 149–70, forthcoming.

Finally, I would like to thank Purdue University for generous support of this publication. From my earliest days in the Department of Visual and Performing Arts, my colleagues have tirelessly supported my research. In 2001, I was privileged to receive a Purdue University Library Research Grant for continuing work at Northwestern University. I wish to thank especially David Sigman, head of the Department of Visual and Performing Arts, and Howard Zelaznik, associate dean of the School of Liberal Arts, for their support in securing funding for the translations and photographic publishing costs from the School of Liberal Arts Research and Discovery Support Program, and Teresa Foley, account clerk, who processed financial transactions with libraries and museums worldwide. Without their abundant support, this book would never have appeared.

EVILBYDESIGN

Introduction

William Adolphe Bouguereau's 1880 painting *Temptation* (figure 1) may appear to be an innocent depiction of a woman and child on a picnic. But the absence of any picnic paraphernalia, the oversized nude baby girl, and certainly the title of the painting suggest a more sinister meaning. I believe it contains a subversive narrative relating to *amazones, filles d'Eve,* and the *femme fatale.* Slickly painted works like *Temptation* are capable of revealing French attitudes toward women during the Belle Epoque, but in this case the artist has obscured the message through his adoption of Salon conventions.

Comparison of the Bouguereau with an 1879 journal illustration by Alfred Grévin, titled "Filles d'Eve" (see figure 108), demonstrates the difference that the medium can make in the transmission of ideas.[1] Grévin's work, which carries the subtitle "my sculpture entry . . . for the next Salon," intends to literally expose coded Salon conventions, specifically those governing representation of nude women in certain acceptable contexts, including religion. Both Bouguereau and Grévin have used a contemporary woman as their model, but only Grévin has explicitly identified his subject as the contemporary daughter of Eve, through visual representation and through the more overt language facilitated by the caption expected in popular press. Grévin's women are nude to the waist; the central woman shares a kiss with a serpent, mediated by the apple of dangerous knowledge. A glass of champagne and a fashionable fan further code the image, bridging the gap between the biblical story and modern material society. A second woman clutches a headless

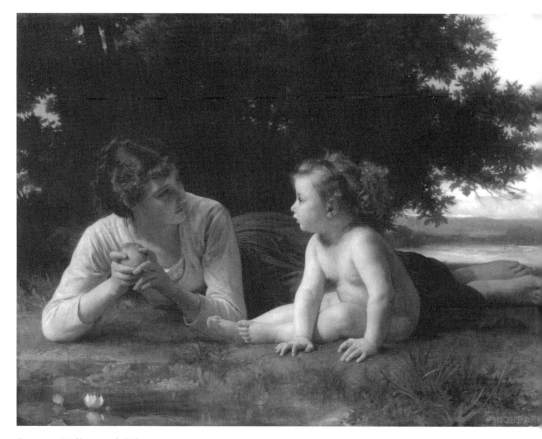

Figure 1. William Adolphe Bouguereau, *Temptation*. Oil on canvas, 1891. Minneapolis Institute of Arts, The Putnam Dana McMillan Fund and the M. Knoedler Fund.

snake, seemingly referring to the Virgin Mary as the New Eve who eventually crushes the serpent. But here the fille d'Eve triumphs over the serpent for a different reason—not to atone for sins, but rather to assume masculine phallic power. The drapery of both women has a serpentine appearance; loose about the hips, it is gathered in twists around the ankles. The skirt of the standing woman falls off like the skin of a shedding snake. Grévin suggests that these women not only consort with the snake, understood to embody the devil, but that they are one and the same.

Can Bouguereau's painting be understood as containing a similar message? Informed by the exposed narrative of Grévin's 1879 illustration, one might suggest that the 1880 painting depicts a contemporary fille d'Eve, stretched on the ground like a serpent, offering an apple to the clearly oversized baby girl, a member of the next generation of amazones—a derogatory French term for feminists. Therefore, both of the characters in Bouguereau's painting can be interpreted as femmes fatales.

This book documents my search for the origins of the femme fatale, the dangerous and deadly woman found frequently in Salon paintings from 1885 to 1900. The term *femme fatale* is found in French literature as early as 1854, and the appearance of women who can be alternately named filles d'Eve or femmes fatales begins in visual representations in the late 1860s. It is my intent to track dangerous women in popular culture sources, such as illustrated journals, literature, posters, and decorative arts, so that the appearance of similar figures in paintings coded by Salon conventions might be better understood as the result of a progressive development from mass art to fine art. The popular culture fostered by social caricature, also known as the study of "manners,"[2] underlies the concept of the femme fatale. Nonetheless, the concept has been largely overlooked by art historians trying to establish connections between this iconic female type and Max Nordau's theory of degeneration. My examination should restore an important context for Salon paintings, such as Bouguereau's *Temptation,* by demonstrating the progressive development of decadent ideas broached first in popular forms such as novels, journal illustrations, and theatrical performances.

In fact, it was in this material "of the people" that radical, political discourse was first introduced throughout the nineteenth century. The Romantic movement was founded in literature some thirty years before it appeared in the visual arts; political cartoons capturing the July Monarchy prefigured the Realism of midcentury France; and the new middle class was depicted in fashion journals long before it became a subject of Impressionism. Popular culture sources also contained the genesis of what became known as Symbolism at the end of the century. Theories of degeneration, an interest in sciences of the mind, and the idea of woman as "fatal" did not suddenly appear at the end of the century. Rather they were tested first within the popular realm before being assimilated into the fine arts of painting and sculpture.

A French popular culture that was mass produced can be traced at least to the period of the July Monarchy (1830–48). While original popular culture was confined to the poor classes in society (as typified by the cheaply produced *imagerie d'Epinal*), this new popular or mass culture gathered a portion of the middle classes as well, and in doing so began truly to represent the majority of the population.[3] With the advent of photography, the academic system of fine arts began to be compromised as student artists utilized the new technology, with or without their instructors' knowledge. The partial breakdown of the Salon system in 1863, marked by that year's Salon des Refusés, and its further decline with the Impressionist exhibitions beginning in 1874, and later, the Independent shows, hastened the blurring of the boundaries between fine art and popular culture, although audiences were slow to realize this. When Edouard Manet painted a wobbling absinthe drinker in 1859 and Spanish themes in the 1860s, he drew on popular culture. The shocked reaction of the public and the critics reflected a general inability to accept themes and modes of visualization in paintings that were commonplace in illustrated periodicals. What became known as a "modern" approach to painting

and sculpture was simply a lessening of academic control over artists' practices. Artists began to examine their own lives and to eschew material gain in favor of exploring their own imaginations. Popular culture played a vital role in this transformation.

The femme fatale's origins are intimately related to the biblical Eve and the narrative of the Fall in the book of Genesis. Eve is arguably the first femme fatale; her daughters, the filles d'Eve—defined broadly as all women who came after her—are also femmes fatales by implication. This book probes the extent of, and reasons for, the popularity of the nineteenth-century daughters of Eve, who serve as the basis for the symbolic femme fatale. An examination of the social and political issues surrounding her creation reveals a profound concern with the rise of the women's rights movement, and a corresponding antifeminist backlash that finds justification in Eve and her femme fatale implications. Scholars including Virginia Allen and Bram Dijkstra believed the emergence of the femme fatale was linked to the rise of feminism in France, but their comparisons between Salon paintings and the documents of feminism yielded little definitive evidence of antifeminist or misogynistic tendencies.[4] Examination of popular culture sources provides this critical link.

The femme fatale has come to be known as an archetypal woman whose evil characteristics cause her to either unconsciously bring destruction or consciously seek vengeance.[5] Mario Praz, who studied the Fatal Woman, did not find a single established type—or cliché—that would have been determined by "some particular figure [making] a profound impression on the popular mind."[6] Praz likened a type to a "chronic ailment [that] has created a zone of weakened resistance" to which similar phenomena will migrate, "until the process becomes a matter of mechanical monotony."[7] I agree with Praz that there is no single femme fatale, and this study presents a constellation of types from the nineteenth century, all of which possess a connection to Eve and her modern daughters. At the same time, the current study is not a comprehensive investigation of the femme fatale in all her guises, for I am most interested in the manifestation of fatality within the supposedly real (but in fact stereotypical) contemporary woman known as the *Parisienne* and termed a fille d'Eve by nineteenth-century French writers. Thus, I will mention what could be called historically based femmes fatales, such as Cleopatra and Medea, primarily when those historical figures were brought to life by real women such as Sarah Bernhardt. Marie Lathers has called the Parisienne "a distorted reapparition of the *grisette*"—a term from the period of the July Monarchy for a female type who traded sex for dinners or merchandise. According to Lathers, the Parisienne "plays the *grisette,* but is, unlike the latter, defined by her insincerity and, often, her vulgarity."[8] Octave Uzanne called the Parisienne—the modern woman in multiple forms—an effect of the "decadent refinement of the present race."[9] The connection of the Parisienne to the fille d'Eve, and by implication to the femme fatale, occurs first in the realm of popular culture and is manifested only later in paintings such as Bouguereau's *Temptation.*

The paintings and literature of the late nineteenth century have been the subject of several studies focused exclusively on the femme fatale. These include Virginia Allen's *The Femme Fatale,*[10] Edward Marsicano's dissertation, "The Femme-Fatale Myth,"[11] and Bram Dijkstra's seminal text *Idols of Perversity.*[12] Patrick Bade's *Femme Fatale* and the exhibition catalogue entitled *The Earthly Chimera and the Femme-Fatale* are more general studies dependent on earlier scholarly work, especially that of Mario Praz. More recent texts and exhibition catalogues centering on the Symbolist movement routinely feature a section on the femme fatale.[13] Studies of the femme fatale in literature, in addition to those of Praz, include H. R. Hays, *The Dangerous Sex;* Peter Gay, *The Bourgeois Experience;* and Charles Bernheimer, *Decadent Subjects.*[14] None of these studies has considered the appearance of the femme fatale in popular print media, or the significance of the modern woman's taking this role. In fact, Allen sees a "substantial distance from ordinary experience, ordinary women," with most attention focused exclusively on the use of historical or mythological prototypes such as Circe and Salome.[15]

In contrast, the present study is centered on the contemporary woman called a fille d'Eve. I trace a set of motifs associated with her as she is transformed into various manifestations of the femme fatale. French journal illustrations and other popular culture forms are central to the current investigation—the images and their captions are the primary source documents. I use literature to locate these visual representations within a larger context; I consider decorative arts, fashion, and painting to a lesser extent, but they similarly serve to show the transmission of ideas from various facets of society.

The femme fatale's link to the rise of the women's rights movement, as well as her appearance as a strong feminine presence, could encourage employment of a contemporary feminist methodology in this study. For many years art history has been experiencing what has been dubbed "a crisis" concerned primarily with methodological expansion of the discipline. In general, it could be said that art history lacks a single identifiable procedure for investigation of the elements of visual culture, which has encouraged art historians to pillage the methodologies of other disciplines and modify them for the interpretation of visual images. Marxism, psychological investigation dependent on Freud, Roland Barthes's semiotic theory, and notions of "the other" as initiated by Foucault have all been appropriated by practitioners of art historical investigation. It is the feminist movement, however, that has had the most wide-reaching and profound impact on the study of art. Due to its influence, the above methodological approaches have been further enriched; in addition, the very nature of what is studied by art historians has broadened to include what used to be called crafts and popular culture (now more often described as design and visual culture, respectively).

Women who spearheaded this movement realized that images were important not only as indicators of what could be called inherently feminine qualities (nature), but also as determinants of expectations (culture). In a similar fashion, they recognized that what has been called "art history" consisted primarily of works of

art by male artists that had been deemed "masterpieces" by male art historians. The discipline, in other words, was a microcosm of the set of circumstances women faced globally. Today, the art historical canon can be seen in the process of expansion through the examination of women artists, or in the process of destruction by multidisciplinary investigation.

For more than two decades, scholars have been engaged in dialogs about a variety of issues raised in the late 1960s by feminists involved in the women's movement. Linda Nochlin led the way in 1971 with the first identifiable feminist inquiry into art history, "Why Have There Been No Great Women Artists?" published in *Art News*.[16] Nochlin's article sparked three identifiable waves of art history, all of which continue today: the rescue of women artists from obscurity; the examination of the political, societal, and cultural conditions that acted against them; and the questioning of the discipline of art history itself (and its methodologies) as an oppressive patriarchal structure.

Scholars working in one or more of these areas did not always agree, especially in terms of methodology. Radical feminist scholars, who work in all three areas but take special interest in the third, view historical facts as tainted by the patriarchal structures in which they existed and were recorded, resulting in an invisible assertion of an objective history. If history itself is a function of what was deemed important enough to be recorded, then history is a function of the same gender, race, and class biases as the rest of cultural production. One of the primary scholars to emerge with this viewpoint was Griselda Pollock, who, with Rozsika Parker, coauthored *Old Mistresses: Women, Art, and Ideology.* In Pollock's *Vision and Difference,* her personal approach became more radicalized. She criticized feminist art historians who spent their time finding forgotten women artists to study, which she identifies as a liberal approach, and called instead for an active evaluation of gender differentiation. In this approach, which has been termed Marxist/feminist, the history of women ceases to be important, as do the images that are created by women or contain women as subjects. She called for the investigation of "women as subjects not masquerading as the feminine objects of masculine desire, fantasy and hatred."[17]

Since the present book employs a methodology that is object-oriented and archival, and because its subject is women as objects of masculine desire, fantasy, and hatred, it does not conform to Pollock's version of feminist art history. I believe that what is currently à la mode from a feminist theoretical perspective can be derived from examination of the images and archival documents used in this study—print media, which is part of what may be referred to as popular culture, mass culture, or visual culture.

Popular culture can be defined as print matter, both visual and literary, consumed by the lower-middle and middle classes; it is, in the words of Noël Carroll, "an ahistorical term" applicable to all periods. Mass culture, on the other hand, "has arisen in the context of modern industrial mass society" and uses "mass technologies of production and distribution—in order to deliver art to enormous

consuming populations—populations that are 'mass' in the sense that they cross national, class, religious, political, ethnic, racial and gender boundaries."[18] A revolution in printing technology during the nineteenth century, which both lowered the cost and significantly increased the amount of available visual material, resulted in what Patricia Anderson has termed "an expanded and transformed popular culture" or "an emergent mass culture" that reached a large and socially diverse audience.[19] From 1881 to 1889 there was an increase in the number of lowest priced journals (five to ten centimes an issue) and a corresponding decrease in more expensive journals (twenty centimes and above per issue), indicating an expansion of readership in the lower and lower-middle classes.[20] At the same time, the mass press "aimed to reach as broad and diverse a constituency as possible and was designed to address an imagined 'universal' reader."[21]

The term "visual culture" encompasses images and other material elements that "serve aesthetic, symbolic, ritualistic or ideological-political ends and/or practical functions, and which address the sense of sight to a significant extent."[22] While all three terms—popular culture, mass culture, and visual culture—are appropriate to the current study, the latter two are especially pertinent. Since the majority of the illustrations reproduced here appeared either in the press or as advertising posters, to a wide and diverse audience, and were the result of new technology, they may be termed part of mass culture. Visual culture focuses "on the visual as a place where meanings are created and contested."[23] It is appropriate to this study since the illustrations not only serve to enhance the appearance of the text, but form a part of vital source documentation for my arguments. "Visual culture" is an attractive term because of its inherently interdisciplinary nature. The inclusion of decorative art objects, which were functional as well as aesthetic; theatrical performances, which of necessity had comparatively limited audiences; and fashion, which was somewhat limited by class and certainly restricted by gender, also warrants the use of this term. While the more generalized term "popular culture" will be used for the sake of convenience in the pages that follow, it should be understood that both other terms apply equally.

The journals considered were some of the more than two hundred satirical illustrated periodicals that circulated in France from the late 1860s to 1914; the artists who completed the illustrations were considered talented caricaturists.[24] In 1865 the art critic Champfleury (1821–89) defined caricature and discussed its durability as a form of social commentary in his *Histoire de la caricature moderne.* To him, caricature was eternal and an effective way of policing the morals of society. Caricaturists could manipulate pieces of reality, adding elements of fantasy at will. Since at least the time of the July Monarchy, satirical journals had considered drawn caricatures to be historical documents.[25]

French caricature was, during the nineteenth century, primarily utilized for political reasons, but a type of social caricature had always existed alongside it, describing the various classes served (or not served) by successive governments. During periods of government repression, social caricature attracted the attention

of the censors both for its overt meaning and for its coded expressions of politi-
cal ideas. The lessening of governmental control in 1867 resulted in a substantial
increase in the number of illustrated publications.[26] In 1881, the abolishment of
censorship led to the free expression of political ideas, but artists quickly learned
that caricatures lost their power in a censorship-free environment. During this
period, political caricatures declined in number and were relegated to a few pe-
riodicals, such as *L'éclipse,* while social caricature was expanded for new publica-
tions. Social caricature retained a critical edge; individuals were still presented for
ridicule, but now they were as likely to be writers or agitators for women's rights
as members of the government.[27]

Most daily publications were not illustrated; visual culture developed in maga-
zines that appeared weekly, monthly, or bimonthly. While these publications
might comment on contemporary events, their focus was limited to themes such
as arts and literature, sports, science, or travel. It was here that the serialized nov-
el appeared, and here that readers developed a taste for a wide range of images,
many providing either overt or covert instructions to its audience on issues such
as proper behavior and gender norms. The history of political caricature employed
to foment unrest provided a model with which antifeminist artists could attack
the burgeoning women's rights movement.

Unfortunately for scholars of this period, the press law changes that occurred
in 1881 have made tracking the total number of periodicals published during this
period nearly impossible, since publishers were no longer required to declare the
number of copies printed.[28] Print runs for these periods, therefore, can only be
estimated based on publication numbers prior to 1881. The focus of most of the
journals examined in this study falls into the category of "manners." I have taken
the most examples from *La Vie Parisienne* (1863–1939), the longest-running periodi-
cal to be considered here, as well as the most lavishly illustrated. Its original subtitle
was "the elegant life, topics of the day, fantasies, travel, theatre, music, fine arts,
sports and fashion."[29] Categorized as "erotic" by Robert Goldstein, *La Vie Parisienne*
was the target of censorship for moral offenses during 1878–81.[30] Théodore Zeldin
determined that its intent was to entertain, providing "mild relaxation for those
with too much leisure," and he attributed its longevity among a female readership
to its treatment of women's fashion and Paris gossip. Its male readership was se-
cured "by dealing with these subjects in a titillating way."[31] Claude Bellanger, who
identified another purpose of *La Vie Parisienne* as the advertisement of the spirit
of Paris, and the city's merchandise, to the provinces and other countries, reports
that in 1866 the circulation was 8,500.[32] Another journal dedicated to a relatively
wealthy clientele who paid seventy-five centimes, triple the price of other publi-
cations, was *L'Illustration,* which had considerably higher press runs, and whose
audience expanded rapidly: 18,000 in 1866, to 37,500 in 1880, to 55,000 in 1904,
and to 92,000 by 1907.[33]

Less lavish publications from which illustrations have been considered in the
current study include *La Caricature* (1880–1904), illustrated and edited by Albert

Robida; *Le Courrier Français* (1884–1913), edited by Jules Roques; and *Le Rire* (1894–1910), edited by Félix Juven. *Le Courrier Français,* which carried the spirit of Montmartre, the red-light district, to the rest of Paris and beyond, has been described by Robert Goldstein as "the most important caricature journal of the 1880s," based on its high-quality illustrations and employment of leading graphic artists, including Adolphe Léon Willette and Louis Legrand.[34] Like *La Vie Parisienne,* its primary focus was on mores and women; thus it was "essentially apolitical [but it] had a general undertone that was critical of bourgeois sexual morality and hypocrisy."[35] This contributed to its being prosecuted on the grounds of corruption of morals, a legal offense that was not protected under the lifting of the censorship law. Other similar periodicals, but of decreasing illustration quality, include the *Le Monde Comique* and *Le Petit journal pour rire. Le Journal Amusant* had print runs in the vicinity of 8,000 and described itself as a "journal for laughter," while the similarly focused *Le Charivari* circulated 2,875 copies, which was considered a mediocre press run.[36]

Ephemeral journals examined in the present study include *Zigzags* (which existed for just six months in 1876), *La Vie Elégant* (1882), *Le Boulevardier* (1879–84), *La Grande Vie* (1899–1901), *Le Monde Parisien* (1878–84), *Paris à l'Eau-Forte* (1873–76), and *La Chronique Parisienne* (1878–79).[37] The biographical caricature publication *Les Contemporains,* two magazines devoted specifically to fashion (*Le Moniteur de la Mode* and *L'Art et la Mode*), and three with a combined social and political focus (*Le Sifflet, Gil Blas Illustré,* and *L'Assiette au beurre*) were also sources of illustrations. Of these, *L'Assiette au beurre* has been called "a weekly of unexcelled graphic quality" by Goldstein. It had a thematic program, featuring cartoons by a single artist in each issue, and although it "had no coherent political program, it brutally and incisively lampooned and savaged all of the pillars of the French establishment and highlighted the ignored social grievances of the poor."[38]

While the print runs of illustrated journals pale in comparison to those of newspapers like *Le Figaro* (which had a press run of 65,000 in 1870) or *Le Petit Journal* (greater than 300,000 by 1870), the power and reach of the journals was increased through a number of methods during the July Monarchy, including the sharing of publications in *cabinets de lecture,* cafés, and kiosks.[39] The number of different illustrated journals (irrespective of individual press runs or length of operation) indicates a persistent interest in the visual among the consuming public. In addition, it is the repetition of certain motifs among the publications that makes them significant indicators of antifeminist sentiments in the last quarter of the nineteenth century. In part, the repetition can be explained by the fact that the same artists worked for more than one of the listed publications.

Théodore Zeldin noted in 1980 that "the humorous press, rather oddly, is one of the least studied aspects of literature and art. Most of the caricaturists of this period are little more than names, and the ideas behind their activities are difficult to discover."[40] While female allegorical types and Spanish journal illustrations featuring women have been catalogued and studied, no such study of French

examples exists, although the topic of women as depicted in French posters has been examined.[41] Most of the illustrators whose work is examined herein conform to Zeldin's description; many are known only by pseudonyms, and only a few—Félicien Rops, Alfred Grévin, Albert Robida, and Henry Somm—have been the focus of dedicated study. Artists who worked in the fields of posters and decorative arts, including Toulouse-Lautrec, Georges de Feure, Alphonse Mucha, and René Lalique, have received broader attention, as has Gustave Adolphe Mossa, whose watercolors and oils bridge the nineteenth and twentieth centuries. But even in the case of these better-known artists based in France, and those, like Edvard Munch and Aubrey Beardsley, who both adopted a fetus motif during trips to Paris, their personal motivations in the adoption of particular themes remain a subject of speculation. The tactic I have adopted is to examine the images as a collective societal enterprise rather than to investigate the personal production of a particular artist, while conducting what the French historian Lucien Febvre termed the reconstitution of the emotional life of the past.[42] Understanding what these images meant to the citizens of France necessarily means trying to reconstruct the psychology not only of the artists and writers who created them, but also that of the people who viewed them.

The images under consideration vary greatly in aesthetic value, but I agree with B. E. Maidment that "images which derive from crudely held graphic conventions and social stereotypes offer the student a better understanding of widely held cultural assumptions" than those by more skilled artists.[43] Nonetheless, I have made every attempt to choose the highest-quality works expressing each of the themes of the book. Each of the selected illustrations stands for dozens, or even hundreds, of others that contain the same theme, with the exception of the fetus motif, which was comparatively rare.

The artist has more control over the development of a caricature when he or she fashions a "stereotype" to represent a group of similar individuals. A "type" can describe an ensemble of characteristic traits or features of a group of similar objects or persons of the same nature. By extension, "type" has been linked to the moral state, goals, or inner workings of humankind.[44] The caricaturist puts individual characteristics into the "types," shapes them gradually, and adds what is imaginary to the real qualities if he wishes. The use of stereotypes synthesizing elements of various classes and professions had a long history in France and formed the basis of two multivolume texts from the period of the July Monarchy, *Les Français peints par eux-mêmes* (1834–39) and *Nouveau tableau de Paris au XIXe siècle* (1834). Specifically female types were the focus of Hadol's *Les femmes de France pendant la guerre et les deux sièges de Paris* (1872) and two key texts that are examined in the current study, Octave Uzanne's *Etudes de sociologie féminine* (1896) and George Montorgueil's *La Parisienne peinte par elle-même* (1897).[45] The female types I examine in this book are fictions created from a combination of the contemporary Parisienne and the fille d'Eve, with all the characteristics implied by the latter. These illustrations, by virtue of their visual nature, give authority to imaginary versions of femininity and provide an index for the antifeminist's similarly hypothetical ideal woman.

The themes that form the structure of this book were selected through careful consideration of the images found in the majority of illustrated journals published between 1865 and 1910. Since I wanted to document the development of the femme fatale, I focused on images that had sinister implications. I have not included the large number of "positive" images: woman as saint, allegorical personification, virgin, mother, caregiver, and so forth. Those representations show women in traditional roles and provide an important contrast to the images I consider here. Examination of such positive female roles would have resulted in a very different book, but one that nonetheless would convey the same basic argument: images of women in French nineteenth-century popular culture are intended to reinforce patriarchy by keeping women categorized as "good" or "bad" but never a combination of both, and never "human." I was most interested in the large number of illustrations of the everyday Parisienne whose character was manifested through contemporary fashion, often combined with subversive, even macabre elements. These were direct attacks by antifeminists against the female population, rather than the glancing blows dealt via stereotypical motifs from antiquity. It is within these images of the contemporary woman—the filles d'Eve of the nineteenth century—that the mythologizing force of the patriarchal system intersects with the agitation of the "new woman" in her many forms. The subversive images of the sexually aggressive woman demonstrate the power she wielded—especially the fear that her traits engendered within the male population. Artists who drew these images controlled the subversive nature of women by exaggerating their potentially frightening characteristics for comic purposes. Most of these representations are satirical and metaphorical, sometimes humorous, and sometimes extremely disturbing.

The book is divided into three parts linked by a strong connection, through visual elements or literary references, to the biblical Eve, who is the central motif. Part 1, "Genesis," presents the first chapter, entitled "*Les filles d'Eve,*" which discusses the importance of Eve from both feminist and antifeminist perspectives as the original prototype for the fatal woman. It examines the "fatal traits" exploited by artists and writers, and surveys the literature treating Eve and her "daughters" during the nineteenth century. An important counterpoint to the fille d'Eve is the New Eve. In the biblical tradition she is the Virgin Mary, sent to atone for Eve's sins through the pain of childbirth. The New Eve is the prototype for the "positive" images of women as mothers, saints, and caregivers that do not form part of this study. On the other hand, "negative" concepts and characteristics associated with the biblical Eve, such as curiosity, temptation, sin, and sexuality, provide the themes treated in parts 2 and 3, entitled "Marketing Temptation" and "Evil Motifs," respectively.

The chapters contained in part 2 deal with the commercialization of temptation in the second half of the nineteenth century. Chapter 2, "Artificial Paradise," considers the role of "ready-to-wear" fashion in conjunction with two venues: the department store and women's clubs. Although men were responsible for the power behind both the fashion industry and the rise of the department store, the

resulting visibility of women was seen as threatening. Fashion designers regained literal control over women's bodies with the successful reintroduction of the corset, despite medical evidence of its harm to female anatomy. Contemporary literature claimed that the phenomenon of shopping in department stores was causing mental instability—from kleptomania to hysteria—in the female population. Images of crazed female shoppers and compromised shop girls suggested that the *flâneuse* (so-called because she appropriated the wandering gaze of her male counterpart, the *flâneur,* or dandy) was dangerous and must be made invisible. Similarly, literary and visual images of women's clubs—*clubs des femmes*—dealt with the "real" clubs by suggesting political subversiveness and by inventing "imaginary" clubs where members' conversation would revolve only around the latest fashions and what to serve their husbands for dinner.

"Decadent Addictions," chapter 3, considers the role of women in advertisements for alcohol and tobacco, as well as in paintings and journal illustrations dealing with the issue of addiction. The concept that women were "closer to nature," a view validated by the biblical Eve, paved the way for images of females as the literal presenters of tempting substances manmade from natural sources. I examine the biological and psychological nature of addiction and the strategies employed by advertisers to avoid allusions to the potential dangers of alcohol and tobacco. As a counterpoint to power advertisements, paintings and popular illustrations frequently reveal what one has to fear with consumption of these substances for pleasure. Doctors believed that substances built upon each other's toxicity, making the café a special area for concern, since alcohol, tobacco, and prostitution were all found there.

Prostitution is examined as an addictive vice in chapter 4, "Dangerous Beauty." Because of her prominent sexuality and frequently aggressive nature, the prostitute was the perfect embodiment of a fille d'Eve, a contemporary woman who couldn't help but repeat the mistakes inherent to her gender. Images of the prostitute in literature and popular journals demonstrate that her attraction was both powerful and dangerous. Many artists and writers attempted to control the prostitute by defining her characteristics, submitting her to a process of classification akin to that in Darwin's *Origin of the Species.* The result was a genre that proposed different types of women and different types of prostitutes, identifiable through their region, dress, and personal habits. While the depiction of prostitution in French literature and painting has been the subject of several contemporary studies, the journal illustrations and the majority of the literature introduced in this chapter have not received critical attention.[46]

Part 3, "Evil Motifs," contains chapters that focus on particular prototypical manifestations of the femme fatale in popular culture as early as the 1860s. Each motif has a dichotomous structure, two distinct ways in which it can function, either reinforcing a domestic and sometimes biblical ideal or subverting the ideal. Chapter 5, *"Les fleurs du mal,"* reiterates the association of women with nature in order to examine what happens when nature, normally a positive force, becomes

subverted. Baudelaire's text by the same name provided the inspiration for many artists and writers who recognized the power of transforming something seemingly innocent into evil. A genre of literature known collectively as "the language of flowers" provides important information about traditional symbolic coding, which artists and writers used in a wide range of media, from journal illustrations to the decorative arts movement known as Art Nouveau. In that movement, the fullest elaboration of the dichotomous possibilities of flowers is realized as natural forms are placed in the service of Symbolist art. Baudelaire's example proved so influential that popular artists would use his title, *Les fleurs du mal,* to describe Parisian prostitutes with whom the disfiguring and deadly syphilis epidemic was connected.

Chapter 6, *"La femme au pantin,"* considers depictions of women controlling tiny puppet-like men. Underlying these representations are the traditional use of dolls in gender training and the controversies over the very modern appearance of dolls in the late 1860s. At that time the term *poupée* came to mean "prostitute," and sciences of the mind, including hypnotism, introduced the use of fetishistic objects such as dolls and puppets into the popular consciousness. The male reaction to the feminist advocacy of birth control forms the basis for chapter 7, "Depopulation Demons," which considers images of the *femme-homme*—the masculinized woman—and fetuses contained in specimen jars as indicative of the fear of depopulation. Both the poupée and fetus motifs suggest that a liberated woman is of necessity a bad mother. The eighth and final chapter, "Serpent Culture," returns full circle to the biblical Eve through the association of women with snakes. Initiated in French popular culture early in the nineteenth century, the motif of the snake, either with or without female companions, later became fundamental to the Symbolist movement and the jewelry, furniture, and other functional items of Art Nouveau. The fashion accessory once simply called a "fur" was renamed a "boa," and a summer version made from feathers became all the rage in the early 1890s. Art imitated life, and vice versa, as caricaturists mocked the popularity of this accessory by depicting women wearing live snakes. A number of women, Sarah Bernhardt and Loïe Fuller among them, embraced the snake motifs associated with the femme fatale and used snake imagery within their theatrical performances. With this motif, the transition between the somewhat ambiguous fille d'Eve and the definitively dangerous femme fatale is broached; in the realm of the theater, the femme fatale became indistinguishable from the woman who played her.

In this study I examine a range of interrelated themes present in literature, illustrated journals, advertisements, and other manifestations of popular culture, in order to trace the development of the French attitude toward women during the fin de siècle.[47] The journal illustrations and the literature involving the fille d'Eve and her transformation into the iconic femme fatale have in common their satiric treatment of gender relations during the nineteenth century. They also trace the evolution of antifeminism in response to women's agitation for equal rights. Because these stereotypical women were repeated in serial form visually,

and because they appeared in both periodicals and the novel, they appealed to a wide audience that could generally be termed antifeminist. Feminists responded by attempting to recast the biblical Eve as a powerful mother of humanity, but, at least in part because they could not take part in a visual discourse, the feminist view was largely eclipsed by purveyors of a more traditional view of woman. The audience for these images included men who believed women were near-equals and men who regarded women as biologically inferior, as well as women who sought equality and those who accepted domestic roles.

Antifeminist attitudes commanded a greater share of the market for the printed word and nearly dominated the art world. Feminist tendencies, while implied by the virulent reaction of antifeminist literary and visual discourse, were muted. Although contemporary feminist journals occasionally examined such issues as the role of Eve in modern society, women writers did not "do" art or popular culture criticism. In fact, the phenomenon of popular culture criticism does not really exist in the nineteenth century. It was rare that images in the popular press engendered a published response during the Third Republic. This is likely because of France's history of censorship and the recognition by the 1870s that objections to inflammatory visual representations only gave the images more power. The way to take away the power of offensive pictures, literature, or music was to ignore it. The feminists ignored these images at least partly as a strategy to gain control over misogyny without stooping to the level of caricature, universally seen as a "low" form of art and humor. But this is where the French feminists failed. By not producing their own images, they allowed those created by men to dominate the popular press.

Part One GENESIS

ONE *Les filles d'Eve*

The motif of the fille d'Eve, or "daughter of Eve," became a charged symbol in nineteenth-century France. In one sense, all women were considered metaphorical daughters of Eve. The nineteenth-century use of the term did not simply refer to a biblical episode, but rather carried a connotation of evil. The biblical subtext is found in contemporary writing devoted to the relationship between the sexes, even though the authors did not necessarily intend to refer literally to the Bible or consciously interpret its messages.[1] Nevertheless, critical facets of the Creation story were questioned. Was Eve destined to sin or did she sin by choice? Was she a femme fatale because she succumbed to destiny or because she brought about the downfall of mankind? Did Eve have a greater responsibility than Adam or the serpent? These persistent questions informed French literature and imagery of the nineteenth century, and they applied to contemporary women by proxy as daughters of Eve.

The story of Eve in the Bible had a counterpart in the story of the Virgin Mary, who was the New Eve destined to atone for the sin of Eve through the Immaculate Conception and birth of the masculine redeemer, Jesus Christ.[2] Tertullian (c. 160–230) dealt with the Eve-Mary antithesis by describing the Fall as the devil's taking captive "the image and likeness of God" (that is, man) through a woman; God used a parallel process to reverse it.[3] For this reason, representations of Mary often show her crushing a ser-

pent. Mary became the image of an anti-Eve and a "pure" mother. Mieke Bal has exposed the self-contradictory notion of Mary's "correction" of Eve's mistake. Eve represented both sexuality and motherhood; in Mary, woman's sexuality was denied.[4]

The preexisting dichotomy between Mary and Eve, which leads to other contrasting pairs, such as virtue versus vice, wife and mother versus prostitute, was put to good use by artists and writers. Although there was great interest in depicting Eve in art, literature, and drama in nineteenth-century France, the reason for her appearance in painting and sculpture had much to do with her nudity before the fall, which was considered appropriate subject matter in the periodic Salons of the Académie des Beaux-Arts.[5] The term *fille d'Eve* thus developed within biblical, historical, and artistic contexts. It is important to examine how and why the term came to be used, and how it related to judgments about woman's role in society during an intensive period of feminist activism.

Fatal Traits

Dee Woellert has stated that Eve, despite being a religious image, was "generalized and secularized to support and justify attitudes, institutions, practices and expectations."[6] Woman's nature was given specific definition and purpose, involving both her appearance and submissive behavior. Eve's deception condemned successive generations of women to obey man's rule; her redemption was through the pain of childbirth. While Eve's character evolved from that of a dupe to that of seductress, two important factors remained: she sought *knowledge* and *led man astray*.

The narrative of Genesis 3:1–8 supports neither the idea that the snake was Satan in disguise, nor the concept that Eve's convincing Adam to eat the apple was part of a sexual seduction. In Genesis, the snake is just a snake, and Eve promises Adam a higher order of knowledge if he eats the apple. Saint Augustine (b. 324), however, in a chapter of *The City of God* entitled "How the Devil Used the Serpent," reconceptualized the snake.[7] Simultaneously, Eve was recast as lacking the moral character to discern the devil's disguise. Tertullian had already extended Eve's guilt to all women with the statement, "Do you not know that every one of you is Eve?"[8] Women's desire was specifically identified as foreshadowing death, for it was Eve's desire for the apple that ultimately caused the death of the Son of God. The cases of Augustine and Tertullian provide two examples of how biblical interpreters, for reasons often wholly their own, recast the light in which Eve was seen. The common understanding of Eve as a femme fatale who caused mankind's downfall through her voice and sexuality was not a notion put forward in the Bible; rather, it evolved gradually through the writings of successive theologians.

As they wrote their descriptions of Eve, these interpreters no doubt took into consideration Lilith, Adam's first wife in the Judaic tradition, either deliberately or due to confusion. Lilith, created as Adam's "equal," refused to become submissive during intercourse with her husband and was cast out of Eden.[9] Subsequently,

she was responsible for abducting newborn children and fostering men's erotic dreams. She was not present in the Garden of Eden during the Fall, but by some accounts she encouraged Satan to tempt Eve with promise of dominance and independence.[10]

When Christianity separated from Judaism, any mention of Lilith was suppressed and Eve became the submissive partner created from Adam's rib. Creation from a part of the body not involved in walking, talking, or thinking sealed her inferiority. Eve also came to be intimately associated with the serpent, later identified as Satan. John Phillips has explained how Eve could be seen as the devil's mouthpiece, or could be "seen in some way to be the forbidden fruit, or the serpent in paradise, or even the fall."[11]

While successive modifications to the Eve myth are significant, we are most concerned with the particular configuration of that mythology in nineteenth-century France. John Milton's *Paradise Lost,* which first appeared in French in 1778, is the source of the contemporary interpretation of Eve.[12] Not only was the whole text widely read in France, but portions of it were quoted by authors concerned with the image of woman that was being promulgated in popular literature at midcentury. Louis Julien Larcher (1808–65) edited a series of twelve books containing the thoughts of famous thinkers about women. Milton's *Paradise Lost* is cited in Larcher's *Satires et diatribes sur les femmes, l'amour et le mariage* (1860).[13] Milton doubtless possessed an understanding of the Creation story already modified by successive generations of biblical interpreters; he would add his own changes.

Milton depicts Eve as having a physical hunger, not reported in the Bible, which leads her to the forbidden fruit. What had been Eve's more general desire is here shown as a "complex set of inner drives, anchored not only in her physical, but also in her intellectual nature."[14] Satan is seduced by Eve's beauty and uses flattery to gain her confidence. It is the serpent's ability to speak that leads a curious Eve to the tree of forbidden knowledge. When Adam learns of her transgression, he makes the deliberate, and romantic, decision to eat the fruit so they may suffer together. In book 10 of *Paradise Lost* the transgression became known and the act described: the serpent perverted Eve and in turn, she perverted Adam. Before exiting Eden, Adam is given a privileged view into the future.[15]

The lopsided nature of the Creation story was exposed only by profeminist French writers, including Ernest Legouvé, whose *La femme en France au dix-neuvième siècle* (1864) disclosed how the Eve story influenced the contemporary perception of women. One activist, Maria Deraismes, described in her 1872 pamphlet *Eve contre M. Dumas Fils* (discussed below) the dangerous precedent set by the "common consciousness of Eve." A similar estimation of Eve is found in the four-volume *La femme dans la nature, dans les moeurs, dans la légende, dans la société: Tableau de son évolution physique et psychique* (1908). The third volume, *La femme dans la légende,* by A. Schalck de la Faverie, contains seven chapters describing mythological representations of women, commencing with Adam and Eve. In

that author's view of the biblical story, woman is tempted, becomes a temptress, and bears an unjust portion of responsibility.

> La Bible met carrément le péché sur le compte de la femme; l'homme a connu le mal et le malheur par la faute de la femme. Aussi trouve-t-on dans les premiers écrits de tous les peuples de races blanches, des allusions à la nature perverse de la femme, des prescriptions restrictives pour en combattre les effets et une tendance qui, de l'antiquité au moyen âge, va s'augmentant et fait, des descendantes d'Eve, autant de créatures d'une séduction fatale et dangereuse, qu'il est nécessaire de soumettre à la loi de l'homme.

> [The Bible places the blame for sin squarely on the shoulders of woman; it was through the fault of woman that man fell into misfortune and evil. Consequently, we find in the earliest writings of all white races allusions to the depraved nature of woman, together with cautions and instructions about combating its effects. In addition, there was a growing tendency from antiquity to the Middle Ages to portray the descendants of Eve as creatures exercising a fatal and dangerous charm, and who needed to be subjugated to the rule of the male sex.][16]

Thus, Schalck de la Faverie also identifies the Bible as the source for the belief that women are perverse by nature and doomed by fate. The association of the terms *fatal* and *fatality* with Eve became fixed during the nineteenth century.

It is important at this juncture to consider the concept of the femme fatale and its evolution. While scholars, including Virginia Allen, have claimed that the term was a product of the twentieth century,[17] it appears at least as early as 1860 in J. de Marchef-Girard's *Les femmes: leur passé, leur présent, leur avenir*. "La femme fatale," the first portion of the book, describes creation stories in various religions and concludes with the idea that since primordial times, "nous trouvons déjà le problème résolu: La femme a été l'être fatal, l'intermédiaire entre l'humanité et le mauvais principe" [We already find the problem resolved: Woman was the fatal sex, the intermediary between humanity and the principle of evil].[18]

Pandora was another literary prototype for the femme fatale during the nineteenth century.[19] Eve and Pandora were both temptresses, and their curiosity caused man's downfall. Marchef-Girard posited that Pandora inherited her traits from Eve.[20] An anonymous diatribe quoted in Edmond-August Texier's *Les femmes et la fin du monde* (1877) suggested that woman, like Pandora, "tenant dans un pli de sa tunique tous les biens et tous les maux, pouvant d'un seul geste répandre sur le monde la rosée bienfaisante des idées de paix, de conciliation, d'amour, ou déchaîner le fléau des corruptions irrémédiables" [held in a fold of her tunic every conceivable good and evil. With a single gesture she could spread upon the world the blessed dew of peace, conciliation, and love; or let loose the scourge of irremediable corruption].[21] The Eve-Pandora equation appears in a painting by Gustav Adolphe Mossa (1883–1971).[22] In *Eva-Pandora* (figure 2), Mossa depicted a dark-haired woman clutching a box and holding an apple, while a serpent coils around her neck.

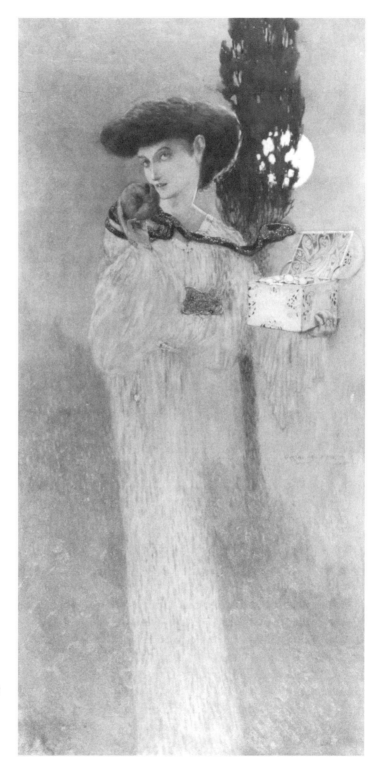

Figure 2. Gustav
Adolphe Mossa,
Eva-Pandora.
Oil on canvas,
1907. Private
collection, Nice.
© 2005 Artists
Rights Society
(ARS), New York/
ADAGP, Paris,
and Associa-
tion Symbolique
Mossa.

As Eve's meaning and significance were altered by theologians, so too was the story of Pandora changed. In the original story, there was no box. As H. R. Hays has pointed out, the acquisition of the box had significant psychological and misogynistic implications.[23] Like Eve, Pandora was originally linked to older fertility goddesses with not just one associative meaning, but rather a collection of positive and negative characteristics. Hesiod, who added an episode that included a jar, later called a box by Erasmus, made her a symbol of evil. The jar is symbolic of Hittite and Syrian earth mothers, but it came to be associated with death through the Greek practice of burying the dead in large urns. The jar, or box, was also associated with sexuality. It could stand not only for a womb, but for the female genitalia, which explains its particular placement in many works of art. The *boîte fatale* is a significant component of Louis Julien Larcher's discussion of Pandora (which is followed by a chapter on Eve) in *La femme jugée par l'homme: Documents pour servir à l'histoire morale des femmes et celles des aberrations de l'esprit des hommes* (1858).

Félicien Rops (1833–98) compared the love of women to Pandora's box in a letter to a female friend in 1892.

> L'amour des Femmes, comme la boîte de Pandore, renferme toutes les douleurs de la vie; mais elles sont enveloppées d'un si lumineux paillon d'or, elles ont de si brillantes couleurs et de tels parfums, qu'il ne faut jamais se repentir de l'avoir ouverte! . . .
>
> . . . Ces parfums éloignent la vieillesse et gardent en leurs relents les fiertés natives. Tout bonheur se paie et j'en meurs un peu des doux et subtils poisons envolés du fatal coffret, et cependant ma main que l'âge rendra bientôt tremblante trouverait encore la force d'en briser les sources mystérieuses.
>
> [The love of Women, like Pandora's box, contains all life's ills. Yet they are wrapped in such a glittering golden foil, and so dazzling are their colors and such their perfumes, that we should never regret having opened it! . . .
>
> [. . . These perfumes repel old age; their bouquets preserve one's native pride. But all happiness must be paid for, and I am slowly dying of the sweet and subtle poisons wafting from that fatal casket. Yet my hand, which soon age will set a-tremble, would still find the strength to break open their mysterious springs.][24]

Rops described a fatal attraction that cannot be avoided through reason alone.

As with Eve, modifications to the characteristics of Pandora heightened her dangerous sexuality while placing her curiosity in the background. Marchef-Girard believed that Eve had become no more than a symbol of sexuality and man's inability to resist it. Considering the implication of a symbolic, fatal Eve, Marchef-Girard determined that persistent ancient beliefs were manifest in the decadence of contemporary society. Prostitution was suggested as a product of the physical weakness of woman. The roles of women as wife and mother, nun, artist, and slave have also derived from traditional beliefs. Already in 1860, Marchef-Girard

predicted an increasing gravitation toward ideal types in both painting and print media, a fact demonstrated in numerous illustrated books of the late nineteenth century.[25]

Many of Eve's traits have been described by John Phillips as weaknesses, including "her curiosity, vanity, insecurity, gullibility, greed, and lack of moral strength and reasoning skill—combined with her supposed greater powers of imagination, sensuality and conspiracy."[26] As noted earlier, Eve's nineteenth-century characteristics were derived from the biblical narrative, either implied by the original text or provided by later interpretations of her underlying motivations. Andrew of Saint Victor (d. 1175) believed Eve's "great simplicity" explained her lack of surprise when the serpent began to speak.[27] But Eve's motivation could also be thought selfish because she gained special knowledge and used it immediately "in a devious and manipulative way to gain power over Adam."[28] The misogynistic reading of Genesis acquired a "status of canonicity." By the nineteenth century, both feminists and antifeminists could agree upon what the original text meant, even if they didn't agree upon the implications.[29] Artists working for illustrated periodicals embraced Eve's ambiguity, focusing most frequently on her curiosity, weakness, and sin. The latter, specifically connected to sexuality, became frequently equated with prostitution.

Henri Gerbault illustrated "typical" female traits in his article "Leurs états d'âme" for *La Vie Parisienne* (figure 3).[30] A woman sprouting like a plant represents the qualities of naiveté and innocence, while the reclining nude, labeled "âme Danaë," is showered with coins and paper money. The curious "soul" is illustrated by a woman robed in a snakeskin climbing toward the apple of knowledge. Curiosity was a fatal characteristic that linked Eve to Pandora.

Denis Caron took this idea further when he stated, "Toutes les femmes sont curieuses, et la curiosité leur est toujours fatale" [All woman are curious, and their curiosity always proves their undoing].[31] Eve's curiosity was treated by Maria Deraismes in *Eve dans l'humanité:* "Cela est si vrai que, dans cette vieille légende de l'Eden, si mal interprétée, la femme, Eve, a pris l'initiative du progrès. A quel tentation succombe-t-elle? A celle de savoir et de connaître. Elle cède à la curiosité scientifique."[This is so true that, in the old myth of Eden, so badly interpreted, the woman, Eve, took the initiative in making progress. What was the temptation she succumbed to? That of discovery and knowledge. She gave way to scientific curiosity.][32] Eve's sin called into question whether women could truly possess a "soul" at all. In Larcher's *La femme jugée par l'homme,* a woman's soul is said to be designed and consecrated by Satan and is thus different from man's.[33] The richer implication of the French term *âme* (which has no equivalent in English and can be only approximated through contemplation of the words "heart," "soul," "spirit," and "sentiment") suggests Gerbault's image is doubly encoded with cause (Eve's weakness) and effects—a constellation of characteristics driven by "impure" desires.

Eve's "weakness" was linked to the specific and somewhat trendy illness neurasthenia in another work by Gerbault, "Consultation gratuite pour jeunes neur-

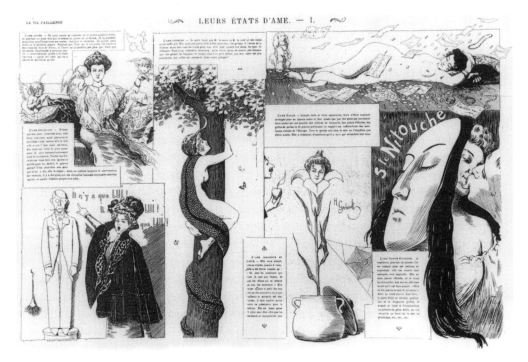

Figure 3. Henri Gerbault, "Leurs états d'âme." *La Vie Parisienne,* Feb. 11, 1899, 76–77. University of Notre Dame Libraries. Photographer, Tim Fuller.

asthéniques," for *La Vie Parisienne* in 1903 (figure 4). This visual history of neurasthenia depicts Eve as "la première neurasthénique" [the first neurasthenic]. The text within the image blames Eve's neurasthenia on boredom with Eden: the monotonous sunshine, butterflies, and flowers caused her to become "l'éternelle malade" [the eternal neurotic]. Luckily, the serpent, the first doctor and phallic stand-in, is present to deliver the cure. It is significant that Eve is described as the "first neurasthenic" in Gerbault's image, for the cause of this "nervous suffering" or "weakness of the will" was attributed to "the excessive collisions and shocks of modernity."[34] Gerbault's humor promotes sin as responsible for both the technological progression of society and the presence of Eve's daughters within it. Neurasthenia was one of many fatigue disorders, one that "stood above all others for its ubiquity and relentless attack on the core of psychic and physical energy."[35] An American doctor, George Miller Beard, had coined the term in the 1860s, using it to describe nervous exhaustion stemming from the brain or spinal cord and caused by the American lifestyle in the industrial age. Before long, French doctors embraced neurasthenia. Despite Beard's insistence on modernity as the cause, French doctors at first considered the disorder hereditary; thus, Gerbault suggested that if Eve was the first neurasthenic, then all women must be predisposed to it.[36] The text's claim that the phallic snake is the doctor sent to "cure" the patient is a reference

to the longstanding belief that sexual desire—too much or too little—was at the root of many "feminine" illnesses, including hysteria, and that intercourse could provide relief.

The most important modification to Eve in later interpretations came when she was assigned responsibility for the Fall. Once shared by Adam, blame for the Fall eventually became Eve's alone. The original biblical text suggested that Adam stood very near Eve at the moment of her transgression. This is confirmed in Early Christian and Renaissance images; but Milton's *Paradise Lost* depicted Eve alone when the snake approached.[37] Several works completed by Félicien Rops in preparation of a frontispiece for Joséphin Péladan's *Un coeur perdu* (1888) demonstrate how a nineteenth-century artist wrestled with Eve's relative responsibility. Péladan was a prolific Symbolist writer, leader of the alternative religious society named the Rose+Croix, and Rops's close friend.[38] In his book, Péladan described the "vie supérieure" [the higher way], by which he meant a life of passion, which he traced to mythological and biblical figures, including Eve.

Rops executed several designs focusing on the Genesis story in preparation for the frontispiece. "Eritis similes Deo" [You Will Be Similar to God], c. 1880–90, depicts two figures in the tree, either Adam and Eve, or Eve and a anthropomorphized serpent. Whatever the case, the figures represent the presence of the mas-

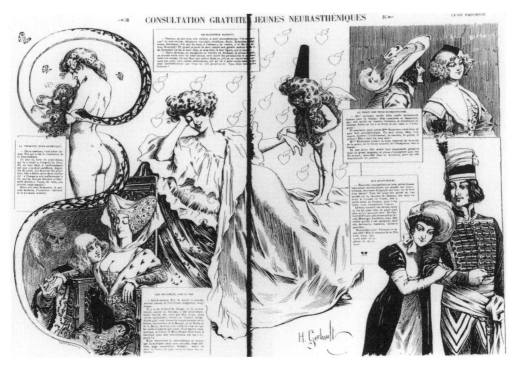

Figure 4. Henri Gerbault, "Consultation gratuite pour jeunes neurasthéniques." *La Vie Parisienne,* Feb. 28, 1903, 118–19. University of Notre Dame Libraries. Photographer, Tim Fuller.

culine and the feminine. A later engraving of this image was entitled "Tentation, ou la pomme" [Temptation, or the Apple].[39] A second engraving bearing the title "Eritis similes Deo," this one from 1896, has a more detailed representation of the snakelike tail, which now clearly belongs to the male figure; the tree behind the couple is more detailed but lacks leaves, suggesting that it is dead or dying.[40] In the version used for the frontispiece (figure 5), the serpent takes on the appearance of a rope binding Eve to the tree, thus giving her sole responsibility for the Fall. Here the tree displays abundant foliage and fruit, and a banner reading "Eritis similes Deo" floats among the branches. Phallic Jack-in-the Pulpits sprout around Eve's feet.[41] In an even later version of the image, from 1905, Eve no longer holds the apple; her hands grasp her face as she shrieks before a dying tree.[42]

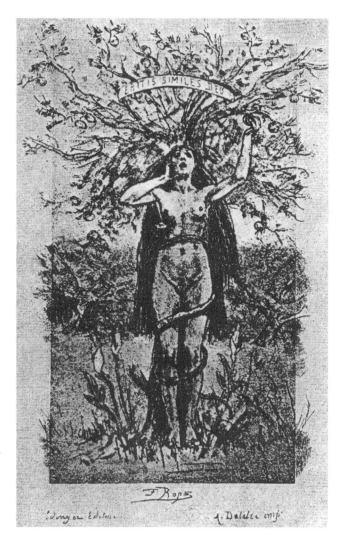

Figure 5. Félicien Rops, frontispiece for Joséphin Péladan, *A coeur perdu* (Paris: G. Edinger, 1888). University of Minnesota Libraries. Author's photograph.

An exchange of letters between Péladan and Rops during 1887 sheds light on the development of the work and suggests that the artist had limited knowledge of the book's content. As Hélène Védrine observed in her introduction to *Félicien Rops, Joséphin Péladan correspondance* (1997), Rops's image did not help the reader extrapolate the text's meaning, nor did the text explain the image. Péladan had already told Rops in a letter of 1883 how much he admired the artist's works, especially their perverse nature, which he believed would complement his work.[43] A letter from March or April 1887 indicates that Rops sent Péladan the drawing of Eve (which Rops called "Pêcheur mortel" [*sic*]); this was followed by a response from Péladan that literally turned up the heat: "Je vous demande à tous les échos de l'enfer" [I beg you until Hell rings aloud].[44] By November it was clear that Rops was concerned that the original version might result in imprisonment. He wrote to Péladan:

> Au reçu de cette lettre, télégraphiez à l'instant à Edinger d'avoir à arrêter le tirage à peine commencé, ou même *pas du tout commencé*, de la planche qui tâche de reproduire l'Eve (Pêcheur mortel [*sic*]). Je n'ai autorisé *personne* à reproduire cette planche & je n'autorise *personne* à le faire! Je ne me refuse pas à vous faire une planche *dans les huit jours*, pour votre frontispice, mais je ne veux pas que s'en [*sic*] même me prévenir on se permette ces polissonneries-là.

> [When you get this letter, telegraph Edinger at once that he must stop the printing of the plate supposed to depict Eve (Pêcheur mortel [*sic*]), whether it has just been started *or not at all*. I never gave *anyone* permission to print this plate, and I will not! I'm quite happy to make you a plate *within the week* for your frontispice, but I will not allow people to take such outrageous liberties without even a word to me first.][45]

Rops explained that the work couldn't appear as originally drawn, with the serpent's head pointed toward Eve's genitals. With retouching, the head eventually pointed toward her breast. The incident caused a temporary rift between the two men.[46] Rops had reason to worry about the censor, given the range of his subject matter; Catholics had condemned him for using satanic and blasphemous themes.[47] A clearly phallic snake appears in Rops's *Eve-tapisserie,* where Eve sits beneath the tree holding the "testicles" (apple) of a long penis (snake).[48] Rops was appropriately dubbed "le dernier peintre du péché" [the ultimate painter of sin],[49] and Péladan, reflecting later on the artist's oeuvre, concluded, "Personne n'a exprimé comme lui, Eve et le serpent: Eve et le serpent, n'est-ce pas la moitié du monde et la moitié de l'art?" [Nobody has ever portrayed Eve and the serpent like him. Eve and the serpent, isn't that half the story of both the world and art?][50]

The most common characteristic associated with Eve was sin, and this generality was expanded dramatically in a series of illustrations and texts that subdivided sin into different categories and levels of severity. Gerbault completed two series on the *péchés veniels* [venial sins] and the *péchés capitaux* [mortal sins] for *La Vie Parisienne.*[51] These were later gathered into a volume that was advertised with a depiction of Eve,

a basket on her arm, and a snake wrapped around a potted tree, now a completely domesticated version of the tree of knowledge of good and evil (figure 6). Eve was not the subject of the series—the contemporary *Parisienne* was. The most consistently depicted sins were those associated with woman's sexuality. As Edouard de Pompéry concluded in *La femme dans l'humanité: sa nature, son role, et sa valeur sociale* (1864), "La femme, c'est le péché, c'est Satan, c'est l'ennemi!" [Woman is sin, Satan, the enemy!][52] Here, as elsewhere, the invocation of Eve was merely a prelude to the "real" problem: the place of woman in contemporary society.

The woman who most obviously manifested the ills of society, from a medical as well as social and moral point of view, was the prostitute.[53] Armand Silvestre entitled his collection of stories about courtesans *Le péché d'Eve* (1885). Pol de Saint-Merry dealt with prostitution in two of the twelve volumes of his *Petite bibliothèque du coeur,* one entitled *Le péché* and the other, *Pécheresses.*[54] In the former text, the "first sin" is deemed the "sin of love"—and this is love in its most seductive aspect. The latter text describes *pécheresses* [women who are sinners] as the "irregularities" of love, women who in biblical times were called *vierges folles* [foolish virgins].[55] Saint-Merry attributed the sin associated with prostitution only to the women involved—not to the male customers. He did not intend to give instruction in moral behavior, but rather to treat the issue from an "aesthetic" point of view. The prostitute is responsible for fostering an illusion, something that only resembles love. In this sense, the *professionel de l'amour* [professional lover] is deemed an "artiste d'un genre particulier" [a particular sort of artist] who considers love as nothing more than an accessory.[56] In successive chapters, Saint-Merry explained how a woman became a pécheresse, aided by a society in which virtue existed as *trompe l'oeil*—a fragile veneer convincing onlookers of its reality.

The Nineteenth-Century Filles d'Eve

Honoré de Balzac initiated the popular use of the term *fille d'Eve* in a two-part essay by that name published in *Le Siècle* on December 31, 1838, and January 1, 1839; later in 1839, the essay was released as a book. Three years later, it appeared as part of the first volume of his *Comédie humaine.*[57] The story revolves around two virtuous sisters named Marie, the elder, Marie-Angélique, and the younger, Marie-Eugénie. The older sister marries a caring man who allows her liberties; the younger marries a controlling, dominant banker. Both sisters are miserable. Angélique's freedom exposes her to the jealousies of society women, who convince her to take a lover, described as "forbidden fruit," to deliver her from the "purgatory" of marriage.[58] Once she finds her "well-regulated Eden monotonous," her husband cannot prevent the inevitable. Balzac explained that the women's coquetry, coldness, tremors, tempers, and unreason causes them to "demolish today what yesterday they found entirely satisfactory."[59] Angélique's desire is characterized as a "symbolical serpent," which Balzac claimed approached the first woman, Eve, who was likely feeling bored. Angélique's lover becomes an "insidious serpent, bright to the eye

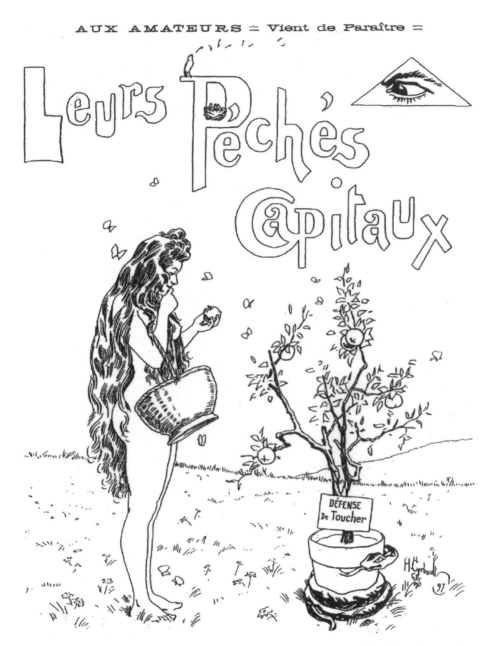

Figure 6. Henri Gerbault, advertisement for "Leurs péchés capitaux." *La Vie Parisienne,* Dec. 4, 1897, 700. University of Notre Dame Libraries. Photographer, Tim Fuller.

and flattering to the ear."[60] When her husband learns of the affair and exposes her lover as deceitful, Angélique begs for forgiveness. Balzac declared her husband triumphant for realizing that society women are to blame for stimulating Angélique's curiosity. Thus, while Balzac initially cast Angélique's lover as the serpent from Eden, eventually it is *other women* who are given that role—and the responsibility for the transgression is placed solely on feminine shoulders.[61]

In 1858, P. J. Martin (a pseudonym for Pierre Jules Hetzel [1814–86]) and Louis Julien Larcher dedicated the first section of their *Anthologie satirique: Le mal que les poètes ont dit des femmes* to "Les filles d'Eve."[62] In successive chapters various authors discussed coquetry, beauty, and different characteristics and types of women, and examined the positive and negative aspects of love and marriage. The section entitled "Les filles d'Eve" includes an interpretation of the Bible by J. B. [*sic*] Rousseau, in which the serpent's motivation is to triumph over human nature. In other sections, Destouches asked, "Les femmes iront-elles au paradis?" [Will women go to Heaven?], and Alfred de Musset declared that women have a "fatal power."[63] From Molière there is a contribution entitled "La valeur des femmes," which includes the rhyming couplet, "La meilleure est toujours en malices féconde; C'est un sexe engendré pour damner tout le monde" [Even the best is full of evil spells / A sex designed to send us all to Hell"].[64] Eve's alluring and fatal characteristics are described by many authors quoted by Hetzel and Larcher; for example, Anseaume, in his "La femme est changeante," claims that female characteristics change in response to the time of day. During the day, a woman's behavior is said to be charming, elegant, engaging, caressing and obliging; during the night it is turbulent, enervating, petulant, distressing, and provoking.[65] His essay provides a transition from discussions of Eve's nature to those treating contemporary women of Paris in the remainder of the book.

Each author modified the concepts of Eve and filles d'Eve, which by now were nearly synonymous. Charles Valette, who apparently didn't associate the terms negatively, dedicated the poems in his 1863 text *Filles d'Eve* to all the beautiful women of Paris.[66] The antifeminist Arsène Houssaye declared in the preface to his 1852 novel *Les filles d'Eve,* "Ce livre est vieux comme le monde, mais il est toujours nouveau" [This book is as old as the world, but always new]. Houssaye, who had previously written about the women of the eighteenth century, now turned his attention to those of the nineteenth, to create a *tableau vivant* of "toutes ces physionomies variées, vivantes, rêveuses, passionnées, mélancholiques, qu'il appelle Les Filles d'Eve" [all these varied types—the vivacious, the passionate, the dreamy, the melancholy—known as the Daughters of Eve]. Houssaye's story focuses on the lives of three very different women—a *grande dame* [aristocrat], a *comédienne* [actress], and a *religieuse* [nun]. Houssaye chronicled their adventures and misadventures with men in order to demonstrate, much as Balzac had, that all women are basically the same due to their connection to Eve, their "real" mother. Houssaye's text evidently continued to resonate with the late nineteenth-century Parisian audience; later editions or reprints were published in 1858, 1863, 1870, 1876, and 1892.[67]

In the last decade of the nineteenth century and the first decade of the twentieth, several authors employed Eve in significantly different ways. While their purposes and audiences varied, their texts were written with a full understanding of the rich symbols traditionally associated with Eve. The authors also understood and mobilized references to Eve's daughters, those Parisiennes of the nineteenth century seen as threatening, whether because of their agitation for suffrage, their excessive sexual power, or their increased visibility.

Jules Bois wrote two distinct types of books: novels, including his *L'éternelle poupée* (discussed in chapter 6), and treatises concerned with morality, religion, and women's rights.[68] His theoretical work *L'Eve nouvelle* appeared between 1894 and 1897, and portions of it were published in major journals, including the avant-garde literary magazine *La Revue Blanche* and the mainstream *La Revue Encyclopédique.*[69] *L'Eve nouvelle* substantially reevaluates the Eve paradigm. Bois's main concern was to link the figure of Eve with the continued subjection of women in French society. As he explained in his introduction, entitled "Fin de l'anthropocentrisme" [The End of Male-Oriented Society]: "J'ai longtemps hésité avant d'écrire ces pages où j'aurais voulu fixer la mission et l'espoir de l'Eve future; elles sont d'ordinaires si écoeurantes, les professions de foi de l'homme sur la femme. Il la juge toujours de son point de vue à lui, pour lui, selon lui, jamais elle ne possède à ses yeux une personnalité propre. Elle est toujours, non pas *la* femme, mais sa femme." [I hesitated for a long time before venturing upon this work, in which I intended to enlarge upon the mission and the hopes of the future Eve; men's professions of faith about women are ordinarily so nauseating. Man always judges woman from his own point of view—for him, according to him; she is never allowed a personality of her own in his eyes. Always she is not woman, but *his* woman.][70] Bois thought *anthropocentrisme* was a misguided belief system of the Middle Ages that was gradually being eroded by modern discoveries and increased freedom of thinking. He predicted that his suggestion of equal rights for women would be met with skeptical smiles, given the common view that a woman was in need of protection, or that she was the "goddess of the foyer [home and family], angel, eternal mother."[71]

Bois argued with Pierre Joseph Proudhon, who had dictated that a woman remain either "courtisane ou ménagère" [courtesan or housewife] or an instrument of "félicité ou de nécessité" [happiness or necessity] for man, which Bois deemed a monstrous injustice.[72] Bois voiced not only his own opinions, but those of others who had participated in the 1896 International Feminist Congress in Paris. It was here that such issues as morality, motherhood, and economics were discussed and debated.[73] One of the primary declarations of the congress was that a woman, before being a spouse, lover, or mother, was a woman: "Il faut la laisser libre; elle est ce qu'elle est et non point que l'homme veut qu'elle soit" [We have a duty to leave her free: She is what she is, and not what men would have her be].[74] Society would only benefit from the equal treatment of women.

In the first part of *L'Eve nouvelle,* Bois recounted the history of the subjugation of women. He hypothesized that prehistoric man realized his physical strength as

well as the existence of his ego; he also realized that woman was different. Darwinian thought emphasized the physical differences of woman, such as her "wound" that caused her monthly bleeding. Woman became the "first slave" and the home became the symbol of the unjust domestication of woman. As Bois observed, "Le foyer moderne est un péril pour la conscience d'Eve" [Modern family life imperils woman's conscience].[75] It was not marriage but the home that enslaved woman, yet while she may have had a million reasons to hate her situation, home was also her only true sanctuary. She may have felt like nothing more than a prostitute, but she had the love of, and for, her children. In the chapter entitled "Eve bienfaitrice de l'humanité," Bois explained Eve's centrality in nature and connected the biblical figure to goddesses in other religious systems. Elsewhere in the book, the development of the Virgin Mary as an "ideal" was discussed, to counter Eve's perceived sexual power.

In his treatise, Bois admitted that he had participated in a system that denigrated so-called evil women of the past, resulting in the current subjugation of contemporary women: "A une seule femme il est bien difficile de pardonner, c'est la femme à la mode. Elle est une forme malfaisante de notre civilisation; il faut la détruire car elle est incurable et un des aspects que prennent les fléaux mentaux et physiques de l'humanité." [One type of woman in particular is extremely hard to forgive—the woman of fashion. She represents a malicious aspect of our civilization; she must be rooted out, for she is not reformable and a manifestation of the mental and physical scourges of humanity.][76] Chapter 4 of Bois's volume provided further consideration of the *femme à la mode* as the adored slave of Paris and the ornament of bedrooms, casinos, theaters, and salons. Bois recounted how Alexandre Dumas fils declared the femme à la mode the true enemy of art and the artist, "la mauvaise, l'inconsciente ou simplement l'inutile, la frivole fit vivre de ses anecdotes bien des gras gentilshommes de lettres" [bad, without conscience, or simply useless, the frivolous woman earned many a fat gentleman of letters his daily bread with her tales].[77] Henry Becque was "son admirable vivisecteur" [her admirable vivisector] while Arsène Houssaye "fut sa corsetière" [was her corsetmaker]. According to Bois, "Max Nordau reste le seul prophète qui osa anathématiser ses toilettes et son goût monstrueux" [Max Nordau was the only prophet who dared to condemn her dress sense and her monstrously bad taste].[78] Bois believed that in the realm of society and luxury, the femme à la mode sank into increasing banality, causing her own destruction. He discussed this type of fille d'Eve as a product of patriarchal society.

The second portion of the book turned from a consideration of the genesis and development of the male-centered model to the "genesis of the New Woman." The New Eve admired by Bois followed a moral path and had a greater love for family than for commercial products. This is the type of woman he wanted to emancipate, the "real" feminist whose tears he heard, "like a grand flood forming, a flood of purification for all humanity."[79] While some claimed the *femme nouvelle* was no longer a woman but a monster—an *homme manqué* [a would-be

man]—Bois demonstrated the ignorance of this belief while also criticizing the common perception that masculinized women in turn created feminized men. According to Bois, the "real woman" remained unknown to most men, certainly to men of letters who simultaneously shaped false ideal women and miseducated women readers. He spoke not of the New Eve, but of the ordinary French woman, in whom dwelled something sacred; she was the very backbone of the nation. Bois charged that it was the antifeminists, not the feminists, who were the enemy of family and society.

In 1897, Bois published *La femme inquiète,* whose female subject stood midway between *L'éternelle poupée* and *L'Eve nouvelle:* "les femmes modernes, pleines d'élans, proches de chutes, admirables et incomplètes" [the modern woman, full of impulses, always on the verge of a fall, admirable and incomplete].[80] At the end of the book, he defended himself against the critics who had reviewed *L'Eve nouvelle* unfavorably in the Parisian press.[81] In 1912, Bois published *Le couple futur,* in which he renewed many of the arguments of *L'Eve nouvelle* and again answered critics, which suggests that his text was still controversial within certain circles.[82]

The audience for Bois's book *L'Eve nouvelle* was clearly sympathetic to the feminist cause.[83] The opposite is true for the science fiction novel *L'Eve future* (1886), by Auguste de Villiers de l'Isle-Adam (1838–89), a principal writer of the Symbolist movement. Interest in this work was such that one chapter, "L'auxiliatrice," appeared in the periodical *La Vogue* several weeks before the book's publication.[84] A reviewer concluded that Villiers de l'Isle-Adam "avait mis en relief l'impossiblité d'entente entre le mâle et la femelle en notre race" [had thrown into relief the impossibility of any *entente* between the male and female of our race].[85] A short notice in *Le Chat Noir* found that the story demonstrated that "la Science positive te fournit l'infaillible moyen de posséder *quand même,* physiquement, *la femme de ton rêve*" [positive science provides you with, *at least,* the infallible means to possess, physically, *the woman of your dreams*] and declared Villiers de l'Isle-Adam a Christopher Columbus in the new world of love.[86] The popularity of the text is demonstrated by the publication of fragments in the widely read *Mercure de France.*[87]

Villiers de l'Isle-Adam's book drew on the antifeminist science of psychology and upon other "scientific" developments of the nineteenth century.[88] The setting is the laboratory of the American inventor Thomas Alva Edison, and the future Eve is Hadaly, a female robot. Hadaly resembles the object of the inventor's desire although she has no freedom of thought or speech. An old friend of Edison's, Lord Ewald, tells the inventor of his intent to commit suicide over an affair with the beautiful singer Alicia Clary, as he was repulsed "by the disparity between her exquisite body and her vulgar, infantile intellect."[89] Ewald finds her personality absolutely foreign to her body and calls her a "living hybrid." Her singing is mechanical, not unlike what one would expect from a puppet, and even her profession seems alien. Edison proposes to relieve Ewald of his predicament by creating a robot-woman that would have female anatomy but whose nervous and circulatory systems would be controlled by wires.[90] The mechanical woman, Hadaly, would

assume Alicia Clary's appearance. Thus, Ewald would possess a woman of incredible intellect who resembled the woman with whom he was helplessly in love. This creation, of course, results in just another puppet, for Hadaly's intellect is not authentic but rather composed of the recorded words of male poets and novelists. From a feminist perspective, it is significant that the female robot is denied her own voice, bringing to mind the belief that Adam's downfall was brought about because he listened to a woman. With the voice and intellect completely under the control of man, the Eve of the future was free of the problems associated with either the biblical Eve or her nineteenth-century daughters. But there is a surprise ending: Ewald commits suicide, and it is revealed that the person in control of the female robot was not Edison but a woman—a Mrs. Anderson—who sought to avenge womankind. Villiers de l'Isle-Adam thus expressed anxiety over contemporary women in Paris as much as he predicted a frightening future. Indeed, Villiers de l'Isle-Adam's *L'Eve future* is a description of the hybridization of the present and future woman.

In *La femme future* (1890), Henri Desmarest used an approach similar to that employed by Villiers de l'Isle-Adam.[91] In this text, which is less well known than *L'Eve future* but just as laden with references to technology, the author travels in time, to the year 1999. In Desmarest's future, women are completely in control of the government and society. Shortly after his arrival in the twentieth century, he is married, an event over which he has no control. He learns that the word "Mademoiselle" is banned; "Madame" is universally used for all women irrespective of age or position. Since the women of the future, described by the term *femmes-hommes,* dress like men, carry briefcases, and smoke cigars, Desmarest finds himself fantasizing about the past. Luckily he discovers a mostly deserted community outside of Paris where he finds one woman who has not "evolved." He conspires to leave his wife, Néolia Cortive, for his dream wife, Nadia. But ridding himself of the appropriately named Néolia is not easy, for only *she* can initiate divorce.

It is clear that Desmarest was not really envisioning a future so much as depicting the complete reversal of contemporary French gender roles. This is also indicated by the space he devotes to two issues of the day: marital/divorce rights and suffrage. While initially the book seems to condemn equal rights for women, a more careful reading reveals a subtle critique of the irrationality of patriarchy. By showing men in precisely the same predicament that women had faced historically, the book exposes the universal control wielded by one sex over the other as unjust and outrageous. Although it is difficult to establish the precise audience for Desmarest's book, it is likely that the author walked a narrow line that allowed feminists or antifeminists to find in his work support for their own arguments, thus guaranteeing successful sales. At the end of the story, Desmarest runs for political office on a platform of "letting women be equal, but still women." However, before the outcome of his candidacy and the fate of society can be decided, he abruptly finds himself transported back to 1890 and happily delivered from the "artificial life" of 1999.

Most male writers did not appreciably alter Eve's significance as a symbol. With the notable exception of Jules Bois, they utilized her traditional associations to solidify the patriarchal system. The daughters of Eve were an especially useful literary device because of the duality of their attraction and repulsion. The Symbolist Jean Floux, in a long poem entitled "Les filles d'Eve," published in *Gil Blas* in 1891, described their daytime appearance as demure women with dainty hands, long hair, and nonchalant gaits, contrasting this with their nighttime persona as temptresses with poisonous but savory kisses and clawlike fingernails.

> Leur langue est docile au mensonge infâme!
> Leur coeur est fidèle à l'ancien péché!
> Mais, offrant une ombre à Satan caché,
> Les pommiers d'Eden embaument leur âme!"

> [Their tongues are on that wicked lie intent!
> Their hearts still fettered to the ancient sin!
> But, offering shade to Satan hid within,
> Eden's apple trees fill their souls with scent!]

Floux further declared these women to be "épouses d'un soir, mères de hasard,—Et jamais vraiment épouses, ni mères" [spouses of a single night, chance mothers,—And never truly spouses or mothers].[92]

Women writers in France at this time also used Eve to comment on contemporary society. At century's end, women continued to have Eve, and the descriptions of her "daughters," firmly in mind. Like male writers, each had a distinct viewpoint from which the Eve myth was reevaluated or repositioned. In Marie Krysinska's poem in the *Revue Indépendante* in 1890, Eve, Helen of Troy, and Mary Magdalene are considered as three positive feminine types.[93] Adam is absent from Krysinska's consideration of Eve, who is described as beautiful and independent. The lascivious serpent is hopelessly attracted to her, and their amorous encounter is conducted "ignorants de leurs prodigieuses destinées" [ignorant of their stupendous destinys]. Sibylle-Gabrielle Marie-Antoinette de Riquetti de Mirabeau, comtesse de Martel de Janville, assigned the name Eve to the title character of her 1895 play *Mademoiselle Eve.*[94] By this time, the comtesse, who adopted "Gyp" as her male literary persona, was practically accepted as an *homme de lettres,* having written dozens of short stories, books, and articles that appeared in *La Vie Parisienne* and other journals.[95] In fact, she published a shortened version of the play in *La Vie Parisienne* in December 1881, using her pseudonym of "S," for "scamp." Her use of Eve as a character was related to her study of the women of contemporary Paris, which she detailed in a manuscript entitled "La femme de 1885."[96]

While the word *femme* had previously evoked a gentle, sensual creature, with "absolute ignorance" and "ferocious coquetry," the woman of 1885 was in Gyp's estimation more independent and not limited to the "femme de science et la femme de sport, [and] la femme de jeu" [the woman of science, sport, and gambling]. The

woman of 1885 was deemed "un bizarre mélange de potache, de bookmaker et de bas-bleu" [a peculiar hodgepodge of schoolgirl, bookmaker, and bluestocking]. The author gave Mademoiselle Eve these characteristics and made her a triumphant heroine. Appropriately named, Mademoiselle Eve was natural, even wild, and transformed by outdoor exercise. She was raised mostly by men, and she was quite content without female role models. As the play begins, however, she is placed in the care of her grandmother, who is charged with finding her a husband. Eve, however, is intent upon marrying a childhood friend, Robert. In a society where women and men alike use any method, no matter how unsavory, to secure a match that will benefit them financially, Eve appears relatively naive in her motivations. Pierre Moray, a friend of Eve's grandmother, finds Eve intimidating and intriguing. He is sent by the grandmother to dissuade Eve from marrying Robert, but things go awry when he finds himself falling in love with her. He tells her that other than himself, she couldn't find a better man than Robert. When Eve asks him about his own situation, he admits that he is unhappily engaged to be married. Returning the conversation to Eve's impending marriage, Moray is surprised to find that Eve desires a large family, which was currently deemed passé. When she declares, "I'm not like everybody," he's taken aback at her ability to speak her mind. A few days later, Eve is involved in a strange incident in the middle of the night, which on the surface appears to compromise her morals. There is an innocent explanation, but Robert does not believe her, and she breaks off the engagement. She chooses to marry Pierre Moray, despite the age difference and the disapproval of her grandmother, because he stood steadfastly by her when the rest of society assumed the worst. Gyp's conception of Eve was consistent with her own experience as a woman, who had possessed a great deal of independence and freedom, but who was not technically a feminist.

Other reinterpretations of Eve were published in so-called radical feminist publications in the 1890s. Maria Martin's *Journal des Femmes* printed "L'Eve future" (1894), an article that consisted of portions of an interview with Eugénie Potonié-Pierre. While not alluding to Villiers de l'Isle-Adam's story by the same name, it is clear that the journal sought to refer to it through the choice of title. In the interview, Potonié-Pierre declares: "La femme de l'avenir sera, je crois, ce qu'est celle du présent, qui voit plus loin que des lois oppressives et des moeurs idiotes" [The woman of the future will, I'm certain, be the same as today's, able to see beyond oppressive laws and idiotic customs]. Blame for the current state of affairs is placed on education and the restrictive costume imposed upon women as part of the "terreurs masculines." Potonié-Pierre hopes that in the future women will not be dependent upon men. In order to obtain this, women would need to transform themselves both intellectually and physically. The "Eve of the Future," envisioned in this feminist article, would base her costume on that of the bicyclist, who was allowed liberty of movement: "le corps que la nature nous a fait, comme si nous en rougissions!" [as if we should be ashamed of the body God gave us!].[97]

An entire series of articles entitled "La révolte d'Eve" ran in the feminist paper *La Fronde* in 1898.[98] Written by Marcelle Tinayre, these articles detail the social situation of women while predicting the future of their status. The first in the series begins with a description of a secularized Eve brought into the future and no longer content with her role. A conversation ensues with Adam, who, in a magnanimous gesture, decides not to silence her or replace her. Adam argues that Eve's very nature has determined her state; she counters that rather than working together to serve their common interests, everything that has transpired over the past six thousand years has been calculated to serve only his ego. Eve demands the right to establish the conditions of her happiness. Successive articles find Adam and Eve in discussions about the introduction of sin into the world and the very biblical interpretations that ascribed blame to woman alone. Eventually, they also discuss the right to divorce and the right to vote. Rather than accepting the biblical Eve as a symbol of woman's servitude to man, Tinayre actively transformed her by making her a part of the feminist movement in nineteenth-century France. Just two years later, the announcement of Maria Deraismes's collected writings, an "oeuvre de bonnes féministes" [good feminist work], entitled *Eve dans l'humanité,* appeared in the *Journal des Femmes,* which similarly appropriated Eve as a feminist symbol.[99]

Artists of the period imagined the filles d'Eve as encompassing a variety of types of Parisian women. J. Beauduin in his illustration "Eves parisiennes" for *Paris s'Amuse* (1883) included a fashionable woman who, we are told, loves her mirror too much. She is shown wearing a veil and carrying a muff.[100] Also depicted are an actress, a maid, a ballerina, and an artist. Both wealthy and poor classes are represented through dress and setting (the street versus the opera, for instance). The message is that the "Eve parisienne" is any and every woman; a perverted sexuality is suggested with the addition of the partially undressed "Lesbos," who touches her breast. Henri Gerbault's "Histoire naturelle" dramatically posited two very different types of women, both considered filles d'Eve (figure 7). These two descendants of Eve—one feminine and fashionable, the other more masculine—represented allegedly dangerous elements in society. The more fashionable type is the consumer model, the woman who is fascinated by new accessories and fashions, increasingly available and increasingly desired. This woman stands for the ambiguous type that would encompass certain prostitutes, certainly those who would sell their bodies for luxuries, but also the leisure-class wife from the upper-middle classes, who would be most likely to find a lover, according to popular novels of the period. The second woman represented is the stereotypical feminist, who, in her quest for freedom and equality, has somehow compromised her femininity and therefore taken on a masculine appearance.[101] Both types of women shared an increasing visibility and freedom, which threatened men in French society.

One of the popular illustrators of the period, Henri Gray (1858–1924), was known as the "dessinateur breveté des Folies-Bergère" [commissioned artist of the Folies-Bergère] and the heir-apparent to another artist considered here, Alfred

Figure 7. Henri Gerbault, "Histoire naturelle: Produits du même sexe, descendants de la même mère, Eve." *La Vie Parisienne*, May 16, 1903, 278. University of Notre Dame Libraries. Photographer, Tim Fuller.

Grévin (1827–87).[102] In a mock biographical article for the series "Nos dessinateurs par eux-mêmes" [Our Illustrators, written by Themselves], Gray allowed a fictional woman named Parisiana to make an address on his behalf, which began:

> C'est moi qui t'écris, moi, Parisiana la fille de ta fantaisie que tu as crayonnée pour le *Courrier Français*. Grâce à cette feuille aimable je me suis trouvée emportée dans les postes avancés du monde intelligent, où je veux à ton profit voir, entendre, et noter ce qui s'y passe. Je ne suis pas *fille d'Eve* pour rien, et ma curiosité aura au moins une utilité; et puis, qui se défiera de moi? je suis en papier! . . . Toi, tu ne peux jamais surprendre par toi-même un avis sincère sur tes productions; eh bien! c'est moi qui t'éclairerai et t'apprendrai bien des choses qui te guideront dans l'avenir.

> [It's me writing, me, Parisiana, the fantasy woman you drew for the *Courrier Français*. Thanks to this charming publication, I have found myself transported to the front ranks of the intelligentsia where, for your benefit, I intend to see, hear, and note what is happening. I am not a "daughter of Eve" for nothing, and my curiosity will at least serve a purpose. And then, who will be on their guard against me? I'm only made of paper! . . . You yourself can never come upon an honest opinion of your work; well now, I will enlighten you and teach you a great deal to guide you in the future.][103]

This statement reveals the presumed sophistication of readers of *Le Courrier Français,* even while it centralizes the notion of the anxiety caused by the "fantasy" woman who carries the title *fille d'Eve.* The fictional Parisiana addresses her critics and also acknowledges Gray's and Grévin's mastery of the genre she represents, while noting that many others were following their example.

There emerged in illustration and literature a fictionalized contemporary Parisienne who, like Gray's Parisiana, was a fille d'Eve. She appeared in many manifestations, the inheritor of "natural" traits within the "New Eden" of nineteenth-century Paris, replete with modern temptations: fashions, addictive substances, and prostitution.

Part Two MARKETING TEMPTATION

TWO Artificial Paradise

French images of feminine evil such as filles d'Eve or femmes fatales developed in the context of materialism, a burgeoning high-fashion industry, and changes in the private and public relationships between the sexes. In the last quarter of the nineteenth century, the department store and ready-to-wear clothing transformed the culture of consumerism. The sartorial appearances of women changed more rapidly than ever before, and new fashion trends were described in the popular press. Advertisements for clothing and couturiers, along with both serious and humorous illustrations of fashionable women, were capable of stimulating an intense desire in women of all socioeconomic groups to acquire whatever was à la mode. Illustrations appearing in such journals as *Le Journal Amusant, Le Monde Parisien, Le Courrier Français, La Chronique Parisienne,* and *Le Rire* identify these patterns of desire while serving as barometers of taste, fashion, and humor. Alfred Grévin's illustration "La première traîne" (see figure 8) demonstrates the symbiotic relationship between fashion and the periodicals, as newspapers made the fashion, and fashion made the newspapers, simultaneously.[1]

The increasing democratization of fashion through weekly updates in many of the periodicals, which included some journals dedicated exclusively to fashion, identified the current trends in an accessible format for women and men alike. The sharing of journals, and the availability of periodicals at *cabinets de lecture,* provided

Figure 8. Alfred Grévin,
"Fantasies parisiennes:
La première traîne." *Le
Journal Amusant,* Mar.
8, 1879, 1879, cover.
University of Minnesota
Libraries. Author's pho-
tograph.

information to an ever-widening circle of women. Eventually, clothing became
unreliable as an indication of social status or class, and frustrated police could no
longer distinguish a prostitute from the bourgeoisie by dress alone.

Similarly responsible for the fostering of material desire was the department
store, which, as its role expanded, was more capable of demonstrating the com-
plete picture of fashion than the specialty stores it replaced. Department stores
also provided greater job opportunities for women within the fashion industry.
Sales women and fashion models were expected to dress more attractively, a fact
that led some to compromise their morals in order to be au courant. Stores in Paris
became a new paradise, and fashion the new temptation. Both facts were ably
described by Emile Zola in his novel *Au bonheur des dames* (1883).

The Parisienne was intricately linked to fashion and to many concepts that
applied equally to certain types of clothing and to women: desire, temptation,
seduction, vanity, luxury, elegance, and "chic-ness." Eve was not only the mother
of humanity, but also the first woman to take an active interest in fashion. This was
humorously alluded to by G. A. de Caillavet and Robert de Flers, who suggested
that Eve's first words to Adam were that she "had nothing to wear"—"Voilà com-

ment la mode fut crée cinq minutes après la femme!" [And that was how fashion came to be created five minutes after Woman!][2] In this construction, fashion can be seen as the apple, while the department store can be viewed as paradise, an analogy actively observed both by the men who built the stores and by individuals who were critical of them. Through the examination of this larger context, the fille d'Eve and femme fatale can be understood as volatile mixtures of fashion and the feminine body, becoming both advertisements of sensuality and a warning against indulgence in pleasure. Perhaps most significant of all, they serve as visual manifestations of conflicting masculine impulses toward women and the women's rights movement.

Eve: Mother of Fashion

Since the seventeenth century, the paradise of Eden had been discredited. No longer able to believe in that paradise, the French created their own conceptualized versions, in the gardens of Versailles and later projects.[3] By the nineteenth century, with the increased buying power of the middle classes, manufactured paradises were found in the center of Paris in elaborate department stores.

The Genesis story, concerned as it was with bodies and sexuality, described the differences between the male and female bodies while noting that certain areas were erotically charged.[4] When the Genesis story underwent theological revision, fashion and makeup were frequently brought into it. Tertullian in particular was concerned with women's fashions during his day, and he interpreted Eve in such a way to instruct women about appropriate clothing and other aspects of physical appearance.[5] During the nineteenth century, there were many anecdotes linking the Eve of Genesis with fashion. Alphonse Karr, in *Encore les femmes* (1858), was concerned with women's contemporary obsession with fashion. The final section of his book, "Grandeur et décadence de la feuille de figuier" [The Rise and Fall of the Fig Leaf], functions as an afterword explaining the connection of the entire text to Eve and the Creation myth. In Karr's estimation, eating the apple was far less significant than the fact that once Eve realized her nakedness, she persuaded Adam to cut fig leaves so that she could clothe herself. But she was hampered by not having a fashion magazine to guide her. Karr quipped: "C'est fâcheux; les anciennes modes reviennent de mode; si celle-là revenait, on serait fort embarrassé" [Dear dear! The old fashions are coming back; if that happens, it would be extremely embarrassing!][6] The demand that Eve made upon Adam to cut the fig leaves, according to Karr, "créait à la fois la pudeur et la coquetterie, la jalousie et la prétendue supériorité des forces de l'homme" [simultaneously gave rise to modesty, the desire to look chic, jealousy, and the so-called superiority of the male's physical strength].[7] Karr maintained that this scenario continued to his own day; only the fig leaves had changed, and successive generations of Eves have expected their Adams to climb higher and higher branches to reach them.

In the late 1860s, a collection of twenty-one illustrations by Alfred Grévin was

published under the title *Filles d'Eve.*[8] Today, Grévin is primarily remembered as the founder of the Musée Grévin, a wax museum in Paris. He was a popular illustrator for a host of periodicals, including *Le Journal Amusant;* he was also the primary artist and editor of the *Almanach des Parisiennes* and a well-known costume designer for theatrical productions. Grévin achieved a reputation for his invention of a composite type of Parisian woman.[9] The "Grévin type" became so prevalent that the playwrights Léon and Frantz Beauvallet prepared a theatrical production in 1876 entitled *Les "jolies filles" de A. Grévin.* It was advertised as *Les femmes de Grévin* because of the original title's offensiveness to censors.[10] The reviewer Achille Denis, however, objected to the word *femmes,* which he believed neither reflected the authors' intentions nor did justice to the inspiration for the production—Alfred Grévin's drawings.[11] Distracted from the task of reviewing the play, Denis waxed nostalgic about the characteristics of the women themselves, and he inadvertently provided critical information about women who held such appeal that they influenced a whole generation of artists and writers.

> Il s'est borné, il a pris plaisir à nous montrer ses curieuses créatures sous leur aspect le plus aimable et le plus provoquant, remuantes, frétillantes, effrontées, et séduisantes dans leurs toilettes tapageuses, riant, chantant, dansant, folâtrant et se moquant de tout; surtout de leurs amoureux, de vraies Parisiennes vouées à la damnation éternelle et qui n'y pensent guère. Jolies Filles, c'est bien leur nom. On pourrait presque dire c'est leur état; elles sont un des côtés étranges du monde parisien qui contient tant d'énigmes redoutables.

> [In the framework of self-imposed limits, he has delighted in revealing his curious creatures in their most winsome and provocative aspects, rowdy, wriggling, impudent and seductive in their loud costumes, laughing, singing, dancing, playing the fool and making fun of everything—especially their lovers; true Parisiennes vowed to eternal damnation without ever giving it much of a thought. "Jolies Filles" is their name. One could almost say it is their profession; they represent one of those bizarre areas of Parisian life packed with formidable enigmas.][12]

Denis's tone shifted as he alluded to a dangerous aspect of these women, which neither Grévin nor the playwrights mentioned, an omission in Denis's view.

> Toute cette jeunesse, toute cette beauté, toute cette grâce charmante servira de pâture au monstre. . . . Il a crayonné ses modèles d'une maine leste et spirituelle, les démons en falbalas qui posaient devant lui sans y entendre malice. . . . Après nous le déluge, telle pourrait être la devise de ces jolies filles qui ne se doutent guère que le déluge est si proche et que cependant elles auront encore, hélas! le temps de bien souffrir avant d'en être submergées. . . . Et allez donc! comme disent ces fiévreux viveurs et ces viveuses endiablées qui ne veulent penser à rien.

> [All this youth, this beauty, all this charm and grace will become fodder to the "monster." . . . He has drawn his models with a nimble and witty touch, demons in frills and flounces posing quite innocently for him . . . "After us, the deluge" could well be the motto of these jolies filles who hardly seem aware that the deluge is so

imminent and that, alas! they will have time to suffer before it overwhelms them. . . . "So what then?" as they say, the fast set, those frantic young men and wild young women, with no thought for anything but pleasure.][13]

Grévin's drawings were admired by Victor Hugo, who believed that the artist had created an ideal after which the women of the period modeled themselves.[14] Some called this creation *la Parisienne,* a "joli petit animal mutin, minuscule et pervers, aux yeux fureteurs, au nez en trompette, à l'allure troublante" [a pretty, mischievous little creature, tiny and perverse, with inquisitive eyes, turned-up nose, and a disturbing way of carrying on].[15] The women in Grévin's album *Filles d'Eve* were composites, forged from personal observations not of women as individuals, but rather of women as a group, indistinguishable now by their social class or historical period. In the twenty-one briefly captioned plates, Grévin took the viewer from the Genesis of Eve's paradise to the twentieth century. Indeed, he predicted a literal return to Genesis.

The first four plates form a kind of subset in the series. The first plate (figure 9) carries a quote from Victor Hugo, "La première des crinolines fut une feuille de figuier" [The first crinoline was a fig leaf], and Grévin's response to that quote: "Alors, voici la seconde" [Well, here's the second]. The illustration features four women wearing elaborate skirts made from large leaves. Each woman's costume is

Figure 9. Alfred Grévin, "'La première des crinolines fut une feuille de figuier.' —Alors, voici la seconde. [Victor Hugo]." *Les filles d'Eve,* c. 1868. Bibliothèque Nationale de France.

made from a different type of leaf, leading to a unique silhouette. The ensembles include parasols and hats; one woman has a large pet grasshopper on a leash. Small vines are entwined around the models' delicate ankles and flowers adorn their hair. Each woman is presumably bare-breasted, although this detail is not emphasized. Several signs reading "Confections pour dames" [Women's Fashions] point up the idea that in Eden, following quickly on the fig leaf, several couturiers began creating elaborate one-of-a-kind garments for the filles d'Eve. Unconcerned about what precipitated this event—the snake or the apple—or about what would happen next—the Expulsion—these ladies are content to compare respective fashions. Grévin shows no men in this environment, leaving the signs to communicate the idea of the couturiers, who, in nineteenth-century Paris, were primarily male. Grévin's women are responsible for original sin, and almost immediately, their thoughts turn to vanity, rather than humility.

The second image shows the women abandoning their floral costumes for animal fur; the third shows them riding ostriches and swans, in advance of the discovery of the horse, says the caption; and the fourth shows women in Egyptian dress. This last plate carries the caption, "Puis vinrent les tissues et les métaux . . . l'utiphardes et Salamboos" [sic] [Then came fabrics and metals . . . the Utiphardes and the Salamboos]. One of the women holds a crocodile and another has a snake wrapped around her. Grévin's intent in this subset of images was to link women to plants, then animals, birds, and reptiles. He made a final reference to the idea of "fatality" through his expression of the close ties of women and nature, and more directly, through the reference to Salammbô, the modern Salome created by Gustave Flaubert in 1862.[16]

The fifth plate serves as a transition to more recent times. Here, a man is shown unfurling a giant leaf, displaying it to women dressed in 1860s fashions, who appear to be taking a tour with opera glasses. The caption reads: "Jetons, si vous le voulez bien, Mesdames, la modeste feuille de la pudeur sur les temps qui pourraient vous sembler par trop . . . mythologiques, et passons sans transition aux premières années de notre histoire" [Ladies, if you will be so kind, let us cast the fig leaf of modesty over times that may seem too . . . mythological, and pass on at once to the earliest years of our history].

Plates three to twenty provide a chronological history of women, from the era of the Gauls to 1840, with a focus on the development of fashion, an intent made clear by the subtitle of the volume: "album de travestissements plus ou moins historique" [an album of women's dress, arranged more or less historically].

The final image in the series is captioned "Le boudoir d'une Parisienne au vingtième siècle" [The boudoir of a twentieth-century Parisienne] (figure 10). The flower-fashion from the first plate has returned, and, in fact, the plants have taken over the woman's environment. The presumed owner of the room and her young attendant are dressed in more elaborate costumes of leaves, which form not only the large base of their skirts but also such accessories as hats and jewelry. Grévin's message is clear: woman's relationship to nature was revived in his lifetime, not

Figure 10. Alfred Grévin, "Le boudoir d'une Parisienne au vingtième siècle." *Les filles d'Eve,* c. 1868. Bibliothèque Nationale de France.

only through the Creation myth, but also through contemporary fashion. His satirical intent is evident, given his sponsorship listed as "aux bureaux du *Journal Amusant,* des *Modes Parisiennes* de la *Toilette de Paris* et du *Petit Journal pour Rire*" [by the magazines *Le Journal Amusant, Modes Parisiennes, Toilette de Paris,* and *Le Petit Journal pour Rire*]. He meant to depict fashion as ridiculous in and of itself, besides using it as a device to stimulate commentary on more general societal issues, including politics and morality.

Fashion was taken seriously by many prominent writers of the nineteenth century. Charles Blanc, who was state minister of the fine arts in the early 1850s and again in the early 1870s, published a series of four articles entitled "L'art dans la parure et dans le vêtement" in the *Gazette des Beaux-Arts,* of which he was founding editor. In the articles, he considered the role of colors in creating harmonious dress, jewelry, and other accessories. These articles were later published as a text that formed a companion volume to his *Grammaire des arts du dessin* (1867). Théophile Gautier called fashion an "index for the changing standards of beauty in the modern world."[17] Baudelaire connected fashion and modern life in *Le peintre de la vie moderne* (1863). He described the contemporary artist's role as one of locating "ideal beauty" through an observation of the continually changing display of feminine dress.[18] Further, he defined fashion as the "permanent and repeated

attempt to improve upon crude nature" and "a symptom of the taste for the ide-
al."[19] Stéphane Mallarmé served as writer, editor, and publisher of eight issues of
La Dernière Mode: Gazette du monde et de la famille, in 1874. But perhaps the most
passionate aficionado of women's fashion was Octave Uzanne, who published
several books on the subject as well as treatises on accessories such as fans.[20]

Uzanne entitled his most extensive work *Etudes de sociologie féminine: Parisiennes
de ce temps en leurs divers milieux, états et conditions: Etudes pour servir à l'histoire des
femmes, de la société, de la galanterie française, des moeurs contemporaines et de l'égoïsme
masculin. Ménagères, Ouvrières et courtisans, bourgeoises et mondaines, Artistes et comé-
diennes.*[21] Uzanne called Paris a paradise that contained hell within it, and he linked
the desire for luxury to primal instincts and life-or-death struggles culminating in
a fall. He declared the Parisienne to have the beauty of the devil.[22]

> Grâce à la Parisienne, la rue devient, à Paris, pour tout artiste et tout amoureux, le
> féerique Eden des désirs subits, des admirations foudroyantes, des aventures étrang-
> es. Le coeur y trébuche et y bondit à chaque pas; les yeux s'y délectent sans fin et
> la flânerie s'y acagnarde en de délicieuses sensations. L'homme qui sait y muser
> lentement et avec amour s'y retrempe à tout âge, rien qu'à regarder, admirer, flairer
> et écouter au passage ces jolies promeneuses à l'oeil gai, au minois chiffonné. Son
> esprit amoureux chante d'éternelles aubades à toutes ces mignonnes créatures d'Eve
> qu'il ne connaîtra peut-être jamais, et ses sens y demeurent heureusement en éveil
> bien au delà de l'heure du couvre-feu et des crépuscules de l'âge.

> [Thanks to the Parisienne, the streets of the capital have become, for every artist and
> lover, an enchanted Paradise of sudden desires, devastating strokes of passion, exotic
> adventures. At every step the heart leaps and misses a beat; the eyes find ceaseless
> sources of delight and the stroller drifts on a tide of delicious sensations. The man
> who can reflect slowly and fondly on these things can recapture their joys, what-
> ever his age, merely by gazing at, admiring, sniffing, and listening to these pretty,
> happy looking passersby with their cute little faces. His love-struck spirit utters
> endless serenades to these darling daughters of Eve whom he will probably never
> get to know, and his senses remain happily awake long beyond the hour when age
> should impose its curfews and its twilight.][23]

Fashion plays an important part in the appearance of the women he describes,
and it makes valuable links between the visual and behavioral. "Elle porte en soi,
par une hérédité en retour, le bariolage psychologique des vices et des vertus des
quatre ou cinq dernières générations dont elle est issue" [Through a process of
heredity, she carries in her genes the psychological mishmash of vices and virtues
of the last four or five generation of her family].[24]

The Parisienne, either *dans le monde* [in polite society] or of *le demi-monde,*
whether *légitime* or *libre,* is declared by Uzanne as a plaything of masculine vanity,
ego, and libertinism. Crushed in her youth by male lust, such a woman remained
unprotected by French law, both in terms of public morals, an issue for all of soci-
ety, and through the economic difficulties that prevented her from making a living

by honest means. This leads Uzanne to another reference to Paris as paradise and to the suggestion that the women are akin to Eve, made to "fall" by circumstances over which they have no control.[25] Uzanne indicates that the effect of middle-class women on the department store, and vice-versa, is critical to an understanding of female nature. "On les voit, en effet, par foules compactes, se promener chaque jour avec une grâce charmante dans ces grands bazars de nouveautés, chercheuses, cu-rieuses, fureteuses, inventoriant les soieries, les lainages, les lingeries, les parasols, les abat-jour et toutes les menues futilités de la toilette" [As it happens, you can see them every day, regular little throngs of them, all charm and elegance, stroll-ing around those big stores offering the latest novelties, prying and ferreting and poking into everything, eyeing up the silks, wools, lingerie, parasols, lampshades and all those silly little whatnots that make up the toilette].[26]

Uzanne believed that the middle-class woman was easily seduced by clever lighting and exotic stuffs displayed in the department stores, but her primary concern in this milieu was fashion, and each new shipment of goods inspired a great deal of anxiety. He went on to note that:

> Pour la Parisienne, la toilette . . . symboliser la divinité. Elle est surtout aujourd'hui comme la préface révélatrice de la femme, de ses idées, de son goût, de son milieu; elle indique le rang de celle qui la porte, sa distinction, son sentiment d'harmonie; c'est la synthèse du caractère général de l'élégante; on peut donc, à la rigueur, ad-mettre l'importance considérable que la bourgeoise de Paris y attache.

> [For the Parisian woman, her toilette . . . symbolizes divinity. Today especially, it is a sort of prefatory revelation of a woman, her ideas, her tastes, the circle she moves in. It indicates the wearer's rank and distinction, her conception of harmony. For the woman of elegance, it is the overall statement of her character. We would do well, perhaps, to admit the considerable importance the middle-class Parisienne attaches to it.][27]

Fashionable Vice

Max Nordau, in *Degeneration,* described fashion as a symptom of fin-de-siècle illness. He ascribed to the majority of the French population what he called a "labored rococo": "with bewildering oblique lines, incomprehensible swellings, puffings, expansions and contractions, folds with irrational beginning and aim-less ending, in which all the outlines of the human figure are now lost, and which cause women's bodies to resemble now a beast of the Apocalypse, now an armchair, now a triptych, or some other ornament."[28]

Through his statement, Nordau effectively linked late nineteenth-century so-ciety to the decadence of late eighteenth-century aristocrats, which had resulted in the French Revolution. His description of bodily distortions caused by fashion also suggests another artistic style, Mannerism, which until recently had been dismissed as a degenerative phase of the Renaissance.

While Nordau's condemnation was descriptive in nature, Georg Simmel, in an article for the *International Quarterly* (1904), attempted to explain how fashion functioned within society.

> Fashion is the imitation of a given example and satisfies the demand for social adaptation; it leads the individual upon the road which all travel, it furnishes a general condition, which resolves the conduct of every individual into a mere example. At the same time, it satisfies in no less degree the need of differentiation, the tendency towards dissimilarity, the desire for change and contrast, on the one hand by a constant change of contents, which gives to the fashion of to-day an individual stamp as opposed to that of yesterday and tomorrow, on the other hand because fashions differ for different classes.[29]

Simmel stated that fashion "reflects the history of the attempts to adjust the satisfaction of the two counter-tendencies more and more perfectly to the condition of the existing individual and social culture."[30] This principle drives what can be called the psychological elements in fashion. Despite the fact that individual pieces of clothing reflect the needs of an individual, fashion itself is a product of larger social demands. Simmel indicated that a competition arises when two social groups, an upper class and a lower class, begin to gravitate toward similar fashion. "Indeed, we may often observe that the more nearly one set has approached another, the more frantic becomes the desire for imitation from below and the seeking for the new from above."[31] Simmel believed that in the modern period, with the division of social classes more sharply etched, fashion played a more important role as more opportunities for defining differences arose.

Simmel tried to provide a reason why fashion changed quickly, citing inherent difficulties in maintaining fashion because of its transient nature. "Fashion always occupies the dividing line between past and future, and consequently conveys a stronger feeling of the present, at least while it is at its height, than most other phenomena. What we call the present is usually nothing more than a combination of a fragment of the past with a fragment of the future."[32] Thus, from a theoretical standpoint, fashion cannot truly be "in vogue" because by its definition it must be distinctly different and new. The individual who subscribed to fashion in essence adopted a certain manner of dressing *before* it became popular.

Simmel found gender inherent in fashion, especially in periods of democracy, when a "mixing of the masculine and feminine principles" led to "emancipated women" who tried to "imitate men, including their indifferent attitude toward fashion."[33] Simmel also suggested that fashion compensated a woman for her indeterminate social position, given that class was often based on profession. Fashion insisted on treating individuals alike, but it is external in nature and at "the periphery of personality," which allows "sensitive and peculiar" individuals to use it as "a sort of mask."[34] While fashion tends to subjugate the individual due to its frequent modifications, this process favors social advancement. According to Simmel, "it capacitates lower classes so much for imitation of upper ones, and

thus the process characterized above, according to which every higher set throws aside a fashion the moment a lower one adopts it."[35] This explains, in part, the tendency toward frequent change in fashions. It also identifies the reasons why the exploration of "types" (stereotypical representations of people of different classes and professions, and even of prostitutes) remained popular throughout the nineteenth century, and why social commentators used fashion as the basis for their observations.

Long before Roland Barthes's *The Fashion System* (1967), the French were concerned with the theoretical possibilities of clothing. Important articles posited a psychological significance for fashion. For example, "La psychologie du vêtement," by Guillaume Ferraro, appeared in *La Nouvelle Revue* in 1894. Ferraro declared that clothing has a "purely psychological" function. Clothing ultimately integrates the physical individuality of the wearer with moral factors; therefore, when something changes in clothing, something also happens to members of society. A new fashion can stimulate joy in the wearer, especially in the case of women. Fashion can also indicate potential danger: "On ne peut donc altérer trop le type moyen de vêtement porté par tout le monde sans troubler quelque peu la vie sociale; pour cela, la police croit devoir empêcher l'anarchie de la mode, qui serait, elle aussi, comme toutes les anarchies, dangereuse" [So one cannot depart too far from the norm in matters of dress without causing some upheaval in society; this is why the police consider it their duty to suppress anarchy in fashion, which would be as dangerous as anarchy of any other sort].[36]

Ferraro also considered the significance of love, and its connection to fetishism, by discussing the appeal of *bibelots* [knick-knacks]: "Voilà l'origine de ce fétichisme si commun de l'amour, par lequel des bibelots, des choses de rien, qui appartinrent jadis à la personne aimée, sont conservés comme des reliques: c'est qu'en regardant, en touchant ou en baisant ces objets, les sensations optiques et tactiles réveillent, par association, toutes les émotions de l'amour, que la seule image ou la seule idée de la personne aimée serait impuissante à exciter" [That is the origin of the habit frequently observed among lovers of preserving, like holy relics, silly little knick-knacks that once belonged to the beloved. By gazing at them, touching them or kissing them, sight and touch arouse, by association, all the emotions of love which a mere picture or thought of the person could never conjure up].[37]

These considerations help to explain how clothing plays a psychological role in society. It can establish a psychological rapport between social classes. Clothing can provide visual evidence of social distinctions, and thus, become a part of a psychological dialogue. It is only natural, claimed Ferraro, for the superior class to search for ways to display its social position. The rich make these distinctions with fabrics and ornaments that the poor cannot possibly obtain, thus ensuring respect for their position through costume.[38]

The same psychology explains rules of conduct between individuals, based on the appearance of their clothing. According to Ferraro, distinctions in clothing

applied not only to social classes, but also to gender. In Paris especially, fashion's power had become a formidable presence, perhaps even a manifestation of history, as it reflects social conditions, social mores, and politics. Each epoch has its own distinct clothing types, with a particular psychology that corresponds to its institutions, taste, and intellectual and moral trends. Ferraro concluded his inaugural article by suggesting that scholars accept clothing as a serious topic of study, along with their investigations of statues, architecture, and ancient manuscripts.[39]

Almost fifteen years later, a series of articles entitled "Psychologie de la mode," by Gomez Carrillo, was published in the political and literary journal *Revue Bleue.* The articles had the advantage of hindsight in their evaluation of fashion during the late nineteenth century. Carrillo suggested that if the Ecole des Beaux-Arts offered a course in "élégance féminine," it just might be more useful than the history and anatomy classes.[40] The influence of feminine fashions on the world was deemed significant. Each Parisian event featuring clothing not only offered moral (or immoral) lessons but provided source material for a course in aesthetics. Indeed, the sumptuous sartorial display was a lesson in ethics. The purchase and wearing of beautiful costumes served as an occupation—and a preoccupation—for women and also reflected the times. Carrillo ventured that a nude Venus was not as seductive as one wearing a costume from the rue de la Paix, that is, Worth's shop. Fashion was responsible, in fact, for feminine beauty: "En notre diabolique orgueil, nous voulons corriger la nature, et faire, grâce à de savantes retouches, plus beau encore le beau corps féminin" [In our diabolical pride, by adding our own refinements, we strive to correct Nature and render the female body even more beautiful than it is already].[41]

The role of fashion was further complicated by the distinction between the fantasy conceptions of costumes portrayed in the popular press and the real clothing that women wore. Male artists saw women as being consumed with a passion for *la mode* that often indicated a frivolous attitude that could compromise traditional notions of domesticity and childbearing. A poster by Félicien Rops advertising the periodical *La Vie Elégante* (figure 11) hinges on fashion versus fantasy, and how clothing, or the lack of it, is identified with certain feminine characteristics. The woman at the left, in the riding dress, is the only one to directly address the viewer. A centrally placed mirror suggests these women are various reflections revealing themselves. A nude figure wears jewelry and holds a compact, which would contain makeup and another mirror. A weather vane signals capricious shifts of fashion, as does a nude holding butterflies on strings, while a woman dressed in a kimono documents the influence of *japonisme* on fashion. Closest to the viewer is a woman holding a mask *identical to her own features* and a pair of opera glasses. Rops's illustration suggests not only the prevalence of feminine types, but also the realm between fashion and fantasy promulgated by popular journals.

Rops represented the Parisienne in his poster much as Théodore de Banville described his mysterious mistresses of elegance.[42] In his *Esquisses parisiennes,* de Banville sought to chronicle the passions and dreams of women who were a prod-

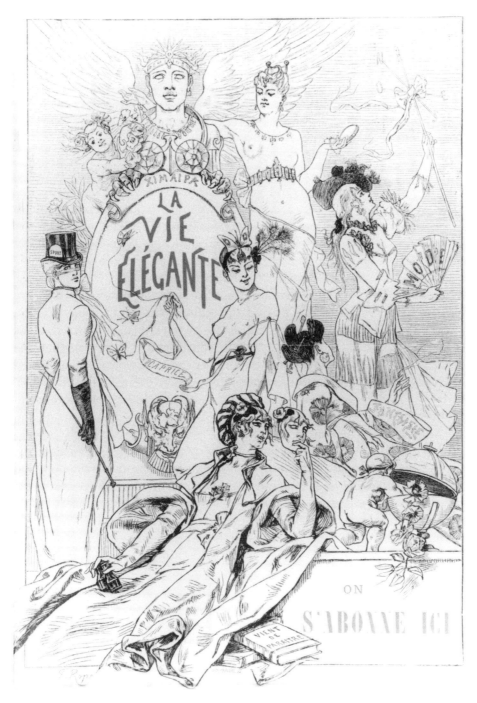

Figure 11. Félicien Rops, advertisement for *La Vie Elégante,* c. 1890. Private collection. Photographer, Tim Fuller.

uct of his imagination but based on real-life experiences. He wrote, "Celles-là, nées parmi les enchantements, et qui sont sorties parfaites de la chaudière où Paris, comme les démons de *la Tentation,* entasse des papillons et des vipères, celles-là, dis-je, sont nos héroïnes, les Parisiennes de Paris" [These women, born amid enchantments, and who emerged perfect from the cauldron where Paris, like the demons of the *Temptation,* heaps moths and vipers . . . those, I tell you, are our heroines, the *Parisiennes* of Paris].[43] De Banville's statement introduces the dual nature of these women, a dual nature hinging on a type of fatal attraction. The term "fatal" here should be read two ways, both as "deadly" and as suggesting "destiny," accounting for why these women were associated with butterflies and flowers as often as with snakes and demons.

M. Le Vicomte de Marennes, in an essay from 1855, wrote that the absence of "elegant" characteristics resulted in shocking physical appearance and behavior.[44] He also indicated that dress could carry coding that revealed characteristics of the woman who wore it. He asserted, "Le caractère du costume lui est imprimé par des lois de deux natures distinctes, l'une physique, et l'autre morale" [The nature of costume is dictated by two distinct natural laws, the one physical, the other moral].[45] De Marenne went on to identify the ability of costume to carry and transmit information about the wearer. He cited two related yet rival passions that had helped define his epoch: a desire for equality and a desire for luxury. The first devours pride and renders one susceptible to ridicule, which can degenerate into monomania. The second, even more dangerous, creates agitation in all social classes, a "monstrous anachronism" that the author blamed for the leveling of fortunes, the watering down of morals, the disintegration of proper manners, and the failure of social institutions.[46] The action of these two passions had begun to compromise, in de Marenne's opinion, the ability of fashion to indicate elegance. De Marenne's ideas can be contrasted with those of Emmeline Raymond in her *Le secret des parisiennes, suivi de mélanges* (1866). Raymond sought to penetrate the mysteries of the Parisienne, in order to allow women from all countries the ability to profit from this *science parisienne* [Parisian know-how]. The essential point Raymond made was that Parisiennes wear their dresses, coats, and hats every day while other women wear them only on special occasions. The result of this basic difference was that the Parisienne is always à la mode and other women are not.[47] Women who wear their good clothes only on special occasions wear them out more slowly, ensuring that they will nearly always be out of fashion.

Invisible *Flâneuse*

Charles Baudelaire, in his 1863 essay "The Painter of Modern Life," characterized the successful artist as a flâneur, or dandy, who, in his wanderings about Paris, discovered fragments of ideal beauty in contemporary women's fashion.[48] In fashion, Baudelaire found a parallel to art; both imitated nature, and both participated in and reflected the transitory, fugitive spirit of modernity. Baudelaire's construction

privileged the male gaze; fashionable women were the objects of visual consumption. Indeed, women were no more than mannequins displaying the fashions that male artists were told to study. Baudelaire made the women invisible in his search for ideal beauty. It is ironic, but not surprising, that at a moment when women were more visible within society, their presence as anything more than decoration was effaced. To be sure, a female counterpart to Baudelaire's dandy existed, as the *flâneuse,* but she was made to appear unimportant in the grand scheme of modernity. She was rendered invisible, in fiction if not in fact, through various literary and artistic means.

In the department store, women experienced a degree of freedom previously not found when shopping. Browsing provided "the liberty to indulge in dreams without being obligated to buy in fact."[49] Emile Zola's *Au bonheur des dames* (1883), the setting of which was modeled after Le Bon Marché department store, examined this phenomenon.[50] Zola considered how women were constrained by others' images of them, and how consumption of goods forged their self-identity. The department store, as a "richly symbolic modern space," combined "woman and money; ideologies of femininity and ideologies of consumption; the image decreed and the image bought; the markings of people and prices; the selling of a society of female customers."[51] These stores targeted women and "multiplied the snares and seductions that both enslaved them and exalted them simultaneously."[52]

This phenomenon was captured amusingly by Albert Robida (1848–1926) in his illustration "Le monstre" (figure 12), which depicted the department store as a huge machine literally swallowing women, based on a phrase in Zola's text where the proprietor, Mouret, is called "the inventor of this machine for devouring women."[53] This is an extreme interpretation given that the department store provided women with a degree of freedom, especially with the legitimization of "browsing" as a shopping strategy. The female empowered to browse merchandise appropriated the male power of the flâneur, the ability to "own" the contents of these spaces through their gazes, a fact Robida did not acknowledge. Robida also failed to indicate the large number of women who were employed in sales positions within these stores, an omission that allows for his exaggeration of the gender roles played out during the shopping process. Zola did discuss both male and female workers in the store, but he also suggested that their individuality was stripped by the machine, and their desire for each other was eliminated by work.[54] But it was the "female crowd" that was cultivated by department store owners; many of their merchandising strategies were designed either to draw a crush of women or to suggest a crowd of female shoppers where none really existed, through use of mannequins and cleverly positioned mirrors.[55]

Robida was one of many artists who expressed male anxiety over the increased visibility of women in nineteenth-century Paris. His 1883 text *Le vingtième siècle* predicted the effects that the women's rights movement would have upon the men of the future. In addition to illustrating his own books, Robida regularly contributed to *La Caricature, Journal Amusant, Paris-comique, La Vie Parisienne,* and *Le*

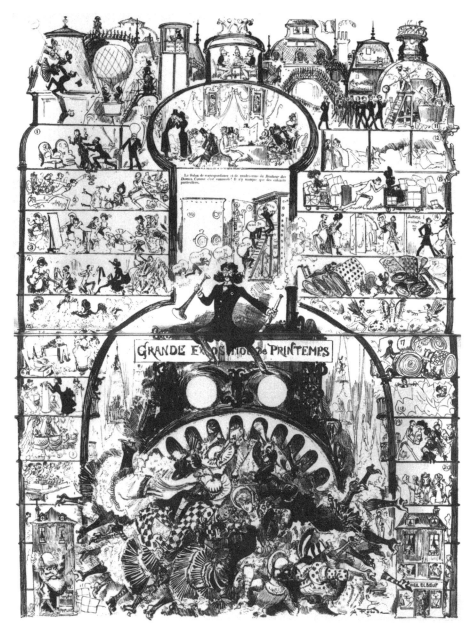

Figure 12. Albert Robida, "Le Monstre." *La Caricature,* Mar. 31, 1883, 100–101. Bibliothèque Historique de la Ville de Paris. Author's photograph.

Rire. The other side of his personality is revealed in his work for *La Nature* and *La Science Illustrée,* where he created fictionalized spaces in which women's experience was trivialized. The depiction of women being enslaved, seduced, and even devoured by the "machine" under the direction of clever male owners, however, was the interpretation preferred by Zola, Robida himself, and others. According to Rémy Saisselin, the "entire machine of the store," which included architecture, techniques of display, and advertisements, "was directed to one end: the seduction of woman. It was the modern devil tempting the modern Eve."[56] Alexandre Weill believed that stores compromised morality, calling them "un fléau national" [the scourge of the nation].[57] According to Jean-Paul Nayrac, the department store was a "machine puissante, formidable, absorbe et vomit sans cesse une foule avide, troublée, amante passionnée d'émotions folles, de désirs jamais assouvis" [a powerful, formidable machine, ceaselessly swallowing and vomiting back a greedy, restless mob that resembles a lover throbbing with frantic emotions and insatiable longings]. Equally important, Nayrac believed it provided a dangerous level of temptation to women, especially those suffering from kleptomania, neurasthenia, or hysteria.[58] Zola's novel described the madness generated by the store and its consumer goods as calculated by the store's male owner to ensnare. The store was depicted as arousing "new bodily desires" in women: "It seemed as if all the seductions of the shop had converged into this supreme temptation, that it was the secluded alcove where the customers were doomed to fall, the corner of perdition where the strongest must succumb."[59]

Importantly, the level of fashion described by Zola and others consisted not of *haute couture,* but of what today is called ready-to-wear, theoretically available to masses rather than the elite. This democratization of luxury was described by Georges d'Avenel in a series of articles for the *Revue des Deux Mondes.*[60] During the Second Empire, fashion became a new temptation, replacing the apple with materialistic fantasies. The new paradise was a realm of consumer goods. In a long poem entitled "Les grands magasins," published in *Le Charivari* in 1883, Charles Grandmougin described department stores as temples to the devil and as Edens that replaced the church and had enslaved women.

> Moloch n'a rien gardé de sa hideur sauvage:
> Ses temples d'aujourd'hui sont de grands magasins; . . .
> Mais Paris n'est pas seul à subir l'attirance
> De ces Edens sans fond aux merveilleux réseaux:
> Leurs prospectus, ailés comme un essaim d'oiseaux,
> S'abattent sans repos sur le pays de France. . . .
> La femme est destinée à ces mêmes délices;
> Esclave, comme tous, du matin jusqu'au soir,
> Elle s'astreint au plus moderne des supplices,
> A ce doux règlement qui défend de s'asseoir!
>
> [Moloch has lost his grim and savage face:
> Today his temples are department stores;

Not only Paris is under the spell
Of these limitless Edens, networked stores;
Their leaflets, winging like birds in their swarms,
Land on the whole of the country as well.
The same delights await Woman in town;
A slave, like us all, from morning to eve,
A martyr to the latest of tortures,
The pleasant rule that forbids her sit down!]

Temptation was a persistent theme, especially in the writings of moralists, who believed that fashion encouraged vanity and coquetry. Some went so far as to blame the advent of the department store and the pastime of shopping for compromising the notion of "family." The fashions Grévin created for his album *Filles d'Eve* (see figures 9 and 10) reinforced the idea of woman as closer to nature, and therefore removed from culture, the domain of man. The irony is that many men ran the department stores and created the fashions. Thus, men were the real tempters in this new Eden. As women continued to succumb to these temptations, the term *filles d'Eve* was applied to underscore the connection with the fall of mankind, which, if we are to believe the implications of the work of Grévin and others, was about to repeat itself.

Pierre Giffard, whose text *Les grands bazars* (1882) was concerned with what he saw as a frightening multiplication of department stores in Paris, described the process of a woman shopping in terms of original sin. "Eve's daughter enters this hell of temptation like a mouse into a trap. . . . In this abyss, whirlwinds are strewn with mirages each one more dangerous than the other. As if from Charybdis to Scylla, she glides from counter to counter, dazzled and overpowered."[61] Giffard consistently referred to the women who befell the stores' temptations as "filles d'Eve." According to Giffard, the female shopper responded variously, including by overindulgent shopping, shoplifting, or even having an attack of hysteria. He described the advent of the department store as marking the complete domination, and undoing, of woman. Reports of this kind undermined the fact that, through the act of browsing within a large space versus the more intimate shopping experience in boutiques, a woman became a flâneuse and assumed an almost masculine power of vision.

Contemporary journal illustrations suggest as much. In 1898, a pair of illustrations appeared in *La Vie Parisienne* with the titles "Leur paradis sur la terre" [Their Paradise on Earth] (figure 13) and "Leur enfer sur la terre" [Their Hell on Earth].[62] A woman's earthly paradise is a day spent shopping for dresses, furs, flowers, furniture, and so forth, with a stop at her hotel where, during an encounter with a full-length mirror, she could compare herself to the rococo heroine Madame Pompadour. The jeweler in this paradise takes on the appearance of the serpent, lurking behind a woman who seems completely absorbed in examining baubles. Further, the text underscores the idea of temptation and the giving in to desire. Repeatedly, the reader is told that the woman "must absolutely have" this or that

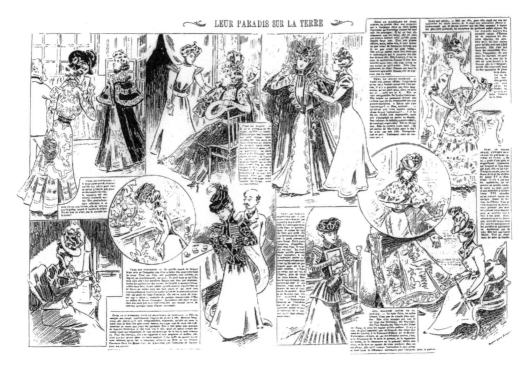

Figure 13. Jules Cayron, "Leur paradis sur la terre." *La Vie Parisienne,* Feb. 26, 1898, 118–19. University of Notre Dame Libraries. Photographer, Tim Fuller.

item. In contrast, "Leur enfer" consists of a series of corporal punishments undergone by the fashionable women, including attending the opera in the off-season, window shopping at fabulous boutiques without being able to buy anything, and enduring strict limitations on the number of new dresses purchased in a year. The illustrations term "excess" as paradise and "restriction," or temptation without reward, as hell.

Robida depicts a Parisienne who has shopped to excess, in *La Caricature* (figure 14). The assault of "Les magasineuses" results in a jumble of packages and fashion accessories that drives the clerk into a panic.[63] Gomez Carrillo, in "Psychologie de la mode," called the transient idea of what was in style "point de reine plus absurde et plus tyrannique, ni de plus cruelle divinité. Elle est Notre-Dame du Caprice" [the most absurd and tyrannical of monarchs, the cruelest of divinities, Our Lady of Caprice].[64]

Au bonheur des dames also identified the modern department store as hastening the undoing of woman: "it was made of women's flesh and blood."[65] Zola referred repeatedly to temptation and seduction. Goods laid out in an intentionally illogical manner, juxtaposed in unusual ways, or repeated throughout the store were designed to disorient customers. As Zola explained through the store owner, Mouret:

Everything depended on [the exploitation of woman], the capital incessantly re-
newed, the system of piling up goods, the cheapness which attracts, the marking in
plain figures which tranquilizes. It was for woman that all the establishments were
struggling in wild competition; it was woman that they were continually catching
in the snare of their bargains, after bewildering her with their displays. They had
awakened new desires in her flesh; they were an immense temptation, before which
she succumbed fatally, yielding at first to reasonable purchases of useful articles for

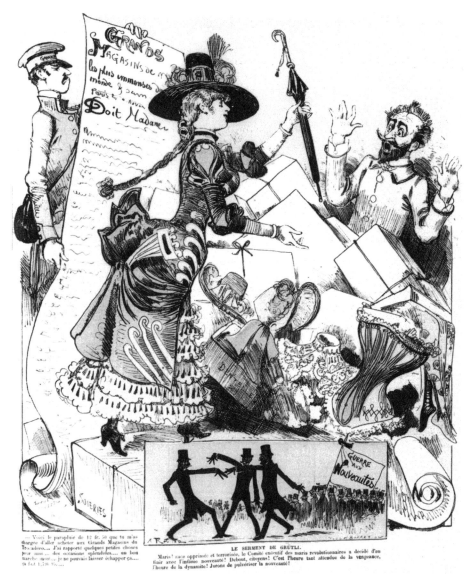

Figure 14. Albert Robida, "Les magasineuses." *La Caricature,* Nov. 11, 1882, cover. Biblio-
thèque Historique de la Ville de Paris. Author's photograph.

the household, then tempted by their coquetry, then devoured. . . . And if woman reigned in their shops like a queen, cajoled, flattered, overwhelmed with attentions, she was an amorous one, on whom her subjects traffic, and who pays with a drop of her blood each fresh caprice.[66]

Throughout the pages of Zola's text, items for sale are sexualized. He writes, "And the stuffs became animated in this passionate atmosphere: the laces fluttered, drooped, and concealed the depths of the shop with a troubling air of mystery; even the lengths of cloth, thick and heavy, exhaled a tempting odor, while the cloaks threw out their folds over the dummies, which assumed a soul, and the great velvet mantle, particularly, expanded, supple and warm, as if on real fleshy shoulders, with a heaving of the bosom and a trembling of the hips."[67]

The store, as a "richly symbolic modern space," combined "woman and money; ideologies of femininity and ideologies of consumption; the image decreed and the image bought; the markings of people and prices; the selling of a society of female customers."[68] An illustration in *La Vie Parisienne* of 1879 demonstrates how literally the exaltation took place; in the center is a "throne" where women could sit, be weighed, and take home a souvenir from the *Magasins du Louvre.*[69] Other details demonstrate the sheer size of the commercial spaces and the elaborate ornamentation. Zola alluded to the "longing, covetous eyes" of the female customers, whose gaze literally seemed to bring the products to life.[70]

At the same time, certain male commentators determined the contemporary woman to be a flâneuse. An 1879 article in *La Vie Parisienne* describing a woman's freedom to walk the streets in search of flowers or pastries—or adventure—was entitled "Flânerie de femme."[71] Pierre Giffard, in his text on department stores, describes different types of flâneurs and names their feminine counterparts flâneuses. He chooses his language carefully to characterize the length, strength, and purpose of the gaze in each case. The most powerful gaze is assigned to the lower-middle-class woman; the weakest is a "long-distance" gaze mediated by catalogues. Giffard's flâneuses range from the rich "elégante" stopping her carriage in front of the store and quickly discerning the new merchandise, to the lower-middle-class woman scrutinizing the merchandise and "ferreting" out the *nouveautés* she desires, to the couturier's employee sent to scout new fashion trends. Foreign flâneuses tended to purchase through catalogues collected on trips to Paris. The most banal of the flâneuses was the married woman who met her lover at the store, having no better pretext to enter.[72] The various flâneurs, as might be expected, come to the department store in search of the daughters of Eve. A woman sought by the flâneur might be an innocent, a prostitute, one of the shop girls, a married woman, or, for the lucky man, a woman of means who might support him. Department stores were sites of temptation for the acquisition of merchandise, which might lead to crime and/or fits of hysteria, as well as sites for sexual temptations.

The discrediting of the biblical paradise of Eden by nineteenth-century French tastemakers did not mean the abandonment of the concept of a utopian place. Manmade paradises supplanted the biblical one and were to be found in the cen-

ter of Paris; fashion became a temptation that replaced Eden's apple. Progressive legitimization of browsing as a shopping strategy among all classes, and the freedom afforded by it, was threatening to men accustomed to wielding social and economic power. Male writers and artists continually attempted to reassert their power and control this phenomenon through their literary and visual descriptions of women shopping. As Mouret asked in Zola's novel: "Doesn't Paris belong to the women, and don't the women belong to us?"[73]

Feminist Paradise: The *Club des Femmes*

If French feminists could be said to have created their own paradise, it was in the form of the *club des femmes*—a new phenomenon in the 1870s. These organizations appeared as the result of a liberalizing of the right to assembly in 1868, and the lifting, in 1877, of a Jacobin-instituted law that had prohibited women from gathering in groups of more than three.[74] A series of laws passed in 1881 strengthened women's rights. The reaction to this new freedom was swift on the part of the satirists who represented men's fears of such clubs. Popular male illustrators could revoke, or at least discredit, these newfound freedoms through one of two approaches; by representing women as old, ugly, and dangerous, or by portraying them as beautiful but extremely frivolous. An illustration from *Le Monde Illustré* in 1871 used the first strategy.[75] Described as being drawn "after nature," the depiction of a meeting at Saint-Germain-L'Auxerrois shows a crowd of aged, undesirable women, including several in the foreground whose faces are twisted into grotesque grimaces. Members of the club des femmes are treated as outcasts of society who might prove dangerous if given the right to vote. The clothing worn by the women is dark and plain, the opposite of the type aggressively advertised by department stores. Feminists adopted a style of dress counter to prevailing fashion; on occasion they criticized the styles promoted in fashion journals.[76]

Clubs des femmes were closely connected with the appellation *amazones,* a term inspired by the mythological warrior women who, in the removal of a breast, symbolically sacrificed femininity and maternal duties for power. French feminists were called amazones, and the clubs des femmes where they held their meetings had a significant political presence in French society immediately following the Revolution of 1789 (until the Jacobins banned them in 1795) and again in 1848 during the change of governments. During the Commune, especially after the Jacobins' law was finally lifted in 1877, the clubs' memberships grew.[77] The clubs' tendency to strengthen during times of political strife doubtless made them seem even more radical than they were. *L'Etoile* reported in May 1871 that there was a proliferation of clubs with different organizing principles—clubs to discuss politics and clubs to propagate incendiary or antireligious ideas. When male writers reported on club meetings, they paid an inordinate amount of attention to the appearance of the members, all but ignoring the content of the meetings, which included such agenda items as the outlawing of prostitution.[78] By focusing on the

frivolous aspects of fashion and interior decor, these commentators trivialized the serious nature of the clubs.

Robida used this approach in a series of images accompanying articles in *La Vie Parisienne* in 1879 and 1880. The first article, described as a project for a club des femmes, featured a cross-section diagram showing secret exits, gaming rooms, multiple bedrooms, and numerous sexual encounters.[79] The anonymous writer stated that since the principal desire of the magazine was to be useful to its female readership, it had begun a project under consideration for some time—the founding of a club des femmes. Unlike the typical club des femmes, this project would not focus on politics. Instead, the goal was simply to provide a place for women to meet. What was a woman supposed to do if left to herself all day? Sit by the fireplace? Attend annoying theatrical performances, that unique refuge of sinners? No, answers the author. Men have long had at their disposition places to find a good dinner at a reasonable price, good conversation, and a way to forget the difficulties of their lives. The proposed club would provide an equivalent location for women, a place where they would be both free and protected. No longer would marriage be needed to escape a parent's grasp, as freedom could be found at the club. Articles to the fictional club's constitution described the primary amenities available to its members.

The second article, entitled "Le club des femmes, quelques lettres," was accompanied by Robida's illustration of a woman sprawled indecorously on a prayer bench.[80] She is smoking and she is bedecked with a spray of jewels but not much else. She appears as a new Danaë receiving a shower of letters instead of gold. Based on the description in the first article, this scene appears to be set in the club's library, where the woman will soon respond to correspondence. The text of the article consists of letters said to be from various interested parties about the prospect of this new club. Included is a mock letter from Louise Abbema, an artist and friend of Sarah Bernhardt, who suggests that the club should have a specially appointed painter to compose portraits of the members. A similar letter, signed "Sarah Bernhardt," expresses a fervent desire to join, but also an awareness that she will likely be blackballed.

The second article also contains a letter supposedly written by Edmond About, publisher of the journal *XIXe Siècle,* who agrees that, in principle, the idea for a club is a good one, especially for those like himself, who support divorce and anything that results in bad marriages. One of the most frequent causes of unsuccessful unions between husbands and wives was the desire for liberty. The club would allow women to take more time before choosing a husband, and in case they still made a mistake, it would provide "grandes facilités pour s'en consoler en tout bien tout honneur" [outstanding facilites to console themselves honorably and in style]. However, the eight bedrooms and coded-card method of entry seem suspicious, and About realizes the club is a thinly disguised brothel. A letter from the editor of the "Crédit illimité" expresses regrets that he is not able to fund the club itself, but it says he is willing to back the inevitable journal, *Le Journal*

du Club. Another letter expresses confusion over the use of masculine pen names under writing that has a "loquacité qui sent sa fille d'Eve" [a loquacity smacking of the daughters of Eve]. Taken together, these statements reveal that Eve's voice was considered dangerous, just as the formation of a journal to advertise women's rights was considered a threat to men.[81]

In the illustration for the third article (figure 15), the fashionably dressed members of the club's newly appointed executive committee contemplate plans for an elaborate clubhouse. In each of the illustrations, Robida has made the club members seem preoccupied with frivolity and fashion, rather than with the equal rights desired by such French activists as Maria Deraismes or Hubertine Auclert. In an accompanying article, the appearance of each woman on the executive committee is described in terms of her hair and eye color and fashion, further undermining seriousness. Plans are being made for the club's kitchen appliances, and a grocery list is being compiled for anticipated menus. This serves to domesticate the club by assigning chores that a woman would undertake in the average home.

The inevitable outcome of the formation of the club is treated in the fourth article, "La dernière séance du club des femmes."[82] President Princesse Sangoff announces that the continued evolution of the club has led to the discussion of women's rights issues, including the right to divorce. Significantly, the women's costumes have been changed; Princess Sangoff appears to be wearing revolutionary dress, and one woman wears the monocle used by illustrators to signify feminists. A second illustration shows the entry of diaphanously clad women into a giant bull's mouth, not so subtly suggesting the fate of women who choose to engage in politics: they will go to hell.

In this series of articles, with its supporting images, *La Vie Parisienne* ostensibly initiates a fictitious women's club, takes it to the heights of ridiculousness, and then shows it destroyed by the desire for social equality. Robida and the anonymous author, possibly the artist himself, effectively sabotaged any notions that such a club might benefit its female members. The final illustration could not be more explicit—the club des femmes devours innocent young women. Through his conceptualization of both the department store and the club des femmes as "spaces of femininity" inhabited by females of unstable mind and insatiable appetites for fashion, Robida inadvertently *confirmed* the power these spaces afforded to women.

These articles represent only a fraction of the essays treating the women's club during the latter part of the nineteenth century in France. Articles in *La Vie Parisienne* in 1887 and 1891 described fictional clubs for *femmes du monde*—high-paid courtesans.[83] A flurry of articles appeared in the mainstream newspaper *Le Figaro* in the 1890s, prompting artists to adopt visual formulas for women's clubs similar to those described above. An illustration for *Le Charivari* in 1896 by Draner, entitled "Mon ladies club," shows women in the gym, smoking, playing cards, and biking in the attached "vélodrome," while their children are tended by male nurses in an adjoining nursery.[84] This concern for children's welfare, the result of their

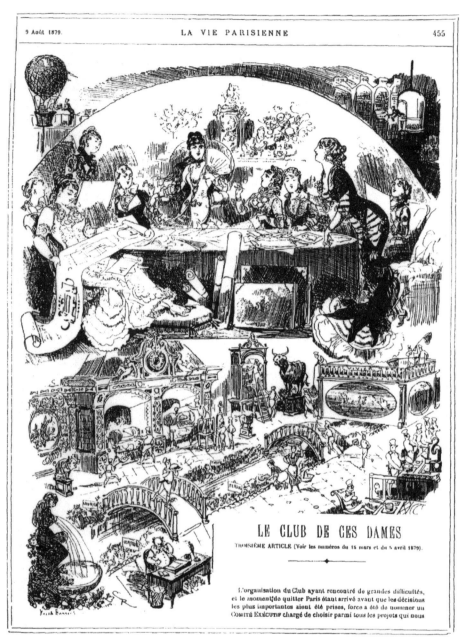

Figure 15. Albert Robida, "Le club de ces dames." *La Vie Parisienne,* Aug. 9, 1879, 455. University of Notre Dame Libraries. Photographer, Tim Fuller.

mothers' increasing freedoms, was reflected often in the popular magazines, as was male anxiety over maintaining gender difference. Such anxieties also permeated the feminine icons used by both the producers of alcohol and tobacco and the temperance movement. Through the association of sexy women with addictive substances, the attractive duality of the fille d'Eve and the femme fatale was used to advertise both the pleasures and dangers of Parisian café culture.

THREE Decadent Addictions

In France during the nineteenth century, the medical and social assessment of smoking and drinking was modified due to a peculiar combination of circumstances. These included the effects of a mass-produced consumer culture, a burgeoning high-fashion industry, and changes in the private and public relationships between the sexes. Comparison of advertisements for cigarettes and alcohol—addictive yet legal substances—with illustrations in popular periodicals and images in oil paintings reveals the degree to which smoking and drinking became stigmatized, especially as practiced within the widely expanding milieu of the café. Works of art and the trappings of popular culture indicate that the complex visual dialogue established with the consumer was, in large part, dependent on images of women. Since men were the greater consumers of addictive substances, images featuring men were more likely to address temperance or warn of the potential dangers of immoderate indulgence.[1]

Advertising by tobacco and liquor companies, however, depended on powerful symbols of female sensuality to promote ambiguous messages. Here the cigarette or champagne glass became a chic accessory to contemporary fashion. The use of women in advertisements for these products underscored the traditional connection of women to nature. Cigarettes, opium, and absinthe and other forms of alcohol are made from natural substances; hence woman, as a representative

of nature, could effectively promote these dangerous products as perfectly natural and safe.

Artists who produced Salon paintings or satirical images for the popular press revealed the brutal realities of addictive substances, which, of necessity, were suppressed in advertisements. The isolation, hallucination, addiction, and diseases attributed to alcohol and tobacco consumption became part of the Impressionists' and Naturalists' views of modern society. The dramatic increase in the number of cafés provided an effective backdrop for the mixing of the working and leisured classes. Symbolist artists invented a female type who seemed to embody the dual nature of café society, and its potions, as simultaneously attractive and dangerous. Embodying sensuality while serving as a warning against indulgence in physical pleasure, the femme fatale symbolized not only the decadence of fin-de-siècle France, but also the very nature of addiction and withdrawal. The characteristics of the femme fatale embody the idea of "aversion" that must be overcome in order for addiction to take place. This mythical icon functions in the same decadent dichotomy of danger/pleasure as do addictive substances such as tobacco and absinthe.[2]

Consideration of the rich visual culture of France's fin de siècle, from large colorful posters to small black-and-white caricatures, in conjunction with archival medical and police records, demonstrates that there was a striking difference between medical opinion and social reality. Dramatic contrasts existed between medical warnings, writing focused on morality, and the seductive high life found in popular imagery that only occasionally conveyed fear and dread of disease and illness. The medical literature warning of the dangers inherent in alcohol and tobacco was disarmed by satirical popular publications and masked by advertisers. Scientific facts were met with skepticism and apathy by all but a few reformers, who were not successful in restricting even the most toxic legal substance, absinthe, until the beginning of World War I.[3] The gulf between scientific text and popular imagery widened due to societal forces such as the changing power relationships between the sexes, which resulted in the depiction of tobacco and alcohol as agents of decadence rather than as conveyors of disease and addiction.[4]

Anatomy of Addiction

Alcohol presented a particular problem since wine and beer supported a significant portion of the consumer economy of France. Beyond that, as Roland Barthes outlined in his *Mythologies,* the venerable national drink had a long-standing reputation of being beneficial to health. Doctors and temperance workers had difficulty quarreling with Louis Pasteur, who praised wine as the "healthiest of drinks."[5] The strategy employed by scientists was to distinguish traditional alcoholic beverages from the new, distilled *apéritifs.* Many of their theories were modifications of the theories of hereditary degeneration propounded by Etienne Esquirol and Bénédict Morel.[6] In 1870, Louis-François-Etienne Bergeret published *De l'abus des boissons alcooliques,* in which he chronicled the effects of alcohol, complete with numer-

ous statistics supporting his claims that drunkenness was the most humiliating degradation of humanity, capable of causing misery for the present population and future generations.[7] Men who succumbed to drunkenness committed crimes, due in large part to the "perversion of moral sense" that alcohol caused.[8] Bergeret linked drunkenness in men to stupidity, impotence, and suicide. Women could expect swelling and ulcers in the genital area, and even problematic scar tissue, from prolonged coitus due to the inability of a man to ejaculate when drunk.[9]

While alcoholism in women was comparatively rare, it was decried by those who blamed this problem for depopulation; there was a deep fear of the growing German birthrate while France's was the lowest in Europe.[10] René Lavollée pointed out that while depopulation could be tracked statistically, it was a tricky proposition to link it directly to alcohol consumption.[11] A primary argument against alcohol was the belief that it caused sterility. Not only did alcohol ruin families through the disappearance of inebriate fathers, but women who drank ran the risk of having miscarriages or causing birth defects in their unborn children. As Dr. Henry Cazalis reported in his 1900 *La science et le mariage: Etude médicale,* "l'alcoolisme est, comme la syphilis ou la tuberculose, gravement foeticide ou infanticide" [alcoholism is, like syphilis or tuberculosis, a major cause of death in infants and the unborn child].[12] Moreover, alcohol consumption could instigate hysteria and cause the drinker to act upon violent impulses. Cazalis called people affected by alcohol "more animal than human," and he published a long list of deviations in normal human development that alcohol caused. In his opinion, it was better for a child born to alcoholics to die (or the parents to do likewise, for that matter) than to see a continued degeneration of body, mind, and soul.[13]

By 1887, a popular journal was declaring that drunkenness "altère la santé physique, intellectuelle et morale des individus, détruit la vie de famille et trouble la société" [saps the individual's physical, intellectual and moral health, destroys family life, and destabilizes society].[14] The temperance journal *L'Alcool* stated that ten thousand alcoholics were known to inhabit Paris by 1896, which translated into three hundred thousand days of hospitalization at a cost of nearly a million francs.[15] In order for alcoholics to be treated, however, they had to be declared insane.[16] Raymond de Ryckère, a criminologist, believed that abuse of alcohol explained scandals of all types that were manifest in the high society of all countries.[17] Emile Duclaux, a member of the Académie des Sciences, and director of L'Institut Pasteur and L'Ecole des Hautes Etudes Sociales, stated, "L'alcoolisme n'est pas une maladie, c'est une passion, chose fort différente" [alcoholism is not an illness; it is a passion: something very different].[18] To Duclaux, it was a matter of social hygiene: "Le corps social peut être atteint non seulement par des dégradations physiques, mais aussi par des dégénérescences morales" [Society as a whole may fall victim not only to physical degradations but also to moral degeneration].[19] He found alcoholism particularly interesting because its social consequences were immediately visible, despite the fact that in moderate doses, most people considered alcohol a mild stimulant, like coffee, tea, and various spices.[20]

Temperance activists such as Dr. Paul Maurice LeGrain depended on women to help in the antialcoholism movement in France, in imitation of American temperance drives by feminists.[21] LeGrain called for adherents in his temperance journal, *L'Alcool.*[22] Members of the feminist movement obliged, leading to a series of articles in the feminist journal *La Fronde,* which, in 1898, declared that four words—Misère, Misère, Alcool, Prostitution—had destroyed thousands of lives. Alcohol was worse than the black plague, which only attacked the body, while alcoholism killed for generations by destroying the creative faculties of an entire population.[23] Mme Hudry-Ménos, who penned this series of articles for *La Fronde,* deferred to the research of Dr. LeGrain for statistics on the degeneration of families. In one of his examples, she reported, a family with a chronic alcoholic father and alcoholic/hysterical mother lost ten children to miscarriages; their surviving six children suffered from nervousness, epilepsy, imbecility, convulsions, and hysteria. LeGrain's bleak picture concluded with the following warning: "Le poison, l'horrible poison qu'est l'alcool d'industrie, ronge et désagrège le cerveau de l'homme; il s'attaque à la source même de sa vie et de son développement, et l'on ose encore plaisanter sur ceux qui lui ont déclaré une guerre à mort!" [The poison, the dreadful poison that is industrial alcohol, gnaws and ravages the human brain; it attacks the very source of man's life and development, and yet people still dare to mock those who have declared war on it to the death!][24]

Absinthe, an aperitif made from wormwood, was stronger than wine or other traditional French alcoholic beverages. It became popular primarily because of its cheapness and increased availability during the grape blight of the 1870s. In 1893, Henri Caen published a poem in *Le Courrier Français* that acknowledged the drink's poisonous yet alluring effects and that showed that the aperitif was replacing wine.[25] The cultural historian Vicomte G. D'Avenal believed that "la couleur verte qui, dans l'esprit du public, semble un caractère distinctif de l'absinthe, lui est tout à fait étrangère, bien qu'elle ait fourni nombre d'aperçus ingénieux et d'agréables truismes aux poètes et aux romanciers" [the color green is associated in the public mind with absinthe, but this is a myth, despite all the ingenious opportunities and happy clichés with which it has furnished poets and novelists].[26]

Despite the romanticized view of absinthe, the medical community knew the aperitif to be dangerous. As early as 1859, Dr. Motet of the Bicêtre psychiatric hospital published his observations of the mental and physical effects of the drink.[27] Others linked its consumption to crime.[28] Dr. LeGrain, who launched a campaign against the ingestion of all alcohol, found absinthe particularly troublesome.[29] It had a noticeable effect on the faces of drinkers, altering their expressions and giving them a brutal cast: "à voir leur regard brillant, mobile, inquiet, il nous est facile de reconnaître des cerveaux sous l'empire de l'absinthe" [their fierce, restless, troubled looks make it easy to recognize folk under the influence of absinthe].[30] From 1885 to 1892, according to LeGrain, the consumption of aperitifs doubled; imbibers not only suffered hallucinations but were more likely to commit crimes. Worse, LeGrain pointed out, the use of absinthe spread like a virus: "Du bourgeois,

la contagion s'est étendue à l'ouvrière, de l'homme à la femme, de la femme à l'enfant. Aucune femme ne rougit maintenant de s'attabler à la devanture des cabarets devant une verre d'absinthe." [The contagion has spread from the bourgeois to the factory girl: from man to woman, woman to child. There is now not a woman ashamed to sit outside a café with a glass of absinthe on the table in front of her.][31] It was a modern plague.

While tobacco was not tied as directly to France's economy, it had a traditional value that made it a difficult target for reformers. In fact, most books written about tobacco during the Third Republic celebrated its history and its use by royalty.[32] The objects associated with smoking were prized collector's items. By 1876, France had established a moderate economic interest in tobacco products; seven French tobacco manufacturers were employing two million workers, processing four hundred thousand kilograms of tobacco, and producing four hundred million cigarettes.[33] The entrance of France into tobacco production evidently helped increase the substance's use, for the total consumption for 1890 equaled the total figure for the years 1811–87. As Blondel termed it: "Les millions vont si vite par ce temps de prospérité et de fumerie générale!" [Millions disappear so quickly in this time of prosperity when everybody smokes!][34]

There were those who openly decried smoking as dangerous. The symptoms of tobacco-related diseases were outlined by Dr. Antoine Blatin in *Recherches physiologiques et cliniques sur la nicotine et le tabac* (1870) and by Dr. Emile Laurent in *Le nicotinisme* (1893).[35] Louis-François-Etienne Bergeret declared that the abuse of tobacco was one of the signs of the decadence of French society.[36] Perhaps the title of Dr. Hippolyte-Adéon Dépierris's text most clearly expressed the potential harm of tobacco on society: *Le tabac qui contient le plus violent des poisons: la nicotine. Abrége-t-il l'existence? Est-il cause de la dégénérescence physique et morale des sociétés modernes?* [Tobacco, which contains the most violent poisons, nicotine. Does it shorten life? Is it the cause of the physical and moral degeneration of modern societies?] (1876). Dépierris determined, through study of the work of other scientists and doctors, that there was little good that could be said of this poison, which was linked to an increase in crime, madness, and the degeneration of the individual and eventually the human species. This sentiment was echoed by Dr. Paul Jolly in his 1887 text *Le tabac et l'absinthe:* "Poison du corps et de l'esprit, poison de l'âme et de l'intelligence, il faut bien le dire, le tabac a su flétrir également l'homme physique, l'homme moral, l'homme intellectuel, l'homme social; et ce qui a pu être encore bien démontré, il le flétrit tout à la fois dans son individualité, dans son espèce et jusque dans sa race." [It simply has to be admitted that tobacco is poisonous to body and mind, spirit and intelligence. It saps mankind physically, morally, intellectually, and socially. Also beyond question is the fact that it weakens not only the individual, but the whole species, affecting even racial characteristics.][37] Dépierris claimed that the use of tobacco caused sterility, miscarriages, and early infant deaths—all contributing to depopulation.[38] Tobacco was similarly attacked for causing birth defects and lower birthrates.[39] Dépierris said that smoking also replaced physical love by desensitiza-

tion of the genitals: "Avant la pipe, il aimait; après le pipe, il n'aimait plus; c'est-à-dire que la pipe avait engourdi ses sensations génitales d'où dérive l'amour, comme l'opium, le chloroforme ou l'éther insensibilisent le nerf d'où dérive la douleur" [Before man took up his pipe, he made love; afterwards, he did not. Smoking had numbed the sexual sensations that inspire lovemaking, just as opium, chloroform, or ether anesthetize nerves transmitting pain.][40] Tobacco, according to Jolly, would not kill every smoker, but it would cause "nicotine amnesia" in most subjects. The smoker would first forget small things, and then proper names would elude him; eventually he would experience concomitant verbal amnesia and the reduction of his vocabulary to a few banal expressions.[41]

Two important changes in traditional use eventually caused the dangers of tobacco to be taken more seriously. The first of these was the extension of this habit to women, and sometimes to children.[42] Women who smoked aged prematurely; this was the fact that Dépierris singled out as perhaps the most likely to dissuade female users.[43] His 1882 text La prise de tabac was even more graphic about the effects of smoking on women. While tobacco could cause serious health consequences in old or infirm women, smoking could subvert the natural charm of younger females; it would first alter their breath and eventually compromise their morals. These young girls would shortly become old, unattractive women with red eyes, raspy voices, terrible breath; they would favor only three things: tobacco, eyeglasses, and a foul-smelling moist handkerchief. It was this image, claimed Dépierris, that would prove a better deterrent than a recitation of probable health problems from smoking.[44] For his part, Jolly suggested, likely tongue-in-cheek, that women seeking equality could give their men cigarettes, and once the men were in a tobacco-weakened state, the women could work to secure their own emancipation.[45]

Seductive Advertising

These very serious concerns were subverted in literary and visual representations. The romanticism associated with alcohol and tobacco, as well as a culture of indulgence, powerfully countered the public's concern about the health risks of these products. As Dépierris put it, "Aujourd'hui, bas-fonds et sommet de notre société, tout est envahi par l'épidémie de la passion" [Today, from top to bottom, our society is completely overwhelmed by this epidemic of passion].[46] The passion for alcohol and/or tobacco was also termed a "seduction." This seduction was necessary, writers maintained, to stimulate their creativity; it could be said that the tobacco or absinthe replaced, or evolved from, the feminine muse of the past. This designation seemed appropriate, given the aforementioned medical documentation about the robbing of sensual/sexual experience by these artificial narcotics and stimulants. Villiers de l'Isle-Adam stated that "le tabac changeant en rêverie les projets virils" [tobacco reduces manly projects to idle dreams], while Barbey d'Aurévilly, who did not smoke, wrote, "Le tabac engourdit l'activité" [Tobacco

paralyses activity].[47] Similarly, numerous poets described the charms of absinthe in sensual, feminine terms. For instance, Montjoye, in an 1870 verse, describes a siren-like quality of the "green muse" that inspired artists and poets alike. He also calls its effect a type of "artificial paradise"—a phrase he borrowed from Charles Baudelaire.[48] For the poets of late nineteenth-century France, substances like tobacco, alcohol and the deadly absinthe symbolized the decadence of the fin de siècle, but instead of decrying their effects, most of these writers became what Doris Lanier has called "ambassadors of narcotic intrigue, euphoria, eroticism, and decadent sensuality."[49]

The medical reality as well as the romantic perception of addictive substances informed the visual imagery that appeared before the public in advertisements, popular journal illustrations, and even oil paintings. Artists could, and did, choose to edit the facts, or reprioritize them. On the positive side were the substances' aphrodisiac or hallucinogenic properties. On the negative side was their effect of isolating the user. These three effects are represented in the medical literature as well as in satirical illustration. Advertisers manipulated all three to convince consumers of the value of their products. The notion of "aversion" advanced by the medical profession had to be overcome by advertisers. In advertisements, and in satirical popular periodical illustrations, the femme fatale became a symbol for the addictive substance that at first evoked aversion but later caused sensual pleasure: the first cigarette caused choking; a first drink of absinthe tasted bitter. In visual representations, each substance developed a particular set of attributes. By focusing on the heightening of sexual pleasure promised by the consumption of alcohol or tobacco, advertisers accentuated the pleasurable rewards that could accrue after users overcame the initial aversion.

It is not clear how familiar poets and artists were with the medical literature, although they knew of the effects of alcohol, absinthe, and tobacco from their own experience. Poets who celebrated the decadence of their era often became targets of temperance reformers such as Dr. LeGrain. LeGrain especially attacked those who romanticized absinthe. He singled out a particularly decadent poem, "Absinthe," by Jean Richepin, a major Symbolist writer.

> Oh! les doux opiums, l'abrutissante extase
> Bitter, grenat brûlé, vermouth, claire topaze,
> Absinthe, lait troublé d'émeraude! Versez!
> Versez; ne cherchons plus les effets ni les causes.
> Les gueules du couchant, dans nos coeurs terrassés
> Vomissent de l'absinthe entre leurs lèvres roses.

> [Oh! Sweet opiates, stupefying ecstasy,
> Burnt-red bitters, clear topaz vermouth,
> Absinthe-milk clouded by emerald! Pour away!
> Pour away! Forget the whys and the wherefores.
> The mouths of the sunset, in our shattered hearts,
> Vomit forth absinthe between rosy lips.][50]

LeGrain contrasted this with the relatively harmless, traditional drinking *chanson,* which celebrated beer, wine, and cider. In his view of absinthe, "c'est que l'alcool est proprement le poison de l'intelligence, c'est que l'ivresse par l'alcool porte toujours un caractère pénible, triste, rapidement abrutissant, parfois tragique" [alcohol specifically poisons the intelligence; drunkenness is always painful, wretched, swift to undermine one's mental powers, and, at times, tragic].[51]

How did visual artists appropriate or, more frequently, recast these dour predictions in advertisements, popular illustrations, and paintings? Above all, they carefully selected what information they included or left out, depending on the purpose of the image. Women appeared in many of these images, due in part to their traditional connection to "nature" and natural products. In addition, advertisers "capitalized on prevailing attitudes regarding [a woman] as a lascivious playmate."[52] Interestingly, the visual images that associated women with absinthe, wine, beer, and tobacco are related both to the poetic literature, through what they show, and to the medical literature, through what they suppress. Fin-de-siècle art seems to acknowledge fully an awareness of the nature of addiction and the diseases caused by consumption of these substances.

Henri Gray (pseudonym for Henri Boulanger, 1858–1924) linked the voluptuousness of a woman with full-bodied wine in "Vierge . . . Cliquot" (figure 16). Cliquot was a brand of champagne created by Madame Cliquot. In Gray's illustration, a nude woman, reminiscent of Eve, arches her back against a champagne flute, so that as the patron reaches for his glass, he will in fact grasp her body, stripping her metaphorically of her virginity. Humor and sensuality were united in this 1881 illustration, which appeared in *Le Boulevardier,* a short-lived publication aimed at the café crowd. This image not only advertises champagne but comments on its role in France's economy. From her nudity, we can presume that the woman is not a consumer but rather the artist's muse, here fortified through an association with Eve. Grapes have replaced the "apple of knowledge" that caused the fall of man. Gray's work unites temptation and addiction, desire and downfall.

Images that did not advertise alcohol yet still appeared in the realm of popular culture weren't fettered by expectations of selling a product. Artists working in this forum satirized alcohol's qualities and the advertisers' use of sex to sell products. The properties of wine were featured in "Les femmes et le vin," an illustration in a 1900 issue of *La Grande Vie* (figure 17). This image extended the aphrodisiac quality of alcohol. Photographs of seminude women are placed in various types of glasses; the text describes the wine (and the women) of different regions—from Champagne to Bordeaux to Argenteuil. The text accompanying "Le vin de Tokay," for example, touts it as a "love potion recommended by gypsies to princesses in search of uncommon excitements." The implicit message is that a sexual encounter will follow on the heels of wine consumption. It suggests also that this wine will be enjoyed in a café or brasserie, where young women of questionable morals will be present. Although the women function ostensibly as "muses" linked to the wine traditions of different regions, they are obviously meant to be consumed like the

Figure 16. Henri Gray
(pseudonym for Henri
Boulanger), "Vierge . . .
Cliquot: Un verre de
Champagne." *Le Boule-
vardier,* Nov. 13, 1881, 5.
Bibliothèque Nationale
de France.

wine itself. What is left out of the image is the message, as conveyed by the medical
literature, that overdrinking can inhibit sexual desire and performance.

Illustrations that focused on the consumption of absinthe as a fashionable
activity also disregarded the harmful effects of this deadly drink. An illustration
from a holiday issue of *Le Moniteur de la Mode,* an expensive subscription fashion
magazine with a long run, from 1843 to 1913,[53] featured the costume "L'absinthe"
as one of three being promoted for the 1900–1901 holiday season (figure 18). The
leaflike forms of the dress on the center figure allude to the wormwood plant from
which absinthe was made, and the spoon ornament in the model's hair refers to
the ritual preparation of the drink. In fact, this ceremony, similar to the prepa-
ration of wine during a Christian Mass, was itself a sensual indulgence. A sugar
cube was placed atop a decorative slotted spoon laid across a glass. Pure alcohol
distilled from the wormwood plant was poured over the sugar, which dissolved

in the bottom of the glass, creating the base for the drink. Water was then added to dilute the alcohol, creating the familiar green color.

It is to absinthe that the issue of "aversion" is most applicable. Since wine and beer were weaker beverages, and most French people were introduced to these at an early age, there was not the same level of unpleasantness associated with the first taste of those beverages as there would be with the stronger, comparatively rare distilled drinks. The industrial production of distilled beverages, in addition to increasing their strength and decreasing production time, was also "less natural" and more mechanical. Advertisers were aware of this and worked hard to make these products *seem* natural through their connection to women, or to make them seem romantic through sexual innuendo. Ironically, it was said by some doctors and poets alike that women had a greater tendency to indulge in aperitifs such as absinthe due to the influence of fashion. Doctors suggested that it was the illusion of the aperitif as more elegant than wine or beer that led to that phenomenon; poets suggested that the tight clothing women wore simply allowed them to consume fewer fluids, and thus they were attracted to stronger drinks.[54]

A cover illustration for the satirical periodical *Frou-Frou* (1900) similarly highlights the fashionable, aphrodisiac qualities of addictive substances, while ignoring

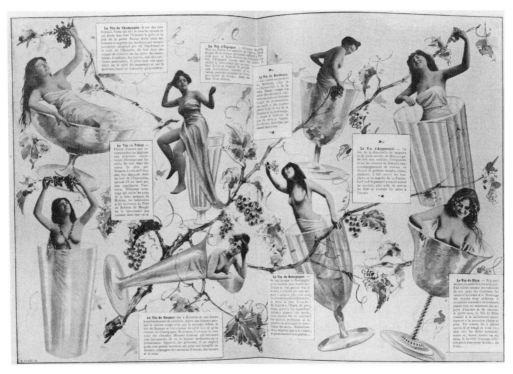

Figure 17. E. Crété, "Les femmes et le vin." *La Grande Vie,* no. 6, 1900, 7–8. Bibliothèque Historique de la Ville de Paris. Photographer, Jean-Loup Charmet.

Figure 18. Costumes entitled "Le congrès des arts," "L'absinthe," and "La belle jardinière." *Le Moniteur de la Mode,* holiday issue, 1901, plate 51. Bibliothèque Nationale de France.

their negative connotations (figure 19). The words "frou-frou" emanate from the cigarette held in the seated woman's hand. The focus of the viewer's gaze, however, is less on the cigarette than on the petticoats surrounding the woman's legs, much like petals of a flower. This image effectively associates cigarettes with the floral patterns of Art Nouveau, and with sensual high fashion, since "frou-frou" refers to the sound of rustling fabric as a woman moves. This journal, which contained more images than text, existed for just a few years, and, in this particular illustration, it connected smoking and fashion to advertise itself. It could be said that the periodical's contents, like cigarette smoke and the fashions worn by women, were fleeting and capricious.

The connection between smoking and fashion was also made in medical literature. Blatin noted that the cigarette had become a fashion accessory. In one article, he wrote, "On devient fumeur, comme on porte telle ou telle forme de chapeau ou de pantalon: parce que d'autres agissent ainsi" [One becomes a smoker just as one adopts a certain style of hat or pants, just because others do].[55] Similarly, Dépierris commented on the "chic-ness" of smoking and its contemporary function as a

Figure 19. Weiluc, "Le
frou-frou." *Le Frou-Frou,*
Oct. 20, 1900, cover.
Bibliothèque Nationale
de France.

rite of passage: "Pour satisfaire un vrai caprice, une folle ivresse, pour se distraire
par un jouet, une pipe et du tabac, voilà donc les sociétés européennes, la France
en tête, comme type de la fashion" [As for satisfying a mere whim, a mad passion,
amusing oneself with a toy—a pipe and tobacco—we have European society, with
the French in the lead, setting the fashion].[56] Dépierris compared exhaled smoke
to perfume.[57]

 Elsewhere, Dépierris wrote about the connection between smoking and prosti-
tution. The smell of smoke was associated with brothels, and also with the power
relations between the sexes. Dépierris claimed, "Ce fut alors une véritable conspi-
ration de la puissance de la volonté de l'homme contre la faiblesse de la femme.
Les dames ont cédé, par ennui de l'existence sans la société des hommes. Les hom-
mes, par contraire, en compagnie d'une pipe ou d'un cigare, dont ils humaient
nonchalamment la fumée, se passaient volontiers du besoin de sentir autour d'eux
le frou-frou électrique de la toilette des femmes." [The result was a full-scale con-
spiracy of male willpower against the weakness of the female sex. The ladies gave
way through the sheer boredom of living without male company. The men, on the

other hand, nonchalantly puffing away on their pipes and cigars, found in these sufficient companionship not to miss the electric aura of ladies' costumes rustling all about them.][58] Dépierris pointed out that while tobacco was once found primarily in taverns and prisons, it had penetrated high society, had become connected to fashion and elegance, could be found in public spaces of royalty and commoners, and had been accepted as part of an innocent pastime. This mysterious and fatal plant contained a poison that "s'est glissé subitement dans nos moeurs" [has suddenly insinuated itself into our way of life].[59]

Advertisements for alcohol and tobacco emphasized their aphrodisiac and poetic qualities—the direct experience provided by the substance. In Alphonse Mucha's (1860–1939) many advertisements for Job cigarette papers, women's hair curls in imitation of the swirling smoke pattern.[60] As Patricia Berman has written, "Job capitalized on the sensual association between women and tobacco to define the cigarette as an agent of seduction, and commissioned artists to create imagery that aligned smoking with sexual fulfillment."[61] Since the woman is shown holding a rolled cigarette, rather than the cigarette paper only, the poster implies the ritual act of rolling the cigarette. The café environment itself, where much smoking and drinking took place, is suppressed. The forms of the woman and the cigarette smoke are transformed into an Art Nouveau pattern suggesting natural fecundity rather than mass-produced industry. Despite the fact that smoking was generally a social activity (it didn't involve hallucination or isolation with normal use), Mucha focused on one figure, a woman, who wouldn't be part of the target audience. He exaggerated the sensuality of her body and the swirling smoke. The image, in its insistence on the decorous arrangement of the curling smoke, calls to mind Louis Figuier's explanation for why people smoke: tobacco excites the imagination and seduces the senses. It is not only pleasurable in its taste, but visually stimulating through the "formes capricieuses que prend la fumée qui se roule en anneaux ou se déroule en spirales bleuâtres" [whimsical shapes formed by the smoke curling into rings or uncurling in bluish spirals].[62]

The linking of tobacco with sex can be traced to Dutch seventeenth-century *vanitas* paintings that related smoking to sexuality through allegorical representations of all five senses: the sight, smell, and taste of smoke, the touch of the cigarette or pipe, and the sound from puffing and blowing.[63] All were sensual pleasures akin to those associated with lovemaking.

Emile Laurent, a physician who wrote about nicotine addiction, acknowledged that tobacco served as an aphrodisiac, despite medical documentation showing that prolonged use actually interfered with the sex drive.[64] Ironically, tobacco initially elicited aversion to smoking, as the first-time user had to endure a period of distaste and coughing before smoking could be enjoyed. This was described by Dr. A. Penoyée in the popular journal *La Cravache Parisienne:* "Les personnes qui fument pour la première fois éprouvent des malaises, qui suivant la susceptibilité individuelle, sont plus ou moins accusés" [When people first start smoking, they experience nausea, the extent of which depends on the individual's susceptibil-

ity].[65] The author went on to explain why addiction took place: the poisonous nature of the drug caused withdrawal, and the body and the brain craved more once they overcame the initial aversion. Mucha's representation heightens the promise of pleasure without indicating the trials of addiction.[66]

Advertisers of alcohol, who emphasized their product's aphrodisiac benefits, understandably ignored the negative effect of social isolation caused by absinthe and other forms of spirits. Advertisements for wines and aperitifs did not show the café environment, which was criticized for its debasement of society because of the cumulative poisons found there. It was café drinking, not the consumption of wine with meals, that was the primary target of temperance movements, even those that advocated complete abstinence. Jules Chéret's (1836–1932) poster for Dubonnet focuses on the bottle of liquor and implies its aphrodisiac qualities.[67] The woman shown advertising the product does not resemble the waitresses from the *brasseries,* understood to be prostitutes, but rather an unattainable ideal. The "Chérette," the Chéret "type" of woman with impossible bodily proportions and an easy but false smile promoting Dubonnet, wears the latest fashions and strikes a pose suggesting relaxation and sensual pleasure. The white cat nearby was an understood symbol for sexuality.

Another poster, Privat Livemont's (1861–1936) "Absinthe Robette" (figure 20), features a diaphanously draped woman raising a glass topped with the characteristic absinthe spoon. This gesture is not unlike that of a priest raising a chalice during the celebration of Mass. There is no café environment to compromise the "purity" of the experience. The woman receives the absinthe from on high. The connection with Art Nouveau is appropriate, for this style attempted to forge a unity between nature and industry, reinforcing a stated purpose: the increased health of the masses. The medical indications of absinthe's dangers are subverted through the combination of romantic fantasy and religious experience. "Toxins" are not combined in these poster advertisements, for smoking and drinking are seldom shown in conjunction with one another.

Café Culture

While poster advertisements rarely showed the café where a product would be consumed, popular images and oil paintings often depicted both the milieu and the temptations found there. According to Bergeret, smoking gave men a reason to leave their families and go to the cafés. Once there, alcohol consumption became natural and this could, in turn, lead to the procuring of a prostitute. Illicit unions were formed under the influence of alcohol, since respectable, sober men would want nothing to do with drunken women. As Bergeret writes, "C'est souvent l'ivrognerie qui conduit certaines femmes à ce degré d'abjection qui en fait les hideuses *proxénètes,* ces êtres dégradés que l'on rencontre dans les antres de la Vénus impudique, de la Vénus Callipyge" [Often it is drunkenness that drags down certain women to the degree of abjection that turns them into hideous *procurers,*

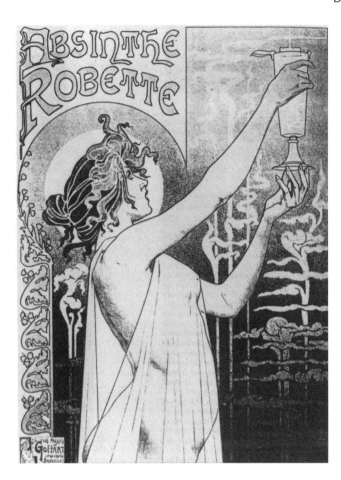

Figure 20. Privat Live-
mont, "Absinthe Ro-
bette." Color lithograph
poster, 1896. Biblio-
thèque Nationale de
France.

those degraded creatures we meet in the dens of the immodest, Callipygian Ve-
nus].[68] While the fathers were out of the house, the children were more likely to
take to the streets themselves.[69]

J. Denis, in his 1903 article "Cabaretisme et alcoolisme," echoed popular senti-
ments that the number of legal cafés had to be limited to "extirper un mal dont les
conséquences sont si redoutables et sont un danger pour la santé publique, pour
l'ordre social et surtout pour les bonnes moeurs" [extirpate an evil whose conse-
quences are so fearful and constitute a danger to public health, the stability of
society and, above all, to morality].[70] In his view, this venue had been overlooked
as a place to study the social consequences of alcohol, including crime, suicide,
madness, and death. Max Nordau claimed that indulgence of and addiction to
stimulants and narcotics was causing French fin-de-siècle society to decay. What
he termed "poisoning through indulgence" would breed "degenerate descendants
who, if they remain exposed[, would] rapidly descend to the lowest degree of
degeneracy."[71]

Cafés were condemned because of what was believed to be the cumulative effect of toxins in these environments. Coffee, which did not cause a problem by itself, was believed to compromise health when mixed with alcohol. Similarly, the use of alcohol in conjunction with tobacco was believed to increase exponentially the toxic effect of either substance.[72] Jolly claimed the smoker's attraction to absinthe was completely physiological, and that the use of each substance encouraged progressive abuse of both, causing an increase in illness.[73] Laurent believed that the effects of tobacco and alcohol would neutralize each other, although he thought it was the action of one against the other that ravaged the body.[74]

Alcoholism also caused otherwise good people to set bad examples. This included savants and artists, who, in Bergeret's opinion, could destroy their talent by losing themselves in alcohol. It was in the cafés that one could find subversive literature, including works that railed against governmental authority or that promoted indulgence in human passions. Laurent characterized the café as a false and cruel enterprise that dispensed poisons to the lower classes under a benign disguise. Here, the naive were exploited and the charlatans supported.[75]

Alcohol consumption and distribution were connected specifically to women in ways other than poster advertisements for various brand-name beverages. T. Barthélemy, in his *Syphilis et la santé publique,* documented the brasserie and the phenomenon of the *filles de brasserie* who became purveyors of alcohol. According to Theresa Ann Gronberg, the *inviteuese* of the brasseries was the waitress who encouraged drinking, literally an *agente provacatrice*.[76] Waitresses generally drank while they served their customers, and many of these women were also stricken with syphilis due to the ensuing sexual contact.[77] As alcohol caused women to lose their resolve in the face of sexual temptation, the taste for alcohol and the debauchery of women were closely linked.[78] Alfred Carel, in *Les brasseries à femmes de Paris* (1884), linked the proliferation of brasseries to the Universal Exposition of 1867: "Les femmes de Brasserie forment une espèce de franc-maçonnerie où, par suite d'une promiscuité continuelle, on en est arrivé à une corruption effrayante" [The brasserie women form a kind of freemasonry which has led to corruption on a frightening scale through endless promiscuity].[79] The women were to do whatever was necessary to satisfy the client, so he would drink more. Léon Richer, in an article for *Le Droit des Femmes,* commented on the decision of the mayor of Bordeaux to make the hiring of women as servers in brasseries illegal, and to prohibit serving alcohol to women known to be prostitutes. Richer criticized the latter proposal, asking how one could tell if a woman is with her husband or someone else. The mayor insisted that the presence of these women was the real cause for concern. By removing their right to work and to drink, debauchery would be reduced. Richer suggested that legal brothels should be eliminated rather than taking such ridiculous measures.[80] The campaign against the *brasseries des femmes,* which were renowned for "coquetterie et flirtage" as much as for the serving of alcohol, gathered strength during the 1880s.[81]

Henri Gray's illustration for the popular periodical *Le Boulevardier,* entitled

"Bock nature" (1881), connects the promise of a drink with the attainment of a woman in a café (figure 21). In this instance, a barmaid dressed and posed like the one in Edouard Manet's *Bar at the Folies-Bergère* (1881–82, London, Courtauld Gallery) is standing in a beer mug. Smoking a cigarette, she faces the viewer as the caption exclaims: "Boum! voilà! Servez . . . chaud!" [Boom! There it is! Serve . . . hot!] The caption contains a double entendre; the phrase "Serve hot!" refers simultaneously to the cigarette, which was thought to stimulate thirst for a cold alcoholic beverage, and to the promised "hot," or sexy, service from an attractive female. Gray's illustration and Manet's painting were executed at about the same time. Both artists imply in their images that the café environment promises a variety of pleasures, and both connect the enjoyment of alcohol with the availability of a woman. While Manet's painting suggests the tragic consequences of the barmaid's life, through the woman's glazed, drunken expression, Gray utilizes sexual innuendo that sidesteps any social responsibility.

Despite the frequent appearance of women in advertisements and satirical images involving these substances, they were not the primary consumers, nor were

Figure 21. Henri Gray, "Bock nature: 'Boum! Voilà! Servez . . . chaud!" *Le Boulevardier,* Oct. 30, 1881, 5. Bibliothèque Nationale de France.

they the primary targets of nineteenth-century reform groups.[82] On the occasions that a woman addict was discovered, however, she was subjugated to an inordinate amount of scrutiny and public outcry. A rare illustration of female public intoxication appeared in *Le Boulevardier* in 1881. Henri Gray's "Sul'zinc" (figure 22) addressed the isolation that alcohol could produce. *Sul'Zinc* refers, in slurred tones, to the phrase for "set 'em up." In the image, a clearly drunken woman with a parasol leans against a large wineglass in a punning visualization of that phrase. Through a manipulation of scale, Gray communicated the control that alcohol has over her. He also moved the image, and thus the debate, toward the idea of hallucination.

Oil paintings of the time also depicted isolated alcoholics who had become distanced from reality. This is probably true of Manet's barmaid in his *Bar at the Folies-Bergère;* the enigmatic expression on her face has caused a great deal of speculation as to the artist's intent with the image.[83] Edgar Degas (1834–1917), in *Au café,* now also known as *L'absinthe* (1876, Paris, Musée d'Orsay), similarly described a place where people congregated but remained socially isolated by their consumption of liquor. Degas effectively contrasted the stupor of the actress Ellen Andrée, drinking absinthe, with the actively engaged Marcellin Desboutin, who is drinking coffee.[84] Desboutin appears to be communicating with someone outside the picture frame.

Figure 22. Henri Gray, "Sul'zinc: '—Ohé! Polyte! Une verrée-eu d'vin!'" *Le Boulevardier,* Nov. 6, 1881, 5. Bibliothèque Nationale de France.

Despite the fact that Andrée and Desboutin share the same space, the opening at the right side allows the man an avenue of escape and intensifies the sense that the woman is trapped within herself. Degas's use of cropping, derived from careful study of photography and Japanese prints, only increases the feeling of isolation. This use of space differs from that of Manet's later *Bar at the Folies-Bergère.* While both artists were influenced by the asymmetrical compositions of Japanese prints, Manet insists on the primacy of the grid to anchor the major forms, resulting in a strictly frontal pose. Manet's barmaid confronts the viewer, while Degas's Ellen Andrée is oblivious to the viewer.[85] Desboutin and Andrée were friends of Degas, but his intent in *Au café* was not to paint their portraits; rather he sought to capture a slice of contemporary life at a Montmartre café.

In an 1876 popular image by Hadol for the satirical publication *Le Monde Comique,* the dangerous nature of absinthe is even more directly connected to the woman who drinks it. In "L'araignée du soir," a woman drinking a glass of absinthe sits within a spider web; she is the black widow, ready to suck the life out of her prey (figure 23). The web not only underscores the idea of a femme fatale about to trap a man, but it also refers to the state of mind that absinthe causes. Quite literally, the toxin creates a web obstructing normal thought processes. The caption indicates that Penelope tends to her web as she waits. In Greek mythology, Penelope wove a shroud for her recently deceased father as an excuse to avoid suitors' advances when it appeared that her husband, Ulysses, had died in the Trojan War. When the shroud was finished, Penelope said, she would choose a new husband, who would become king. Secretly hoping that Ulysses had not died, she spent each night unraveling her weaving from the day before, using this strategy to wait for nineteen years until her husband returned. The myth reveals the place of woman in Greek society, for Penelope could not assume the role of Ulysses as ruler of the country, but the suitor she chose would automatically become king, irrespective of his background or qualifications. Likewise, in Hadol's illustration, the woman, despite her threatening nature, needs a man to attain her goals. Gronberg interpreted Hadol's illustration as showing a prostitute waiting for a client, quoting the French doctor L. Martineau: "Mais, c'est surtout chez les marchands de vin que la tenace prostitution clandestine s'exerce le plus communément et le plus commodément. Ces boutiques sont comme le centre d'une toile d'araignée où viennent se prendre les consommateurs. Les femmes s'y tiennent, soit comme bonnes, soit comme habituées." [But it is particularly at the wine shops that this tenacious form of clandestine prostitution flourishes. These are like the centers of a spider's web where drinkers come and get entangled. The women ply their trade here, either as waitresses or habitués.][86]

Highly addictive and likely to cause hallucinations, absinthe was described in poetry and prose as a female lover—the "green-eyed fairy"—a full-fledged femme fatale. The poetic term for absinthe was "la dame verte."[87] The user hoped to reach a hallucinogenic state and be transported to a fantastic world, yet the actual effect was isolation from others, from reality, and eventually from his or her mental fac-

Figure 23. Hadol, "L'araignée du soir—cinq heures! Heure de l'absinthe. Penèlope a tendu sa toile." *Le Monde Comique,* no. 194, 1876, 775. Bibliothèque Historique de la Ville de Paris. Author's photograph.

ulties. "L'heure de l'absinthe," which indicated the time of day that people usually engaged in the ritualistic preparations, between five and seven in the evening, was equated with notions of fatality and destiny by André Gill.[88] Charles Cros, in his poem "L'heure verte," described the time when absinthe permeated the air as the "emerald" hour.[89]

A realist rather than a romantic, Gustave Geoffroy, who worked diligently to discourage alcohol abuse, provided an interpretation of the "absinthe hour." He

penned articles for *Gil Blas,* including "Paysage d'alcool," which was illustrated by Théophile-Alexandre Steinlen (1859–1923). In 1897, Geoffroy published part of a story entitled "La bonne Absinthe" in the journal *L'Alcool.* His setting was one of the huge new bars packing in customers each night. "Partout, dans tous les verres, l'absinthe, et l'atmosphère embaumée du violent parfum de forêt" [Absinthe was everywhere, in every glass, and the atmosphere reeked with an overwhelming forest scent], he writes. One minute everything is fine; the next, violence erupts. "Ce n'étaient pas des isolés, des maniaques de l'absinthe: ils commençaient, à n'en pas douter, leur apprentissage du poison; ils y trouvaient la saveur charmante, l'appât délicieux" [It was not just a case of isolated troublemakers, crazed absinthe addicts: these were undoubtedly apprentices to the poison who found the taste delightful, the lure irresistible].[90] In his story, women are numerous, and they drink their absinthe just like men.

Indeed, women were connected to the use and abuse of absinthe in many different literary examples. René Asse, in the satirical journal *L'Esprit Gaulois,* provided another example of poetry that documented crime and associated absinthe with adultery, infanticide, and suicide.[91] Women's susceptibility to drink was also discussed by the playwright Henri Balesta: "Elle assimile avec une facilité remarquable tout ce qui, en bien comme en mal, agit violemment sur son organisation, essentiellement impressionable. Soyez-en bien persuadé, s'il y a des absintheuses, c'est que préalablement, il y a eu des absintheurs." [Women take with remarkable facility to anything—good or bad—that has a violent effect on their constitutions, which are essentially impressionable. You can be sure that if there are women addicts, there were male ones first.][92] Absinthomania was thought to be contagious, spreading from men to women, who were then called *absintheuses.* This effect has been called the "socialization of abuse."[93]

An image that hints at the "socialization of abuse" phenomenon is the illustration "Mystique et sceptique" (figure 24). Louis Legrand (1863–1951) drew it for the widely distributed *Le Courrier Français.* Legrand's illustration contrasts two types of women, in an age-old tradition that stereotyped women as "good" or "bad." Mystique, wrapped in a white veil, is a member of a religious order, while Sceptique, wearing a black revealing outfit and smoking a cigarette, appears to be a prostitute. Sceptique moves toward Mystique aggressively, threatening to corrupt her with a stream of expelled smoke. Because their facial features and body types are identical, the women appear as twins, split between good and evil. As in Emile Zola's naturalist novels *Nana* and *L'assommoir,* Legrand seemed to suggest that both qualities exist in every woman, and that a substance such as tobacco tipped the scales toward evil. Commenting on the decay of moral values, Legrand proposed that addiction, either to substances or religion, affected the direction of women's lives.

A more pointed commentary on the connection between smoking and prostitution was provided by Henri Gray, whose "Rêves bleus: Fumée de cigarette" appeared on the cover of *Le Courrier Français* in 1885 (figure 25). A woman wearing only shoes, thigh-high stockings (the "uniform" of the prostitute), and artificial

Figure 24. Louis Legrand, "Mystique et sceptique." *Le Courrier Français,* May 13, 1888, cover. University of Minnesota Libraries. Author's photograph.

Figure 25. Henri Gray, "Rêves bleus: Fumée de cigarette." *Le Courrier Français,* Feb. 1, 1885, cover. University of Minnesota Libraries. Author's photograph.

butterfly wings seems to engage the viewer in conversation. She sits on a large, lit cigarette from which smoke rises to mingle with the smoke from the cigarette in her raised hand. The caption has a double meaning, linking the prostitute directly to cigarette smoke, which is fleeting and inconstant, like the butterfly-woman, who could fly away at any minute. The illustration suggests that smoking and prostitution are both decadent addictions.

Albert Maignan (1845–1908), in his 1895 painting *La muse verte,* unites the ideas of hallucination, isolation, and sexual stimulation (figure 26). A writer or a poet stands near his desk, which is littered with books, papers, and a glass of absinthe. In the foreground is a broken bottle, while a pile of papers lies dangerously close

Figure 26. Albert Maignan, *La muse verte.* Oil on canvas, 1905. Musée de Picardie, Amiens.

to the open door of a coal-burning stove. The complex image relates the creative process, symbolized by a burning flame, to a hallucinatory muse, in this case a female symbol for the dangerous liquor. Maignan has transformed the woman, the traditional muse for poet and artist, into an imaginary figure, emanating from the vapors emerging from the broken bottle of absinthe. She grasps the man about the temple, the seat of creativity. The expression on his face communicates not only intoxication but also the pleasure and pain resulting from his encounter with this hallucinatory muse, clothed in green. Absinthe drinkers spoke frequently of the "green fairy" that brought the desired intoxication along with the deadly addiction. Quite clearly, Maignan has dramatically connected the motif of the femme fatale to the dangers of addiction. The viewer is left to guess how the poet will meet his demise. Will his downfall occur only because of the consumption of absinthe? Or will there be a secondary accident, due to his proximity to the furnace, or to the balcony railing overlooking the street?

Apoux's undated illustration "Absinthe" is even more direct in its equation of the liquor with both women and death.[94] It is clearly aligned with temperance imagery that evolved in the early twentieth century. Illustrations for temperance campaigns used scare tactics stimulated directly by medical literature. These embraced the very imagery that the advertisers and satirists sought to avoid. In Apoux's work, the beautiful body of a woman rising from the glass is crowned with a skeleton's head. One leg is bare while the other is clad in a prostitute's black stocking. She carries a robe or shroud and a jester's staff, which mocks authority. The image unmasks the promise of addictive substances, exposing the ugly truth that lies beneath their seductive appearance. Apoux uses the femme fatale to communicate the decadence and disease associated with tobacco, drugs, and alcohol. This is an effective association because the femme fatale focuses on the same dichotomy of danger/pleasure in "narcotic intrigue, euphoria, eroticism, and decadent sensuality."[95]

Alcohol, tobacco, and absinthe offered escapism, while also contributing to male anxiety, as the medical community increasingly warned of the danger of disease and the undermining of morality. Both men and women participated in the café culture of fin-de-siècle France, but advertisers used only women to promote these products, by tempting male customers with a fantasy ideal. At the same time, a woman could symbolize the danger these products posed when consumed liberally by members of either sex. The environment of the café, as well as the territory of the female body, became politically charged due to historical events; the Franco-Prussian War, and the Commune that followed, caused the government to fear radical groups that congregated in the cafés. Depopulation, a major concern of the day, was blamed in part on the "new woman's" desire for greater freedom; further, it was linked to the consumption of toxins that could interfere with sexual drive or cause miscarriages, birth defects, and high infant mortality rates. Under these circumstances, it is hardly surprising that the prostitute was associated with tobacco, alcohol, and absinthe. As Zola suggested in his novels, society produced

the milieu in which these connections became inevitable; prostitutes did consume absinthe and tobacco. However, it was also the case that women who chose to drink or smoke were automatically and unfairly labeled as prostitutes or sluts, as indicated by the critical reception of Degas's *Au café*. An evolution of thinking with regard to women took place at this time, and its repercussions still reverberate in today's advertising culture.

FOUR Dangerous Beauty

The last quarter of the nineteenth century in France saw women making significant progress in terms of personal freedoms, playing a variety of roles in an increasingly modern society. No longer exclusively restricted to being wives and mothers, women entered the public arena through work and leisure activities, including shopping and participation in feminist organizations. But in popular illustrated journals, male artists attempted to limit the range of these contemporary women by employing the literary device of juxtaposing virtue and vice, and by ignoring nuances of character or social advances. This led them to investigate a variety of types of women, including barmaids, dance hall performers, singers, and delivery girls—those in professions that collectively comprised a thinly disguised network of unregulated prostitution.[1]

The prostitute became the primary focus of male fantasies of female sexuality, fantasies fueled by the ambiguous nature of the prostitute. She was a mixture of pleasure and danger, the known and the unknown. Artists became preoccupied with defining her attributes and mapping her various manifestations. Images created by these artists implied that harm could befall a man who looked specifically to the cafés and cabarets of Montmartre for a female companion. The "modern woman" who was becoming a new force in society was seen as impudent, challenging, and even dangerous. These themes and popular images of women came to be centered in Montmartre, itself a capital of

pleasure and vice. Located on the outskirts of Paris, and not subject to the strict regulation of sex or alcohol, Montmartre was first the bastion of the workers, but eventually it became a destination for members of the middle class looking for excitement tinged with danger. Montmartre was at the center of changing values that would have a lasting impact on future generations in France and elsewhere, as the idea of segregating classes gave way. Increasingly, cabarets and brasseries became places where the classes mixed, and where women assumed nondomestic roles. Frequently, the point of contact between the upper and lower classes was the prostitute.

Sins of the Flesh

Charles Bernheimer has written that the prostitute served as a vehicle for the expression of "male fantasies of female sexuality" and "male ambivalence about desire, money, class, and the body."[2] The duality of attraction and repulsion stemmed from both the fear of sexual desire and the belief that the prostitute's ability to operate across class lines could lead to a breakdown of social divisions and even to "cultural ruin, in which individuals become easily replaceable substitutes for one another, [as] the encroachment of universal mediocrity threatens all differential structures of meaning."[3] Artistic and literary representations of the prostitute's body thus function as attempts to control her public sexuality and avert the destruction she is capable of causing.

These responses are not surprising, given the diseases spread by prostitutes, especially syphilis, which not only caused madness and death but also was often passed on in a dormant form to appear generations later. There was a fear of depopulation that struck at the core of the French nation, especially following the humiliating defeat of the Franco-Prussian War. Medical and social institutions began to regulate prostitutes through health inspections and to register and restrict them to the so-called *maisons de tolérance.* This regulatory approach is significant, for it suggests that fear of the prostitute increased if her location could not be tracked. Artists and writers also "regulated" prostitution through their invention and promotion of prostitute types, complete with careful descriptions and sometimes illustrations, to facilitate knowledge about the unknown. Their quasi-scientific investigation was intended to reassert masculine control over feminine sexuality.

This particular approach evolved from earlier nineteenth-century literary and artistic strategies. During the Romantic period, the prostitute was a sympathetic figure who fell in love, rejected her former life, and then typically punished herself by denying the love she had sought. This figure operated very much like the biblical Mary Magdalene—a whore who was converted through meeting Jesus but then spent years of deprivation in the wilderness. *La dame aux camélias* (1848), by Alexandre Dumas fils, may have been the last successful novel modeled on this prototype. Later in the century, this particular manifestation was no longer credible. In contrast, the prostitute in the literature and art of the Second Republic was

a figure of conspicuous consumption on the modern boulevard, "a brilliantly arti-
ficial construction" whose "spectacular theatricality appealed to the misogynous
artists at mid-century because it obscured the libidinal animal they imagined to
lurk under her synthetic surface."[4] This woman had a duality imposed on her by
men—they created for her a mask or shell to disguise her nature.

Bernheimer explained the literary function of prostitutes in the works of sev-
eral prominent authors. Balzac provided a transitional presentation of prostitu-
tion in *Splendeurs et misères des courtisanes* of 1845–47. According to Bernheimer,
Flaubert radicalized the "association of prostitution with the male denial of female
sexuality"; Zola tore away the masks constructed by earlier artists and writers; and
Huysmans determined that "female sexuality = prostitution = castration = syphilis
= the organic world."[5] These literary strategies are paralleled in the structure of
types developed by artists and other writers.

Camille Mauclair declared that the body of the prostitute is her reason for be-
ing, her method of attack, and her mode of defense. She is not capable of a moral
existence, and her hatred of man is her most constant sentiment. After years of de-
bauchery, the courtesan still has rage for the first man who took away her dream of
a sentimental, idyllic love. This leaves her, according to Mauclair, "profondément
anarchiste, parce qu'elle voit l'homme dans sa primitive animalité" [a profound
anarchist, since she can see man in all his primitive, animal-like state].[6] She also
detests her dependence upon men for money, and she disdains the public who
loathes her. She is an egalitarian because desire makes all men equal. Her body
must adapt to her activities. While the body of the ordinary woman is made for
reproduction, Mauclair believes, the body of a prostitute "ne doit comporter au-
cune fécondité, et est machiné pour s'emparer impérieusement du désir mâle"
[must never bear fruit, and is engineered to make the uttermost of male desire].[7]
Mauclair likened her body to a potentially lethal war machine: "Cette machine de
guerre, en effet, s'apprête à déterminer chez le mâle acheteur de spasmes la phtisie,
la paralysie, la congestion cérébrale, la névrose, les affections génitales, la folie"
[This war-machine, in fact, is preparing to smite with consumption, paralysis,
strokes, neuroses, sexual infections and insanity the male who buys his orgasms
for cash].[8] Love for a passionate and educated mistress, or for an esteemed wife, is
insufficient since man will continue to desire the prostitute "aux heures perverses
où il convoite le plaisir aigu de descendre d'un degré au-dessous de lui-même et
d'être vu dans cet état sans que pourtant son prestige social doive en pâtir" [at those
perverse moments when he craves the heightened pleasure of descending a degree
below himself and being seen in this state without, however, paying the penalty
with his social prestige].[9] Mauclair declared sin to be a primary attraction.

> Chez presque tous les hommes en qui survit l'atavisme catholique, c'est l'irremplaçable
> attrait de l'idée de péché, de dévotion à Satan, qui nimbe d'un prestige criminel l'acte
> banalement hygiénique. Et précisément parce que cet acte a été majoré, déformé et
> outré dans sa signification et ses conséquences par l'idée de péché, la pensée de son

accomplissement inspire à l'homme une sorte de frénésie nerveuse et mentale qui
mêle à la simple satisfaction organique un attrait presque tragique.

[In virtually all men in whom there survives a sort of Catholic atavism, it is the irre-
placeable attraction of the idea of sinning, of devoting oneself to Satan, which lends
the commonplace physical act an aura of criminal prestige. And precisely because
this act has been overvalued, distorted and blown out of proportion through its
connection with sin, the contemplation of its accomplishment inspires in a man a
sort of nervous and mental frenzy where the simple satisfaction of an organic desire
acquires an almost tragic appeal.][10]

The prostitute knows that she is a force of nature. Vice is her vengeance, and "la
nature ne connaît pas le vice. C'est l'éducation qui l'a inventé" [vice is unknown
in Nature; it was invented by education].[11] Mauclair believed that artists who used
prostitutes as models barely acknowledged their perversity and their vengeful at-
titude against the middle class.

Pol de Saint-Merry's popular 1898 text entitled *Pécheresses* examined the ori-
gins and significance of contemporary prostitution. In his opinion, novels taught
a woman to play a game in which she appeared to protect her virtue but eventu-
ally, and inevitably, succumbed to vice. While prostitutes came from all social
classes, a disproportionate number came from the lower class. He estimated that
in Paris alone, with a population of 2,500,000, there were about 30,000 *pécher-
esses*.[12] Pol de Saint-Merry linked heredity and social class to the relative beauty
of these women. The aristocratic world gave rise to marriages that show a certain
degeneration, while the bourgeoisie, which come in closer contact with the work-
ing classes, "laisse apercevoir d'une façon plus sensible encore cette démarcation"
[reveals this demarcation even more clearly].[13] Many prostitutes were recruited
among rural women, who moved to the city and eventually became part of the
"masse des pécheresses vulgaires" [mass of commonplace sluts].[14] But of all the
categories of women, those in the domestic professions—maids, cooks, or nan-
nies—were most likely to end up as prostitutes. Paul Bourget, in his *Physiologie de
l'amour moderne* (1890), described a downward spiral that began with a woman's
becoming a man's mistress. From here, it was six months to the Latin Quarter, one
year to a brasserie, five or six to the Folies-Bergère or what he called an "Eden,"
and finally to a brothel.[15]

Elsewhere, Saint-Merry discussed the difficulty of distinguishing between the
pécheresse and the *femme du monde,* a task made more complicated by the increas-
ing numbers of café singers and actresses.[16] He also tried to classify prostitutes as
either "official" or "unofficial," the latter those who escaped notice of the *police
des moeurs.* Many of them had legitimate but low-paying occupations and turned
to prostitution to supplement their income and satisfy their taste for luxury. In
this category were women in the fashion trade: *modistes, couturières,* and *plumas-
sières.* According to Saint-Merry, industries that provided luxuries and typically
employed women at a very low wage, as the fashion industry did, were disastrous

for female virtue.[17] True love was rare among such *pécheresses,* and Saint-Merry suggested that what replaced it was the pursuit of luxury items. The courtesan becomes an "actress of love," making it difficult to identify those who profited by the sale of their sexual favors.[18]

Among the many problems Saint-Merry addressed was the use of nude models in art; if prostitution were to disappear, would artists find their models in cloisters or convents?[19] Furthermore, the female performer, whether a dancer, singer, or actress, inspired beauty, as did the mistresses of poets and painters. If the world suddenly became completely virtuous, what would happen to art and entertainment? Saint-Merry concluded that the ancients had a more tolerant attitude toward the courtesan and gave her a legitimate role within society.

In an article for *Gil Blas Illustré* in 1897, Catulle Mendès wrote of woman's appearance and her ability to transform herself through makeup.[20] He claimed that as a source of ecstasy, or an excuse for crime, nothing compared to the power of a woman. In order to manipulate men, women learned the art of donning guises, aided by the application of cosmetics. With practice, any woman could take on a variety of personas.

> Elles ne bondiront pas de la vierge à la prostitutuée! Elles se transmueront, comme à peine, avec des arrêts à chaque point de la transformation; elles mettront beaucoup de ressemblances diverses,—la coquette, la consentante à demi, la consentante tout à fait, la rétracteuse de l'aveu, la rétracteuse des rétractions, l'ignorante presque, la savante entièrement, . . . la soumise, la triomphante, et le déni des chuchotements.

> [They do not suddenly make the leap from virgin to prostitute! They will pass through scarcely discernible changes, pausing at each stage of the transformation, adopting a whole variety of appearances—coquettish, partly consenting, totally consenting, retracting admissions, retracting retractions, the virtually naïve, the utterly wily . . . submissive, triumphant, and giving the lie to whispers.][21]

Mendès suggested that the women affecting these personas did not completely understand the complexity of the emotions and actions they were capable of stimulating in men. The average man, on the other hand, had difficulty decoding feminine artifice. It was left to the poet or artist to supply additional information.

An 1897 cover for *Le Courrier Français* suggests the ease with which women could move between roles (figure 27). Here a nude woman, striking a pose with a cigarette dangling from her mouth, asks the artist in the background: "Should I pose for Vice or Virtue?" Whether an image of a nude was considered "classical," that is, virtuous, or "pornographic" had to do with the accoutrements of a composition. The fact that this nude is smoking indicates that the models who posed for artists came from the lower classes and often also engaged in prostitution to make ends meet. Indeed, there was a name for women associated with poets, musicians, and artists from Montmartre; she was called the *Montmartroise.* The masculine form, *montmartrois,* was used by writers such as Eugène Lemercier, in his *Autour du moulin, chansons de la butte* (1898), as a an adjective relating to activities undertaken in

Figure 27. Adolphe Léon Willette, "Vais-je poser pour le Vice our pour la Vertu?" *Le Courrier Français,* Feb. 7, 1897, cover. University of Minnesota Libraries. Author's photograph.

Montmartre, for example, *plaisirs montmartrois* or *cabarets montmartrois.* The use of the word *Montmartroise* to describe a woman who inhabited this neighborhood was an extension of the practice of applying place names to French citizens from various regions of the country.[22] However, Montmartre was not a region but the red-light district of Paris. Appropriately, the magazine *La Vie Parisienne* described the *Montmartroise* as cunning, possessing loose morals, and attractive in an unusual way. She was said to be "more *parisienne* than the *Parisienne.*"[23]

"Voilà le plaisir," an illustration by Karl Happel, known as Carl-Hap (1819–1914), published in the journal *Le Chat Noir* (1894), depicts the most common

role of the *Montmartroise*.[24] In this illustration, a woman announces herself as "pleasure," and the presence of a black cat signals that the pleasure is sexual. As the official organ associated with Rodolphe Salis's cabaret by the same name, this magazine pertained to life in Montmartre, and specifically to activities linked to Salis's establishment. An illustration by Adolphe Léon Willette entitled "La chanson" indicates another pleasure to be had in Montmartre. For this cover of *Le Courrier Français* (1898), Willette drew a bare-breasted performer whose dress seems to spin a spider's web (figure 28). In the background, Father Time sits transfixed, his feet sprouting mushrooms. The sand has run out in his hourglass. The suggestion here is that the Montmartre performers ensnared their audiences, causing time to stand still.

Willette took this theme of Montmartre pleasures and vices even further in his stained glass window for the Chat Noir. The design for the window (now lost but known from an oil maquette) features a woman holding a black cat (signifying sexual pleasure) over her head, a gesture that again is reminiscent of a priest raising a chalice during Mass (figure 29). The full moon in the background indicates not only the hours when the cabaret did most of its business, but also suggests that the woman is the priestess of an alternative religion. Placed in the bow around her waist is a lily, traditionally associated with the purity of the Virgin Mary, but here subverted by the rest of the symbolism. The woman's dress is covered not with

Figure 28. Adolphe Léon Willette, "La chanson." *Le Courrier Français,* Apr. 24, 1898, cover. University of Minnesota Libraries. Author's photograph.

Figure 29. Adolphe Léon Willette, *La vierge au chat (La vierge verte)*. Oil on canvas, c. 1882. Jane Voorhees Zimmerli Art Museum, Rutgers, the State University of New Jersey, Regina Best Heldrich Art Acquisition Fund, 2001.0371.

fleurs-de-lys, but with beetles, associated with death since they feed on carrion. Sahib (pseudonym of Louis-Ernest Lesage, 1847–1919), refers to the window in his illustrations depicting the cabaret Chat Noir, including one for *La Vie Parisienne* (1887). This demonstrates the importance of Willette's image in identifying the nature of the cabaret.[25] The black cat and the occult associations came to be incorporated into all future references to the cabaret. The most widely recognized of such portrayals of the Chat Noir is Steinlen's famous poster of 1896.

In juxtaposing a woman with a black cat, Willette drew a direct parallel between the two. This is underscored by their rhyming bodies, as well as the fact that the woman wears a bell around her neck. On the platform below, mice scurry, startled as much by the woman as by the cat. The bell, which is worn by cats to warn off innocent creatures, here warns men of this attractive woman's dangerous sexuality. The motif of the lily adds complexity to the image by introducing the concept of virtue to the predominant theme of vice. In this respect, Willette's work relates to other depictions of women popular at the time, such as Henri Gerbault's "Ah! les demi-vierges" for *Gil Blas* (1896).[26]

To these men, the status of the *demi-vierge*—the flirt who stayed just technically within bounds of virginity—was a desirable state for a woman to occupy. An article in the journal *Le Chat Noir,* entitled "Contemporary Virgins," posed the rhetorical question of where exactly virginity begins and where it ends.[27] A similar idea is explored in Louis Gautier's "A Modern Leda," an illustration in the same journal (1893), in which the artist recast the myth of Zeus, who takes the form of a swan to impregnate the mortal maiden.[28] In Gautier's work, the swan is replaced with a black cat; the woman has wings that could be interpreted as either swan wings or angel wings, again suggesting the virtue/vice duality. Another article in *Le Chat Noir* described Leda as being "perverse in her desire and subtle in her caress."[29] These are just a few of the many examples that link the *Montmartroise* with the sexuality of the black cat, which also symbolized a specific cabaret in Montmartre.

The powerful symbolism of the black cat, which was utilized so effectively in Manet's *Olympia* (1863, Salon of 1865, Paris, Musée d'Orsay), did not go unnoticed by poster designers, who were busily promoting popular performers like the singer Yvette Guilbert.[30] Henri Dumont, the artist of the poster "Tous les soirs aux Ambassadeurs, Yvette Guilbert" (c. 1890), shows the singer emanating, like a genie from a bottle, from the tail of the black cat (figure 30). The cat rubs or grooms itself, releasing the image of Guilbert, complete with her signature black gloves. In this way, an abstract symbol for Montmartre served advertisers, even when performers associated with the area were booked in establishments other than the Chat Noir cabaret.

The Chat Noir transcended its physical domain in many ways. It promoted its ideas in an illustrated journal and became a recurring symbol in posters for Montmartre performers. An illustration by Henri Rivière shows that the realm of the cabaret environment literally spilled out into the streets.[31] The street provided a direct expression of sexual pleasures, through the presence of prostitutes. Street-

Figure 30. Henri Dumont,
"Tous les soirs aux Ambas-
sadeurs, Yvette Guilbert."
Color lithograph poster, c.
1890. Bibliothèque des Arts
Décoratifs, Paris.

walkers were linked to the condition of modernity in several articles and poems published in *Le Chat Noir*.[32] While prostitution itself was not new, the attitude of the prostitute had changed. For instance, Jean Lorrain contributed the following verse: "Modernity, Modernity! / The brazenness of sluts / Despite the boos and tut-tuts / Gleams brightly through eternity."[33] A cover for the *Courrier Français* (1897) by Adolphe Léon Willette sets the action squarely in Montmartre, showing the stained glass window of the Chat Noir and a sandwich board advertising the Moulin de la Galette (figure 31). A woman approaches two men and in the caption says to one of them, "Trust me, friend, it's not love, it's a wild ride." The shock on the man's face, as well as the anonymity of the faceless and footless woman, suggests a threatening encounter.

Sex workers were viewed by men as "liberated" and therefore suspect. Prostitutes were feared for the diseases many carried, but also for the power they appeared to wield over their clients. In Gray's image "Guerre éternelle" for the *Courrier Français* (1885), a bare-breasted woman wearing a contemporary Parisian hat and an Egyptian-style skirt suggests both a prostitute and an amazone (figure 32). The accompanying verse explains:

Figure 31. Adolphe Léon Willette, "Méfie-toi, camarade, c'est pas de l'amour, c'est la Vache enragée!" *Le Courrier Francais,* Dec. 19, 1897, cover. University of Minnesota Libraries. Author's photograph.

L'amour est un combat entre l'homme et la femme
Qui rive au vaincu le vainqueur.
Tendresse et volupté, nous dit-on!—Lutte infâme!
L'un l'autre on s'y mange le coeur!

[Love's a battle between man and woman
Binding victor to vanquished with its arts.
Tenderness, delight? No! Ghastly struggle
Where combatants devour each other's hearts!]

In this particular combat, the woman will be the victor; the man will have his heart eaten. The woman cracks a whip at a winged, flaming heart as she stands atop a skull, representative of her domain, complete with what are likely intended as *fleurs du mal.* In the background looms a heart-shaped shadow, suggestive of a moon. The multivalent references to Egypt—specifically Cleopatra as a powerful, sexually active, and dangerous woman—and to contemporary Paris are typical of the complexity of images drawn by male artists for the popular illustrated press.

Figure 32. Henri Gray, "Guerre éternelle." *Le Courrier Français,* Apr. 12, 1885, cover. University of Minnesota Libraries. Author's photograph.

Mapping the Sexual Terrain

For his "Femmes automatiques," for *La Vie Parisienne* (1892), Ferdinand Bac drew a variety of women behind velvet ropes, as if they were exhibits in a museum (figure 33). Male customers are required to pay coins to animate these automatons, and the subtitle reads, "You get what you pay for." A number of the women shown are types to be found in Montmartre, including a dancer, similar to those often seen in Degas's works; a chamber maid; and a barmaid reflected in a mirror, as in Manet's *Bar at the Folies-Bergère* (completed in 1882). This illustration clearly indicates that these women were sex workers masked by so-called legitimate professions. Their "value" was based on their social class and the perceived rarity of the second profession; the famous actress "costs" more than the barmaid, who can be purchased for a package of cigarettes, according to the caption. Also featured in Bac's illustration is a dancer from the Moulin Rouge, made familiar by Toulouse Lautrec, but also found in images by Henry Somm and others. The dress of the male customers indicates that these female types were primarily consumed, visually as well as literally, by members of the bourgeoisie and the military. Indeed, men of varying incomes patronized the prostitutes in Montmartre and contributed to the stratification of the business.

Figure 33. Ferdinand Bac, "Femmes automatiques: Ce qu'on y met, ce qu'il en sort." *La Vie Parisienne,* Mar. 19, 1892, 160–61. University of Notre Dame Libraries. Author's photograph.

The artist Gerbault suggested that a woman's level of virtue or vice could be determined by how she lifted her skirt. One work illustrating this theory was "Comment elles retroussent leur robe," published in *La Vie Parisienne* in 1897 (figure 34).[34] At center is a delivery girl, an amateur prostitute, or *trottin,* who would step in front of potential clients on the sidewalk and then hitch up her skirt.[35] At the right are the dancer of the *chahut* (specific to Montmartre) and the lowest form of streetwalker, who raises her skirt only slightly and glares at her customer. Ranked from high class to low class (from left to right), the women also suggest different areas of Paris. The trottin is positioned in the middle, indicating her special attraction; since a man did not know how experienced she was, his excitement was stimulated by the possibility that he would be her first. The text accompanying the image explains that she is in search of a specific type of man, for whom she will lift her skirt to indicate she is available. The dancer from the Moulin Rouge moves in contorted, erotic movements that can be equated with more specialized sexual pleasures to be obtained later in the evening. The action of the woman at far right, who is shown against a dark, foreboding background, is engaged in "l'horrible retroussie" [the shocking lifting of the skirt]. The text poses the question, "Quel être charitable se laissera tenter?" [What charitable person will allow himself to be tempted?] Her desperation represents the continued downward spiral of women caught in the cycle of prostitution.

Figure 34. Henri Gerbault, "Comment elles retroussent leur robe." *La Vie Parisienne,* Aug. 28, 1897, 494–95. University of Notre Dame Libraries. Author's photograph.

An artist known as Job, also working for *La Vie Parisienne,* went even further with two series of images called "Pronostics et résultats" (1893).[36] To him, the easiest way to see what was available was to show the women with and without clothes. In his estimation, the trottin fares quite well, as a well-kept secret ripe for exploration, but the barmaid yields an ugly truth once her corseted costume is removed.[37] Job's images, like those discussed thus far, link clothing both to class level and to occupation.

Octave Uzanne, in his *Parisiennes de ce temps* of 1894 (discussed in chapter 2 for its use of references to Paris as Eden), examined women from different social spheres: workers, prostitutes, actresses, and middle-class housewives. He also demonstrated that morals and masculine ego inherently inform such an examination of feminine types. In his introduction, Uzanne identified his reason for undertaking the enterprise, connecting his project directly to the multivolume *Les Français peints par eux-mêmes,* of 1840–44, as well as to the eighteenth-century work of Restif de la Bretonne and Sébastien Mercier.[38] Uzanne recognized that French society had changed, due to politics, industrialization, and scientific advances. He proposed treating the "physionomies les plus caractéristiques de la Parisienne de tous rangs sociaux au début de notre vingtième siècle" [the characteristics of all ranks of Parisian women at the start of our twentieth century].[39] A sense of instantaneity was critical to his definition of female types, and in fact, he compared it to photography: "Aussi nous sommes-nous complu à activer le défilé des principaux types de la femme actuelle, en n'accordant à chaque physiologie professionnelle qu'un menu croquis en silhouette ou ce que la vogue photographique de notre heure nomme en argot consacré—un *instantané*" [So we happily set in train a parade of the principal types of modern woman, restricting the analysis of each class to a sort of quick sketch in profile, or what the present passion for photography calls in its jargon—a *snap*].[40] He attempted to address all facets of women's lives, public and private, with prostitution forming a significant portion of his content. Uzanne at times took a reformist position regarding women's wages and the issue of equality. And he seemed aware of issues that affected power relationships between the sexes, like nature versus culture, and the role of the male ego in the contemporary construction of society.[41]

Uzanne's text is divided into four sections. The first part, "Physiologie de la contemporaine," includes general observations on the *Parisienne,* including her psychology, the nude, and fashion. Part 2, "La femme à Paris, dans ses différents milieux, états et conditions," features chapters on types of women found in discreet areas of Paris: domestic servants, clerks in small boutiques, workers in the great department stores, women in administrative positions, women artists and *bas-bleus* (feminists), actresses and theatrical performers, women in sports, and finally *la bourgeoise parisienne.* This section moves from the private to the public, as does the first part. The third section of the book, "La femme hors des lois morales," classifies prostitutes in a strict hierarchy, from poor streetwalkers, to clandestine prostitutes, to highly paid courtesans. The fourth and final section contains only

one chapter, on the role of woman as daughter, wife, and mother. This chapter, which contains the moral of the book, suggests that Uzanne's "real" *Parisienne* is educated and leads a morally uplifting life.

Uzanne was aware that urban women held an ambiguous position in fin-de-siècle French society; they were simultaneously lofty queens and lowly victims, as a result of masculine passion and vice. The immorality of man, born of idleness and brutal instincts, resulted in the corruption of women. Uzanne condemned French society for boasting of its refinement while denying equal status to women, and for failing even to recognize the dire state of the female population.[42] The modern female professions only masked the reality of their situations with a refined outward appearance. Everything conspired against these women, the laws and "nonprotection" of the police, as well as "la légèreté et le désir de séduction qui y règnent dans les milieux les plus opposés" [the laxity and desire for seduction flourishing in the most dissimilar surroundings].[43] The relaxing of moral standards, according to Uzanne, was more the fault of men than the "weaker sex." Many of the poor *Parisiennes,* victims of what Uzanne called "Don Juanisme inférieur" [a base type of Don Juanism], were sacrificed to the "Minotaur moderne" [modern Minotaur].[44]

So too were women of Paris victims of French institutions. Uzanne remarked on the increasing uncertainty in determining the line dividing the demi-monde from the upper classes due to dress. "Ce demi-monde, du reste, dont nous aurons largement à nous occuper pour lui donner la place qu'il accapare en réalité dans le féminisme parisien, est devenu, cela ne pouvait manquer, un petit Etat dans la grande ville, et il comprend les castes les plus variées, les aristocraties les plus étranges" [This demi-monde, which we need to examine in detail to give it the importance it has acquired among Parisian feminists, has inevitably become a small state within the great city, and includes the most varied caste systems and the most bizarre aristocracies].[45] According to Uzanne, there was a demi-monde of sports, of dramatic and fine arts, even of Parliament. And within these multiple demi-mondes, there was a further stratification that separated the most influential and seductive women from those who only occasionally dipped into vice, those from honorable families who worked as independent prostitutes, the large number of poor women, and the "incurably debauched."[46] A primary problem was the indifferent attitude taken by both men and women toward adultery. While moralists believed that prostitution led to a lower birthrate, Uzanne identified moral isolation and unstable love as the true causes of depopulation.[47]

A chapter in Uzanne's book is devoted to the concept that certain types of women could be found in certain geographic regions of Paris. Women of the Right Bank were supremely elegant and chic, while those of the Left Bank presented a marked contrast.[48] By touring from the Place de la Nation to Vincennes, a flâneur could discover "le plus amusant défilé de femmes qui se puisse voir en suivant la hiérarchie exacte des diverses classes sociales de la femme à Paris" [the most fascinating imaginable parade of females, from the bottom to the top of the city's

social hierarchy].⁴⁹ Around the Bastille, the flower sellers and shop girls had the airs of the industrial petite bourgeoisie. Near the Hôtel de Ville, delivery girls, laundresses, maids, and teachers dominated. In the northern section of the city, women were employed in food industries, as fruit sellers or cashiers for butchers. There was a dramatic change near the Palais-Royal, where women who worked in the fashion industry, governesses, women who studied music at the conservatory, and dancers were found. Along the Champs-Elysées to the Place de l'Etoile, the flâneur could observe "la vie élégante."

> L'amazone, la bicycliste, le modèle, la soubrette, la lectrice, la costumière mondaine, la manicure, la masseuse, la pianiste, l'androgyne aux manières lesbiennes, à la tenue étrange, au regard froid, la femme galante, les femmes hygiénistes de tous les rangs et qualités, et, parmi celles-ci, des Anglaises très *lady-like,* des dames de charité, des dévotes évoluant lentement vers les églises de Chaillot ou de Saint-Philippe, des dames touchées par la ménopause et qui ne veulent pas grossir, des neurasthéniques et des entraînées.

> [The amazon, the bicyclist, the model, the soubrette, the reader, the fashionable costumer, the manicurist, the masseuse, the pianist, the androgynous type with her lesbian mannerisms, strange garb and frigid looks, the *femme galante,* the health fanatics of every rank and quality, including very ladylike Englishwomen, charity ladies, the devout slowly wending their way to the churches of Chaillot or Saint-Philippe, women who have reached the menopause and don't want to grow fat, the valetudinarians and those in peak physical form.]⁵⁰

At the end of the chapter, Uzanne concluded that his tour around Paris proves that one cannot judge women's lives by a quick glance at the activity on the Champs-Elysées alone. Many women in the city lived in misery, in morally corrupted circumstances beyond their control. Low wages led them inevitably to prostitution, in order to survive.⁵¹ This is a recurrent claim that the author supported by examining nearly every paid position a woman could hold, from domestic servant to flower seller to worker in the fashion industry. In every profession, there was an element of the demi-monde, and it is here that clandestine prostitution was simultaneously located.⁵² Like previous writers, Uzanne believed costume to be a primary indicator of a woman's profession, with the possible exception of the woman of *haut commerce,* who was sometimes confused with the *femme du monde,* since her role was to advertise, by her own elegant dress, the prosperity of the shop in which she worked. The world of sports was another area of fashion confusion and, according to Uzanne, was no more than a pretext for cross-dressing.⁵³ Uzanne's ideal *Parisienne* was charitable, sensible, and either a modest virgin or a prudent mother.

Georges Montorgueil, a member of the Montmartre community and the author of several books on cabarets and theaters, undertook what was perhaps the most encyclopedic examination of female types. His book *La Parisienne peinte par elle-même* (1897) differs from Uzanne's in the quality of its illustrations, drawn by the

artist Henry Somm. Those in Uzanne's were quite ordinary, while Montorgueil's consisted of twenty reproductions of etchings by Somm, who was also a player in the world treated in the book, through his direct interaction with some of the female types. Montorgueil's volume was descriptive, but it did not have the altruistic focus of bettering the feminine condition. He may even have written his book in response to Uzanne's, although this is difficult to prove. In a letter attached as a frontispiece, L. Conquet stated the goal of *La Parisienne*. "Ce livre comprend vingt chapitres qui sont autant de silhouettes de la Parisienne, de la grande dame à l'ouvrière, du modèle au trottin, de la demi-mondaine à l'ingénue; c'est la Parisienne dans le monde et dans la rue, telle qu'elle pose, telle qu'elle passe—et telle qu'à son insu, diverse d'état et de condition, mais partout charmante, elle se peint elle-même." [This book comprises twenty chapters, each a profile of the *Parisienne,* from the *grande dame* to the factory girl, the model to the streetwalker, the *demi-mondaine* to the ingénue. What it reveals is the *Parisienne* out in the world, in the streets, the way she acts, the way she walks—and the way in which, unconsciously, always full of charm whatever her rank or condition, she chooses to portray herself.][54]

By its very title, Montorgueil's text refers to the same series of volumes mentioned by Uzanne: *Les Français peints par eux-mêmes.* In his preface, Montorgueil proposed his book as a postscript to the earlier series. Unlike Uzanne, who saw the segments of society as more or less contiguous, Montorgueil believed that an enormous distance separated *le monde* from the demi-monde. The first part of the book concerns women who are involved with family in some way: *la grande dame, la ménagère, la jeune fille à marier,* and *la dévote.* The last he considered a latter-day Mary Magdalene, "Pécheresse impénitente dont le grand chic extérieur s'associe volontiers à la foi exaltée et manifeste, elle est toujours l'assidue des offices, fervente et troublée" [An unrepentant sinner, whose strikingly elegant exterior creates an immediate impression of exalted and theatrical religiousness, she is a regular churchgoer, fervent and spiritually disturbed].[55] By this, Montorgueil suggests, as others had, that Mary Magdalene was an ideal fille d'Eve, who understood that she would have to eternally repent for the sins of her mother.

The second part of Montorgueil's book focuses on women who work in the home or with children: *la nourrice, l'institutrice, la domestique, la petite bonne duval,* and *la petite blanchisseuse.*

The last two parts of Montorgueil's book are concerned with women in the fashion industry and women in various levels of prostitution, respectively. I have considered a selection of the images illustrating these types, in the order in which they are found in the book, that is, in the order of increasing perversity. The demi-monde had its class levels and castes, and "le triomphe d'une courtisane est rebelle à l'analyse" [the triumph of a courtesan is impossible to analyze]. Montorgueil discussed the special role that fashion played in the lives of these women: "La mode—cette divinité despotique—décrète la célébrité en vertu d'on ne sait quelles obscures raisons" [The ways in which that tyrannical divinity, Fashion, decrees celebrity are quite unfathomable].[56]

The type named *la fille,* according to Montorgueil, primarily frequented the cabarets, those "musical Edens" like the Moulin Rouge.[57] She used provocative language to entice her clients and wore her professional smile like a mask. Montorgueil called her a "flower of the asphalt," to indicate where she might be found—if not in the dance hall, then on the street.[58] Her role was predetermined by her instinct for pleasure. The companions that she conquered found her words to be provocative clichés and her ambitions comprised of lascivious nighttime behavior. Montorgueil explained la fille as emblematic of the virtue/vice dichotomy that made Montmartre such an attractive area to men. Even if she was able to find a man who could assure her of a leisurely life, says the author, la fille will ultimately return to the streets. As a "bohemian of love," who could be swayed by materialistic possessions, she would eventually wax nostalgic for illicit love, thus sealing her fate. Montorgueil described her as Eve, the original temptress whom man could not resist.[59]

The last two types included in the book are *la bicycliste* (figure 35) and *la perverse* (figure 36), which are linked in a significant way, for the bicycle was deemed responsible for ushering in a sexual revolution of frightening proportions. This was due especially to the cyclist's pantslike costume, which, in Montorgueil's estimation, was neither masculine nor feminine.[60] In addition, the author associated the costume with the idea of temptation, given that the motion of a woman's genitals against a bicycle seat was thought to be responsible for sterility.[61] Although feminists hailed the bicycle as a way to combat the muscular weakness of women, Montorgueil countered that the question "to be or not to be a bicyclist" was the rough equivalent of "to be or not to be an ape"—indicating the evolutionary regression (both physically and morally) that he associated with the mechanical contraption.[62] A woman on a bicycle was "émancipées plus qu'émancipées, elles passent parmi les hommes, les mains dans les poches, l'air de gamins vicieux, et s'étonnent que les hommes soient plus familiers et moins tendres—comme s'ils regrettaient de ne point retrouver, dans l'effronté camarade en culotte, la charmante et discrète maîtresse en jupe d'autrefois" [emancipated beyond emancipation, wandering about among the men, hands in pockets like a vulgar urchin, and astonished that the males are more familiar and less affectionate with her—as if disappointed on encountering this brazen, trousered buddy in place of the charming and discreet mistress in skirts to whom they had become accustomed].[63]

The increasing mobility of women, represented by the bicycle, was a threat to the male population as it implied her move away from the home and maternity. This was discussed by the art critics Camille Mauclair and Marius-Ary Leblond, who identified three dangerous characteristics of the "new woman": independence, critical thinking, and mobility.[64] The increased mobility and moral ambiguity associated with the bicycle explains its frequent appearance alongside women in the pages of *Le Chat Noir.* For example, two illustrations by Carl-Hap show women posing by their "mounts"; one is on her way to a funeral in full mourning regalia, while a second sports angel wings and wears very short culottes.[65]

The diatribe against the bicycle—which, not coincidentally, was linked to the

women's rights movement—continues in a chapter on la perverse. Here it is stated that the bicycle created a Third Sex as a result of women's trading the power of charm for that of liberty.[66] La perverse, called by Montorgueil a "perverted Eve," was a "precocious marauder" who used the bicycle to deliver the apple to an unsuspecting Adam.[67] A sorceress of disasters, and loyal to the black masses of Satan, this demi-vierge intensified her vulgar desires through demonic practices.[68] Montorgueil described her "abnormalities" thus:

> Jeune, ce fut un drôle de petit animal, d'une morbidesse prenante, d'une gentillesse féline, câline et brusque, aux caresses longues et sournoises. Ça avait de jolies dents, mais aiguës comme des dents de chatte se plaisant à mordre; de jolis ongles, mais acérés comme des griffes, et industrieux à se roser du sang des coeurs lacérés; de jolis yeux, mais d'un cristal qui miroitait comme au fond d'un gouffre et don-

Figure 35. Henry Somm, "La bicycliste." Georges Montorgueil, *La Parisienne peinte par elle-même* (Paris: Librairie L. Conquet, 1897). Bibliothèque Historique de la Ville de Paris. Photographer, Jean-Loup Charmet.

Figure 36. Henry
Somm, "La perverse."
Georges Montorgueil,
*La Parisienne peinte par
elle-même* (Paris: Librai-
rie L. Conquet, 1897).
Bibliothèque Historique
de la Ville de Paris. Pho-
tographer, Jean-Loup
Charmet.

nait le vertige. Au gré de sa fantaisie, ça ornait les propos de son esprit à facettes et
à paillettes, de son esprit de diable-à-quatre en maillot d'Arlequin. Sans gaieté, ça
sonnait faux la gaieté dans l'oliphant du rire. Et sans chagrin, de la rosée des pleurs
ça perlait le long velours de ses cils lourds.

[When young, she was a quaint little creature with a fascinatingly languid grace
and a feline gentleness; she was affectionate though brusque, and her caresses were
long and sly. She had pretty teeth, but as sharp as those of a cat that loves to nibble;
pretty nails, but deadly as claws, eager to dye themselves with the blood of lacerated
hearts; pretty eyes, but like crystals sparkling from the depths of a gulf, inducing

vertigo. When the whim took her, she bedecked her conversation with sparkles and flashes of wit, her devil's own wit one could liken to a Harlequin's costume. Lacking gaiety, her gay, trumpeting laughter rang false, and when her tears formed a pearly dew on her long velvet lashes, there was no sorrow.][69]

This particular inhabitant of the demi-monde of prostitution was repeatedly described by Montorgueil as toxic, poisonous, and a source of destruction to mankind. Her sirenlike voice weakened the conscience, and her instinctive duplicity clothed a desire to watch others suffer, making her the most dangerous of the women described in Montorgueil's manual. He even implied that she maintained her youth through the realization of her victories, stopping just short of characterizing her as a vampire. While the book began by describing "real" women of contemporary society such as maids and dressmakers, the final section on the various levels of prostitution made clear the slippage between the worlds of fantasy and reality when it came to the supposedly "sexually liberated" woman. Montorgueil's connection of la perverse to Eve is significant, for it links his thinking to a larger trend within French society. Jean Floux, a writer for *Le Chat Noir,* noted in his poem "Les Eves" that such women were neither spouses nor mothers, but their kisses were savory poison. The apples of Eden contained their soul, and their friendships were both lascivious and chaste.[70] Thus, even Eve was seen as embodying the desirable virtue/vice duality.

Victor Jozé, writing under the persona of a Second Empire courtesan, Comtesse de la Vigne, in *Les usages du demi-monde* (1909), condensed prostitute types into three levels, identifiable through behavior, habits, and clothing. He promised that his book would interest observers of contemporary life as a sort of guidebook to love. In the first chapter, he explained how a trottin could become the queen of Paris. Such women were to be considered *filles du peuple* and the street their Eden.[71] Naive young women came to prostitution after being seduced by their first love, usually believing that love would deliver them from an unhappy home life. At first, they sought love, not money, because they had only a vague idea of what constitutes luxury.[72] Jozé declared that prostitution was a necessary evil and could be genetically inherited.[73] In Jozé's view, the notion of a demi-monde as it evolved under the Third Republic could be defined as "La Halle aux cocottes." As he explained, "La demi-mondaine d'il y a quarante ans était une mondaine déclassée; la demi-mondaine de nos jours est une simple courtisane plus ou moins lancée, plus ou moins riche, plus ou moins instruite, mais, en somme, une professionnelle, une marchande de l'amour" [The *demi-mondaine* of forty years ago was a society woman who had lost her status; the *demi-mondaine* of today is a mere courtesan, more or less established, more or less wealthy, more or less educated, but, in short, a professional purveyor of love].[74]

Jozé devoted several chapters to comparing the characteristics of three distinct classes of prostitutes. The courtesan at the highest level was beautiful and intelligent. She had a carriage, hotel, maid, and everything she desired: "Elle est

l'idole" [She is like an idol].[75] She could be seen at the theater and opera, and her potential clients were politicians, journalists, and "hommes du monde" [men of the world]. Carefully recruited shortly after being abandoned by her first lover, she could sleep late, answer letters from admirers, and plan her day before going out. The finest fashions occupied a great deal of her time, and she had numerous mirrors in which to contemplate herself from several angles; *and* she had at least three manicures a week.[76] Her favorite sport was horseback riding, and she could afford the costume required for it. She rarely dined alone, preferring to be seen in public with a large group of friends. After lunch, she could nap for two hours, and had the ability to dream. She had a mutually favorable relationship with her couturier, whom she trusted implicitly and treated as a confidant. She shopped at the department stores between 2 and 6 P.M. She nearly always needed something: "sa coquetterie n'est jamais satisfaite, son besoin d'élégance est toujours insatiable et son luxe est sa première arme de combat" [she is never satisfied, she looks seductive enough, her hunger for elegance is always insatiable, and her wealth her principal weapon].[77] Should she bring a client with her, she could generally flatter him into picking up the tab. For such a woman, a *promenade* in the park brought admiration from men and jealousy from women. There she walked slowly, sure of her power. For the rich man, she was a possession, and proof of his wealth. Jozé described the relationships formed by the courtesan as mutually beneficial—she needed a rich man, and he treated her like an expensive object to be exhibited. But the courtesan could be resentful of her place and play cruel games.[78] Only in rare instances would a courtesan at this level make use of a hotel for a tryst. Her dream was to sleep alone, and it was something she managed to achieve upon occasion.

A woman at the middle level had no hotel or carriage, and although she desired the finer things in life, she was unable to afford the expensive clothing and jewelry of her rival. Her clients were drawn from crowds at public dances and "pleasure establishments." Women at this level most often had a form of low-paid employment, and were "aux allures louches, aux mines confites" [shifty and sour-looking]. They remained on the prowl in Paris. Men who were interested in them made small talk and eventually invited them to their homes.[79] Her life was less planned, more accidental, than that of the high-level courtesan. She might or might not have a chambermaid, time to lounge in her peignoir, and a weekly manicure/pedicure. A woman at this level would get a walk only while out running errands. Generally, she could not afford horseback riding, but she could occasionally play tennis or croquet. She dined frequently in cheaper restaurants, usually meeting a friend there. She might rest after lunch but did not dream while she slept. Some women in this category could afford to wear clothes made by a couturier, while others bought them ready made. Others wore used fine clothing. This woman constituted the "true" *demi-mondaine,* commonly called *la cocotte.* She also frequented the department stores in the afternoons but was rarely accompanied. There, women at this level "flânent, rôdent autour des comptoirs et ne se décident pas aussi facilement à commander que leurs soeurs en haute noce"

[roam and prowl about the counters and don't make their minds up to buy some-
thing as quickly as their sisters out on spending sprees].[80] These women were more
romantic and less conniving. A promenade in the park was generally taken alone;
the woman was not an object displayed. She believed true love possible. For her,
maisons de rendez-vous were great resources.[81] Her dream was also to sleep alone,
but she realized that this was possible only at the expense of her budget.

At the lowest level flourished "la femme apache, la pierreuse qui *saigne* le bour-
geois tout aussi proprement que le *dégringole* son petit homme, son marlou, le
blême voyou, graine d'assassin" [the *femme apache,* the street-walker who *bleeds*
the bourgeois as surely as her male friend, her pimp, knocks him down, the pasty-
faced thug with all the makings of a murderer].[82] She had no comforts and had to
approach her clients. Her realm was the street and the police frequently pursued
her. Such a woman was recruited from an environment of misery, vice, and alco-
hol. She awakened with her client, and she had no idea of the luxury of a peignoir.
She wore only cheap makeup and two shirts she took off only long enough to wash.
Her only walking was done "on duty," especially when being chased by the police.
Sports were out of the question, unless drinking absinthe could be considered a
sport. Her meals were taken irregularly and might consist only of sausage and
fries. In part, this was because she had little money, but also because "ses goûts
sont dépravés" [her tastes are depraved].[83] Her only nap might be in the corner of
the wine merchant's shop where she ate lunch. She had no couturier and rarely
went to the department stores. A walk in the park would likely invite scandalous
propositions and police surveillance, for this woman was part of a population
"crapuleuse, canaille et misérable parmi laquelle les filles de troisième marque
se font principalement remarquer" [that was drunken and wretched: the riffraff,
amongst which the basest prostitutes were the most noticeable].[84] Since her clients
were mostly drawn from the working class, their meetings took place primarily
at night. If a middle-class man showed up, it would be to experience a sense of
danger. Of the prostitutes at the lowest level, the one who made use of *maisons de
tolérance* belonged to "l'aristocratie de la prostitution populaire" [the aristocracy
of popular prostitution].[85] Her dream was to have only one or two clients a day,
and she yearned to return to her innocence.

Jozé concluded his text, still in the character of the Comtesse de la Vigne, by
dispensing advice to her fellow prostitutes. "Ne dépassez pas la limite que votre
situation vous commande de ne pas franchir. S'arrêter à temps, juste à temps, c'est
faire preuve d'intelligence et d'habileté; c'est vous acquérir la gratitude de votre
amant; c'est fortifier votre puissance, votre domination." [Don't cross the limits
your situation warns you not to. Stop in time, just in time; that shows intelligence
and skill. It will heighten your partner's gratitude, strengthen your hand and your
power over him.][86]

In the 1880s, *La Vie Parisienne* ran a series of fantastic topographical illustra-
tions, by the artist known as Sahib, that addressed the ambiguity of love in Paris by
literally mapping the shifting territory of the prostitute. The article of December

10, 1881, initiating the series, explained that the maps were meant as a tongue-in-cheek guide for those inexperienced in love, and proclaimed Paris to be a "New Cythera." Cythera was the island where Venus came ashore following her improbable birth. Watteau conceived of the island in the eighteenth century as the scene for aristocratic erotic fantasies (*Embarkation from Cythera,* 1717, Paris, Louvre). The composition of the first map, entitled "Nouvelle géographie du pays du tendre," envisioned as the sail of a boat, clearly refers to Watteau's masterpiece (figure 37). Its proposition is that the upper-middle classes are marking their power within society by writing themselves into a fantasy previously intended only for the aristocracy. The map gives a birds-eye view of the entire *pays du tendre,* which, not surprisingly, resembles France.

Additional maps provide a closer look at the various provinces: "High-Life," "Théâtre," "Haute-Bicherie," and "Basse-Bicherie." The capital of the country of Love is New Cythera, which is situated precisely on the equator and occupies roughly the position of Paris. The accompanying article describes the capital as providing the grace and charm of a civilization at its height, with a government modified to a great degree by universal suffrage, since the New Cythera is the only city where women have been given the right to vote. French women were not granted this right, in fact, until the twentieth century, but in 1881, when the maps appeared in *La Vie Parisienne,* new laws reaffirmed women's right to meet in groups of more than three. Many artists reacted to the repeal of this law like prophets of doom, speculating that women would abuse their new freedoms, that male livelihood would be threatened, and that the power of France would be diminished through depopulation.[87]

The artist of the map illustrations took the approach of trivializing the effect of the new laws of 1881 by including industries such as perfumeries, jewelers, flower shops, lingerie stores, bakeries, and furniture stores, underscoring domestic aspects of feminine life. Luxury hotels, with exits on several streets, appear; they were known to facilitate surreptitious rendezvous, but also discovery by jealous spouses.

"High-Life" is a detail of the central area occupied by the upper-middle classes.[88] Here New Cythera is located at upper left and features no less than six Venuses. Amusements such as horseback riding, ice skating, lawn tennis, and dinner in a cabaret are to the south of the "Grand Chic railway," while politics, the academy, and "Bas-Bleus Island" are to the north, thus on the fringe, but still part of high-class activity. A series of islands located on the "High Life" map compare virtuous and nonvirtuous love: the *île des soupers* and *île de rendezvous* are contrasted with the *île des maris, gouffre du mariage,* and the *rochers de la vertue.*

A third map describes the theater province, which can be accessed by the same Grand Chic railway, and a fourth, "Haute-Bicherie" (figure 38), overlapped by a portion of "Théâtre," situates various levels of prostitution.[89] The close proximity of the theater district and the *haute bicherie* confirmed that many women arrived at prostitution through theatrical professions. The map shows that there are

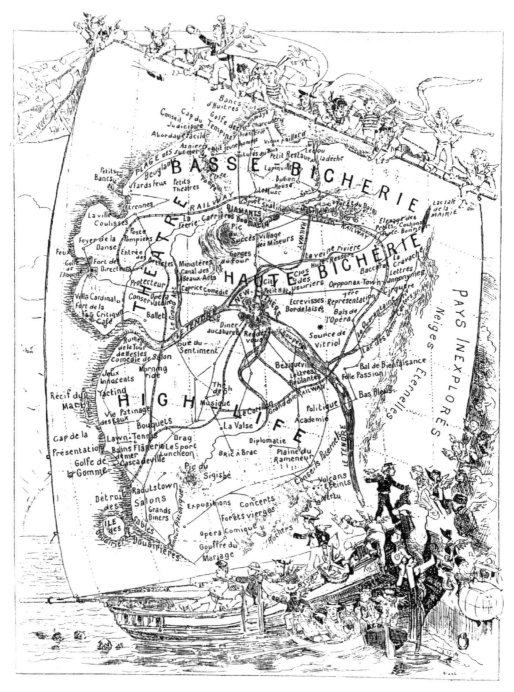

Figure 37. Sahib, "Nouvelle géographie du pays du tendre: Carte générale à vol d'oiseau."
La Vie Parisienne, Dec. 10, 1881, 710. University of Notre Dame Libraries. Photographer,
Tim Fuller.

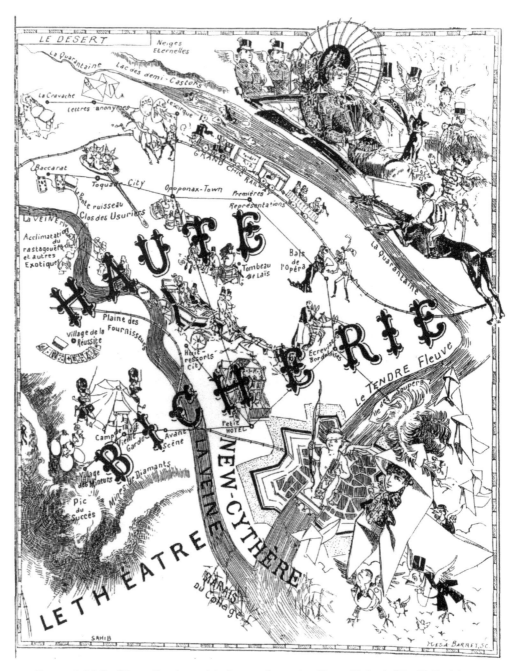

Figure 38. Sahib, "Nouvelle géographie du pays du tendre: Haute-Bicherie." *La Vie Parisienne*, Dec. 17, 1881, 732. University of Notre Dame Libraries. Photographer, Tim Fuller.

many ways to reach the "little hotel," via a game of baccarat or even the circus. From the Bal de l'Opera, one can travel to the *île des soupers*. This island contains symbols that make the connection with prostitution clear. A folded piece of paper appears several times in the lower right corner and also encloses the figure of a young woman. This is a symbol for a cocotte, a fictional type of woman whose characteristics were nonetheless based in reality. The folded-paper form may appear at first to be Japanese origami, but it originated in Spain, where it is known as a *Pajarita* [little bird].[90] The Pajarita became very popular in France because it was easy to make—easy enough that young children could fold it. As a child's toy, it thus became a sign of innocence. One might also say that the Pajarita was cheap, delicate, and disposable, all of which explains why it came to symbolize the cocotte. Meant to resemble a chicken, the abstract form facilitated a complicated punning relationship dependent on the French use of double and triple entendres. The cocotte was a disposable toy, a "chick," and easy prey for the French male on the make. To some, she was literally a prostitute; to others, she was a naive girl who too quickly succumbed to masculine advances; and to others still, she was a cold, calculating, and dangerous woman.[91]

The earliest printed publication that used this term was a satirical pamphlet entitled *Les Cocottes!!!!!* (1864), which covered a wide range of meanings, from amusing to violent.[92] Definitions are given as, first, a child's term for a chicken; second, a small square of paper folded to resemble a hen; third, a term of affection for a little girl; and finally, a term used for a grown woman "dans un sens *un peu libre*" [somewhat freely].[93] There is the sense, even in this early document, that men had an uneasy relationship with this woman who occupied a gray area between the respectable and the liberated woman. Edouard Siebecker, in *Physionomies parisiennes: Cocottes et petits crevés* (1867), confirmed it was not easy to pigeonhole a cocotte: "Elle est multiple, et lui assigner une origine n'est pas chose facile" [She is of many sorts, and it is no easy matter to assign her a background].[94] Ultimately he suggests that the cocotte must choose sides between being a respectable woman and a prostitute.

Charles Virmaître proposed a more comprehensive terminology in his *Paris-Galant* (1890).[95] There he classified cocottes according to their place of work—the *rameneuse,* who saw customers at home; the *grue,* who started out in the theater; and the *allumeuse,* who procured clients in alleys. Yet, they shared common characteristics: "comme elle n'est pour celui qui paye qu'un instrument de plaisir ou de caprice de la mode, un objet de luxe, elle est aussi souvent lâchée qu'en exercice" [since she is, to the paying client, a mere instrument of pleasure or the whim of the moment, a luxury item, she is just as often idle as employed].[96] Virmaitre singled out the Moulin de la Galette, Elysée Montmartre, Folies-Bergère, Moulin Rouge, Chat Noir, and Divan Japonais as places where the *grand cocottes* could be found. Further, he claimed that all the *cocottes chics* adopted Montmartre as their home.[97]

A journal illustration by Henri Gray entitled "Cocotte" (and subtitled "Un jou-

jou dangereux") shows the dual nature of this popular contemporary icon (figure 39). Here an otherwise nude woman wears the folded paper symbol as a dress, but her monocle identifies her as sympathetic with the feminist movement. Siebecker's text on cocottes seems to describe Gray's image: "Ce n'est pas un être de fantaisie; il existe. Chaque cocotte est doublée de quelqu'un; les moeurs de Lesbos ont fait des progrès rapides et effrayants dans notre siècle; aussi, lorsque ce n'est pas d'un homme, c'est d'une femme." [She is not a mere fantasy: she exists. Each cocotte is paired up with someone. The ways of Lesbos have made rapid and frightening progress in our century, so, when it's not a man, it's a woman.][98] Her male customers, who have been delivering bags of money, are represented by winged hearts with top hats. Their payment has not kept them from harm, however, as one of the flying hearts lies dead from a gunshot wound, at the woman's feet. As Siebecker characterized the cocotte, "C'était une bonne créature, fort belle, un peu bête, comme elles sont toutes,—le coeur sur la main,—mais la main un peu pour tout le monde" [She was a good creature, extremely beautiful, slightly stupid, as they all are; open-handed, but with a hand for almost anyone].[99]

Figure 39. Henri Gray, "La cocotte: Un joujou dangereux." *Le Boule-vardier,* Sept. 25, 1881, 5. Bibliothèque Nationale de France.

Another map in *La Vie Parisienne,* "Basse-Bicherie," describes an even lower level of prostitution, complete with the absinthe river, the cancan, and "Lapin-ville"—all associated with lower-class activities.[100] The Grand Chic railway does not run through this section of the map. Here are located various brasseries, and the most popular hair color among cabaret performers—*chignons rouges*—is identified. A futuristic map by Sahib entitled "Paris en 19 . . ." demonstrates how some of these activities eventually came to dominate the very heart of Paris (figure 40). They did so through a proliferation of brasseries, where drink and sex were available from barmaids. Flanking the center of the city are new railways, rather than the fantasy railroad of the previous maps, that would soon bring vast numbers of visitors to the capital, and the numerous brasseries that sprang up to cater to the revelers. All the major monuments of Paris, including the Arc de Triomphe, the Musée du Louvre, and the Stock Market, have been transformed into brasseries. The accompanying text claims that the legitimate theater had essentially been abandoned in favor of the red-light pleasures of Montmartre, in the same way that the public monuments of Paris had been compromised by the brasseries and the consumption of liquor.

The attention paid in this last map to the area of Montmartre, at upper right, with clear identification of the Moulin Rouge and the Chat Noir, suggests that it had become the true capital of pleasure and vice. In the earlier maps, a New Cyth-era was made accessible from the center of Paris. On the outskirts of Paris, and not subject to strict regulation of sex or alcohol, Montmartre had become a destination for the middle classes looking for excitement with a *frisson* of danger. Montmartre was at the center of a change in value systems, in which clearly defined spheres of existence were eroding. The breakdown of masculine and feminine realms is evident in the proliferation of prostitution, and in the appearance of the "new woman." Artists and writers responded through the production of types, including the fille d'Eve, the cocotte, and the femme fatale, which attempted to restore order to society, if only in an imaginary sense.

The maps published in *La Vie Parisienne* provide a visual key to popular imagery, satire, and new ways of seeing Paris in the years leading up to the Universal Exposition of 1900. In these maps, a fantastic vision of French identity was intertwined with the pleasures of drink and prostitution. In Montmartre, the world of the performer and the prostitute revealed that a revolution had taken place; this placed on the stage a number of issues pertaining to sexuality and the power struggle between the sexes. The revolution in the popular press centered on images of women who were seen as vessels of virtue and vice. This virtue-vice duality of the Parisienne or the fille d'Eve permeated much of visual culture throughout Paris during the last quarter of the nineteenth century.

Figure 40. Sahib, "Paris en 19 . . ." *La Vie Parisienne*, May 15, 1897, 284–85. University of Notre Dame Libraries. Photographer, Tim Fuller.

Part Three MOTIFS OF EVIL

FIVE *Les fleurs du mal*

Woman's place in society in late nineteenth-century France was represented through flower symbolism in popular illustrations and literature. Representations of the woman-flower may be organized into two broad categories. The first, more traditional and positive imagery suggests a parallel between women and the natural world.[1] Dressed in costumes that liken them to plants, fruits, or even insects, these fictional women are subject to cultivation or control by men. The second, negative type, in imitation of Charles Baudelaire's *Les fleurs du mal* (1857), subverts flower imagery to indicate a fear of powerful new women, whether feminists or prostitutes. Flower imagery was used to symbolize what some hoped would be the transient power of the women's rights movement with its alleged destruction of the social order. Other images suggest death by diseases associated with prostitution. Often positive and negative representations are found simultaneously, with the New Eve depicted as variously good or evil. These forms existed in an uneasy, ambiguous relationship symbolic of the continual renegotiations of the relationship between the sexes in the latter half of the nineteenth century.

Eve's Nature and the Language of Flowers

In the Genesis story, Eve was closely connected to nature in Eden, a garden of lush vegetation containing the tree of life and the tree of the knowledge of good and evil.

The gender encoding of nature itself as inherently feminine had its basis here as well, although much scientific literature made similar claims.[2] Biblical descriptions did not specify species of flora and fauna, nor did they identify the fruit that Eve ate and shared with Adam. After a great deal of debate, the apple and fig were both later associated with the fall of man. Some proposed the banana as a more appropriate fruit, with its phallic associations, for better expressing the masculine knowledge Eve acquired in the transaction.[3] By the twelfth century, Bernard de Clairvaux had elaborated on the nature of Eden through specific floral imagery.[4] Subsequent theological literature employing flower imagery had a restricted audience, until Milton's widely read *Paradise Lost* of 1667. Milton used flowers as symbols for man's descent into sin, and, more important, described Eve *as a flower,* unsupported and therefore free to fall.[5] He wrote that the flowers of Eden had a dark side due to their ambiguity, and he linked them to sexuality, described by Herman Rapaport as "at once forbidden and offered, hidden and revealed, pleasurable and painful, criminal and holy."[6]

With Milton, the ambiguity of Eve and flowers, which could stand for either good or evil, became a common literary theme. Eden was also now inextricably linked to flowers. P. Buchoz, a botanist, demonstrated this connection in his book describing the gardens of Versailles, *Jardin d'Eden: Le paradis renouvelé dans le jardin de la reine à Trianon,* of 1783–85. Edmond-August Texier, the author of the 1877 text *Les femmes et la fin du monde,* used flowers as a symbol of Eve's feminine beauty, and of her intuition with respect to harmonies found in nature. He wrote, "Si une tentation d'Eve adamique a fait pousser les ronces et les épines dans le paradis terrestre, il suffit d'un regard de l'Eve régénérée pour fair épanouir toutes les fleurs de la patrie céleste" [If a temptation of the old Eve, wife of Adam, caused the brambles and thorn bushes to grow in the earthly Paradise, one glance of the regenerate Eve was sufficient to bring into bloom all the flowers of heaven].[7] In F. Maréchal's historiated letter "E," published in *Le Courrier Français,* depicting Eve confronting the serpent, a significant portion of the design is given over to flowers. Similarly, his letter "M," which takes as its theme *mort* [death], refers simultaneously to the role of Eve as giver of life and agent of death through the representation of flowers and skeletons.[8]

Not surprisingly, male writers identifying the contemporary French woman as the daughter of Eve also explored her floral associations, even as increasing pressure from the women's rights movement led some to question the biblical association of woman with Eve and nature. Edouard de Pompéry's response in his 1864 text *La femme dans l'humanité, sa nature, son rôle et sa valeur sociale* was infused with traditional floral metaphors. The contemporary woman, called by de Pompéry *la fille d'Eve,* was created, after God, by man and society, and the latter bore the responsibility for her current position. "Comme les belles roses, les femmes ne peuvent éclore que quand la science et l'industrie de l'homme ont défriché le sol, purifié l'atmosphère et constitué un milieu favorable à l'épanouissement de la fleur humaine, quand l'homme lui-même est devenu digne de la cultiver et de

la cueillir en ce nouvel Eden créé de ses mains" [Like beautiful roses, women can only blossom when Man's know-how and labor have cultivated the soil, purified the atmosphere and established favorable conditions for the human flower to bloom in; when he has become worthy to grow it and pick it in this new Eden he has created with his own hands].[9]

In sharp contrast to de Pompéry's text is *Le vrai livre des femmes,* written one year earlier, in 1863, by the feminist activist Eugénie Niboyet, who declared: "Nous n'avons jamais eu la ridicule fantaisie de prétendre corriger l'oeuvre sublime de Dieu, en dénaturant le caractère de la femme. La souhaiter l'*égale* de l'homme, c'est obéir aux lois de l'éternelle justice et non intervenir celles de la nature qui en procèdent." [We have never entertained the ridiculous fantasy of aspiring to correct the sublime work of God by trying to alter the character of Woman. To wish her the *equal* of man is to obey the laws of eternal justice and not to interpose those of Nature that are subordinate to them.][10]

Niboyet blamed the Bible and those who cited it for hindering the equality of women through phrases such as "le Tout-Puissant a créé, dans la même pensée, les femmes, les fleurs, les oiseaux" [The Almighty created, in the same thought, woman, flowers, birds].[11] She countered, writing, "Vous tenez à ce que *nous n'oublions pas que nous sommes* les filles d'Eve? et vous ajoutez: *Nous avons amené le péché sur la terre.*" [You want us not to forget that we are the daughters of Eve? And then you say: It is we who brought sin upon the Earth.][12] This reaction is particularly dramatic in its directness because Niboyet was a woman arguing against an elaborate iconographic tradition that had been well established long before the nineteenth century.

In the previous century, Jean-Jacques Rousseau had popularized the view of woman as "natural" and "domestic." Floral metaphors abound in his *Julie, ou la nouvelle Héloïse* (1761), *Emile* (1762), and *Confessions* (1782–89). It is no coincidence that Rousseau considered himself a botanist; he was strongly influenced by the scientific association between flowers and fertility promoted by Antoine de Jussieu and Sébastien Vaillant.[13] By the end of the eighteenth century, nature was increasingly seen "to be ethically neutral and blindly amoral."[14] This was apparent not only in works of literature, such as Pierre Choderlos de Laclos's *Les liaisons dangereuses* (1782), but also in the paintings of such rococo artists as Antoine Watteau, François Boucher, and Jean-Honoré Fragonard. It is likely that the botanists' focus on plant sexuality contributed to the writers' and artists' changed views of the moral character of nature. As moralists, as well as men in the medical profession, discussed the nature of woman in relation to plants, the hermaphroditic quality of many flowers became problematic.[15] This seamy side of plant life was ignored by some and exploited by others and, more important, the gap between the "good" and "evil" aspects of flowers widened. Plant sexuality could represent piety, associated with the Virgin Mary, or alternately, sin, associated with Eve.

Earlier French literature linking women with forms in nature is vast, and it encompasses "scientific" writings as well as poetry and prose.[16] Eighteenth-cen-

tury works, in addition to the already mentioned Rousseau writings, would include Denis Diderot's *Le rêve d'Alembert* (1769) and Bernardin de Saint-Pierre's *Paul et Virginie* (1788). In the early nineteenth century, Honoré de Balzac's *Le lys dans la vallée* (1836) was one among many novels whose heroine was a "floral" woman. Any of these texts could be cited as contributing to clichés associating women with flowers prior to the Second Empire (1852–70). Extremely influential throughout the nineteenth century were a series of nonfiction works by Jules Michelet: *L'oiseau* (1856), *L'insecte* (1857), *L'amour* (1858), and *La femme* (1859). These books were enormously popular, much more so than Michelet's *Histoire de France,* which was also written in the 1850s.[17] While each of his texts posits nature to be feminine, none is as dramatic in its connection of women to flowers as *La femme,* where woman is seen both as the caretaker of the garden (in the role of nurturer) and *as* a plant that will "bloom" for her husband in marriage. In this sense, Michelet's work provided a basis for later nineteenth-century reformers to blame the "new woman" for the decline in population. Michelet's audience consisted of men and women of the middle class who shared his views about the "naturalness" of marriage and family.

The chapters in *La femme* correspond to different developmental stages. In chapter 7, entitled "Love at Ten Years—Flowers," Michelet stated that the female child is called upon to love "vegetable life" through her connection to nature.[18] According to him, woman can learn from plants all she needs to know in order to fulfill her domestic role. He described the flower as "a whole world, pure, innocent" and then connected woman directly to it: "The little human flower harmonizes with it so much the better for not being like it in its essential point. Woman, especially the female child, is all nervous life; and so the plant, which has no nerves, is a sweet companion to it, calming and refreshing it, in a relative innocence."[19] Michelet also made a direct association between the blossoming of a flower and human sexuality: "It is true that this plant, when in blossom, excited beyond its strength, seems to be animalized."[20] He further suggested that the perfume given off by flowers could be dangerous in its ability to hasten "the sensual crises, and forcing the blossom that should rather be delayed."[21] Only the husband should open this "blossom."

Michelet was by no means alone in this particular interpretation of woman's inherent nature, but as a respected historian, he affirmed these ideas in the popular vernacular by 1859. Women continued to be linked with flowers, as, for example, in Pol de Saint-Merry's book, also entitled *La femme* (c. 1898), in which the author declared: "Les femmes sont les fleurs brillantes du parterre humain" [Women are the glorious flowers of the human border].[22] This statement is characteristic of the positive type of association between women and flowers in the nineteenth century. Michelet later influenced such articles as "Nos belles jardinières," published in the *La Vie Parisienne* in 1897, which combined text and images to describe woman both as a tender to the garden and as "floral" in nature.[23]

Nature continued to be characterized as feminine (benevolent and maternal)

by nineteenth-century scientists, such as Charles Darwin in his *On the Origin of Species* (1859).[24] But woman's sexuality could be destructive. The well-known philosopher and political agitator Pierre-Joseph Proudhon said that "la femme est un joli animal, mais c'est un animal" [woman is a pretty animal, but an animal nevertheless]. According to Proudhon, a woman craved elegance and luxury by nature, which would inevitably lead her to compromise herself and the men around her.[25] This dichotomy of woman's potentially bringing either fertility or destruction to mankind would resonate throughout the nineteenth century. This pseudoscience was bolstered under the Third Republic, when a recommitment to scientific inquiry took place, partly to answer criticism of Louis Pasteur, who claimed that lack of government support for the sciences contributed to France's loss in the Franco-Prussian War. By 1880, Paris was the most active center of biology in the world, and the idea that woman was developmentally inferior, and lower on the evolutionary scale, was now "confirmed" by anthropologists.

The popular genre of flower literature, known as "the language of flowers," contained coded messages based on the idea that flowers could communicate through species, color, or even method of presentation.[26] Flowers that opened and closed at a certain hour communicated time in flower language. In a similar way, flowers could symbolize the day of the week and the month. These floral glossaries or vocabularies were widely read by a primarily female audience. A combined serious botanical guide and symbolic reference to the language of flowers, *Les fleurs animées* (1844), also contained a history of the appreciation of flowers in France. One of its several contributors, Taxile Delord, noted, "Flowers are the expression of society," a statement that remained valid until the very end of the nineteenth century.[27] The significance of a particular flower was subject to modification by an individual author, and even external events, like the performance of Dumas's *La dame aux camélias* in 1851, could permanently affix a new set of meanings to a flower variety.

Marie dans les fleurs, by the Abbé Thiébaud (1867), approached the subject through the Christian symbolism of certain flowers, most notably roses and lilies, in order to initiate the reader into "les mystères du monde moral" [the mysteries of the moral world]. Henri Lecoq, a professor at the Faculté des Sciences of Clermont-Ferrand, nevertheless included a chapter entitled "De la toilette et de la coquetterie des végétaux" in his *Le monde des fleurs* (1870), in which he mimicked Michelet: "Toilette, coquetterie, désir de plaire et certitude de réussir, sont donc l'apanage des femmes et des fleurs" [Dress, flirtatiousness, the desire to please and the certainty of doing so are thus the province of women and flowers].[28] The use of flowers in the context of fashion was the focus of the 1882 publication *Les parfums et les fleurs: De leur influence sur l'économie humaine et de leur usage dans la toilette des femmes: Mystère et merveilles dans l'empire de flore: Symbolique et langage des fleurs,* by A. Debay, who combined flower language with a description of the effect of flower perfumes and advice for harmonizing the color of flowers with clothing.[29] At this time, flowers were everywhere in women's fashions: gathered

into bouquets, made into corsages, entwined into the hair, and affixed to another important fashion accessory, the fan.

Over time, the language of flowers became increasingly complex. Sirius de Massilie's *L'oracle des fleurs: Véritable langage des fleurs* (1902) combined astrology, numerology, a psychological interpretation of color, and the "traditional" flower meanings. However, the literature concerning the language of flowers and the floral dictionaries remained popular, and journal articles further disseminated the ideas. For example, on January 1, 1897, a front-page series in *Le Figaro* by Jean-Bernand, entitled "Au jour le jour," focused on "Fleurs & bijoux du jour de l'an." The author, clearly assuming his reader to be female, described the code used by jewelers and "grands fleuristes," providing a list of color and species symbolism. The interest in flowers, and their symbolic possibilities, culminated with Art Nouveau, which embraced painting, jewelry, textiles, and furniture. Popular illustrations made primarily by men within this movement present an ambiguous construction that must be decoded for its description of women.[30]

The Politics of the "Femme-Fleur"

Alfred Grévin was known for his creations of fantasy costumes based on natural forms, including flowers, animals, and insects. Grévin's designs were published in a volume entitled *Costumes de fantaisie pour un bal travesti,* and several designs, including "Le cactus," also appeared in *Le Journal Amusant* in 1874 (figure 41). It does not appear that many of these costumes were actually produced, although a few are documented for theatrical productions; rather the purpose was to "indique la manière de confectionner ces costumes et les étoffes à employer" [indicate how to make these costumes and the materials to be employed].[31] These designs provided source material "où les femmes du monde trouveront d'excellentes ressources pour leurs toilettes, et où l'industrie des modes pourra puiser des rensignements précieux pour la haute nouveauté en confections, coiffures, chaussures, etc." [where women of the world will find excellent resources for their dress, and where the fashion industry can research priceless information for the latest crazes in clothes, hairstyles, shoes, etc.].[32] By creating a floral envelope around the woman's body, the flower costumes furthered the connection of women with nature, in the sense that Rousseau believed that the plants and trees were "la parure et le vêtement" [clothing and jewelry] of the earth.[33] Wearing Grévin's costume, a woman would literally become a flower symbolic of her sexuality.

However original his designs might appear at first, Grévin's costumes indicate a familiarity with illustrations by Jean-Ignace-Isidore Gérard, known as Grandville (1804–47), in the aforementioned *Les fleurs animées* (1844).[34] Grandville's images, and the stories accompanying them, have been interpreted as satires on the genre of the language of flowers.[35] The texts contained in *Les fleurs animées* demonstrate the traditional, romantic view of flowers prior to the publication of Baudelaire's subverting Symbolist contribution, *Les fleurs du mal* (1857). A story

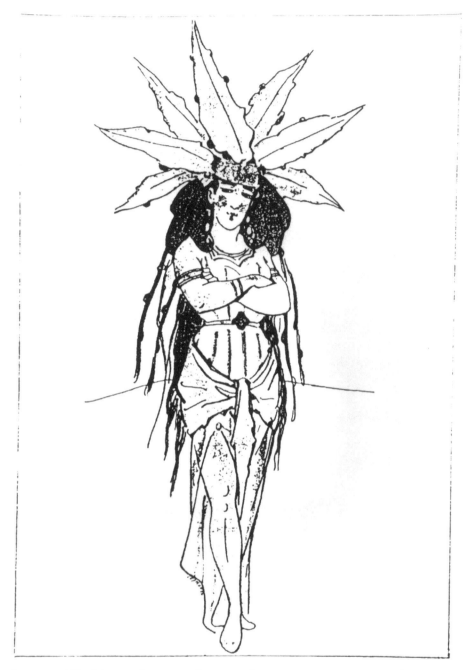

Figure 41. Alfred Grévin, "Le cactus." *Le Journal Amusant,* 1874. University of Minnesota Libraries. Photographer, Tim Fuller.

entitled "The Flower Fairy," by Taxile Delord, provides a pretext for Grandville's illustrations. In this tale, flowers rebel against the language of flowers, as they are tired of supplying mankind "with their themes of comparison" and being charged with "their virtues and their vices, their good and their bad qualities."[36] The flowers demand to assume human form to judge if the metaphors are accurate, and they are transformed into women. These flower-women are depicted in the individual plates of *Les fleurs animées*. In a related story by Delord, "The Trick of the Flower Fairy," an attempt is made by men to regain control of the flowers who had become women, by denying them their admiration, and by smoking to repel them. If tobacco drove woman away from man, the flower-women would be forced to return to the Flower Fairy's realm. But the men's plan failed because women "found a way to re-conquer man: they began to smoke themselves."[37] This story demonstrates an important characteristic of *Les fleurs animées:* its blending of fantasy and reality. Tobacco did actually strain male-female relationships, as women began to smoke.

The messages in two particular illustrations from the book, "Eglantine" [Wild Rose] and "Ciguë" [Hemlock] (figure 42), would prevail throughout the later nineteenth century.[38] Wild Rose left the kingdom of the Flower Fairy to become a literary figure. Discredited in Paris, she settled in Toulouse, where she hosted a popular salon, and she was cited as a model of wit, good taste, and elegance. Her passion for intense blue stockings led to the term *bas-bleus* for women who dabbled in poetry and literature. Wild Rose is able to transmigrate, animating successively the bodies of Margaret of Navarre, Madame du Deffand, and Madame de Staël. In the later nineteenth century, she certainly would have been at home in the bodies of Georges Sand and Maria Deraismes.[39]

While Wild Rose was a prototype for the real woman who upset late nineteenth-century men, Hemlock served as a model for the dangerous imaginary woman later termed the *femme fatale.* She was one of several flower-women that the Flower Fairy wished to recall because of their dangerous nature. Hemlock, in Grandville's illustration, grinds her poison. The text reads, in part, "Enter her abode at midnight, and you will find her bruising her drugs. She will then summon before you the gods of darkness; she will reveal to you the future and disclose the secrets of life and death."[40] The text about three female poisoners, Xanthis the Thracian, Locusta the Roman, and Brinvilliers the Parisian, is adapted from a story by Racine. In *Les fleurs animées,* it is suggested that all three poisoners were actually the same, due to their successive animation by Hemlock. The expression of the idea of a flower's inhabiting, or animating, a woman's body at this early date is significant. This belief, especially in regard to poisonous flowers, recurs in Baudelaire's *Les fleurs du mal.*

The complex connection between woman with nature—and man's need to control both—has historical precedent. While women had long been encouraged to study flowers, particularly during the eighteenth century, they were expected to approach them as amateurs, as suggested in Rousseau's *Lettres inédites de Jean-*

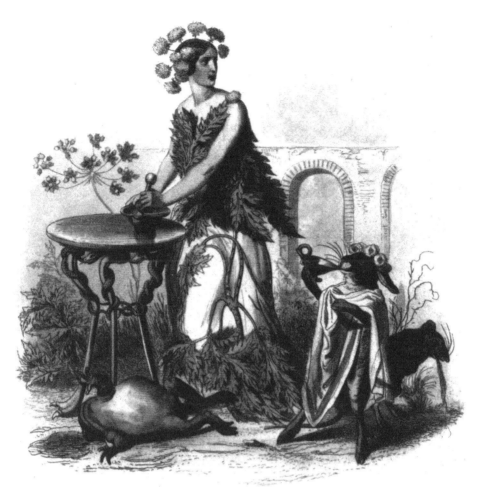

Figure 42. Grandville (pseudonym for Jean-Ignace-Isidore Gérard), "Ciguë." *Les fleurs animées* (Paris: G. de Goret, 1847), unnumbered plate between pages 200 and 201. University of Minnesota Libraries. Photographer, Tim Fuller.

Jacques à Mmes Boy de la Tour et Delessert, comprenant les lettres sur la botanique.[41] But the science of botany was a masculine domain; indeed many of the images discussed in this chapter, drawn by male artists, are like scientific illustrations in that they attempt to dissect and explain how women operate. Male control of nature is implicit. A comparison of works by Grandville and Grévin illustrates this clearly. In his 1883 cover illustration for *Le Journal Amusant,* entitled "Fantaisies parisiennes: Essay d'horticulture en chambre, boutures, 1882–1883," Grévin drew himself in the role of the horticulturist (figure 43). He is holding potted plants with women's heads for blossoms. In an earlier plate, Grandville's "Traite des fleurs," from *Fleurs animées* (figure 44), the flower seller is not male but female, underscoring this tra-

Figure 43. Alfred Grévin, "Fantaisies parisiennes: Essai d'horticulture en chambre, boutures 1882–1883." *Le Journal Amusant,* Jan. 6, 1883, cover. University of Minnesota Libraries. Photographer, Tim Fuller.

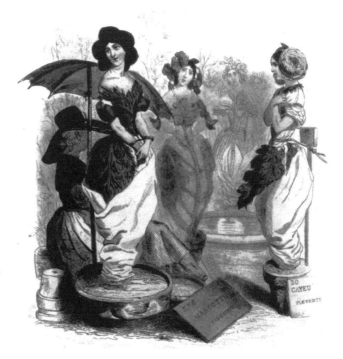

Figure 44. Grandville, "Traite des fleurs." *Les fleurs animées* (Paris: G. de Goret, 1847), unnumbered plate between pages 289 and 299. University of Minnesota Libraries. Photographer, Tim Fuller.

ditional role played by women, and serving to further connect them with flowers. The flowers in this illustration are presented as unhappy female prisoners, likened to slaves being sold at auction. Grévin's image reestablishes masculine control, both in the realm of science and the domain of the bedroom, as indicated by the subtitle of the image—"bouquets of the boudoir." Though this is intended as a humorous commentary, it truthfully communicates male expectations. Another difference between the images is that in Grandville's illustration, the women-flowers are entire individuals, while in the Grévin's, they are only heads, or blooms to be harvested. Grévin showed himself as the creator/scientist/harvester responsible for the appearance, propogation, and distribution of these women-flowers. At the same time, his illustration comments on the artist's reputation for creating female types. In short, this image reflects men's struggle for control over women's bodies and their activities in fin-de-siècle Paris.

The evolution of a similar symbolism, combining women with flowers, is found in *La Vie Parisienne,* which published a significant number of articles and images on the subject from the late 1860s onward. Selections from the last quarter of the nineteenth century demonstrate an important shift from the traditional flower symbolism to a more avant-garde iconography. "Les fleurs," a two-page spread with illustrations and text published in February 1876, emphasized the importance of flowers to women.

> Les fleurs font aujourd'hui partie intégrale d'une existence de femme, le luxe à la fois le plus rare et le plus simple; . . . car les fleurs, les feuilles ont une véritable personnalité et une influence réelle; elles disent tant de choses, elles en évoquent tant d'autres! elles font rêver à tant d'espérances; rien de vivant, elle parlant comme une fleur; c'est le langage même de l'amour.

> [Today, flowers form an essential part of women's life, a luxury that is both the rarest and the simplest; . . . for flowers and leaves have a definite personality and a tangible influence: they say all sorts of things and suggest so many others! They conjure up so many hopeful dreams; they have no living language, only the language of flowers: the language of love itself.][42]

The accompanying illustration placed women among different flowers, with text boxes highlighting symbolic meanings. Featured were the lilac (flower of chaste love), the violet (woman's friend through the ages), the rose ("lady killer" of the flowers), and the camellia (an artificial beauty, so considered because of its lack of fragrance).

A spread entitled "Femmes et fleurs," of November 1876, applied similar flower symbolism and discussed it in conjunction with women. The "femme aux oeillets" [the woman of carnations] is "Une coquetterie raffinée, de l'esprit qui relève tout, des caprices qui bouleversent tout, un caractère panaché comme ses fleurs chéries, passionnée et *voulante,* ardente et timide, un incendie dans un encensoir" [a refined flirt, her soul all brilliance, her fickleness all destruction; her character is as variegated as her beloved flowers, passionate and insistent, ardent and timid,

a fire in a censer]. In similar fashion, the petite bourgeoisie is associated with the reseda, or mignonette; the "modern Venus," with the rose; and the fortuneteller, with the daisy. Tulips are associated with foolish women who are lucky enough to have good *couturières*.[43]

An illustration from 1880, "Leurs caprices: Les fleurs naturelles à la ville," demonstrates the sway of flowers over fashion. The text sarcastically claims that eventually the corsage as an accessory will disappear, to be replaced by flowers alone to cover woman from head to toe, making her a *Femme-Fleur*.[44]

One of the most elaborate centerfolds to examine flower symbolism is the "Bouquet de femmes" (figure 45). Here women *become* the flowers themselves. While traditional flower symbolism remains, the highly detailed descriptions focus on the women, indicating their hair and eye color, as well as personality traits. Included is Foxglove, a pale brunette with violet eyes, her quiet appearance interrupted by a cruel mouth and a tendency toward naughtiness. Lazy Poppy is elegant, with sapphire-blue eyes, black hair, and milky skin. Hyacinth, with black eyes and violent red lips, has a classical, cold exterior that hides an excessively passionate nature. Orchid is infatuated with luxury and "chic-ness." The reader is warned to beware of the sarcastic, corrosive nature of Nasturtium, the self-involved Primrose, and the introverted Pansy. While the sexuality of flowers

Figure 45. Artist unknown, "Bouquet de femmes." *La Vie Parisienne,* Mar. 24, 1883, 160–61. University of Notre Dame Libraries. Photographer, Tim Fuller.

was frequently revealed in eighteenth-century botanical texts, the sexualization of women *as* flowers occurred only during the late nineteenth century.

The most comprehensive of the many articles in *La Vie Parisienne* was a five-part series entitled "Petit traité d'horticulture pratique," which appeared from December 8, 1900, to January 26, 1901.[45] The academically trained painter Eugène Lami (1800–1890) provided illustrations linking prototypical female types with specific flower varieties. The introduction to the series connects the study of flowers with Eve and Paradise, through allusion to Milton's *Paradise Lost*.[46] The author, identified only as "C," explained the purpose of the article: to provide men with a manual for cultivating "des fleurs féminines." The text and images are rife with none-too-subtle sexual innuendoes linking "dangerous" flowers with femmes fatales. In some cases, formerly innocuous varieties are given sinister characteristics; chrysanthemum petals flutter in "perpetual menace"; the mysterious poppy is "the result of ancient violent lives." Red poppies, dubbed "strange demons," are powerful and seductive while the white poppy (opium) is described as "une fleur froide qui garde un masque pâli de l'effort des sorcelleries qui s'accomplissent en elle" [a cold flower that preserves a mask drained to pallor by the sorcery brewing within]. Clematis seduces man with her apparent fragility; the accompanying illustration depicts a man who has become tangled in the vines and died. The exotic tuberose, placed in a closed room, will exude the odor of crime and "infâmes sataniques" [devilish wickednesses]. The passion flower is associated with "sadistic sentimentality" and is said to camouflage venomous snakes in its foliage. The nettle rash, the plant without vanity, can kill with a poisonous sting. Of the new flowers introduced in this series, none is more deadly than the thorn apple, illustrated by a short-haired woman who smokes and holds a large bloom against her genitals—"superbe plante de haut style pervers et d'aspect fatal" [a haughty plant with a tall, wicked style, fatal to behold]. Poison fills the calyx of this large flower. She has a mysterious, malignant allure and requires the cold earth of "paradis artificiels: laudanum, morphine . . . et le reste" [artificial paradises: laudanum, morphine . . . and the like]. This was a clear reference to both Baudelaire's *Fleurs du mal* and the increasing drug culture.

Related imagery heightened female sexuality through the powerful use of metaphor, as in "Femmes-fruits," of 1889, by Sahib (figure 46). Here woman *is* orange, plum, cherry, apple, grape, pear, peach, strawberry, or apricot. The orange, "fruit of the street and the theater," opens into sections, revealing a nude woman. The cherry, represented by a nightgown-clad girl with her legs spread, is called the fruit "of the end of childhood and the beginning of adolescence." But not all of the fruit is sexually appealing; witness the fat pear called an "honest woman." Eve is referred to directly with the apple featured at center. Described as the most French of all the fruits, it is declared to be not only in the hand of Eve, but in the corsets of all the women of Paris, reinforcing an apple-breast equation found in a now famous 1884 cover for *Le Courrier Français* (figure 47).

Other illustrations included insects, which naturally lived in the vicinity of

Figure 46. Sahib, "Femmes-fruits." *La Vie Parisienne,* June 1, 1889, 300–301. University of Notre Dame Libraries. Photographer, Tim Fuller.

Figure 47. Henri Gray, "La marchande de pommes: On peut goûter . . ." *Le Courrier Français,* Nov. 30, 1884, cover. University of Minnesota Libraries. Photographer, Tim Fuller.

flowers. Grévin's costume design "Demoiselle," from the series *Costumes de fan-taisie pour un bal travesti* (1873), looks more like a bee than the "dragonfly" suggested by the title.[47] Bees, like butterflies, have a mutually beneficial relationship with flowers linked specifically to reproduction. An 1883 centerfold for *La Vie Parisienne,* entitled "Papillons de jour et papillons de nuit" (figure 48), presents women as butterflies in categories arranged by their characteristics and fashion. The blonde "Grisette des prés" loves city bustle and seldom stays in one place. The intelligent nocturnal Phoebus is of the "genre parnassien" [Parnassian type]—a student of love. Remarkably beautiful and cognizant of her own power is the diurnal bronzed Argus, dressed in green satin and peacock feathers. The nocturnal Grand Emperor Moth, wearing a satin corset over a transparent skirt and chemise, is a gourmand and sensual. The coquettish and spiritual Sylvanus, active at night, wears a corset of *capucine* watered silk while holding a fan made of money. The petite, ordinary Sphinx comes out at twilight, wearing muslin petticoats, but no corset. Beneath the surface of this catalogue of types lurks a politics of representation that has at its core the notion that nature is feminine, and that it must be controlled through science and technology.

The equating of women with insects and flowers existed in other realms of popular culture. In the 1880s, Henry Somm executed a group of watercolor designs

Figure 48. Artist unknown, "Papillons de jour et papillons de nuit." *La Vie Parisienne,* Jan. 6, 1883, 6–7. University of Notre Dame Libraries. Photographer, Tim Fuller.

for the Haviland porcelain manufactory (figure 49), featuring women's faces superimposed on leaves of different botanical specimens identified by the artist as Fuchsia, Liseron, Capucine, Camélia, Nénuphar, Violette, Chèvrefeuille, Fraise, Rose, Lierre terrestre, and Cymbalaire. A second work by Somm included the same flowers but substituted butterflies for the women. Somm's designs were never used, as his delicate impressionistic approach was incompatible with Haviland's style, which, during the late nineteenth century favored large flower patterns consistent with Art Nouveau.

The dependence of the Art Nouveau style on floral motifs has been well studied.[48] The natural forms of Art Nouveau were combined with industrial techniques to mass-produce decorative arts, including furniture, wallpaper, and jewelry. Like its English counterpart—the Arts and Crafts style of William Morris—Art Nouveau seemed to promote a return to more healthful living, by bringing references to nature directly into the home, but the movement in France was encoded with symbolism. The biomorphic forms and whiplash lines simultaneously reflected increasing anxiety in the culture. Women were involved in the movement through the production of ceramics, and as the most visible consumers of Art Nouveau items, especially jewelry.

One Art Nouveau artist who bridged fine art and popular culture was Alphonse Mucha (1860–1939), who was born in Moravia and trained in Vienna and Munich. Mucha's art was transformed by his move to Paris in 1887. While he designed jewelry, most notably for Sarah Bernhardt, sculpted a bust of a woman entitled *La nature,* and even engaged in architectural planning, Mucha remains best known for his posters. The majority of Mucha's oeuvre fits easily into a discussion of the association of women with nature during the late nineteenth century. In particular his decorative poster series entitled "Les fleurs" was marketed to a wide audience through advertisements in *Revue Illustrée* (figure 50), *Cocorico,* and other publications between 1898 and 1899.[49] Each of the four paper posters measured approximately one meter by one-half meter, a size suitable for display in middle-class homes. The price for all four—forty francs—was a significant sum of money, but not a fortune.[50] For one hundred francs, the same prints were available on satin fabric. The printer, F. Champenois, advertised the works as "large decorative panels," implying a connection with painting or fine art.[51] Beneath the illustrations of each poster was a description of the woman/flower: Rose, Lily, Carnation, and Iris. For instance, Lily is described as follows: "Le visage exquisement pur, avec ses yeux pâles d'une fraîcheur naïve, est bien celui d'une vierge qui incarne la fleur glorieuse du lys" [The exquisitely pure face, with its pale, naively bright eyes, is undoubtedly that of a virgin incarnating the glorious flower of the lily]. The marketing of these Mucha posters focused on parallels between the qualities of women and flowers, rather than the flowers' traditional symbolic meanings of beauty, majesty, pure love, and conceit.[52]

The well-known decorative designer Georges de Feure (1868–1943) also made use of flower imagery in posters, as well as in book illustrations and ceramics.[53]

Figure 49. Henry Somm, porcelain designs proposed to the Haviland Porcelain Manufactur-
ers, 1880s. Photo courtesy Laurens d'Albis.

La ROSE, le LYS, l'ŒILLET, l'IRIS, telles sont les fleurs que symbolisent les quatre compositions nouvelles de A. MUCHA. Grâce au charme très personnel dont cet artiste sait revêtir ses figures féminines, et aux qualités de dessin et de couleurs qui lui sont habituelles, nous sommes certains que LES FLEURS obtiendront vite le même succès que LES SAISONS du même artiste, aujourd'hui épuisées.

LA ROSE

Roses rouges, roses roses, roses blondes, roses blanches .. voici toute la gamme nuancée et odorante des roses! Elles enveloppent de la coloration diverse de leurs pétales, de la variété infinie de leurs parfums et du pittoresque enchevêtrement de leurs ramées la jeune fille — rose elle-même — qui, d'un geste si ingénu, ramène vers ses épaules découvertes, comme pour s'en cacher, deux des fleurs qu'elle personnifie.

LE LYS

Le visage exquisement pur, avec ses yeux pâles d'une fraîcheur moite, est bien celui d'une vierge qui incarne la fleur glorieuse du lys. En méduse, à ses pieds, les blanches fleurs aux pistils d'or lui font une vivante litière ; comme vers une sœur qu'elles aiment, elles tendent vers elle leurs calices lancéolés, entourent sa robe légère, montent le long de ses bras et se rejoignent autour de sa tête qu'elles embrassent et s'étalent de leur chair neigeuse.

L'ŒILLET

Appuyée d'un bras au tronc d'un arbre qui la soutient gracieusement, la jeune femme révèle aux regards le haut de son buste rouge cambré que dévoile la robe dont les plis vont, plus bas, se perdre dans le flot des fleurs. Du bout de ses doigts charmeurs, elle offre — à quelle invisible main ? — la fleur rose que son caprice vient de cueillir dans le parterre des œillets médiculées.

L'IRIS

Les belles fleurs aux tons mauves sont éclatne et resplendir, par opposition, le flot d'or de la chevelure blonde. Mais, absorbée par la songe intense qui donne à son joli visage cette mélancolie un peu attristée, la jeune fille semble rester indifférente à l'appel silencieux des fleurs, et elle caresse la tige fluette d'un iris du geste rêveur de ses doigts distraits.

Figure 50. Advertisements for Alphonse Mucha, "Les fleurs," decorative panels: la rose, le lys, l'oeillet, and l'iris. *Revue Illustrée,* May 15, 1898, 7. University of Minnesota Libraries. Photographer, Tim Fuller.

Typical of his imagery is "Fleurs et fruits," an 1893 illustration for *Le Courrier Français,* which makes an explicit connection between women, flowers, and fruits (figure 51).[54] Through the attitudes of the women depicted, the viewer can interpret the meaning of these images without necessarily being able to identify the specific flowers. In the picture at the left, the woman seems to be weeping. She stands apart from the flowers, connected only by one leaf that overlaps her leg. The flower here appears to be belladonna, a poisonous hallucinogenic. At right, the woman is seated on what appears to be a persimmon. From a botanical standpoint, the flower represents the unfertilized aspect of the plant; the fruit is the result of successful fertilization. The two women's attitudes therefore would communicate the sorrow of barrenness and the joy of fertility. Both women are voluptuous and would seem to be fertile, from their external appearance, but the flowers suggest otherwise. Given the presence of the poisonous belladonna, de Feure seemed to say that it is not possible to tell, at first glance, the difference between a "good" (reproductive, domestic) woman and a "bad" (the liberated "new woman" or the prostitute) one.

As the turn of the century approached, the femme-fleur took on increasingly negative associations. This coincided with the rise of the Symbolist movement and

Figure 51. Georges de Feure, "Fleurs et fruits." *Le Courrier Français,* July 9, 1893, 7–8. University of Minnesota Librar-ies. Photographer, Tim Fuller.

intense feminist agitation for women's rights. The view of the Symbolists vis-à-vis the women's rights movement cannot be neatly summarized. Some were undoubt-edly antifeminist, even misogynistic; others employed such negative imagery for its own sake, as a means of exploring the subconscious, the danger of the "other," or the unknown. In any event, artists and writers at the turn of the century who used negative flower imagery often invoked Charles Baudelaire and his seminal work, *Les fleurs du mal.*

Parisian Prostitutes as "Fleurs du mal"

Charles-Pierre Baudelaire's poetic suite *Les fleurs du mal* has been the subject of numerous studies.[55] Written beginning in the 1850s, the poems remained popular throughout the latter half of the nineteenth century, influencing countless artists and writers in their use of woman-flower imagery.[56] Although literary tradition employed such standard negative phrases as "flowers of transience" or "flowers of pathos," the title of Baudelaire's work nevertheless was shocking in its con-necting flowers with the concept of evil. Philip Knight has demonstrated that

the term *fleurs* was already rendered ambiguous by its longstanding use to signify simply "poems" or "morceaux choisis" [choice pieces] and, in some cases, "the Christian idealization of grace and virtue." When *du mal* [of evil] was added, it made an ambiguous term more mysterious, implying that the poems are "about evil." Knight notes that the title "suggests at least that evil can be as attractive as good . . . and at most that the author is a confirmed Satanist."[57] Significantly, Baudelaire had original sin on his mind when he was writing *Les fleurs du mal*. In a letter to Alphonse Toussenel of 1856, Baudelaire claimed that the suppression of original sin was "la grande hérésie moderne" [today's great heresy].[58] In other correspondence, he stated that "la nature entière participe du péché originel" [nature in her entirety participates in original sin].[59] One of Baudelaire's statements could well explain the position of woman in *Les fleurs du mal:* "The strange thing about woman—her pre-ordained fate—is that she is simultaneously the sin and the Hell that punishes it."[60]

Interpretation by contemporary critics of Baudelaire's poetry also proved highly influential on art and literature. In fact, the literary authority of *Les fleurs du mal* has been compared with that of Dante's *Inferno* and Milton's *Paradise Lost.*[61] Théophile Gautier publicized his interpretations of the significance of *Les fleurs du mal* first in 1862, in Eugène Crépet's *Les Poètes français,* then in *Le Moniteur Universel* (1867), and again in *L'Univers illustré* (1868). The definitive version of Gautier's thoughts eventually became the preface to *Les fleurs du mal.*[62]

Gautier described Baudelaire's belief that original sin was found in even the purest souls, an "evil counselor urging man to do what is harmful to him, precisely because it is deadly to him."[63] Gautier referred to the language of flowers and indicated Baudelaire's subversion of it, in a passage declaring that sweet, traditional flowers, like daisies and roses, did not grow in the "black mud that fills in the interstices between the paving stones in the great cities."[64] In other words, Baudelaire's evil flowers were appropriate to modern life in the city. In related comments Gautier described Baudelaire's preferences on the subject of women's fashion, noting that the crinolines, makeup, and exotic perfume separated woman from "nature" through their artificiality. Gautier believed the title of the work was appropriate since it summed up Baudelaire's intention to represent "modern depravity and perversity."[65] The diverse female figures featured in the poems were interpreted by Gautier as types that represented the "eternal woman," including some that were "symbolical of unconscious and almost bestial prostitution." Others were "more coldly, cleverly, perversely corrupt" with "hysterical, mad fancies," who engaged in "trampling upon hearts that they crush with their narrow high heels."[66]

Paul Bourget, whose novel *Physiologie de l'amour moderne* was serialized in *La Vie Parisienne,* also discussed *Les fleurs du mal,* in 1881. His writings were reprinted in collected volumes of his criticism in 1883, 1885, and 1899.[67] He and other influential critics kept Baudelaire's works before the public until the turn of the century, moving themes of women and evil to the forefront of social consciousness.

Fifteen of Baudelaire's poems were composed by 1843. By this time, the au-
thor had apparently already contracted syphilis, probably from a prostitute, likely
the mulatto actress Jeanne Duval.[68] Baudelaire seemingly could not live without
Duval, despite his, and his friends', belief that she was a dangerous beauty. The
photographer Nadar, whose mistress she was before meeting Baudelaire, described
her in terms of Eve and the Fall—with a figure that "undulated like a snake" and a
bosom that gave the appearance of "a branch weighed down with fruit."[69] Marcel
Ruff called her a "misfortune" that had befallen Baudelaire; Gonzague de Reynold
called her a "bird of prey"; and the poet's mother, Mme Aupick, wrote on the oc-
casion of Baudelaire's death that "the Black Venus tortured him in every way."[70]
By the time the 1861 edition of *Les fleurs du mal* was published, with thirty-five
new poems, Baudelaire was exhibiting more syphilitic symptoms. Many scholars,
including George Heard Hamilton, have linked Baudelaire's relationship with
Duval to specific poems in *Les fleurs du mal*.[71] Some have suggested that the poems
document his ambiguous feelings toward her. A compelling aspect is the linking
of venereal disease with the language in the poems. In women, venereal disease
manifests itself as petal-like patches that form around the genitals (figure 52).

Figure 52. Artist unknown, "The Genitalia of the Female Syphilitic." Jean-Louis Alibert,
Description des maladies de la peau (Paris: Chez Barrois l'aîné, 1814). University of Minnesota
Libraries. Author's photograph.

When Baudelaire subverted flower symbolism, he connected a negative meaning, "mal," with what had previously only been the positive "fleur."[72] Might Baudelaire also be speaking about prostitution and disease? His poem "Carrion" suggests as much. It reads, in part:

> legs in the air, like a whore, displayed,
> indifferent to the last,
> a belly slick with lethal sweat
> and swollen with foul gas
> . . .
> and heaven watched the splendid corpse
> like a flower open wide—
> you nearly fainted dead away
> at the perfume it gave off.[73]

This poem was reputedly inspired by the sight of the rotting corpse of a horse, witnessed by Baudelaire and Jeanne Duval while walking through the woods. According to Baudelaire's biographer F. W. J. Hemmings, the poet told his mistress that this fate would be hers someday: "after the last sacrament . . . you will be left under the grass and the rankly sprouting weeds, to moulder among the skeletons."[74] Throughout the *Les fleurs du mal,* the images of flowers, their scent, decay, and death are repeatedly linked to attraction, compulsion, and repulsion. Baudelaire replaced traditional "positive" characteristics of flowers with those of darkness and evil.

The Belgian graphic artist Félicien Rops integrated only a few of the poet's ideas into his frontispiece for *Les épaves,* of 1868, a new edition of the banned poems from *Les fleurs du mal* (figure 53). Rops was familiar with both scandal and syphilis. He was publicly labeled a pornographer after letters to a former mistress, Alice Renaud, were read at the trial of the man who married and then murdered her. Having seen the beginning of Baudelaire's struggle with syphilis, Rops was well acquainted with its symptoms, and for a time he believed that he too had been stricken. While Rops did not, in fact, develop the disease, many of his works, especially those that demonize women, have been interpreted as communicating the "unspeakable fear" of syphilis.[75]

Les épaves, published in a limited edition of two hundred fifty copies, appeared in 1868, shortly after Baudelaire's death. Rops described his frontispiece: "Under the fatal apple tree, whose skeleton recalls the fall of the human race, blossom the seven deadly sins, represented by plants whose shapes and attributes are symbolic."[76] Close examination of the tree whose branches spell out the title, "Les épaves," reveals a serpent, with open mouth and probing tongue, intertwined with the pelvis of the skeleton. The plants representing the deadly sins allude directly to *Les fleurs du mal,* the origin of the censored poems, which did not reappear within Baudelaire's intended format until the 1950s. The flowers Rops depicted are not chosen at random. A letter from the artist to his publisher, Poulet-Malassis, indi-

Figure 53. Félicien Rops, frontispiece and detail for Charles Baudelaire, *Les épaves* (Paris: Michel Lévy Frères, 1868). University of Minnesota Libraries. Photographer, Tim Fuller.

cated his awareness of symbolic flower language. He asked Poulet-Malassis to send him a drawing of "l'Orchis Satyrion qui doit représenter la luxure dans le bouquet des fleurs aimables" [the Satyrion Orchid, which is to represent lust lurking in the bouquet of lovely flowers].[77] Rops noted that he was unable to find either a living specimen or a picture of this particular variety of orchid in Brussels. In the same letter, Rops provided a further description of the frontispiece as containing "l'arbre squelette au milieu . . . à ces mains-branches pendent les pommes du paradis terrestre; le serpent d'Eve enrôle le tronc" [the skeleton tree in the middle . . . with the apples of the earthly paradise hanging from its arm-like branches and Eve's serpent twined round the trunk].[78]

Rops's father, it turns out, was a "grand amateur de plantes" [great plant-lover] who successfully cultivated a variety of exotic and tropical plants on the family property.[79] Erastène Ramiro, who compiled a catalogue raisonné of the artist's graphic work in 1887, identified this inherited botanical interest. Ramiro wrote that only Rops's love of plants rivaled his love of printmaking.[80] The artist used his knowledge of plants and flowers to create metaphors in works such as *The Monsters, or Genesis* (c. 1880), where animated assemblages of genitalia copulate in the presence of flowering plants, and *Félicien Rops: Oeuvres inutiles et nuisibles* (1879), in which a nude woman holds flowers cascading from a skull. Much earlier, in 1859, he employed floral metaphors in *Fleurs et fruits: Horticulture passionnelle*. In this image, a woman named Camélia reads to a gentleman as a prelude to a sexual encounter.

Rops's predilection toward things sexual led him to use the flower as a powerful metaphor for the most common agent of male desire—the prostitute. In 1884, Rops produced a frontispiece for a collection of stories, *Les fleurs lascives orientales* (figure 54).[81] Both the anonymous author and Rops wished to evoke Baudelaire's *Fleurs du mal*. Rops altered the title in his frontispiece, eliminating the word "orientale." The women in the image are typically "Ropsian" in that their primary attire consists of thigh-high stockings identifying them as prostitutes.[82] The central woman symbolizes Japan; China is likely represented by the woman at the lower right. The other women appear as members of a harem. While all the women are erotically posed, the one at lower left shown fellating the flower's phallic member, and the lower-most one displaying the deep cleft of her pudendum, are the most overtly sexual. The much-feared jack-in-the-pulpit has been chosen for its phallic appearance and its poisonous, carnivorous nature.[83] Its prey is attracted to sweet liquor that resides deep in its calyx, where it eventually drowns. Rops may also have liked the hermaphroditic appearance of the plant, which has both a prominent phallic member and an inverted tubelike shape, a type of *vagina-dentata* capable of inspiring fear. The collection of exotic, erotic stories is based loosely on *One Thousand and One Nights*. Few of the tales, however, live up to the expectations promised by Rops's frontispiece. In various stories, the women are metaphorically referred to as flowers, and the study of these women is compared to botany; masculine protagonists are termed "gardeners in the garden of love."

Figure 54. Félicien Rops, frontispiece for *Les fleurs lascives orientales* (Oxford, 1884). Private collection. Photographer, Tim Fuller.

In the story "Le saint livre d'amour," metaphors are explicit. Here, women called *filles de joie* (slang for prostitutes) undulate before the "poet" while covering him with "caresses lascives." The poet has an encounter with one of the women, only to have his member trapped in her "kumil fleuri"—her vagina-dentata.[84]

Baudelaire had other imitators, among them Edmond André Rocher (b. 1873). An illustrator and a poet, Rocher worked occasionally for *Le Courrier Français,* which drew its fair share of censorship.[85] Rocher's illustration for his poem "Des fleurs" (figure 55), appeared in that journal in 1897. It shows a woman in a position of abandon, appearing headless due to her pose, next to a flower resembling a lady slipper, a poisonous member of the iris family.[86] The name and shape of that species suggest fashionable women's shoes, but Rocher might just as easily have been referring to the perse iris and its association with the devil, since its petals were tinged with flaming red.[87] The accompanying poem clearly imitated Baudelaire in its description of the powerful "hot and heavy" perfume and its comparison of parts of the flowers to the anatomy of his beloved. A second illustration by Rocher, published in *Le Courrier Français* in 1898, pays homage to Baudelaire as well. "Cruauté" (figure 56) depicts a nude woman grasping a thistle plant. The title translates as "cruel deed," suggesting woman's lack of humanity. According to the Bible, God sent the thistle after the Fall to further punish men, who now had to work the land for food. However, the thistle had contradictory meanings, for it was a symbol not only of rejection but of protection, through its association with the Virgin Mary. While she breastfed the Christ Child, drops of milk descended onto the plant, leaving white veins. The traditional meaning assigned to thistle [*chardon*] in French flower manuals is "austerity," due to its ability to withstand arid conditions. Contact with the thistle plant could cause an uncomfortable rash; in his choice of this plant, Rocher may have been alluding to venereal disease, thereby communicating more fully the danger of woman.

A persistent feature of Baudelaire's *Fleurs du mal*—one that also characterizes the poetry of Edmond Rocher—is the olfactory sense, used for subversive purposes. Perfume, which ordinarily has a positive association, is often described as a foul stench. An understanding of how perfume was viewed in France prior to the publication of Baudelaire's text is helpful in order to clarify the role scent plays, not only in communicating the idea of evil, but also in furthering the specific connection between prostitution and venereal disease.

Before the eighteenth century, bathing was seen as a decadent indulgence; it was thought that water corrupted the body morally as well as physically.[88] A. Delacoux associated frequent bathing with the infertility of courtesans.[89] When bathing was practiced, a floral toilet water was used; one sixteenth-century French hygienist recommended rubbing the skin with a "compound of roses."[90]

Floral scents were preferred in the late eighteenth century, when they came to be associated with the sweet smell of the rich, in contrast to the "filth and stench" of the poor.[91] While there were times when animal musk was popular, lighter floral scents overwhelmingly dominated the perfume market until the twentieth

century. They were deemed especially appropriate for women, through the same traditional language of flowers.[92]

Strong perfumes were blamed for various neuroses, including hysteria.[93] Alain Corbin, in *The Foul and the Fragrant,* argued that the importance of the sense of smell "increased astonishingly" since clothing covered nearly all of a woman's body. "To arouse desire without betraying modesty was the basic rule of the game

Figure 55. Edmond Rocher, illustration for his poem "Des fleurs." *Le Courrier Français,* June 13, 1897, 6. University of Minnesota Libraries. Photographer, Tim Fuller.

Figure 56. Edmond
Rocher, "Cruauté." *Le
Courrier Français,* Mar.
6, 1898, 11. University
of Minnesota Librar-
ies. Photographer, Tim
Fuller.

of love. Olfaction played a crucial role in the refinement of the game, and it turned
primarily on the new alliance between the woman and flower."[94] This alliance was
certainly demonstrated in the many poems and articles in illustrated journals of
the day. "Femmes et parfums," which appeared in *La Vie Parisienne* in March 1879,
was illustrated with women wearing flower costumes that represented perfumes
and their ascribed characteristics; lilac, for instance, symbolized youthfulness.[95]
"Etudes sur la toilette: nouvelle série—II. Les parfums," of 1882, showed nearly
nude women as the perfumes themselves.[96] In 1900, in the journal *La Libre Parole,*
the columnist known as "India" gave advice to female perfume-wearers confused
by the myriad options. Not surprisingly, women were warned to steer clear of cheap
perfumes, which were usually badly prepared and would begin to decompose in
the air, "et devient insupportable pour les voisins" [becoming unbearable to those
in close proximity].[97] The best scent was the type that one preferred, since perfume
was known to affect the temperament.

These beliefs about the role of scent in "honest" male-female relationships contrasted sharply with views concerning smells and prostitutes, who were considered perverse in their sexual desires, and willing to have relations with women as well as men. Alain Corbin, in his article "Commercial Sexuality in Nineteenth-Century France," listed four contemporary assumptions about prostitutes that employed olfactory images, and that helped inspire the regulation of prostitution during the period:

> 1. The prostitute is *putain* (whore) whose body smells bad. . . .
> 2. The prostitute enables the social body to excrete the excess of seminal fluid that causes her stench and rots her. . . .
> 3. As putrid body and emunctory/sewer, the prostitute maintains complex relations with the corpse in the symbolic imagination of these times. . . .
> 4. The prostitute symbolizes, and even incarnates, the ailment that testifies, more than a disgusting smell, to the infection of the social structure: *syphilis,* the only malady where one dare not deny the power of contagion.[98]

The poetry of Baudelaire, Edmond Rocher, and other members of the Symbolist group drew on these very virulent attitudes toward prostitution and venereal disease, often describing them with words such as "putrid" or "rotting."

The vast popular literature and imagery focusing on prostitution suggest that Parisian males had a persistent desire to identify sex workers. A number of texts sought to provide the male public with clues as to the habits, appearance, and relative desirability of different types of prostitutes. One reason that this kind of literature became popular is that, during the latter part of the nineteenth century, it was difficult to differentiate prostitutes from other women.[99] Prostitutes were seen wearing the latest fashions, and eventually they set the trends. This issue is addressed in an 1888 illustration by Henri Gray that appeared in *Le Courrier Français,* entitled "Fleur de trottoir," from the series *Microbes parisiens:Phalène nocturne* (figure 57). It depicts a woman wearing the current fashion with full bustle; she sprouts from a budding plant and is lifted to a light post where she ignites a cigarette from the flower-shaped flame. The flower in question, with its spiky thorns, appears to be a "false rose," thus communicating the idea of "false love" and "false beauty." The cigarette clearly identifies her as a prostitute for, although upper-class women did smoke, they did not do so in public, especially not in the street. Among the blooms of the flower, this woman is a fruit, ready to be deflowered or defrocked. *Femme de trottoir* was slang for prostitute, and the title of this illustration, "Fleur de trottoir," is a further manipulation of the very fluid French argot.[100]

Gray might also have been referring to an 1885 book of poetry by Emile Goudeau, *Fleurs de bitume,* which contained poems dedicated to prostitutes in the section "Cueillette sur l'asphalte." The poem "Paroles perdues," for example, describes a woman as working in a beastly and brutal moonlight, and as having "calices fumant d'amour pur" [calyxes smoking with pure love]. Attracted fatally to the woman, the male victim gradually descends into hell, in a vertigo-like swirl of hallucination. "Dans l'insouci du monde et dans la mécréance / Le satanisme vous

Figure 57. Henri Gray, "Microbes parisiens: Phalene nocturne: Fleur de trottoir." *Le Courrier Français,* 1888. University of Minnesota Libraries. Photographer, Tim Fuller.

éteint" [Satanism snuffs you out, / in unbelief, in a world that does not care]. Already realizing he's lost, the victim commits suicide by shooting himself. Goudeau, clearly under the influence of Baudelaire's *Fleurs du mal,* concluded:

Et de ce mort-d'amour, et de ce meurt-de-honte
Cotés à la bourse du coeur,
La fille fait un beau prospectus qu'elle conte
Avec un sourire moqueur.

[And of this creature dead of love and shame
Quoted on the stock exchange of the heart,
The girl delivers a fine prospectus
With mocking, guileful art.][101]

Goudeau's text and Gray's image were not alone in applying Baudelaire's poetry to the street. Robert Hyenne penned the poem "Fleurs de vice" for *Le Charivari* in 1891. The work included several different types of women to demonstrate "Le goût du sexe fort pour le fruit défendu."[102] An illustration by Hyp for *Gil Blas* in 1899 included "Fleur de pavé," "Fleur de crime," "Fleur de chic," and "Fleur des champs."[103] Probably the most frank treatment of the subject was Georges Pioch's poem, "A une femme," for the widely read *La Nouvelle Revue* of 1902. Following Baudelaire's lead, he described the woman in floral terms: "Ta croupe ondule ainsi qu'une fleur monstreuse / Le mensonge d'amour s'étire par tes bras" [Your rump sways like a monstrous flower; / Love's lie extends itself with your arms]. But he didn't disguise the woman in poetic terms when he wrote the lines "Voici le corps vendu que je croyais doté" [Here is a sold body; I thought it was a gift] and "Simule le plaisir, fière prostituée!" [Pretend to enjoy it, stuck-up whore!].[104] In contrast to the subtlety of Baudelaire's verse, directness was a virtue in the realm of popular culture.

Flowers could indicate one type of clandestine prostitute—the flower seller. According to Corbin, such prostitutes were familiar with the language of flowers and sometimes used flowers to subvert their prevailing association of virtue and health: "lit up and framed by curtains, the bouquet could . . . be transformed into an inviting signal."[105]

Even more detailed in its description of *Parisiennes* as flower-prostitutes is an illustration entitled "Les fleurs du mal" that appeared in *Le Charivari* in 1900 and *La Vie Parisienne* in 1902 (figure 58). Executed by the painter and graphic artist René Préjean (1877–1968), best known for his creation of "La béguinette," a female type characteristic of the period circa 1910, this design from the artist's early period presents a bouquet of different prostitutes.[106] Here, it is asserted that many types of women trade sexual favors for money or possessions. Included are the ballet "rat," who meets her customers in the wings offstage after a performance, and the "semi-virgin," who has the appeal of not looking like the type of woman that she really is. The *femme du monde,* who is closer to a courtesan, is not sure how she is going to pay her *couturière;* her abandoned pose suggests she might decide to pay with sex, which indicates the centrality of fashion to her existence. "L'étoile du café-concert" [the star of the café-concert], who performs at venues such as the Moulin Rouge, can also be had for a price, much like Zola's *Nana.* A specific courtesan, Liane de Videpoch, is featured at lower center, with the lesser types on the outer fringes. Rounding out Préjean's collection is the exotic "beautiful stranger," whose exact location and status are unknown, making her all the more desirable, and *le trottin,* the delivery girl, described earlier.

The connection that artists and writers made between prostitutes and elements from the natural world was not expressed only through flowers. In Louis Vallet's 1887 illustration "Exposition des insectes: Insectes utiles, insectes nuisibles" (figure 59), for *La Vie Parisienne,* several of the "insects" are clothed in outfits similar to those worn by Rops's well-known women.[107] The "Demoiselle," a slang term for a prostitute but also meaning "dragonfly," is dressed as an athletic rower. The

Figure 58. René Préjean, "Les fleurs du mal." *Le Charivari,* Feb. 1, 1900, 5. University of Notre Dame Libraries. Photographer, Tim Fuller.

Figure 59. Louis Vallet, "Exposition des insectes: Insectes utiles, insectes nuisibles." *La Vie Parisienne,* Sept. 24, 1887, 540–41. University of Notre Dame Libraries. Photographer, Tim Fuller.

"sacristy bug" can be found at six o'clock in the morning in churches, inhaling the odor of incense. The "grasshopper," depicted as a circus performer, is described as having a robust nature, remarkably long legs, and teeth strong enough to support her weight for acrobatic tricks. Voracious and devastating, she tends to focus on men with money, symbolized here by the two small puppets she holds. The "ant" is shown as a woman in a hammock with her bloomers revealed. With "remarkable mandibles" and found in many places, she's deemed a useful insect. A bare-breasted woman wearing gloves and a skirt, the "flea" comes in two subspecies: "sauteuse" [a leaping floozy] and "d'intérieur" [the indoor variety]. Both have mouths designed for sucking and can be found multiplying in the "baraques de foire ou les bas-fonds de la galanterie" [fairground booths or seedy sex dens]. The reader is advised that each is an "insecte plutôt d'agrément que d'utilité. Piqûre à prix fixe, débattu d'avance" [an insect for pleasure rather than practical purposes: stings at fixed price to be agreed in advance]. A nude woman posed like the goddess in Botticelli's *Birth of Venus* symbolizes the "firefly," who, after a night of love, redresses herself in a skirt of spun gold with diamonds, rubies, and sapphires. "La

mouche de Monsieur Zola" [M. Zola's fly] is depicted as a woman who cleans the bathrooms in train stations. Her relative the "Spanish fly" is clearly a streetwalker of the Ropsian variety. The "golden wasp" is depicted as an *amazone* on horseback. A remarkable "riding master," she's described as ferocious, happy to stab her rivals and cut them to pieces. A woman in black, who appears to be knitting, illustrates the "spider." An indoor insect, she tends to her web, which is generally found in the atelier of painters or in the apartments of old men; her technique for immobilizing her prey is described. The "bed bug" displays her cleavage and fixes her stockings. While this illustration is meant to be humorous, it conveys a serious message: prostitutes are everywhere—in many guises—and a man must be on his guard if he is to engage their services.

Gustave Adolphe Mossa took the subversion of flower imagery to new heights in many of his artworks, including his treatment of poppies in *Judith* (1904) and *Eros repu* (1905), daisies in *Ophélia* (1907), violets in *David and Bathsheba* (1906), lilies in *Eros et la chasteté* (1905), and roses in *Le démon au paradis* (1909).[108] Rightly considered a Symbolist, Mossa was a master watercolorist who came under the influence of Baudelaire. Mossa's women, such as his *Vénus* of 1904, are fully realized femmes fatales (figure 60). Unlike Botticelli, who depicted Venus's birth, or Watteau, who focused on imaginary visits to her likeness on the island of Cythera, Mossa has his Venus spread apart the petals of a lily to chew on the phallic reproductive organs, an image inspired by Baudelaire's poem "Un voyage à Cythère." Mossa frequently illustrated Baudelaire's poetry, sometimes integrating portions of the chosen poems into his works. (See, for example, the discussion of the *Duellum* in chapter 6.) That Mossa chose the lily, usually associated with the Virgin

Figure 60. Gustav Adolphe Mossa, *Vénus*. Watercolor, 1904. Musée des Beaux-Arts, Nice. © 2005 Artists Rights Society (ARS), New York/ADAGP, Paris.

Mary, further indicates his subversive intention.[109] The watercolor implies an evil side to Venus's beauty and warns of the danger of her sexuality. The motifs of the fish, which in various French slang phrases refer to the penis; the flower stamen; and Cupid's arrow are all symbols for male sexuality, and Mossa's Venus seems intent on their destruction.

Mossa employs a similar strategy in *Salomé: Le goût du sang*, of 1904 (figure 61). Mossa hand-lettered the poem of the same title by J. F. L. Merlet under the image.[110] In Mossa's watercolor, Salomé kneels on a bed, with a large rose bush looming in the background. Immense spiky thorns are visible on the stems. In the four oversized blooms are decapitated heads, each one oozing blood. Salomé is licking clean the agent of the crime—a large bloodstained saber. Again, traditional flower language has been utilized in a subverted way, as Baudelaire did in his title *Fleurs du mal*. Working in a period when simply implying that the flowers are evil would seem passé, Mossa intensified the horror by choosing flowers associated with a religious sense of purity and placing them in a new context. The rose was traditionally the symbol of Christ.[111] The four flowers—and four decapitated heads—suggest serial action on the woman's part, indicating that *this* Salomé is an heir to her biblical ancestor. According to Mossa, Salomé's "taste for blood" motivates her further actions, which will involve the education of a new generation of femmes fatales, as represented by the child's doll on the bed. Salomé's dress, or lack of it, suggests both birth, in the swaddling fabric between her legs, and breastfeeding, in the exposed breast and the nipple-like pendant. Next to her on the flower-decorated pillow is a comb and two straight pins, symbols of female beauty and domesticity, respectively, which, like the saber, could inflict pain if used against either the doll or a mate.

As these examples show, French artists and writers working in the realm of popular culture sought inspiration from life around them. Their transformation of traditional flower imagery is one example of how they acted as both social critics and arbiters of taste. Sometimes so-called high culture—for instance, the prose of Milton and the poetry of Baudelaire—needed to be modified for the masses. Artists such as Alfred Grévin, Félicien Rops, Henri Gray, and Gustave Adolphe Mossa employed their knowledge of flower language to interpret the trend of flowers in fashion and in the decorative arts movement of Art Nouveau, against the backdrop of "scientific" works on nature by Jules Michelet and Jean-Jacques Rousseau. Inspired by the scandal surrounding Baudelaire's *Fleurs du mal,* artists and writers for popular journals translated the poet's indications of evil, which were for him a very interior experience, and exteriorized those ideas. In their hands, the "flower of evil" was not an abstraction; it became the ever-present prostitute on the street corner.

The motif of the flower worked well within the realm of popular culture because it had a visual ambiguity that gave it the fluidity of spoken argot. With or without explicatory text, the flower embodied the duality of good and evil and, most im-

Figure 61. Gustav Adolphe Mossa, *Salomé: Le goût du sang.* Watercolor, 1904. Private collection, Nice. © 2005 Artists Rights Society (ARS), New York/ADAGP, Paris, and Association Symbolique Mossa.

portant, this duality turned on female sexuality. Whether sexuality was managed in "wholesome" relationships or in liaisons with prostitutes, it involved issues of control. Men strongly sought to exercise their accustomed power over women in the diagnosis and treatment of radical elements in society. While the motif of the flower was employed to address issues of sexuality, other symbols emerged that also reflected men's desire for dominance over women's rights agitators.

SIX *La femme au pantin*

An 1879 drawing by Henry Somm entitled *Jouets* shows dolls and marionettes in a toy-store window (figure 62).[1] A woman passes by on the sidewalk, accompanied by four miniature men, one in a breast pocket, one in a hip pocket, one that strains on a string in front of her, and a fourth held in her left hand. Each is in a state of heightened distress. The figure on the leash has fallen to his knees; the one in the back pocket has removed his top hat and seems to implore the dolls in the toy store for help. The man she holds in her hand begs for mercy. Somm carefully planned the composition to indicate that the men possessed by the woman are not toys.

Within this context, the specific toys shown in the background have a symbolic function. Hanging high in the left window is a small dog on wheels that corresponds to the man on the leash. Also in the left window are two dolls of the relatively new Baby Jumeau variety, a toy designed to be used by little girls to train, in an updated way, for their traditional roles as good mothers and wives. These domestic functions contrast with the conduct of the woman in the foreground, who has seemingly not learned that lesson and has turned instead to the torture of adult men. At the same time, however, she seems disconnected from her actions; she makes no eye contact with her little companions and moves as if in a trance. The final toy in the left window is a soldier on horseback wielding an unusually large saber. He seems positioned to further threaten the puppet man held by the woman, whose

Figure 62. Henry Somm, *Jouets*. Ink drawing, 1879. Private collection. Author's photograph.

head is at the same level. The window on the right exhibits marionettes, including Pierrot and Polichinelle, the figures that come from the tradition of the Italian *commedia dell'arte:* the former is the sad clown who is unlucky in love; the latter is known for comic violence. The third marionette, slightly separated from Pierrot and Polichinelle, is a male figure based on a rag picker, a popular character from earlier in the nineteenth century that epitomized poverty in the city. The ball in

this window serves to emphasize the fact that the marionettes are hanging help-less (much like the dog at left), under the control of some unseen force. The ball might also suggest the Earth upon which these power struggles take place.

Another drawing by Somm, *Ramasser le gant* (1879), reiterates several of these ideas (figure 63). A jump rope, a toy from childhood meant specifically for girls, has been fashioned into a tightrope. It is tied to a peg at the left and held at the right end by a woman in a fancy floral dress. One puppet man, who has already tried crossing the rope, has fallen and injured his leg. His top hat lies on the ground between him and the standing male figure, who is presumably next to try his luck. The puppet man in the process of crossing has clearly lost his footing. Together with the upward motion of his hat, this suggests that he too is in peril. The goal or prize for walking the rope seems to be the woman, who, for her part, seems quite unconcerned about what is happening. She does not seem to see the man's ac-tions as she holds the end of the jump rope limply. In the background, an Asian is fishing for carp, a metaphor for the helpless men. Everything in the composition suggests the naturalness or ease by which the woman has achieved control over her puppet domain.

This puppet motif seems to have struck Somm as ripe with possibilities to ex-press his own, and other's, difficulties in forging relationships with capricious

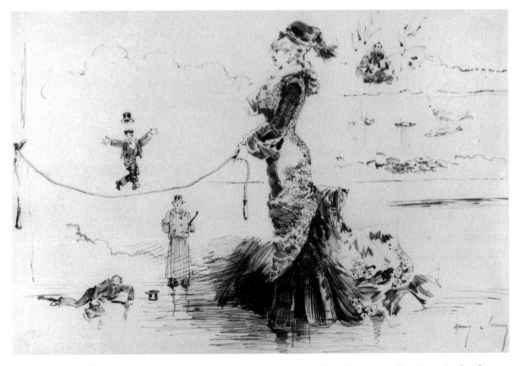

Figure 63. Henry Somm, *Ramasser le gant*. Ink drawing, 1879. Private collection. Author's photograph.

women who paid more attention to contemporary fashion than to the feelings of the men who flocked to them. In transforming what seemed to be an innocuous object into a powerful symbol, Somm relied on meanings already attached to dolls and puppets, not the least of which was the traditional use of dolls to aid in training preadolescent girls for motherhood. He depicted human men who were treated as dolls by a woman. The demeanor of the woman psychically separates her from her actions, so that she moves in a trance, oblivious to the effect she has on men. Hundreds of works by Henry Somm carry a similar message. He was among the first and by far the most prolific of the artists to use the motif of the doll-sized male in relationship to the larger, controlling female. This motif would become very common in popular literature and journal illustration by the turn of the century.

Sexual Playthings

There were several types of toys that artists and writers used repeatedly to symbolize the changing nature of the relationship between the sexes: *poupées* [dolls], *pantins* [hand puppets], and *marionnettes* [puppets manipulated by strings]. While all are toys, they are distinct because of the power relationships they suggest. Dolls are made for girls to play with in a mock mother-child relationship. The term *poupée* referred originally to a "rigid or semi-articulated figure that represented an older girl or woman."[2] This definition was expanded during the last half of the nineteenth century to refer as well to figures representing young children or infants. The latter type also became known as the *bébé*—a modification of the English word "baby"—and while the terms overlap within the period 1855 to 1875, in the toy industry the term *poupée* most frequently referred to a fashion doll representing a grown woman or *Parisienne*.[3] *Poupée* also was the slang term used by men to refer to young women of dating age whom they might see on the street or in a café. A pantin, or puppet, usually used by someone to tell a story, implies some type of manipulation. The difference between the puppet and the marionette is the degree to which such manipulation is visible to the viewer. The marionette, controlled by visible strings, tends to be more mechanical, and less organic, than a puppet.[4] Some considered the pantin inappropriate for young children. One writer warned that, although they might seem frivolous toys, "ces petites figures peignent par leur égalité, la promptitude avec laquelle les plus faibles ressorts peuvent mettre en jeu la machine humaine" [the responsiveness of these little figures reveals how easily the feeblest mechanisms can set the human machine in motion].[5] This interpretation of puppets as signifying power or powerlessness was fully exploited by artists.

The tradition of dolls in French culture is important to consider, because it reveals just how powerfully Somm and other artists were able to manipulate the culture's underlying social values. In *La femme* (1859), Michelet provided a useful introduction in his chapter entitled "Love at Five Years: The Doll."[6] He wrote

that typically a young girl would make a primitive doll for herself because she had been scolded. Michelet claimed that this activity was "serious play." Not only could the little girl imitate motherhood, but she also found in the doll her "first love"—a gentle younger sister and confidante. Michelet characterized the relationship between a girl and her first doll as a significant psychological one; to illustrate this, he related a story of a child who died of grief after disaster befell three successive dolls.

Michelet's text takes a romantic, poetic view of the relationship between a girl and her doll, a view echoed much later in the century. Antonin Rondelet, writing for the *Journal des Demoiselles* in 1880, declared the doll to be the "jouet par excellence" [the best possible toy] for little girls.[7] Marie-Louise Néron, writing for the feminist journal *La Fronde* in 1899, noted the role that dolls played in developing "noble sentiments," as well as preparing girls for motherhood. Néron began her article with a statement that the relative education of women in various societies could be gauged by examining their dolls. Her intent was to impart a sense of importance to a subject her readers often deemed frivolous. The journalist Léo Clarétie, writing for *Le Magasin Pittoresque* in 1897, had already declared that nothing was as serious as the doll, suggesting that it was at the center of grave questions regarding political economy, commerce, industry, philosophy, morals, and pedagogy.[8] Henry René d'Allemagne rationalized the necessity of his extensive study *Histoire des Jouets* by stating that although it was possible to imagine a family without lace or jewels, it was impossible to imagine a family without toys, which helped in the development of the child's "corps, esprit ou sentiment" [body, intellect and emotions]. Wherever there was an infant, there was a toy, "le premier instrument de l'activité humaine" [the earliest instrument of human activity].[9]

The French toy industry expanded dramatically during the later part of the nineteenth century. Whereas only six patents for toys were filed between 1791 and 1824, there were some two hundred fifty patents filed in the year 1893 alone. The number of toy stores grew from twenty-six in 1816 to eighty-three in 1830, and close to four hundred in 1889.[10] There were significant changes in production as small family enterprises that assembled and clothed dolls in the 1840s and 1850s were replaced by large factories and specialized boutiques. Publicity generated after the French dolls swept the awards at the London Exposition of 1862 made Paris the favored shopping destination as parents from the provinces and abroad sought the best dolls for their children. New illustrated journals were devoted to children and their dolls: *La Poupée* (1863–64), *La Gazette de la Poupée* (1863–66), and *La Poupée Modèle* (1863–1923). François Theimer and Florence Thériault credit these magazines with the creation of the fashion trend called "mode enfantine," a style developed in the 1870s in response to the promotion of doll clothes that were eventually adapted for the wardrobes of little girls.[11]

The doll market expanded in part because of innovations in fabrication, culminating in the patenting of an articulated doll body by Brouillet in 1861. The dollmaker most responsible for revolutionizing the industry was Emile Jumeau, son of

Pierre-François Jumeau, who had established a dollmaking company in 1845. The Jumeau innovation was the bébé, or doll with child's proportions, which stormed the market in the 1870s, replacing the previous adult-proportioned doll. The bébé was introduced at the 1878 Universal Exposition in Paris and was at first produced with only modest changes to older doll models—eyes were enlarged and bodies were made smaller. Stimulated by the demand for luxury goods under Napoleon III's Second Empire, changes in the manufacture of dolls were similar to those in the fashion and home furnishing industries.

Emile Jumeau wrote about the evolution of doll manufacturing in his *Notes on the Manufacture of Jumeau Bébé* (1884). He described the shops of the 1860s as dark and dusty enterprises ruthlessly demolished, concurrently with the Haussmannization of Paris, but replaced with "elegant, spacious stores with bright interiors and luxurious apartments."[12] During the Franco-Prussian War and the Commune, luxury shops either closed their doors or simplified their products, and when the economy recovered in the late 1870s, huge department stores replaced family-run businesses. While the Jumeau firm mass-produced dolls destined for sale in department stores, its main competitor, Léopold Huret, produced a luxury doll (designed by his daughter, Adélaide) that was hand worked and used a comparatively expensive rubber compound for the body.[13] Luxury dolls inspired increasingly elaborate fashions and accessories.[14] In 1897 Léo Clarétie estimated that there were few products not affected by doll manufacturing: from wood, iron, paper, rubber, and porcelain to lingerie, musical instruments, clocks, and cabinets.[15]

The Huret Company, like Jumeau, was interested in producing a doll to which the child could relate. Adélaide Huret believed that the doll "should both emulate and instruct the child, and, while possessing 'grown-up' jewelry and accessories, would wear clothing more specifically designed as child's wear."[16] These child-oriented doll fashions sharply declined in popularity, however, and by 1878 the vogue was adult-inspired doll fashions. Thériault, who has written several studies on French dolls and their fashions, observed that such fashions represented "a microcosm of the clothes 'real people' wore."[17] Her books contain hundreds of illustrations of doll corsets, hoops, petticoats, bustles, and elaborate costumes in silks, satins, and velvets, in addition to accessories: handbags, umbrellas, fans, hats, muffs, boots, gloves, even eyeglasses and jewelry. The luxuriousness of doll fashion became a persistent facet of the industry; it was also a detail that became increasingly suspect as the nineteenth century progressed.[18] While these dolls were realizing gains in elegance, they were losing their unique character.[19] Dolls were too "grown up," which caused concern regarding the education of girls and the possible consequences for public morality.

Vociferous criticism of the French doll industry began with exhibition reviews of the 1867 Exposition Universelle. George Sala, an Englishman, in his *Notes and Sketches of the Paris Exhibition* (1868), attacked the opulence and decadence of the doll industry, connecting it to the policies of Napoleon III, which included the Haussmannization of Paris, a comprehensive city-planning venture that destroyed

housing of the poor to benefit the rich.[20] While Sala's views were no doubt affected by British Victorianism, they were soon echoed by French critics. Sala cited not only the initial cost of these dolls, but also the expense of maintaining them, such as the high prices washerwomen charged to clean doll clothing. Sala sarcastically derided what he believed would follow—"doll entertainment"—including dinners at expensive restaurants, nights at the Moulin Rouge, and summers at the beach. In Sala's opinion, dolls had served a useful purpose in the past when they were sold undressed, a "mere bifurcated bag of bran," to teach little girls to be "neat and tidy" by working scraps of fabric into dresses.[21] Sala speculated that dolls dated from the beginning of humanity, as Eve, "tired of stitching her fig-leaf apron," probably took the time to make "something pretty" for Cain and Abel to play with.[22] But this was a far cry from the "doll's wardrobe shop" on the rue de Choiseul, which he believed to be a corrupting influence. At the 1867 exhibition, the displays were "extravagantly absurd, but irresistibly fascinating," with some including lap dogs for the dolls. Sala decried the necessity of providing a Paris doll with a furnished interior, complete with grand piano and designer products. Assuring his reader that he was discussing dolls, and not the contemporary women of Paris, Sala warned that these French dolls, "to feed their own insatiable appetite, would eat you out of house and home, mortgage your lands, beggar your children, and then present you with a toy revolver to blow out your brains with."[23] His chief indictment of the new dolls was that they had "nothing to do with the happy, innocent, ignorant time of childhood," and rather "looked like *cocottes,* [leaving] an unpleasant taste in the mouth."[24] The term *cocotte* was far from neutral, since it referred to a woman whose morals were questionable, somewhere between those of a *femme entretenue* [kept woman] and a common streetwalker. The *cocotte* was considered by many to be a negative force in modern French society.[25]

Despite their desire to claim the superiority of French products, French critics joined Sala in criticizing the doll industry. An anonymous writer for *L'Exposition Universelle de 1867 illustrée* told of meeting a little girl who wished she was one of the dolls, believing their lifestyle to be far superior to her own.[26] But the author also quoted an economist, who, upon seeing the expensive displays, remarked: "Si le pays des poupées existait, ce serait le Paradis" [If a land of dolls existed, it would be heaven].[27] A writer of an 1867 article in *L'Illustration* went even further, declaring "real" dolls, and thus public decency, dead. "Voulez-vous connaître le *fin du fin* des moeurs actuelles? Regardez, à l'Exposition, les vitrines des marchands de jouets d'enfants. Mais quoi! Il n'y a plus des enfants. Aussi n'y a-t-il plus de jouets! . . . point de bébés, plus de poupées. Grave symptôme. La poupée se meurt, la poupée est morte!" [Want to hear the very latest? Look in the toyshop windows at the Exposition. What's this! There are no more children. So no more toys! . . . No *babies,* no dolls. A very serious sign. Dolls are dying out; dolls are dead!][28] The doll of 1867 was described as neither child nor woman, but as an indefinable hybrid with disdainful airs and a mocking mouth. Rather than treating the doll as her own child, the little girl considered it a close friend, or possibly a superior. How could

a girl play the mother to someone who was better dressed and wearing makeup? The author declared that the child would no longer "modèle la poupée sur elle-même, c'est l'enfant qui se modèle sur la poupée" [model the doll on herself, but model herself on the doll].[29]

The belief that dolls actually controlled fashion had been similarly expressed in *Le Monde Illustré:*

> Qui fait la loi? . . . Les poupées.
> Qui impose les toilettes les plus grotesques,
> les plus absurdes et les plus ridicules?
> Les poupées.
> Qui change la mode tous les quinze jours?
> Les poupées.
>
> [Who makes the rules? . . . Dolls.
> Who imposes the most grotesque,
> the most absurd, the most ridiculous outfits?
> Dolls.
> Who dictates fashion changes every fortnight?
> Dolls.][30]

Dolls had been used in the French fashion industry to advertise the correct way to wear accessories and to indicate the textures of materials for hundreds of years, but for a very exclusive clientele in foreign countries.[31] In Paris, they were employed to show a great number of fashions within a small shop window. This was also done at world's fairs, where precious little display space was allocated to a clothing or accessories firm.[32] Almost as soon as the practice of sending the dressed dolls to other countries began, criticism emerged. A seventeenth-century lampoon, published in *Der deutsch-französische Modegeist,* carried the admonition, "not only do our women folk themselves travel to France, but they pay as [much] for their models, these dressed-up dolls, to be sent to them, as would serve them to emulate the very frippery of the devil."[33] This comment indicates a fear not of the dolls themselves, but of the behavior that the products inspired.

The increased commodification of fashion and accessories for the home following the Second Empire brought with it new condemnation of the "other" poupées—the real women of Paris. By the 1880s, there was more to fear as real women gained increasing independence, and a corresponding visibility. This fear made the "adult" dolls, which seemed to be preoccupied with fashion and makeup, dangerous models for young females. Antonin Rondelet reported that he knew of a two-year-old who had been given perfume to use on her doll; he feared that makeup and rice powder would be next.[34] Unlike the traditional doll that encouraged little girls to practice mothering, he observed, "la poupée moderne est une jeune éman-cipée qui répand autour d'elle la contagion du mauvais exemple" [today's doll is an emancipated young thing who spreads bad examples like the plague]. Rondelet urged parents to protect their children from the "spectacle of the exterior world,"

presented through elaborate doll displays with adult accessories in shop windows, and at successive world's fairs; these were capable of stimulating an appetite for conceit, *coquetterie,* and domination. In Rondelet's opinion, it was dangerous to give little girls dolls with "allures provocantes" [provocative appearances] and to allow them to dream of extravagant fashions. This would introduce them to the frivolous aspects of life, and would stimulate in them a precocious *coquetterie.*[35]

Rondelet went so far as to blame modern dolls for societal decay. In a second article, he reminded readers that dolls continued to play an important role in the education of future mothers, and he warned that the introduction of improper dolls could compromise maternal instinct. The primary issue, as Rondelet saw it, was the desire for ready-to-wear clothing and accessories, first for the doll, later for her owner. The result was a young woman's preoccupation with material objects that would ultimately undermine any maternal instinct the doll was supposed to stimulate. Rather than domesticity, the new dolls promoted a more theatrical, fantastic, and exaggerated world, which the child was in danger of understanding as reality. Rondelet's fear of feminism—that is, of woman's desire for a life outside the home and outside the domestic sphere—was strongly connected to fears about the disintegration of the family unit, and of a corresponding decrease in birthrate. Modern dolls promoted materiality over maternity, and self over family.

Rondelet's condemnation of the desire for beautiful clothing and objects, especially by those who could not normally afford them, closely mirrors nineteenth-century writings on prostitution that describe a strongly stratified network of sex workers where women became prostitutes to acquire personal items they desired but did not really need. Such fears must have been heightened by the names of Parisian doll stores, among them Au Polichinelle vampire (1826–68), A l'enfant sage (1848–87), Aux bébés sage (1871–1914), Aux enfants sages (1863–94), A la tentation (1879–1900), Au bonheur des enfants (1862–1901), and Au paradis des enfants (1861–1925).[36] Eventually the dolls themselves were given erotic or suggestive names, such as Bébé Baiser (1892), Bébé Moderne (1896), Bébé Parisiana (1902), Bébé le Séduisant (1903), and Eden Bébé (1905).[37]

While the harshest criticism of dolls came from men, the harmful moral effect of the new dolls was also critiqued by women, including Jeanne Sizon, in the *Bulletin de l'Union Universelle des Femmes* in 1890, and Jeanne Peyrat, in the *Libre parole illustrée* in 1893.[38]

In December 1901, *La Vie Parisienne* published Sahib's illustration ostensibly representing the year's most popular toys. Far outnumbering the other modern amusements, such as the magic lantern and toy submarines, are large, elaborately dressed dolls called the "poupées à la mode" [fashion dolls]. The text explains that these poupées are for men, not children. They will dance, sing, and not talk too much. Since they are more expensive if purchased nude, the author recommends that they be bought with clothes.[39]

George Sala had denied that his description of dolls at the 1867 Universal Exposition was actually a discourse about real women, but an author in *La Vie Parisienne*

in 1901 demonstrated that, by this time, it was common to conflate the notion of the poupée with the contemporary Parisienne. Already in 1877, Edmond August Texier had stated, "La femme est devenue une sorte de poupée artificielle" [Women have become like artificial dolls] due to an increasing focus on external appearances by members of the middle classes.[40] A January 1902 cover illustration for *Le Charivari,* "Les boutiques du boulevard," exemplifies this parallel (figure 64). Three fashionably dressed women pause at the window of a doll store on the boulevard. It is the women, not the dolls, however, who attract the attention of the viewer. The contours of women's bodies break out of the border demarcating the edge of the illustration as their hips sway provocatively. The woman at left looks out at

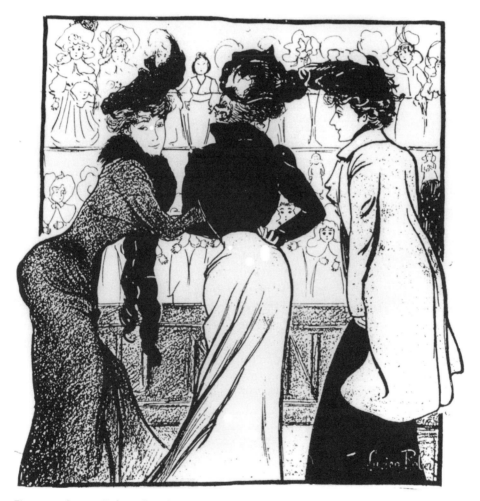

Figure 64. Lucien Robert, "Les boutiques du boulevard: '—C'est encore nous les plus belles poupées.'" *Le Charivari,* Jan. 10, 1902, cover. University of Minnesota Libraries. Photographer, Tim Fuller.

the viewer, as if to intone the caption: "C'est encore nous les plus belles poupées!" [It is we who are the most beautiful dolls!]

One year earlier, *La Vie Parisienne* had published six, two-page spreads entitled "Divine poupée," which chronicled a woman's life from puberty to grandmother-hood.[41] We learn of her early romantic conquests as well as her marriage, infidelities, and reconciliation with her husband. The final installment shows her at age fifty, relieved from the strong passions of youth and reconciled with her failure to realize all her dreams. She now becomes very involved in her daughter's love life and lives vicariously through her. With the birth of her granddaughter, she has arrived at the stage when "women love for the sake of loving and not to be happy." This comes surprisingly close to Michelet's description of doll play mentioned earlier.

> Quand elle regarde dans les yeux frais levés vers elle, les forces et les faiblesses de son être s'exaltent en splendeurs de dévouement, tout ce qui fut en elle de tendre et de violent: amour filial, tentatives de sensibilité qui s'essayent à la passion, rêves de gloires partagées, ferveur conjugale, espoirs d'amoureuse, se fond et se purifie à la flamme de la suprême tendresse, c'est le moment où s'exprime avec le plus de magnificence le grand poème du coeur de la femme . . . divine poupée!

> [When she gazes into the clear, bright eyes lifted toward her, all the strength and weakness of her nature wells up in an ecstasy of devotion, everything tender and violent—motherly love, affection approaching passion, dreams of shared glory, conjugal fervor, a lover's hopes—is melted and purified in the flame of this supreme emotion. It is the moment when the wonderful poem that is a woman's heart expresses itself at its noblest—woman, the divine doll!][42]

Evident in this series of articles, which are sprinkled with quotations from Flaubert's *Madame Bovary,* is the notion that fate controls cyclical actions. It is no coincidence that the girl's mother lacked a "tender temperament," since subconsciously she spends the rest of her life searching for love. The series depicts the plight of modern woman, torn between desires for independence and family, and increasingly confused as she is pulled from man to man in search of happiness—happiness that she never realizes. Her "true" love is experienced vicariously through her daughter, and then with the birth of a grandchild.

The role of masculine imagination in the desire generated by fashionable women is confirmed in a work by Alfred Grévin, published in *Le Charivari* in 1883, with the caption: "Sans notre sale imagination, que ces jolies poupées-là seraient peu de chose!" [Without our dirty imagination, these pretty dolls would be absolutely nothing!] This observation is made by a man as he watches a woman strolling by. Her shadow ominously predicts both fertility and inherent danger, as it seems to show that she has a swollen abdomen and apparently carries both a newspaper and a gun.[43]

Poupée was not new slang in the nineteenth century, but the word seemed to change in meaning as the dolls became more mature and thus more threatening

to male society. For example, the term was often used to describe an actress, a use that conflated the meanings of *poupée* and *pantin* since the theater suggested actions being manipulated by an unseen force.[44] In a sense, actresses were pulled between the world of the play, written primarily by men, and world of the courtesans, the most "liberated" women in Paris. In 1896, *La Vie Parisienne* published "Les poupées de Paris," in which dolls' heads, presented on wooden stands that made them seem lifeless, were portraits of actresses from all the major theaters: Mme Bernhardt representing the Renaissance; Mlle Hirsch from the Opéra, and Mlle Lara from the Théâtre-Français.[45] At the edge of the composition a group of men, not unlike those in Degas's paintings of dancers, wait in the wings of the theater to pick their dates for the evening.

But *La Vie Parisienne* more often presented different types of women as poupées. The 1900 Exposition Universelle provided a significant inspiration, especially since it exhibited new fashions by prominent clothing designers. The third illustration in the series, entitled "Nos visites à l'exposition," carries the subtitle "Voyez poupées." The drawings, by Eugène Lami, suggest that the exterior attributes of women indicate their interior states. In that spirit, the first series included the Amazonian "Grosse poupée chasseresse," seen riding horseback; the refined "Petite poupée tailleur"; the "Poupée pour loges ou avant-scènes à l'Opéra"; the modest "Poupée d'affaires"; and the very expensive "Poupée héraldique," who sported costly clothing and who dated foreign princes. The "Poupée pratique," presented in her underclothes, described herself as an "article exclusivement parisien" [an exclusively Parisian article]. Her locations, "Folie aux environs de Paris" [a folly near Paris] and a "flower boat," identify her as a courtesan. Also affirming this is her statement, "Je coûte . . . horriblement cher, mais personne ne se plaint de la qualité de la marchandise" [I cost . . . horribly dear, but no one grumbles about the quality of the merchandise]. She's interested in purchasing merchandise too, unlike the almost nude "Poupée exhibitrice," who boasts that she has little need of a couturier—only a jeweler. Also a woman of the night, she tells the reader that he knows well what she costs. The "Poupée psychologue" is shown reclining on a chaise with a book close at hand. She has used what she's learned from novels to create her environment. She doesn't cost much, just the name of an editor she can mention when introducing herself, or tickets for a reception at the Académie. The "Poupée fêtarde," shown dancing the *chahut,* claims that, during the daytime, she blends in with all the other women of Paris, but at night she's recognized for her "jupes suggestives" [suggestive skirts] and "les corsages catapultueux" [catapult-like bodices], but above all, for her fantastic hats.

A second series with the same title followed three weeks later. This contained more troubling and amusing representations of female types, including the *morphinomane* "Poupée détraquée"; the "Poupée américaine," shown sitting atop bags of money; and the "Poupée qui joue à la madame," who spends her day calling on a variety of men, including ambassadors and ministers of the government.[46] The "Poupée modern art" spends her nights at Montmartre brasseries and declares that

one day she'll be the wife of a member of the government. Her price? One glass of absinthe. She is joined by the "Poupée chauffeuse," dressed in a coat and goggles for a ride in an automobile; the "Poupée snob," with her tight, high-necked dress; and the narcissistic "Poupée dernier cri." The "Poupée sacrée" is shown locking a door as her dress falls off. She tells the reader that her primary purpose is for show—at receptions, for instance—but she's not available for intimacy. The "Poupée intellectuelle" describes her anarchist leanings, suggesting ties with then current modes of thought. She admires assassins, heroes who always have one hand in a pocket, meaning that they're carrying bombs. On the one hand, she costs nothing, but on the other, perhaps she costs everything, since a relationship with her could well cost a man his life. These spreads for *La Vie Parisienne* communicate on many levels simultaneously. They evoke a tourist atmosphere, while at the same time addressing the mania for dolls, the expensive nature of doll's clothing, dolls' use by couturiers to promote fashion, and the tendency to treat a woman like a "doll" to be possessed and dressed according to contemporary whims. They also used humor to convey their messages.

 Poupée was also commonly used to refer to a woman participating in prostitution. Moumoute's "Maison de poupées," [Dolls' House], described in a series of articles for *La Vie Parisienne* in 1892, is a brothel, while the "poupées de l'Aphrodite populaire" [dolls of popular Love] provide the focus of Marcel Schwab's "Les Marionnettes de l'amour."[47] The critic and writer Gustave Coquiot used the term in this sense in his comprehensive study of prostitutes, entitled *Poupées de Paris: Bibelots de Luxe* (1912), illustrated by Lobel-Riche. The prostitute of Paris was to his mind a "bibelot, enfin adorablement inutile et léger qu'on appelle la Parisienne" [a trifle, adorably useless and inconsequential, which we call the Parisienne].[48]

 Many of the dolls that come to life to tell their stories in Théodore de Banville's novel *Les belles poupées* (1888) describe exceedingly racy affairs, suggesting that they too are prostitutes. The book begins with a narrator's investigating the residence of a dollmaker named Chanderlos who lives on the rue des Archives. The name of the street suggests the documentary nature of the stories; the name of the dollmaker is likely based on that of Pierre Choderlos de Laclos, the famous author of *Les liaisons dangereuses*. De Banville's narrator wants to buy a doll for the daughter of an acquaintance, but he finds the prices of Chanderlos's dolls excessive. He learns from the owner that these are special dolls; in fact, they are not dolls but real people. The narrator is encouraged to inspect them carefully, in order to recognize them: "c'est des effigies d'êtres vivants, comme ces portraits d'après lesquels un Michelet devinait toute une histoire, la genèse d'un personnage illustre et l'âme d'un siècle" [They are effigies of living people, like those portraits from which a Michelet could divine a whole history, the background of a famous personage, and the spirit of a century]. Chanderlos leaves the narrator alone with the dolls, which then tell their individual tales. The dollmaker returns to provide the epilogue, stating that since the first years of the century, women had determined the moral trends in Paris. According to Chanderlos's account, there were

historical periods when "honest" women triumphed. This was not, however, the case in 1888, when, "mues par le désir de la vengeance, les diablesses qui avaient enseigné aux dames une profitable vertu, leur enseignèrent, en revanche, les plus détestables de tous les vices" [moved by the desire for vengeance, the she-devils who had taught the women a profitable sense of virtue instructed them instead in the most detestable of all vices]. The Parisienne described by Chanderlos is completely artificial, with her false hair, false eyelashes, and unnecessary extravagances like flounces and baubles that increased the price of a simple dress twenty times. In closing, Chanderlos tells the story of a woman of heart, bravura, and genius, who realizes the superficiality of her false accoutrements and renounces them all. But now she has disappeared, to Chanderlos's dismay, and in her place emerges a monster described as an "exterminatrice" [exterminator] and a "vengeresse" [avenger] belonging to "la race d'Eve ou à la race de Lilith" [the race of Eve or Lilith]. This new form of woman, Chanderlos says, underscores the "incontestable modernisme" [incontrovertible modernity] of the stories told by his poupées.[49]

Narratives of Control and Domination

Henry Somm exploited contemporary meanings of the term *poupée* in his complex imagery. His watercolor for the cover for Gustave Droz's *Oscar* (1875), for example, shows a man with a miniature woman on a leash (Oscar's wife), and a woman (his mistress) with a similarly tiny man wearing a macabre-looking muzzle (figure 65). The text reveals that the man in the muzzle is none other than Oscar himself. Somm's cover reflects Droz's entire story. Oscar treats his wife, "a ravishing doll," as a prisoner, criticizing her and accusing her of infidelities without evidence. His relationship with his mistress, Niniche, is completely different. She is a courtesan with many admirers; Oscar knows this and accepts it, just as he accepts her constant humiliating remarks about his stupidity, weakness, and unattractiveness. A short verse by Droz provides the moral of the story: "Lecteurs du *Figaro*, protecteurs des cocottes, / Dont la morale est de jouir!" [*Figaro* readers, protectors of sluts / morals for them mean enjoyment!][50] Thus, Droz criticized the hypocritical morality of the bourgeoisie, who made up the readership of the daily Paris newspaper *Le Figaro*. Without men who acted so inconsistently, prostitutes would have no customers.

Somm's motif of the "lover on a leash" evolved to images of a one-sided affair, with women always controlling men. In his vignette illustrations for *Le Monde Parisien* in 1879, Somm showed puppet men being walked on a leashes, like dogs (figure 66) or about to be executed (figure 67). Numerous works by the artist are variations on this theme, an extended narrative of domination and control. The puppet men can be found chained to perches in the place of parrots, or, as in the case of *Pupazzi*, crowded into an acid bath for etchings, presided over by a fashionably clad amazon who has a burin and a scraper dangling from her sleeve (figure 68).[51] In the latter work, the program, headed "Pupazzi," is written tongue-in-cheek, with

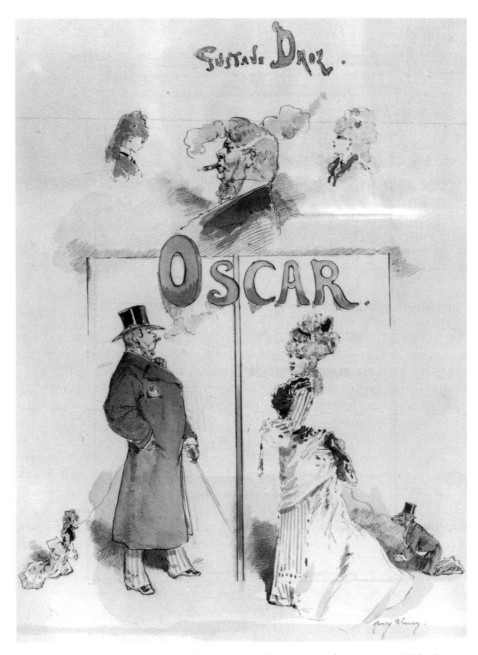

Figure 65. Henry Somm, watercolor for the cover of Gustave Droz's *Oscar,* 1875. Bibliothèque Nationale de France.

Figure 66. Henry Somm, vignette illustration of a woman with puppet on a leash. *Le Monde Parisien,* June 7, 1879, 8. Bibliothèque Nationale de France.

Figure 67. Henry Somm, vignette illustration of a woman about to execute a puppet. *Le Monde Parisien,* Oct. 25, 1879, 4. Bibliothèque Nationale de France.

Figure 68. Henry Somm, *Pupazzi*. Etching, c. 1880. Bibliothèque Nationale de France.

the first performance, "Une Séduction," featuring M. Blancminet and Mme Julie de St. Amour. During the second performance, "L'Affaire St. Ménuphar," "toutes les questions du jour sociales ou autres seront traitées à l'eau-forte et produiront sans doute une TRES BONNE IMPRESSION" [all the great questions of the day, and others, will receive the acid-bath treatment, and will doubtless produce AN EXCELLENT IMPRESSION]. The evening's entertainment will conclude with a performance by Jacques Offenbach of *Orphée aux enfers*. Offenbach did compose a work by this name, with lyrics written by Somm's friend Ludovic Halévy. Somm cleverly associated the corrosive etching process with the seduction of men by powerful, and often evil, women: after his ill-fated marriage to his beloved Eurydice, Orpheus was dismembered by the Maenads.[52] The Greek myth leaves unresolved the issue of the good versus the evil woman, since Orpheus was essentially destroyed by both types. In referring to this myth, Somm also alludes to the idea that the passion men feel for seemingly innocent women is their Achilles heel. Moreover, his use

of the motif of etching, his preferred medium, indicates that he considers himself to be among the victims. His awareness of woman's evil will not save him.

Somm seems to have developed this type of imagery in 1874 or perhaps even earlier.[53] Almost immediately, other artists borrowed his constructs. A. Humbert's series "La ménagerie humaine," for *Le Sifflet* (1875), included number 5 in the series, "La gommeuse," a well-dressed woman who uses her teeth to crack open the head of a male puppet chosen from the "oyster bar" (figure 69). The accom-

Figure 69. A. Humbert, "La gommeuse." Number 5 in the series "La ménagerie humaine," *Le Sifflet,* Apr. 18, 1875, cover. Bibliothèque Nationale de France.

panying text explains that this figure is partial to fashion and has an increasingly dangerous nature. She is described as "un mammifère carnassier qui s'apprivoise assez facilement; cependant, même à l'état domestique, elle est peu susceptible d'attachement" [a carnivorous mammal, easily tamed; however, even in the domestic state, she cannot easily be tied down]. She has voracious habits, leaving her den at twilight to search for food and using her "pink claws" (painted nails) to exhume "petits gommeux" (her male counterpart, known as "dandies"), which she eats alive. Her "digestive apparatus" works on the basis of prodigious force and elasticity, which effectively likens her to a snake. In addition to describing this creature's appearance and method of procuring food, Humbert also provided a recipe for creating her by artificial means. Start with a carefully washed goose girl; infuse her with "essence of laziness," gluttony, and coquetry; add several glasses of champagne, a false chignon, and several pinches of erotic spices. Then the "object" should be dried, dusted with white powder makeup, touched with rouge, sprayed with perfume, and wrapped in velour or silk. Humbert's final instruction is to "serve cold."

Humbert's "Gommeuse" appeared in a journal that was primarily political in focus, but images of large women exercising control over miniaturized men could also be found in the widely read *La Vie Parisienne.* In a spread by Ferdinand Bac describing how various women kept themselves warm, the *cocotte* roasts eight puppet men on a spit.[54] Henri Gerbault, in "Leurs états d'âme, II," also in *La Vie Parisienne,* illustrated "l'âme perverse" with a nude woman manipulating puppet men by their strings, then discarding them in a heap at her feet (figure 70). A similar approach can be seen in Lucien Métivet's "Pluie d'or," in *La Vie Parisienne* of 1899, where puppet men are placed in a closet to illustrate money saved for a rainy day.[55]

In a more popular variant of the "woman and puppet" theme, the woman takes the role of the "trainer" of the puppets, which learn to perform tricks. Such is the case in another illustration by Henry Somm for *Le Monde Parisien* (1879), in which a woman dressed as a ringmaster holds a whip under her arm while directing the actions of her puppet figures (figure 71). The accompanying poem by A. de Lyne, "Dompteuse," explains:

> Pour dompter daims et canaris,
> Trop petite serait ta cage;
> Il te faudrait mettre un grillage
> Tout autour des murs de Paris.
>
> [To tame a deer or canaries,
> Your cage would be too small;
> You'd need to erect some fences
> All round the city walls.]

The puppets represent the real men of Paris, threatened by increasingly independent women: prostitutes, whose sexual behavior was considered perverse

and unnatural; actresses, who might cross-dress as men; and especially "women of letters," who followed in the footsteps of Georges Sand. Women who declared themselves feminists, or who were thought to be, posed the greatest threat, not only to individual men, but also to French society. Most of the illustrations considered in this chapter depict this new powerful woman as an amazon, primarily through manipulation of scale, while others link the puppet imagery more directly to the emergent French feminism.

In a cover illustration by Henri Gray for the *La Chronique Parisienne,* titled "Les pantins de 1885" (figure 72), a monumental amazon with short hair dominates the composition. The woman, in the pose of a classical ruler and wearing a toga and tiara suggestive of the garb of Greek goddesses, cradles the 1885 volume of *La*

Figure 70. Henri Gerbault, "Leurs états d'âme, II" (detail). *La Vie Parisienne,* Mar. 4, 1899, 118–19. University of Notre Dame Libraries. Photographer, Tim Fuller.

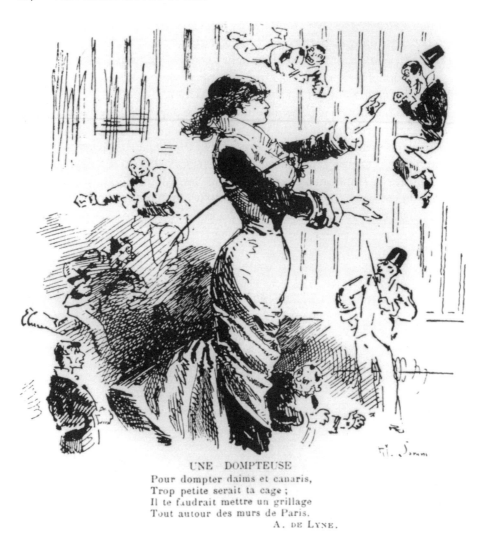

UNE DOMPTEUSE
Pour dompter daims et canaris,
Trop petite serait ta cage ;
Il te faudrait mettre un grillage
Tout autour des murs de Paris.
 A. DE LYNE.

Figure 71. Henry Somm, "Une dompteuse." *Le Monde Parisien,* Mar. 29, 1879, cover. Bibliothèque Nationale de France.

Chronique Parisienne in one hand; in her other hand she holds strings connected to smaller figures. A man sporting a monocle and top hat has been elevated on his string, grinning stupidly at the spectator like a child's toy. Another string controls a fashionably dressed Parisian woman wearing a large bustle and carrying a parasol. Interestingly, this is the only figure to share the pedestal on which the amazon sits. Three doll-like male figures sprawl lifelessly at the base of the pedestal. The only other female figure is nude, and in a position of abandon, just to the left of the journal volume; indeed the string that manipulates her is coming from the tome. Gray has utilized the puppet imagery to suggest not only that there is a new,

Figure 72. Henri Gray,
"Les pantins de 1885."
La Chronique Parisienne,
Dec. 27, 1885, cover.
Bibliothèque Histo-
rique de la Ville de Paris.
Author's photograph.

dangerous woman in Paris, but that current fashion and the popular press have
helped create her dominion.

Even more closely associating puppet imagery with feminism is another wa-
tercolor by Henry Somm, entitled *Droits de la femme* (figure 73). The title is placed
inside a circle that suggests a full moon and a halo simultaneously, perhaps re-
ferring to an alternative religion, like a cult or witchcraft. The woman's costume
can be dated to about 1881, the year new laws guaranteed women the right to
assemble in groups. The woman holds the scales of justice in one hand, but this
is not a representation of "blind" justice. With the other hand, she uses a pistol
to murder miniature men, who fall in a crumpled heap near her feet. Both the
nearly balanced scales and the burning candles suggest the passing of judgment.
The ground behind the woman is littered with dead bodies. One of the figures
floating safely (for the moment) behind her back is dressed as a government min-
ister, symbol of changes in law. He smiles uncomprehendingly at the spectator,
seemingly unaware of the carnage. Again, Somm advances the idea that men are
being controlled or eliminated by a new powerful woman, but he also suggests,

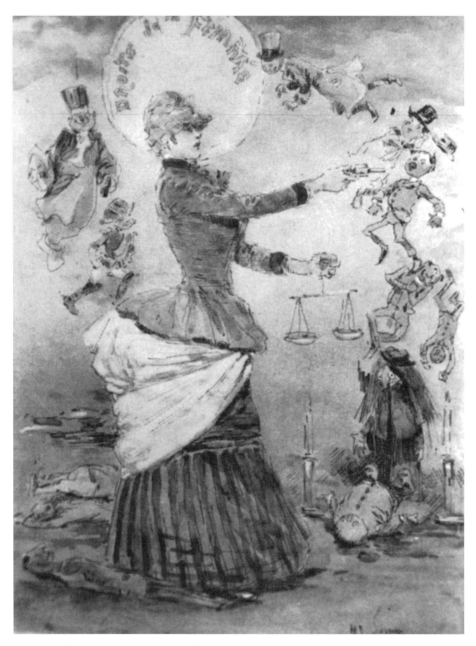

Figure 73. Henry Somm, *Droits de la femme*. Watercolor, c. 1881. Private collection. Photographer, Yvonne M. L. Weisberg. Courtesy Sotheby's.

through the blank stare of the woman, that she is acting in a trance. This alludes to a prevalent concern of the period that adds a further level of meaning to popular imagery: the phenomenon of magnetism and hypnotism, which involved a similar domination to produce psychic control.

Sciences of the mind were in vogue in the late nineteenth century. For example, an article entitled "Le magnétisme et le somnambulisme" appeared in *L'Illustration* (1878).[56] Paul Janet wrote a series of four articles detailing the history and characteristics of hypnotism for the *Revue Bleue* in 1884.[57] General articles appeared in *La Revue Encyclopédique,* in 1894 and 1897.[58] The case that gripped the public's imagination, however, was that of Gabrielle Bompard, a twenty-two-year-old woman accused of complicity in murder and robbery. It was not the nature of the crime but the nature of the defense—that Bompard had acted under posthypnotic suggestion—that aroused discussion.[59] It was feared that hypnotism would awaken "animal tendencies in this unconscious and suggestible side of bourgeois womanhood, with the result that such sexual energy might meet with the appropriate, and moreover, uncomplaining, response from the victim."[60] Outrage at this possibility was expressed in the feminist journal *Le Droit des Femmes.*

> Traiter l'amour comme un cas pathologique, cela nous semble blesser toutes les lois naturelles. Ne pas laisser à l'amoureux le libre cours de ses sensations, nous appelons cela violer la liberté humaine. Persuader par des moyens factices qu'un être qu'on avait cru bon est mauvais, qu'un coeur qu'on avait cru sincère est fourbe, voiler les doux et bons côtés de l'être aimé pour ne laisser béantes que les plaies de son caractère et de son esprit, c'est là une action vile, c'est là une duperie au rebours de l'illusion première. M. le docteur Emile Laurent, dans son *Amour morbide,* tente de démolir, à l'aide de l'hypnotisme et de la suggestion, le seul brin d'idéal et de bonheur qui rende, sur notre triste et arriérée planete, l'homme capable de l'élever au-dessus de lui-même, de sentir et souvent de créer le beau.

> [To treat love like a disease seems, to us, to fly in the face of all natural laws. Not to give a lover free rein to his or her passions, that in our opinion is a violation of human rights. To persuade someone by artifice that a person he or she had thought good is bad, that a heart once considered sincere is in fact deceitful; to conceal the good qualities of the loved one, leaving blindingly obvious only faults of character and intellect, that is a vile thing to do, an act of treachery against the initial illusion. Dr. Emile Laurent, in his *Amour morbide,* attempts to demolish, by means of suggestion and hypnotism, the only scrap of happiness and idealism which, on our unhappy and benighted planet, allows Man to rise above himself and experience—and sometimes even create—something of beauty.][61]

Perhaps just as disturbing was the claim by some doctors, such as J. Grasset of Montpelier, that if the courts accepted the defense of hypnotism in the commission of a crime, women would begin to fake the symptoms.[62] Women might *use* hypnotism as a method of control, even if they were not literally practitioners of it.

A humorous 1888 illustration by Ferdinand Bac (1859–1952) for *La Vie Parisienne,* entitled "Hypnotisme, hypnotisées, et hypnotiseurs," demonstrated that

passage of a law making the practice of hypnotism illegal had not dimmed public interest or satiric commentary.[63] Many of the varieties of hypnotism shown in the illustration and described in the accompanying text examine sexual relationships. In "Hypnotisme politique," a woman under a briefcase's spell suffers through annoying dinners and her husband's infidelities to achieve the "ecstasy" of entry into the government ministry. An advertisement of December 3, 1887, for *Le Bébé Jumeau* took the form of an article entitled "Le Bébé Jumeau et le magnétisme," written by Paul Laur, and dedicated to M. Liégeois, who advocated the "moral inoculation" of women to protect them from charlatans. The article described the plight of a child named Madeleine, who had been terribly disappointed the previous Christmas when she had not received a Bébé Jumeau and thus practices hypnotism upon her father—a strategy that yields the desired result.[64] The ad humorously suggests to parents that they not wait for their own children to use the techniques of "magnetic suggestion" on them, but rather to make the conscious decision to buy the doll now. Both Bac's illustration and the Bébé Jumeau advertisement suggested how women could profit from hypnotism. Both also indicated an important scientific "fact"—the *magnétiseurs* could stimulate obsessions in their "victims."[65]

That a person could be overcome by desire for some type of object was exploited by magnétiseurs in their use of fetishes to induce a hypnotic state. By definition, a fetish is "a natural object, or an object of art, with which a cult is associated, and to which its possessor ascribes supernatural powers."[66] Sandra Hampson has studied the presence of fetishism in the French fin de siècle as manifested in the work of J. K. Huysmans, and she has linked fetishism to the concept of material excess.[67] While she is primarily concerned with the "fetishistically endowed environments" created by Huysmans, especially in *Au rebours,* the basic argument applies to the consumer-driven environment of department and toy stores.[68] A fetish works by arousing suggestion. While any material object can become a fetish, human forms traditionally predominate, leading to the possibility that the women depicted in popular illustrations are presenting miniature men as fetishes. This was not a new idea, for Chateaubriand had mentioned the use of dolls by "savage mothers" in the New World to prolong "les illusions de leur douleur" [the illusions of pain]. In this case, the doll was treated like a live infant.[68] This is a variation on the use of the doll for "gender education." Another connection between the French doll and fetish object is found in the practice of giving dolls to women when they reached age twenty-one, the "majority age." Dolls were also common wedding and anniversary gifts.[69] This practice encouraged unmarried women to marry, and recently married women to start a family, while those who were already mothers were urged to consider having another child.

A fetishistic quality runs throughout Pierre Louÿs's short story *La femme et le pantin,* which appeared in serial form in *Le Journal* in 1898, at least twenty years after the appearance of the "woman and puppet" motif in popular illustration. Although Louÿs set the action for *La femme et le pantin* in Spain, the story had au-

tobiographical references to the women of Paris, especially to his own doomed relationship with Marie de Régnier, which he attempted to terminate just days before *La femme et le pantin* was serialized.[70] Elsewhere, Louÿs connected the plot of *La femme et le pantin* to another fatal relationship that he had witnessed in Paris, the tumultuous affair between André Lebey and a woman named Estelle from the Latin Quarter. The questionable Estelle had quickly revealed "un caractère effroyable" [a dreadful character] possessing an odious penchant for luxuries and a tendency to publicly humiliate Lebey.[71]

In *La femme et le pantin,* Louÿs slowly revealed man as a puppet, controlled by woman through sexuality. The protagonist, André Stévenol, has a chance meeting with a mysterious woman, who "smiles with her legs as she spoke with her torso."[72] Louÿs repeats the motifs of fatality and obsession as the story unfolds in a series of flashbacks related to André by Don Mateo, who had earlier succumbed to the wiles of Concha Perez, allowing her repeatedly to humiliate him and eventually receiving perverse pleasure from it. The story ends with Don Mateo and André Stévenol as helpless puppets under Concha's control. In July 1898, Sahib executed a two-page illustration based on Louÿs's short story in *La Vie Parisienne* (figure 74). Throughout Sahib's illustration, Mateo appears as a jointed marionette. Mateo progressively shrinks to puppet size in response to his complete humiliation. Only in the depiction of a scene when Mateo beats Concha does he appear without the jointed arms, and at full size. At this particular moment, in Sahib's estimation, Mateo is a man, but he's a puppet by the end of the story, sitting discarded, as a bare-breasted Concha lifts her new traveling partner—a now puppet-sized André.

Félicien Rops produced three major images entitled *La femme au pantin,* which predate the publication of Louÿs's book. In all three versions, the puppet has an egglike shape and resembles the *commedia dell'arte* character Polichinelle. The first version, an etching, shows a woman wearing a low-cut dress with tight waist and a bustle (figure 75). She holds a fan in one hand and a dead puppet in the other.[73] In the second version, an 1877 work that appeared as both a pastel and an etching, the puppet is lifted higher and the woman's costume has been altered significantly. Her breasts are bared and a suggestive swath of fabric encloses her hips. She still holds a fan, but it now opens slightly toward her chest, and the other end points to a small cup decorated with a serpent, as does her curled finger. The setting is a temple decorated with hieroglyphic figures suspended by strings and the words "Ecce Homo" [Behold the Man], which are usually associated with Christ's dying on the cross. Below are a head of a faun or devil and a satyr herm. In the background looms a sphinx. The third and final version was published in Octave Uzanne's book *Son altesse la femme* and was reproduced widely through *Le Courrier Français* in 1896 (figure 76). Here, the woman, in a black costume that bares her breasts, raises the puppet high above a font as if to make a sacrifice.[74] Below sits a court jester holding a baton with a skeleton's face. In the two later versions, the puppet's body has been sliced open (in the third version the woman holds a knife in her left hand) and coins pour out into the cup or font.[75]

Figure 74. Sahib, "La femme et le pantin." *La Vie Parisienne*, July 9, 1898, 392–93. University of Notre Dame Libraries. Photographer, Tim Fuller.

The woman in the third image is typical for Rops.[76] A further nuance in our understanding of Rops's *Femme au pantin* is provided by the context of the illustration in Uzanne's book.[77] In this case, the image clearly represents a dangerous female described by Uzanne. Woman, symbol of the foyer and "terre promise des renouvellements de son *soi*" [promised land of eternal self-renewal] will someday lose man's devotion. Who are her victims? Fools, wrote Uzanne in the accompanying text, impertinent, powerless, or grotesque fools, who might be students of positivism or doctors of materialism. These disillusioned pawns, sleep-inducing philologists, cripples of nature, with "constipated souls" and cramped hearts, ironically expressed contempt for "le culte des fervents de la créature d'Eve et des amoureux indomptés par l'ennui de la vie" [the cult of woman-worship and lovers undismayed by the tedium of life].[78] Vice embodied in this woman derives power from misery, a characteristic Uzanne equated with prostitution despite the

Figure 75. Félicien Rops, *La femme au pantin.* Etching, c. 1877. Private collection. Photographer, Tim Fuller.

Figure 76. Félicien Rops, "La femme au pantin." *Le Courrier Français,* May 10, 1896, 7. University of Minnesota Libraries. Photographer, Tim Fuller.

sometimes glamorous exterior of a courtesan. Uzanne claimed that this corruption is the fruit of lassitude and distaste, an innate perversity fueled by idleness, and an ennui that pervades the simple pleasures of ordinary life like a pungent spice. What he called "le vice mondain" [worldly vice] is deemed indestructible. Not surprisingly, Uzanne's thoughts eventually turn to Eve, who is ultimately blamed for vice, corruption and perversity.

> Dieu a mis sa signature ineffaçable sur Eve en paradis. Eva la blonde sera l'éternel pro-
> totype de la femme, de la beauté fine, élégante, distinguée, ensorcelante, comme la
> blonde Vénus du paganisme fut l'expression la plus parfaite de la créature de l'amour.
> . . . elle exprime toutes les provocations d'amour; sa chevelure, toison d'or où se
> blottissent les désirs des passionnés, possède toutes les irisations, toutes les caresses,
> toutes les ardeurs, toutes les promesses paradisiaques de la femme originelle.

[God put his indelible mark on Eve in the Garden of Eden. The blond Eve will always be the prototype of woman, of the beauty who is refined, elegant, distinguished, bewitching, just as the blond Venus of pagan mythology was the most perfect created expression of love. . . . She expresses all love's provocations; her tresses—that golden fleece where passionate lovers' desires nestle—possesses all the iridescence, all the caresses, all the ardors, all the heavenly promises of the original Woman.][79]

In the context of Uzanne's text, it seems that Rops depicted the evisceration of a bourgeois man's pocketbook and heart simultaneously, by a prostitute. A reference to Eve is found in the snake that wraps around the base of the font and arches over the basin, an apple in its mouth. In particular, Eve is associated with satanism or devil worship, and the concomitant ritualistic sacrifices. Fatality is intimated by the skull on the jester's baton, intended as a reflection of the bearer.

Erastène Ramiro, who produced the first catalogue of Rops's prints, in 1887, called the woman typically featured by the artist "ondoyante et diverse, souple, féline, enveloppante, robuste aussi, et dompteuse d'hommes" [sinuous, fickle, supple, feline, enveloping, but robust, and a man-eater]. Ramiro characterized Rops's women as physically powerful, modern in their costumes and accessories, but nevertheless supernatural.[80]

Camille Mauclair noted that Rops's woman was

la dompteuse d'hommes. Elle s'impose par la crânerie hautaine, la perversité canaille et superbe, la terrifiante et sombre lueur de ses yeux fardés. Cette faunesse, cet prêtresse des aphrodisies de la décadence, l'artiste, avec une audace folle, lui a donné les bas moirs, le masque, l'éventail et le chapeau à plumes de la Parisienne; cette ligne grecque, cette carnation flamande supportent contre toute vraisemblance la *chic* ultra-moderne, et la courtisane éternellement identique s'y incarne.

[the man-eater. She imposes her will by her hauteur and boldness, her vulgar and disdainful perversity, the dark, terrifying flashes of her heavily made-up eyes. This female faun, this priestess of sexual power and decadence—the artist, in his audacious folly, has given her the Parisienne's shimmering silk stockings, fan, and feathered hat. This Greek line and this Flemish carnation bring off an ultramodern *chic* against every expectation, incarnating the eternal, unchanging courtesan.][81]

Maurice Kunel, considering Rops's oeuvre in retrospect, concluded:

C'est à travers la femme, Eve primitive, femelle sauvage, bétail de bouge et fille de trottoir, que Rops veut concréter et synthétiser son siècle. Pour lui, pour Baudelaire, comme pour la plupart des écrivains décadents de la fin du 19e siècle, la femme est la beauté tentatrice, la fleur du mal, le fruit de luxure. Le destin l'a engendrée pour la perte de l'homme, comme le diable semble n'exister que pour la damnation d'Eve.

[It is through this woman, primitive Eve, the female savage, a beast of the low dive and the pavement, that Rops tries to encapsulate his century. For him, for Baudelaire, as for the majority of decadents writing at the end of the nineteenth century, Woman signifies the beautiful temptress, the flower of evil, the fruit of lust. She was

created by fate to destroy the male species, just as the devil seems only to exist to encompass Eve's damnation.][82]

It is easy to see the progression in these appraisals of Rops's work as consistent with increasing fears, his own and others, about deadly diseases carried by prostitutes. It became common to connect the prostitute with witchcraft and ritualistic practices that were then gaining popularity, especially in Montmartre. An alliance with the devil determined her power over man and the true source of her sexuality. Not of this world, she was explained best by the Greeks in their description of goddesses, who used sexuality and poisons to gain control over mortal men, as well as over male gods.

Works by Gustave Adolphe Mossa show miniature men engaged in extremely violent acts. His *Duellum* illustrates Baudelaire's poem by the same name from *Les fleurs du mal* (figure 77):

Two warriors have engaged in combat: swords
flash and clash together, blood is spilled.
Such passages of arms are the result
of love in its earliest phase, a loud pursuit.

The blades are broken—like our youth, my dear:
no more than teeth and nails, discreetly filed,
must try where sword and tricky dagger failed.
—O rage of ripened hearts at grips with love!
Our heroes, wickedly entwined, have rolled
into the lynx-infested gully where
their flesh will fertilize the greedy thorns;

the place is Hell, and crowded with our friends,
so leap right in, my heartless Amazon,
to keep our hatred's fire perpetual.[83]

Mossa inscribed only the first verse of the poem at the bottom of the watercolor, but he illustrated it in its entirety. He recast the nature of the fight, which in Baudelaire's poem seems to be a war between the sexes, with a man and woman engaged in mortal combat.[84] His illustration shows a woman in a flowered hat, calmly holding a pair of opera glasses as she regards two naked men fighting with daggers. Mossa subtitled the work "combat des coqs," or "cock fight," in pencil just above his signature. In the background are skeletons clad in black robes; they play musical instruments that metamorphose into flowers known as Convolvulus (*liseron* in French, a favorite with the Symbolists because of its sexual connotations).[85]

The motif of the fashionably dressed Parisienne with the puppet man on a leash was connected to Eve in an article by Jean Alesson for *Le Courrier Français* in 1884, in which he suggests: "Tomber à la renverse, en extase, devant la femme que vous désirez. C'est vieux comme Eve, rien n'est plus neuf." [Fall back in ecstasy before the woman you desire. It is as old as Eve, yet nothing is newer.][86] Declarations of

Figure 77. Gustave Adolphe Mossa, *Duellum.* Watercolor, c. 1905. Private collection, Nice. © 2005 Artists Rights Society (ARS), New York/ADAGP, Paris, and Association Symbolique Mossa.

love, audacious acts followed by prompt apologies, and conversations that revolve around minuscule details of no importance complete the man's humiliation.

In his introductory advice to the reader in *Fleurs du mal,* Baudelaire wrote that "the devil holds our strings in puppetry."[87] In 1883, Joséphin Péladan made a similar, telling statement in discussing Rops's images of women: "l'homme est le pantin

de la femme, et la femme est le pantin du diable" [man is the puppet of woman; she is the puppet of the devil].[88] Rops, like his artistic contemporaries discussed above, saw woman as an embodiment of evil, an agent of the devil.[89] Eve, as the contemporary *fille d'Eve,* thus became a substitute for the devil.

 Henry Somm apparently agreed with this estimation. In 1876, he drew a frontispiece for a modern edition of J. Olivier's seventeenth-century book entitled *Alphabet de l'imperfection et malice des femmes.* Somm's drawing shows a devil controlling women by the means of strings (figure 78). Next to the devil sits Eve, holding an apple. The "M" in the word "malice" is transformed into a striped snake. The text itself was a lengthy diatribe against women. Olivier declared, "Man hath not in the world a more cruel enemy than Woman, and which more sensibly and apparently is hurtful to his life, his honor, and all his fortunes, nor which more maliciously opposeth all his designs."[90] In this text, woman is seen as ruining houses, families, and the health of men. "She is the sworn enemy of friendship, an inevitable

Figure 78. Henry Somm, frontispiece for J. Olivier, *Alphabet de l'imperfection et malice des femmes* (Paris: A. Barraud, 1876). Bibliothèque Nationale de France.

pain, a natural temptation, a desirable calamity, and domestic danger."[91] The at-traction-repulsion dichotomy that typifies the femme fatale is clear in the phrase "desirable calamity." She is also a "natural temptation," both "closer to nature" and "closer to the devil." The biblical creation story is cited by Olivier as evidence of woman's propensity to cause "hurt, loss and damnation" to her husband, when she ought to procure his good—a fate sealed specifically by the devil's manipula-tion of woman.[92] The ability of woman to control man, in turn, was described by Olivier as "terrible tyranny," in which the woman is deemed to be the "head of sin, the weapon of the devil," and the cause of man's expulsion from Paradise.[93]

Somm connected the devil to both witchcraft and hypnotism in his "Sugges-tion," of 1885, for the cover of *Le Courrier Français* (figure 79). Here, a devil floats behind a fashionable woman at center; his large claws reach toward her head, as if to implant a suggestion in her brain. She walks with her arms outstretched, as if sleepwalking. At her feet are three *putti,* indicating sexual love; in the background is a collection of puppet men. One figure hangs from a tree, his tongue projecting from his mouth, indicating the violence of his demise as well as his disapproval of the woman as the visible culprit.

Witchcraft and devil worship occur in other works by Mossa that include min-iature men as poupées. His 1905 watercolor entitled *Les parques* depicts the Three Fates (figure 80). The daughters of Zeus and Themis (Clotho, Lachesis, and Atro-pos), the three were responsible for spinning the thread of life and predicting, in song, the future of Greek gods. Mossa depicts the spinning wheel of fate as comprised of dozens of poupée- or pantin-like men. Representations of Eve and the serpent decorate the stained-glass window in the background. Hidden in the scene are a cat, a gargoyle, and an owl, all associated with witches. The women wear contemporary fashions but have large headdresses made from the bodies of crows. As in the case with *Duellum,* the horror is at odds with the decorative style of the work.

Mossa's fullest development of this idea is seen in his oil painting *Elle,* also done in 1905 (figure 81). "She" is an amazon, sitting on the dead, bloodied bodies of hundreds of men. She wears skulls on her fingers as rings. Her necklace is orna-mented with charms shaped like a pistol, a dagger, and an amulet. Her elaborate headdress contains more skulls and two black crows, and features a modified halo embellished with the words "hoc volo sic jubeo / sit pro ratione voluntas" [This I wish, this I bid / let my will take the place of reason], a quotation from the sa-tirical Latin poet Juvenal.[94] A cat peers from between her elbows, concealing her genitalia. She stares out at the viewer hypnotically, her eyes in shadow.

One major literary work, *L'éternelle poupée,* by Jules Bois, ties the imagery of poupées to Eve and to satanism. This text appeared in *Gil Blas* in 1894, with a cover illustration by Théophile-Alexandre Steinlen (figure 82). *L'éternelle poupée* was re-viewed in both the *Revue Encyclopédique* and *La Plume,* demonstrating that it was widely read. Bois's intentions, described in his introduction, were reprinted in the subsequent review in *Revue Encyclopédique:* "L'éternelle Poupée . . . c'est notre

Figure 79. Henry Somm, "Suggestion." *Le Courrier Français,* Oct. 4, 1885, cover. University of Minnesota Libraries. Photographer, Tim Fuller.

Figure 80. Gustave Adolphe Mossa, *Les Parques*. Watercolor, 1905. Musée des Beaux-Arts, Nice. © 2005 Artists Rights Society (ARS), New York/ADAGP, Paris.

Figure 81. Gustave Adolphe Mossa, *Elle.* Oil on canvas, 1905. Musée des Beaux-Arts, Nice. © 2005 Artists Rights Society (ARS), New York/ADAGP, Paris.

Figure 82. Théophile-Alexandre Steinlen, "L'éternelle poupée, par Jules Bois." *Gil Blas,* Mar. 14, 1894, cover. University of Minnesota Libraries. Photographer, Tim Fuller.

société en décadence . . . c'est encore la Femme de nos jours. . . . J'ai décrit en ce roman les trois gestes contemporains de cette 'Eternelle Poupée' que sont notre société et ses femmes: le geste de flétrissure morale, le geste de cérébrale perversion, le geste d'homicide." [The Eternal Doll . . . is our decadent society . . . the woman of our time. . . . I have, in this novel, outlined the three contemporary tendencies of this "Eternal Doll" that enshrines contemporary society and its women: moral laxity, perversion of the intellect, and homicide.][95] Bois was well aware of Max Nordau's famous condemnation of contemporary Parisian society in his *Degeneration,* which Bois mentioned in his preface.

 L'éternelle poupée describes the progressive conquering of Paris, the new Babylon, by a collection of evil women, continually called "Eves," led by Circé, the personification of anti-love. Toward the end of the novel, Circé declares love to be the perverted agent of decay and degeneration. Paris has been converted into an urban center populated by marionettes controlled by Circé by means of invisible wires. At the end of the novel, when one of the men in her entourage dies, Circé names all men and women, including "pères frivoles, épouses habiles, amantes trompeuses, amis imposteurs" [frivolous fathers, cheating wives, deceitful lovers,

false friends], as accomplices in death. Circé declares that all of society is nothing more than "une poupée frottée, vernie, peinte, mais sans noblesse, sans héroisme et sans coeur" [a polished, lacquered, painted doll—but lacking nobility, heroism or heart], and she demands in conclusion, "IL NE FAUT PAS AIMER!" [ONE SHOULD NEVER FALL IN LOVE!]

Steinlen's illustration depicts Circé as a female satyr who manipulates one of her poupées in the company of a young, gaunt aesthete smoking a cigarette. His heavy-lidded, glazed eyes contrast vividly with Circé's snakelike ones. Behind his head is a crown of thorns embellished with roses, a reference to his own martyrdom in the story, as well as to Joséphin Péladan's formation of a Rosicrucian sect in Montmartre under the symbol *Rose+Croix*. A winged cat, alluding to Le Chat Noir cabaret, also of Montmartre, sits on a pedestal with a cobra coiled around its base. In the foreground lie the ruins of civilization, with skeletons raising their hands from the earth.

The theme of the pantin, or the puppet, became a powerful nineteenth-century symbol in literature and art. Writers and artists initially adopted this motif to depict modern woman as an amusing figure, but they increasingly used it to portray her as a dangerous femme fatale. The debate over the role of dolls in educating girls, and the use of dolls to sell fashions to adult women, allowed Henry Somm to encode his early images of women controlling male puppets. His works ultimately allude to "bad mothers," who had been brought up not with the traditional baby doll that inspired maternal devotion, but rather with a coquettish adult doll that stimulated lust for material goods. Both Somm and Félicien Rops progressively developed imagery that referred to the contemporary women of Paris through carefully described ready-made fashions and accessories. Their intent was to visualize the presence of the femme fatale in modern Paris by blending elements of fatality and modernity. These artists and others faulted feminism as another mechanism by which women could gain power over French men. At the same time, there emerged a pair of motifs that connect feminism to the specter of the "bad mother," while blaming the women's rights movement for depopulation.

SEVEN Depopulation Demons

French artists and writers progressed from merely describing the biblical Eve to symbolically representing the women around them as filles d'Eve, assigning them motifs by which they could be identified. Costume provided a way of distinguishing between two stereotypical representations: the masculine *femme-homme* and the fashionable woman likely to trade sexual favors for material wealth. Depopulation, the feminine appearance of males, and the destruction of the family unit were all blamed on the fille d'Eve. Eve lived on, not as the mother of humanity, but as a harbinger of death—the original femme fatale.

The fetus motif presented an additional way of communicating increasing male fear, anxiety, and hatred of the "new woman" in any of her guises. When shown in combination with the Virgin Mary, the fetus suggested a lack of trust in the biblical prescription of woman's redemption through childbirth. Fashionable women shown visiting the abortionist, or in conjunction with a deformed fetus, suggested the sacrifice of the French family in the pursuit of luxurious commodities. Abortion as a form of birth control was specifically associated with feminism. The monstrous appearance of the fetus communicated a belief in hereditary degeneration that antifeminists were anxious to attach to the women's movement, which they felt was partly to blame for France's increasingly weakened position following the Franco-Prussian War.

The *Femme-Homme*

The earliest prototype for the masculinized woman in the nineteenth century was Georges Sand, who, as a "femme de lettres," crossed into male territory.[1] As Annelise Maugue has written, when the New Eve successfully dominates a traditionally masculine enterprise, "she becomes a man[,] . . . confirming . . . that power constitutes the essence of masculinity."[2] Sand's writings were compared to those of men; Balzac and Flaubert, both of whom considered her as one of them, called her a man. During the nineteenth century, women conveyed masculinity through their appearance—for example, wearing trousers as Sand did, short hair, or glasses—or through their behavior: smoking, participating in certain sports, or exploring intellectual pursuits. All of these traits are depicted in a double-page illustration that appeared in *Paris-Caprice* in 1868 and was appropriately entitled "Les droits de la femme."[3] The accompanying article began with the words, "Elles veulent avoir des droits! . . Voyez-vous ça!" [They want rights! What do you make of that!], which relates the scene to the concept of the *club des femmes*. Women have made a great choice, the author claimed satirically, in renouncing their makeup and jewels and becoming, like men, "rudes, rêches, farouches, électeurs et barbus" [rough, boorish, uncivilized, able to vote and bearded]. The author quoted Léon Gozlan, who stated, "Le jour où les femmes porteront culotte la population s'arrêtera [The day women wear the pants will bring the population to an end], an indication of how even the dress of the feminists was linked to depopulation.[4] The author concluded by imploring women to give up the pursuit of what is masculine and to return to their feminine domain, dominated by perfume and cut flowers.

A caricature of the feminist Hubertine Auclert (whose surname is surely misspelled intentionally in the heading as Auclerc, since *clerc* is French for "scholar"), drawn by Alfred le Petit (1841–1909) for *Les Contemporains,* suggests that women's rights could be obtained only by compromising male rights (figure 83). Auclert is depicted on horseback, leading a feminine assault upon the "Bastille des droits de l'homme" [Bastille of men's rights]. The accompanying poem suggests that Hubertine, with her breasts, might make claims to equal rights, but in the end, "les droits les plus sûrs sont les droits du plus fort" [the surest rights are those of the strongest]. In other words, while she might in theory have an argument, it is in no way as solid as the Bastille erected by men. Hubertine Auclert was considered one of the *amazones du siècle* by Jehan des Etrivières; she described herself as a crusader and likened taking up feminism to "going to war like a medieval knight."[5]

Auclert wasn't the only feminist to describe her struggle for suffrage in inflammatory tones. Olympe Audouard had declared *Guerre aux hommes* in an 1866 text of that title that celebrated Eve's initiative and imagination in the Genesis story involving the apple.[6] According to Annelise Maugue, such a woman presented man with a mirror image of himself, seemingly performing a sex reversal that "reflected the depth of the masculine crisis more than anything else," and effectively stripping man of his identity.[7] The feminist Maria Martin stated that the popular

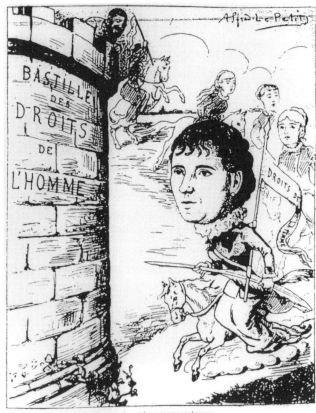

Figure 83. Alfred le Petit, "Hubertine Auclert." *Les Contemporains,* no. 15, c. 1893, cover. University of Minnesota Libraries. Photographer, Tim Fuller.

expression "porter la culotte" [to wear the pants] was used by men who believed that, in addition to starting the war between the sexes, feminists were demanding rights above and beyond those of men.[8] Jules Barbey d'Aurévilly, an antifeminist, related this mirroring or impersonation of a man to the creation of Eve: "Toujours Eve sortant du flanc d'un homme, la femme, cette *réceptivité,* . . .la femme n'est jamais que la réverbération de quelque chose, l'écho et le reflet de quelqu'un, . . . le caméléon singulier qui prend toutes nos couleurs et nous les renvoie" [Always Eve issuing from the ribs of a man; woman, so *derivative.* . . . Woman is never anything but the echo of something else, someone's image, reflection . . . the peculiar chameleon that adopts our every color and then mirrors it back].[9]

The other implication inherent in the masculinized female was the existence of a commensurate figure, a feminized male. The fear of the impending feminization of men is consistently depicted in popular images, literature, and even social criticism. For example, Barbey d'Aurévilly underscored the belief that if Georges Sand were to be made a member of the French Academy, then "men will

be making jams and pickles."[10] Because appearance was the fastest way for men to identify problematic women, cross-dressing became an immediate indication of a threatening female. Whether or not a feminist activist wore trousers, caricaturists would depict her in either masculine or androgynous dress, signaling her subversive nature. Even satires on the popular transvestite dances in Montmartre were quick to poke fun at women in masculine dress. Such is the case in an 1891 cover for *Le Petit Journal pour Rire* by Barthélémy Gautier (1846–1893), which carries the caption, "La comédie parisienne: bals masqués: Fille d'Eve en fils d'Adam" (figure 84). This illustration at once satirizes cross-dressing, which indicates a woman who *acts* like a man, and connects the term *fille d'Eve* to this practice.

The masculinized woman was known by a number of different names. The term *bas-bleus,* the French version of the English "bluestockings," was popularized during the 1840s in a series of satirical lithographs by Honoré Daumier, including one of a "femme de lettres" at her desk writing furiously while her baby is neglected, up-ended in its bath.[11] Daumier did not specifically feminize the appearance of the men in this series, although some were shown as weak when they reluctantly adopted their wives' chores of child rearing. The term *bas-bleus* remained in use throughout the nineteenth century, and its origin continued to be discussed, for instance in *La Revue des Revues* (1893) and *Le Figaro* (1896).[12]

Figure 84. Barthélémy Gautier, "La comédie parisienne: bals masqués: Fille d'Eve en fils d'Adam." *Le Petit Journal pour Rire,* c. 1891, cover. University of Minnesota Libraries. Photographer, Tim Fuller.

In his treatise on modern women, *Parisiennes de ce temps,* Octave Uzanne in-cluded a chapter in which he connected women artists and bas-bleus to the theories of Cesare Lombroso, the celebrated Italian physiologist, who argued that female inferiority had a biological basis. In rare cases, when the female of a species dem-onstrated superiority, "in bees or ants, for example, power was accompanied by di-minished femininity."[13] When it came to the "femme de lettres," Uzanne believed it would be wise to remember the formulation of a contemporary physiologist: "Le développement de la vie psychique est en raison inverse du développement de la vie sexuelle" [The development of spiritual life is in inverse ratio to that of the sexual].[14] Jules Barbey d'Aurévilly wrote an entire book on the subject of the bas-bleus, making a similar argument and stating further that "desexualized" women writers are nothing without their male counterparts, whose influence was neces-sary for their development.[15]

Other writers, such as John Grand-Carteret, in his *La femme en culotte* (1899), addressed masculine dress directly, calling the "femme en culotte" [woman in pants] the "femme de demain" [woman of tomorrow]. This book looks specifically at costumes for evidence that the masculinization of women leads to the feminiza-tion of men. The author maintains, "A femmes culottées, hommes enjupponés" [Women in pants means men in petticoats]. The bas-bleus were just the beginning, leading inevitably to women who smoked, preached, and participated in politics. They initiated an inevitable progression to feminism "au moment où s'entassent livres sur livres, consacrés à la femme future, à l'Eve nouvelle, à la femme du XXe siècle" [just when book after book is appearing devoted to the woman of the future, the new Eve, the twentieth-century woman].[16] Other dangerous cross-dressing women were the Vésuviennes, women warriors from the 1848 revolution, and the Pétroleuses, from the period of the Commune (1871).[17]

The femme-homme eventually came to stand for the androgynous woman who dressed and acted like a man, and in turn created a feminized male counter-part. This is evident in Draner's illustration for an 1890 issue of *Le Charivari,* where women in various roles are shown pants-clad.[18] Originally, the term was coined as *homme-femme*—the title of a book by Alexandre Dumas fils, which, in its 1873 English translation, carried the subtitle "the Temple, the Hearth, the Street."[19] While the translator interpreted the phrase *homme-femme* to refer to "that perfec-tion of coupled humanity," that is, man and wife, it was clear in Dumas's origi-nal text that his intended meaning was "man before woman." Dumas's occasion for writing his book was a controversial murder case, the *affaire Dubourg;* a man murdered his wife and then claimed he had caught her in the act of adultery, a valid legal defense. The case became more complicated when it was determined at trial that the man had also been unfaithful; further, he was aware of his wife's infidelity and had arranged to catch her in the act. The trial resulted in a series of articles in *Le Figaro,* both for and against the man's acquittal, and extended argu-ments concerning the current legal divorce debate. A letter by Henri d'Ideville published in *Le Soir,* recommending that an adulteress be pardoned rather than killed, inspired Dumas to take up his pen for a male audience.[20]

Dumas's resulting diatribe portrayed women as three classically derived, hierarchically organized types: "vestals," at the top; "matrons," in the middle; and "hetairae," at the bottom. In more familiar terms, these were "women of the temple," or virgins; "women of the hearth," or wives and mothers; and "women of the street," or courtesans. But this categorization was deceptively simple, since classifications determined primarily on the basis of outward appearance led to what Dumas considered the perpetual confusion of masculine society.

Throughout the text, Dumas used the Bible to justify his claims. Man, as "fetish worshiper and idolater," is destined to adore woman "in her exterior form." Man is faced with the choice of either submitting to her or dominating her. Feminists (a neologism, he claimed) are misguided in their demand for equal rights, for "woman is not an equal" but a "value of another kind, just as she is a being of another form, and of a different function."[21] The Dubourg affair gave him a landmark by which to retrace events from Genesis. "We accept the Bible, do we not? If the book is not in the eye of science irrefutable as a historic tradition, it is at least the book which goes back the farthest; . . . a moral, a religious tradition, as a tradition of man and woman in their relations to God and nature, it is the most complete. Myself a man, I seek out myself at the sources consecrated and accepted by man."[22]

It is from Genesis that Dumas derived his formula for the homme-femme. Propagating an already manipulated understanding of the Genesis story, Dumas described Eve as a helpmate. Since Eve was not specifically forbidden to eat the fruit, she had the right to say what so many of her sex would repeat when found at fault: "*I did not know.*"[23] To explain why Adam was driven from Eden, Dumas says it was not because he ate the fruit; "that is only the second reason. The first is, *because he has listened to the voice of the woman.*"[24] In the author's view, the drama continued through future generations as woman would compulsively seduce man, conceive children, and immediately want to disengage "herself from the male, the formal intermediary, who now appears to her as only instrumental and accessory; . . . she aims to place herself above the hierarchic creation . . .—in fact, common with God."[25] Thus, she would suppress man, the "intermediary," until nature called her to reproduce again. According to Dumas, woman declares her superiority to man through her form, sentiment, function, utility, and "by the subjection of man himself to the sensation which he finds in her."[26] In the new Eden, Dumas envisions that the serpent must have no influence upon woman, and woman must not influence man.

In the last portion of the text, written as advice to an imaginary son, Dumas warned:

> Never marry a girl of a mocking spirit. Raillery, with a woman, is a mark of hell. . . . [If you find later that] you have been duped by appearances or deceits; if you have associated your life with a creature unworthy of you; . . . if nothing can prevent her from prostituting your name with her body; if she cabins and confines you in your destined movement as man; . . . if the law, which has assumed the right to bind, has interdicted itself and pronounced itself impotent to release, then declare yourself in person, in

the name of your Master, judge and executioner of this creature. She is not your wife, she is not even a woman; she was not in her conception divine, she is purely animal; she is the babooness of the land of Nod, she is the female of Cain: slay her![27]

The commotion that the Dubourg affair raised in the daily press paled in comparison to the response to Dumas's book for more than a decade following its release. Many transformed the title of the book, as did Emile de Girardin, in his *L'homme et la femme—l'homme suzerain, la femme vassale—Lettre à M. A. Dumas Fils* (1872). Others, including Jules Hoche in an 1886 article in *Le Charivari,* embraced the phrase "Tue-la" [Kill her] as a rallying cry.[28] Lucien Solvay entitled his 1872 treatise *Tue-La ou elle te tuera! ou l'homme-femme! ou la femme-homme! ou ni homme ni femme! ou Alexandre embêté par Emile, ou Emile embêté par Alexandre.*

Several writers, such as Abbé P. Moniquet in *Autopsie de l'homme-femme* (1872) and Maria Deraismes in *Eve contre M. Dumas fils* (1872), objected to Dumas's invocation of Genesis to bolster his argument. As Deraismes deconstructed Dumas's arguments, she reinterpreted Eve as a powerful woman, the mother of humanity. She placed the biblical Eve in opposition to the symbolic filles d'Eve portrayed in the literature and illustrations of the day. She rewrote Dumas's advice as if for a daughter: "s'il te ruine, s'il arrive même à corrompre la pureté de ton sang, n'oublie pas que cet homme *souille le plan primordial, la conception divine,* qu'il est indigne de figurer au triangle; c'est le singe dont parle Darwin, c'est Cain en personne; TUE-LE, *n'hésite pas*" [if he ruins you, if he even manages to corrupt the purity of your blood, don't forget that this man *is defiling the primordial plan, the divine concept,* that he is unworthy to be part of the triangle; he is Darwin's ape, Cain in person; KILL HIM; *don't hesitate*].[29]

While Deraismes intended her statement to be satirical, it was true that the right of a man to kill an adulterous wife did not work in reverse. This was demonstrated some years later, when Mme de Tilly was accused of dousing her husband with acid after catching him with another woman. Again Dumas took up his pen, this time coached by Jules Clarétie, who issued a challenge in *Le Figaro;* the result was a pamphlet entitled *Les femmes qui tuent et les femmes qui votent* (1880).[30] In connection to Mlle Tilly, Dumas invoked the name of Hubertine Auclert, who was then agitating for women's right to vote. Were he forced to choose between them, he preferred the murderess, a stunning condemnation of feminism. Dumas justified his choice with passages from the Bible.[31] An 1883 illustration by Moloch for *L'éclipse,* on this same theme, shows the "killers" at left, with one woman holding a dagger, a vat of acid, and a cup of poison, and another wearing skull earrings, holding two weapons, about to devour a heart (figure 85).[32] The illustration on the facing page depicts the "voters"—an old crone votes "oui" and an attractive younger woman in bloomers votes "non" for the adoption of a free union. Neither is an admirable type and both pose a danger to society.

Eventually, writers rewrote the equation *homme-femme* as *femme-homme,* among them the anonymous woman in a 1872 rebuttal to Dumas, entitled *Al-*

Figure 85. Moloch, "Les femmes qui tuent, les femmes qui votent." *L'éclipse,* May 31, 1883, 388–89. University of Minnesota Libraries. Photographer, Tim Fuller.

exandre Dumas Fils, La femme-homme: Mariage—adultère—divorce: Réponse d'une femme. An article in *Le Charivari* gave one reason for the transformation:

> Alexandre Dumas écrivit jadis l'*Homme-femme.* C'est la femme-homme qu'on veut nous donner à présent. On vous a parlé de la pétition qu'une dame a adressée à la Chambre pour revendiquer le droit au veston. Ce n'est, en somme, qu'un symptôme accessoire d'une situation pathologique. Il est évident que l'idéal d'un certain nombre de femmes est aujourd'hui de se masculiniser.

> [Previously Alexandre Dumas wrote *L'Homme-femme.* Now it is the femme-homme they would like to inflict on us. You've heard about the petition a woman addressed to the Chamber demanding the right to wear men's jackets. That is merely a minor symptom of a general pathological disorder. Obviously, a certain number of today's women dream of becoming men.][33]

This author of this piece was concerned about women's wearing men's clothing, which he felt, went against nature.

Alphonse Lafitte preferred the term *femme-garçon* [woman-boy]: "Il y a non-seulement l'homme-femme et la femme-homme, mais il existe encore une autre catégorie de bipèdes que nous appellerons: les femmes-garçons" [There is not only the *homme-femme* and the *femme-homme,* but another kind of two-legged creature

we shall call the *femme-garçon*].[34] The idea of women's "going against nature" in one way or another, whether they wore pants, thereby appropriating male attributes, or engaged in sexual practices outside marriage, was intimately connected to the tremendous fear that a drop in the birthrate would threaten France's cultural identity and geopolitical power.

Fetus Envy

The disastrous defeat of France in the Franco-Prussian War in 1870 led artists and writers to focus on the issue of depopulation.[35] The magnitude of this growing concern is suggested by the more than two hundred works listed in Victor Turquan's *Contribution à l'étude de la population et de la dépopulation* (Paris, 1902). An illustration by the artist Draner for *Le Charivari,* early in 1900, depicts various members of society stating their reasons for not having children. The women cite primarily personal reasons. A feminist says, "je vais rester femme et non dévenir femelle" [I intend to stay a woman and not become female]. One woman fears her child would not resemble her husband; another claims that being pregnant would interfere with her sex life; and yet another says she would be obliged to reduce her clothing and jewelry budget. The men blame the women in their lives, or the lack of any.[36] The economist Paul Leroy-Beaulieu provided statistical corroboration for the claim that feminism was to blame for the decline in the birthrate, while others, including G. Vacher de Lapouge, linked feminism to the intellectual degeneration of the population and suggested that intelligent women who chose not to have children were turning back the evolutionary clock.[37] Popular magazines promoted the idea that the emancipation movement was destroying the family. *Le Courrier de France* stated: "Wives and mothers, no more baby clothes; just a flag. No more *pots-au-feu,* just the ballot box: Woman the voter and soldier."[38]

Politicians and prelates had a stake in the size of families; each group blamed the feminist movement for the decline in population. Feminists such as Marie Huot, Marguerite Durand, and Gabrielle Petit provided fodder for their critics by actively discussing the necessity of limiting family size. From their perspective, the "restriction of fertility represented a form of 'revolt' against the dictates of nature and the dominance of men."[39] Not only was the smaller family alarming because of the population numbers, but many men feared that too much attention paid to fewer children would result in "effeminate" adults.

Feminists resented being demonized as the principal destroyer of families, the "Moloch de l'espèce" [Moloch of the human race].[40] In a public lecture, Maria Deraismes dismissed the popular notion that it was "love of luxury" and the desire to lavish attention on one or two infants that caused the current state of affairs. Both Deraismes and Maria Martin, publisher of the *Journal des Femmes,* believed that better care of children *after* their birth, especially those born out of wedlock, would be the most effective method of solving the serious problem of depopulation.[41]

Bound up in this debate were the issues of sexual abstinence and various forms of birth control, including abortion, which was considered both a "backup meth-

od" and a "female method." Statistical evidence suggested that the drop in birth-rate was due to two factors—fewer children born in each marriage, and an increase in unmarried women. Moreover, an increase in children born out of wedlock caused some to predict that France might become populated exclusively by "ille-gitimates."[42] The perception within the medical community was that infanticide and abortion were being practiced at an alarming rate. Angus McLaren has shown that the type of woman likely to seek an abortion shifted from the "seduced girl," early in the nineteenth century, to the "married woman seeking to control the size of her family," after 1880.[43] There was also a shift in the proportion of "medically justified" abortions to those that were conducted not necessarily by doctors but by "midwives, matrons, pharmacists, herbalists, veterinarians, bonesetters, masseurs, and quacks."[44] In 1884, Charles Pajot claimed that there were as many abortions each year as live births, although McLaren believes this to be exaggerated, due, among other reasons, to French doctors' being "angered by emerging feminism [and blaming abortion] on the selfish act of an independent woman."[45]

Simultaneously with the emergence of these societal issues centered around sexuality, a specific motif appeared in art and literature: deformed and sometimes preserved fetuses. An early example of this is found in Frédéric Soulié's *Physiologie du bas-bleu* (c. 1842), where a deformed fetus is identified as the result of an ex-periment in procreation between a very intelligent man and a gracious, coquett-ish bas-bleu.[46] The two reportedly discussed the child's conception over dinner, in terms of mathematical theorems. Every truffle and each glass of champagne consumed by the couple was accompanied by a new algebraic equation. When their brains and senses were properly stimulated, they began "l'oeuvre de Dieu" [God's work]. Nine months later, an infant was born, but instead of the predicted exceptional child, it was a cretin.[47] An illustration of a fetus in a specimen jar ac-companied this declaration, implying that a bas-bleu's intelligence produced not a better human being but a degenerate one. The baby is shown as a medical speci-men to demonstrate how far it is from a real child, in a real family.[48] The insertion of mathematical and scientific discourse into a treatise on liberated women not only suggests a fear of women who might acquire certain types of knowledge, but also reflects the general trend of popularizing, or vulgarizing, "science" to a public insufficiently prepared to distinguish facts from satire.[49]

The anomalous-infant motif is connected directly to women's rights in an il-lustration for *Paris s'Amuse,* entitled "L'émancipation de la femme."[50] As in works discussed earlier, women are shown taking on masculine roles, which in turn re-sults in males' adopting feminine tasks. At lower center is an infant who has been left to take care of himself, because "Mesdames les mères étant trop absorbées par la politique" [Mothers are too busy with politics]. The child has been given a bottle of wine to suckle, while a medical specimen in the background refers to alcohol as a means of preserving dead organisms.

Aborted fetuses had been stored in glass flasks as early as the sixteenth century, in order to demonstrate the developmental stages of human beings. Pierre Robin, an obstetrician from Rheims, reported in his *Catalogue of Anatomical Specimens* (c.

1800) that he had ten fetal skeletons, as well as "embryos, fetuses, and products of miscarriages," which he used to train midwives.[51] In 1833, the collection of Geoffroy Saint-Hilaire, part of the Natural History Museum in Paris, contained forty-three fetal specimens, all of which were "anciens trouvés dans des tombeaux bretons et gaulois" [ancient, having been found in the tombs of Bretons and Gauls]. The bottled fetuses in the Natural History Museum's collection were added later in the nineteenth century.[52] The galleries of comparative anatomy, zoology, botany, and geology were open to the public. An 1884 issue of *La Nature* documented the popularity of specimens in the museum.[53] Since at least the July Monarchy, artists made a habit of studying the animals in the zoo, and it seems unlikely they would have overlooked the large collection of comparative anatomy specimens in the Natural History Museum, or other locations where they were available. Another collection, in the Ecole de Médecine, included bottled specimens in different stages of growth, as part of extensive exhibitions on gestational development within the womb (figures 86 and 87).[54]

Figure 86. Medical specimen, eighteenth to early nineteenth century. Musée Dupuytren, Paris. Photographer, Cédric Crémière.

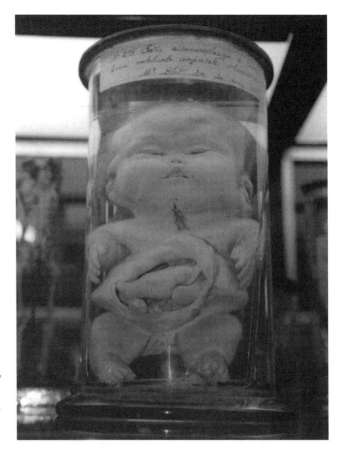

Figure 87. Medical specimen, eighteenth to early nineteenth century. Musée Dupuytren, Paris. Photographer, Cédric Crémière.

Fetuses could also be found on display in traveling sideshows that obtained examples from various sources, both legal and illegal. Among the anecdotal references to the motif of the fetus in literature was the decadent poet Paul Verlaine's remembrance of his mother's miscarried fetus, kept in a kitchen cabinet.[55] Maurice Mac-Nab, a well-known Montmartre performer, included in his repertoire "Les foetus," a poem that describes the "life" of specimens, "privés d'amour" [deprived of love], from "cabinets médicaux" [medical collections]. Mac-Nab compares them to alcoholics because, preserved in alcohol, "il passe tout le temps à boire!" [they spend all of their time drinking!]. He also chronicled in rhyme their various deformities. One of the couplets reads: "Les uns ont des figures douces / Venus au monde sans secousses / Sur leur ventre ils joignent les pouces" [And some had sweet little faces, / With none of birth trauma's traces, / Their thumbs on their tummies enlaced].[56] A still life incorporating a fetus in a bottle was satirized in *Le Charivari*, in 1900, indicating the use of this motif by popular illustrators by this time.[57] The image of an imprisoned fetus, the product of an unsuccessful or unwanted pregnancy, must have struck many men as a fitting symbol of depopulation.

The fetus motif became increasingly common in the late nineteenth century as male artists expressed their fear of the independent woman. In his etching of c. 1881, distributed as a type of calling card, Henry Somm combined representations of a monstrous fetus with webbed feet, a fashionable woman, and a man hanging from a gallows (figure 88). The artist's message is consistent with others in his oeuvre: the fashionable Parisienne will cause the death of the man who loves her, and their offspring will be deformed. Somm also employed the fetus-in-a-jar motif for a "self-portrait" (figure 89). He modified this motif in works where full-grown men were shown in liquor bottles, such as in "Psychologues," for *Le Rire,* where the imprisoned man is described as "une sorte d'esthète, un *interverti*" [a sort of esthete, an example of inversion].[58]

Figure 88. Henry Somm, *Cause et effet.* Etching, c. 1881. Private collection. Author's photograph.

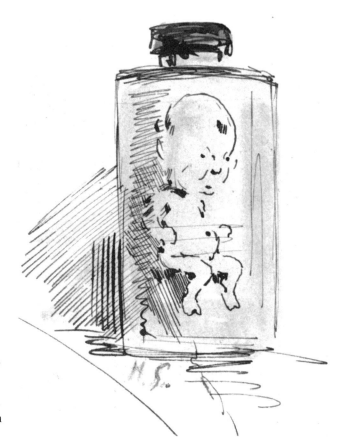

Figure 89. Henry Somm,
*Autoportrait comme un
foetus.* Ink drawing.
Undated. Private collec-
tion. Photographer, Tim
Fuller.

Common to all these satiric images by Somm is the idea of degeneration, which
might be the result of the birth process and heredity, or of outside agents, such as
artistic theory or alcohol. The enlarged heads of the fetuses drawn by Somm and
others could be seen in medical illustrations of the day (figure 90). Somm added
webbed feet to his fetuses; the resulting embryos seem informed by contemporary
theories of monstrosity. Fetal specimens with webbed hands and/or feet did ex-
ist and were called *sirènes,* a term that would have interested Somm because the
female mythological figures known for luring sailors to their deaths were femmes
fatales, like those who appeared in his work.[59]

In a sense, the bottled baby might be considered a "monster," a concept fed
by theories of degeneration popular in Symbolist circles in Paris. Since degenera-
tion was believed to be a hereditary condition, embryology became increasingly
important to the study of comparative anatomy.[60] A monster was a creature with
any perceived physiological abnormality. Ambroise Paré (1510–90), a physician to
the kings of France, described monsters as "things that appear outside the course
of Nature (and are usually signs of some forthcoming misfortune)."[61] According to

I I I I

II II II II

III III RABBIT. MAN.
TORTOISE· CHICK·

Figure 90. George John Romanes, biological drawings, after Ernest Haeckel, 1892. University of Minnesota Libraries. Photographer, Tim Fuller.

Paré, there were thirteen primary causes of monsters, including the imagination of the mother, her too-small womb, and her bad posture. In the seventeenth century it was believed that the thoughts of the mother during intercourse or pregnancy could imprint upon the fetus whatever was imagined, no matter how innocuous or bizarre.[62] The placing of blame for abnormalities upon women continued during the Enlightenment, when the respected scientist Jean Palfyn (1650–1730) determined the female organs to be "the source of errors."[63]

The beliefs of the "imaginationists" were held to be true until the beginning of the nineteenth century, and, while these ideas were debated within the scientific community, they were largely accepted by the public.[64] Remnants of the theories appear in Villiers de l'Isle-Adam's story *Claire Lenoir* (c. 1888), confirming as much.[65] Males were still thought responsible for infertility and stillbirths. Robert Nye has observed, "In the earliest stages of embryological development, it was the 'male' element that formed the 'ectoderm' of the embryo where the nervous system and circulation were located, while the egg shaped the dark and passive regions of the interior."[66] However, the male most likely to produce a stillborn infant was one

who had been "feminized" in some way. Paul Bourget, in his *Physiologie de l'amour moderne* (1891), attributed degeneration in the male not only to the pace of modern life, but also to sexual exhaustion caused by, among other things, frequenting prostitutes. The result was impotence and the onset of effeminate qualities, which in turn compromised a man's ability to sire healthy children. In the end, no matter what form the argument about depopulation took, women were held responsible.

The fetus's monstrously large or swollen head was a focus of antifeminists, who used it to characterize an intellectual woman, calling it "une sorte de Quasimodo femelle: un corps en tuyau de poêle, une tête énorme, congestionnée: construction audacieuse de têtard intelligent" [a sort of female Quasimodo: a body like a stovepipe, an enormous, swollen head: the audacious shape of an intelligent tadpole].[67] The "congested" or "hydrocephalous" heads of fetuses pointed up the idea of hereditary degeneration: a "Quasimodo" female will beget a "Quasimodo" child. The term "hydrocéphale" was applied to Isidore Mathias, director of *La Revue Littéraire,* and to the militant feminist Mme de Sainte-Parade. In his caricature of Hubertine Auclert (see figure 83), Alfred le Petit used a swollen head on a tiny body for humor as well as to imply psychological abnormalities.

The British artist Aubrey Beardsley (1872–98) exploited the motif of the fetus in his work, which was disparaged by London critics for being infected by the "French germ" of decadent art. Although he did not publicize it, he collected the art of Félicien Rops.[68] Beardsley's works became well known and appreciated in France in the 1880s and 1890s, especially in Symbolist circles.[69] The fetus, or embryo motif, as Beardsley scholars prefer to describe it, first appears in his work in 1892–93, perhaps not coincidentally following a trip to Paris, where he worked with the progressive academic painter Puvis de Chavannes. It is possible that he saw the motif in Somm's work, but it is more likely that he saw a display of medical specimens, either at the Ecole de Médecine or in a traveling sideshow. Walt Ruding's *The Evil Motherhood* (1896), for which Beardsley provided an illustration, demonstrates the existence of the fear in England, as in France, that the emancipated woman will produce sons who are weak and effeminate.[70]

Milly Heyd has described Beardsley's use of the embryo as related to an interest in "primordial states," and in the subject of creation, as seen in works by artists such as Otto Runge, William Blake, and Odilon Redon. According to Heyd, Beardsley's use of the fetus motif is similar to Redon's use of the cell motif, revealing a "subjective and personal approach" in which "the embryo as symbol of Beardsley is witness to the essential narcissistic modernism of his work."[71] Other scholars have speculated that Beardsley's use of the embryo motif emerged from his illness (which may have prompted his study of scientific texts), or from his having witnessed a miscarriage first-hand.[72] But Beardsley called the motif "an unstrangled abortion,"[73] and this designation fits well with the artist's hatred of social hypocrisy and his "dismantling of Victorian sexual stereotypes."[74]

Beardsley first used the embryo motif in several of the "grotesques" he pro-

vided as illustrations for the *Bon-mots of Sydney Smith and R. Brinsley Sheridan.*
He described working on them in the fall of 1892, following his trip to Paris in
June of that year.[75] A vignette of a woman receiving a fetus from an alchemist, or
abortionist, appears early in the text, near a paragraph calling for an "expression
of hostility to the Church Establishment" (figure 91). The skull of the embryo is
divided into zones suggestive of adult cranial development, and the hands and
feet are misshapen. Later in *Bons Mots,* the embryo receives a lobotomy; from its
severed skull emerges a skeleton (figure 92). This example has been interpreted as
representing the cycle of life, which necessarily includes death. The accompany-
ing text describes Mrs. Marcet visiting Sydney Smith, who introduces himself as
a doctor and describes his medicines: "there is the Gentle-jog, a pleasure to take
it; the Bulldog, for more serious cases; Peter's Puke; Heart's Delight, the comfort
of all the old women in the village; Rub-a-dub, a capital embrocation; Dead-stop,
settles the matter at once; Up-with-it-then, needs no explanation."[76] Mrs. Marcet
is then taken into a room stocked on one side with medicines and on the other
with meat, "a beef, veal, mutton, pork, lamb, venison show!"[77] In this context,
Beardsley's embryo or fetus motif seems to comment on the practice of abortion,
and the treatment of prospective human life. Linda Zatlin has argued convinc-
ingly that the fetus in Beardsley's work expresses "a woman's ambivalence towards
pregnancy and motherhood's difficulties."[78]

Beardsley also used the embryo motif in a series of illustrations for *Lucian's
True History* (1894) that he began in 1892. The story Beardsley illustrated involved
the impregnation of a man by a pack of dominating women. "Dreams" (Fogg Art

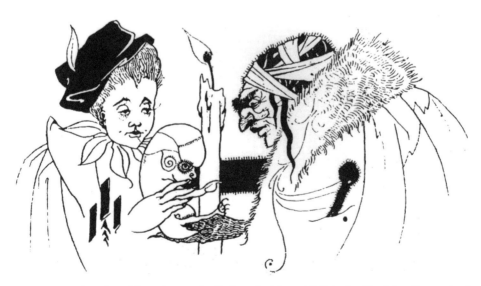

Figure 91. Aubrey Beardsley, vignette for Sydney Smith and R. Brinsley Sheridan, *Bon-mots of
Sydney Smith and R. Brinsley Sheridan* (London: J. M. Dent, 1893), 26. Author's photograph.

Figure 92. Aubrey Beards-
ley, vignette for Sydney
Smith and R. Brinsley
Sheridan, *Bon-mots of
Sydney Smith and R. Brin-
sley Sheridan* (London:
J. M. Dent, 1893), 88.
Author's photograph.

Museum) is a twisted version of a Christian adoration scene, with the embryo held
up for the admiration of hybridized grotesque creatures. But the femme fatale idea
is most fully developed in a plate that fell victim to the censors, "Lucian's Strange
Creatures," in which a fetus is held by what appears to be a priestess, in the com-
pany of a large snake and masked beings.[79] Linda Zatlin has suggested that the
fetus may be pointing accusingly at the woman for its aborted status. Beardsley
showed an embryo in a bell jar just once, in an 1894 design for *St. Paul's Magazine*
(figure 93), in which the embryo becomes the object of the woman's gaze yet is
denied contact with her. As a recurring motif, Beardsley's embryos represent the
product of aberrant women who are responsible for depopulation.

Figure 93. Aubrey
Beardsley, design for *St.
Paul's Magazine* 1, no. 1
(Mar. 1894). Albertina,
Vienna.

A powerful aspect of the fetus motif involved its connection with the hypo-
thetical ideal of virtue: the Virgin Mary or New Eve. The subverting of the Catho-
lic symbol of purity appears in Beardsley's *Incipit Vita Nova* (1893) and in Edvard
Munch's well-known *Madonna* (1894–96) (figure 94), which exists as an oil painting
and in several lithographs.[80] Munch, who was Norwegian by birth, studied in Paris
from 1889 to 1891 in the atelier of Léon Bonnat, an academic artist who made full
use of anatomical studies.[81] Munch's exposure to bottled fetuses at the Natural
History Museum, the Ecole de Médecine, or a sideshow seems likely, especially
since the oil painting *Madonna* was completed immediately following a stay in
Paris, and the hand-colored lithograph illustrated here was destined for an exhibi-
tion there.[82] His model for the fetus that appears in the corner of the lithograph
may have been a mummified specimen, such as one still on display at the Ecole
de Médecine.[83] Robert Rosenblum has suggested that a Peruvian mummy in the
collection of the Musée de l'Homme served as the inspiration for Munch's 1893
painting *The Scream,* either directly or through Gauguin's reinterpretation.[84]

Scholars have cited numerous personal relationships or incidents that in-
fluenced Munch's depictions of women, including the deaths of his sister and
mother, and a number of tragic love affairs. However, his decision to modify the
already shocking image of the *Madonna* with the addition of sperm and a fetus

Figure 94. Edvard Munch, *Madonna*. Hand-colored lithograph, 1895. National Gallery of Art, Washington D.C., Epstein Collection.

in the lithograph seems, in retrospect, to be a calculated move to curry favor with French Symbolists. The *Madonna* was one of a series of works by Munch that dealt with the Eve story.[85] The artist persistently connected Eve with death, which could be explained by a consideration of the biblical text, but more specifically was related to the death of his mother and to his failed relationships with other women.[86] Munch believed that living with a woman would result in the death of a part of himself. His description of the *Madonna* blended life with inevitable death: "It is the smile of a corpse. Now life reaches out a hand to death. . . . [It is] the chain that links thousands of generations that have gone before with thousands of generations to come. Life is born only to be born again, and die."[87] Strindberg, who saw the print at Siegfried Bing's gallery L'Art Nouveau in Paris, commented: "Immaculate or not, it's all the same. The red or gold halo that crowns the consummation of the act, the only justification for this creature's life—with no existence of its own."[88] Strindberg believed that sexual decadence was the leitmotif of the "new woman."[89]

Munch would use the fetus motif again, in his 1896 painting *Madonna in a Graveyard* (Munch Museet, Oslo). In this work, the Madonna appears haggard rather than orgasmic, and the fetus exists in skeletal form, holding two arrows and a broken bow in a macabre imitation of Cupid. The straightforward interpretation is that love implies death, or love may be coupled with death. Arne Eggum has suggested that, for Munch, "pregnancy means death."[90] In Munch's 1898 lithograph entitled *Inheritance,* a sickly fetus squirms on a woman's lap, a "syphilitic recapitulation of the Madonna and child theme."[91] The death of an infant, by accident, disease, or a deliberate act of abortion, represented a death of a part of the father's "self"—and it was in this sense that Munch interwove his personal feelings in these Symbolist works.

By 1902, the motif of the bottled baby was blatantly linked to abortion by Charles Léandre (1862–1930), in his series of illustrations entitled "Les monstres de la société," for *L'Assiette au beurre.*[92] The series was an homage both to circus sideshows and to popular theories of degeneration, as identified by the introduction to the images:

Vous croyez peut-être, bonnes gens, que Barnum a ermporté avec lui tous les phénomènes vivants dont s'amuse l'attention publique. Bonnes gens, vous avez mal regardé: les monstres sont toujours là, grouillant du haut en bas de l'échelle sociale, étalant leurs difformités physiques ou morales; les monstres, ce sont les détraqués, les neurasthéniques, les avariés, que nous coudoyons dans nos maisons, dans la rue, sur les places publiques, monstres difformes, répugnants, dont les tares hideuses révèlent un état social putride.

[Maybe you think, good people, that Barnum has made off with all the human curiosities that amuse the public. Ah, good people, you didn't look very carefully: the monsters are still there, swarming up and down the social ladder, exhibiting their physical or moral deformities. These monsters, they are the neurotics, the deranged, the disfigured, with whom we rub shoulders in our homes, in the street,

on the public squares: misshapen, repugnant, their hideous flaws revealing the rottenness of society.]

The "monsters" identified by Léandre were primarily members of the bourgeoisie, many of whom were known individuals, carefully caricatured, who had repeatedly engaged in illicit sexual affairs. Many of the illustrations alluded to theories of evolution by combining human and animal physiognomies. Nowhere was this more apparent than in the plate entitled "L'homme, roi des animaux." Degeneration was also addressed in the plate entitled "Paris, le plus grand monstre du monde," which showed a nude woman riding a monster who is consuming the masses. Also caricatured in the series were members of the government, snobs, journalists, and the bas-bleus, the latter described as asexual and ageless. The plate featuring an abortionist is entitled "Le monstre des monstres" (figure 95). Here the "monster of monsters," a grotesquely rotund midwife with masculine facial characteristics, greets a new client who is clearly in an advanced stage of pregnancy. Rows of specimen jars in the background indicate the impending outcome of the visit. The caption reveals that both women partake of the dual role of creator and destroyer: "Ici l'on fabrique des anges. On fait la concurrence à la maison Bon Dieu" [Here we manufacture angels. We're in competition with the Church.]

Figure 95. Charles Léandre, "Le monstre des monstres." From the series "Les monstres de la société," in *L'Assiette au beurre*, 1902. University of Minnesota Libraries. Photograher Tim Fuller.

In 1907, Gustave Adolphe Mossa treated the theme of the abortionist and the bottled baby in a pair of watercolors. The first image is of *Dr. Forceps,* in a death's head–patterned coat, as he visits a woman in her bedroom. Her spouse, seen in the background, is apparently complicit in the action. A host of floating, ghost-like fetuses announce the result of the doctor's visit. The second work, *The Foetus,* continues the story of the same couple post-abortion (figure 96). The elaborately dressed woman is powdering her face at her vanity table. The man appears at the

Figure 96. Gustave Adolphe Mossa, *Le foetus.* Watercolor, 1905. Musée des Beaux-Arts, Nice. © 2005 Artists Rights Society (ARS), New York/ADAGP, Paris.

back of the room next to a stack of boxes, obviously recent purchases. Poppies, a symbol of decadence, are strewn around the base of an elaborate reliquary-like container for their fetus. The clear glass allows the woman's costume to be seen in conjunction with the unborn child, suggesting a parallel between her body and the container as a vessel of death. Thus, Mossa equated the frivolousness of high society with spiritual and physical decay, illustrating the sacrifice of the French family for the pursuit of luxurious commodities.

The fetus motif alluded to women as bad mothers who were not fulfilling their prescribed roles as filles d'Eve, that is, those who bore the pain of childbirth to atone for Eve's sin. The last motif to be considered in this study brought the fille d'Eve most directly into contact with her biblical predecessor by representing contemporary fashionable women with snakes, or even *as* snakes.

EIGHT Serpent Culture

The association of woman with the devil evolved from interpretations of Genesis that identified the serpent as Satan in disguise. What had originally been a dialogue between Eve and a snake became a conspiracy between Eve and the devil. In modern French society, depictions of snakes with contemporary women conjured up the fille d'Eve. Fashionable Parisiennes even came to be depicted as part snake. The historical significance of snakes, especially in religious cults that predate Christianity and in traditional representations of the snake in Eden as female, provides a context for such depictions.

Several factors influenced the development of these misogynistic images in the nineteenth century: the revival of the story of the ancient mother goddess and her snakes, the tradition of the female snake who tempts Eve in Renaissance works, and the more recent patriarchal association of the snake with phallicism. In addition, nineteenth-century French artists showed the fille d'Eve to be heavily involved with fashion, for it was her contemporary dress that identified her as the modern descendant of Eve. A range of snake-inspired accoutrements, including jewelry and the feather boa, became popular at century's end, demonstrating the commercial viability of the woman-serpent connection. The Art Nouveau movement, with its use of serpentine forms, capitalized on the motif in content as well as style. Popular illustrators satirized the trend by suggesting that boas were substitutes for genuine snakes. Accessories in snake form were

developed for specific female performers—Sarah Bernhardt, Loïe Fuller, and Jane Avril—bringing the motif to the stage and the femme fatale to life.

Serpent-Devil or Woman?

A conflated snake-woman figure emerged in popular culture as the nineteenth century progressed. This was not a new phenomenon, but a revitalization of a tradition that may be as old as visual representation itself, for snakes in ancient cultures were associated both with deities and with women. Throughout history, a significant number of cults have been devoted to snakes, in part due to the reptiles' seemingly otherworldly attributes, including unblinking eyes that were interpreted as all-seeing and all-knowing.[1] Their cold-bloodedness and their ability to change their skin made them appear immortal. Snakes were associated with creation stories in some cultures; in others, a coiled snake came to represent the endless cycle of life and death. Snakes were associated with the Great Goddess or mother goddess in ancient mythology: Kali for the Hindus, Demeter for the Greeks, Coatlicue for the Aztecs.[2]

According to Erich Neumann, the archetype of the Great Mother has three forms: the good, the terrible, and the good-bad mother. In the first two, the elements of good and evil are separate; the third unifies good and bad characteristics.[3] This good-bad mother is present in Kali and Coatlicue, both of whom are associated with life as well as violent death. The negative = feminine equation in the "terrible female" has been associated traditionally with the unconscious and monsters. In this configuration, the womb is not a protective place of fertility but a "deadly devouring maw of the underworld."[4]

In Sumeria, serpent goddesses were responsible for intellectual activity, including predicting the future and interpreting dreams, in addition to fertility.[5] Statues of priestesses holding snakes (or encircled with coiled snakes) are common archaeological finds on Crete, where the female deity is referred to as the serpent goddess. In Greece, snakes were later linked with the male gods who gained supremacy over the goddesses, such as the case of Python, who was female in early accounts but later was characterized as male.[6] The Cretan examples and the Egyptian cobra goddess are the ancestors of Greek depictions of Athena. Serpents came to be associated with many Greek mythological figures, both male and female, but it is significant that the earliest myths linked a female snake with a goddess.

There have always been ambiguities associated with the mother goddess and her serpent symbol stemming from the snake's phallic associations.[7] It is likely that the original pairing of mother goddess with the phallic snake was to represent shared female-male power without the strict gender divisions instituted by Western societies. Snakes were "believed to mediate between life and death, earth and sky, this world and the next."[8] Numerous, disparate meanings are conveyed by the symbol of the serpent: "good, evil, wisdom, power, eternity, and everything that is base, low or dark, depending on the circumstances into which the rep-

tile is drawn."[9] When the positive and negative characteristics of the snake were combined, it was possible to see the snake-woman as a "bad mother," which had implications in light of nineteenth-century French feminism.[10]

Serpents have two means of attack—by biting or by strangling with their own bodies. Nineteenth-century artists were most interested in representing the latter, either to communicate the deadly nature of a woman or to exploit the curvilinear coiling as a decorative motif in Art Nouveau patterns. The snake's negative characteristics—its cold-blooded nature, its forked tongue, its ability to blend in with its surroundings, and its lack of limbs, which put it in a "permanently-debased position"[11]—originally inspired fear and respect, but eventually came to provoke hatred. These characteristics were most frequently associated with Eve in the Genesis story. The original biblical text supports interpretations of the serpent as a symbol of recurring youthfulness, wisdom, chaos, and evil.[12] Some interpreters of this text associated Eve with Semitic fertility goddesses who consorted with snakes (Astarte, Ishtar, Anat). Even the Hebrew word for Eve, *hawwah,* is similar to *hiwya,* which is Aramaic for "snake."[13] Interpretations of the creation myth led to changes in the narrative of Eve and the snake, and there were corresponding modifications in visual representations. The snake was shown as female, despite the fact that it had come to symbolize Satan and was itself a phallic symbol (the Hebrew word for serpent, *nahash,* is masculine).

Images of the snake-woman occur most notably in the Renaissance, although examples can be found in earlier manuscript illumination and in church sculpture, including that of the cathedral of Notre-Dame at Chartres.[14] Since there is relatively little extant visual evidence from the earliest periods of Christianity, the snake-woman motif seemed to appear suddenly. John K. Bonnell demonstrated that it existed as early as the thirteenth century, when it was represented in mystery plays, the medieval dramatizations of biblical stories.[15] In Bonnell's opinion, the motif was perpetuated because the appearance of the female snake in a mystery play suggested church sanction of the representation, thus encouraging the increased use of it. The motif also proved practical, for while early performances used a mechanical device to represent the snake, eventually the snake was played by an actor with flowing hair who dressed in a skin-tight costume, which allowed the performer to double as the angel before the Fall and as a feminine presence.[16]

According to Bonnell, this stage character influenced artists in their representations of the motif. A female serpent could emphasize Eve's propensity to sin. The theologian Peter Comestor gave the only reasonable explanation for the snake's having a woman's face. According to Comestor, Eve would be more easily ensnared if the creature looked like her, an idea based on the principle of *similia similibus applaudunt* [like is attracted to like].[17] The facial similarities between the snake and Eve in Renaissance representations are most clearly demonstrated in Masolino's *Adam and Eve: The Fall* of c. 1425 (Florence, Brancacci Chapel, Santa Maria della Carmine) and Hugo van der Goes's *The Temptation* of c. 1470–80 (Vienna, Kunsthistorisches Museum). Another well-known representation of the

snake as female is found in Michelangelo's scene of the Fall in the Sistine Chapel, of 1508–12. Female snakes also appear in French illuminated manuscripts, such as François Fouquet's miniature depicting original sin, from the *Manuscrit de la cité de Dieu* (c. 1473, Paris, Bibliothèque Nationale). While the serpent in this example is winged, it bears a facial resemblance to Eve and is clearly of the female sex—it has breasts and the swollen abdomen common to representations of women of the period.

Nineteenth-century literature depicts a struggle between the devil and Eve through the snake. L. J. Larcher, compiler of the 1858 text *La femme jugée par l'homme,* devoted an entire chapter to "Eve, le serpent et le diable," and his 1860 *Satires et diatribes sur les femmes, l'amour et le mariage* cited many religious authorities who connected woman to the devil. Among them are Saint Bernard ("La femme est l'organe du diable" [Woman is the instrument of the Devil]) and the French seventeenth-century poet Desportes ("La femme et les démons ont beaucoup d'alliance" [Women and the Devil have much in common]).[18] Others, like Victor Hugo, felt that woman was literally a devil: "La femme est un diable très-perfectionné" [Woman is a highly polished version of the Devil].[19] Jacques Olivier, author of the *Alphabet de l'imperfection et malice des femmes,* believed women were worse than snakes, for "jamais serpent n'y vipère n'eust tant de poison qu'une femme meschante en a partout le corps, et particulièrement en sa langue" [never did serpent or viper possess such poison as a bad woman has throughout her body, and particularly in her tongue].[20]

Edouard de Pompéry, in his 1864 book *La femme dans l'humanité: sa nature, son rôle et sa valeur sociale,* discussed the presumed camaraderie between woman and snake in the chapter entitled "Le mensonge de la femme." After describing woman's natural weakness, de Pompéry wrote: "Ainsi que la Pythonisse, la femme est agitée et possédée par le dieu. Elle vibre tout entière sous cette influence dominatrice et sans avoir conscience de ce qu'elle dit. Elle est l'instrument d'une situation." [Like Pythia, the prophetess of Apollo, woman is convulsed and possessed by the god. Her entire body quivers under this all-pervading influence, and she is unconscious of the words she utters. She is merely an instrument.][21] This, then, explains how woman becomes a liar. In a later chapter, "La ménagère et la pythonisse," de Pompéry identified two directions that a woman might take in life. She might live like a butterfly, predisposed to metamorphoses aided by the malleability of her feminine nature; happily, maternity can provide her with moral equilibrium. In addition to the mobile butterfly, she resembles a flower because of her charm; a dove for her tenderness; a bee or an ant for her indefatigable activity. But her malleability also subjects woman to the opposite extreme: "De même qu'elle produit la ménagère patiente et minutieuse, elle peut donner la pythonisse, la sorcière, l'inspirée" [Just as it produces the patient and meticulous housewife, it can also give us the sibyl, the witch, the woman possessed].[22]

Biblical interpreters have cast the Genesis snake as a cunning trickster; as woman became more closely associated with serpents, she took on that quality.

Thus, Milton described Satan's approach to Eve in terms of his seduction by her. So tempted is Satan by Eve that he is "abstracted" from "his own evil."[23] French literature of the nineteenth century contains many examples in which women have alliances with the devil,[24] or, as is the case with Jules Barbey d'Aurévilly's *Les diaboliques,* become demons in their own right.[25] The anonymous writer of *Maximes et pensées sur la femme* (1880) quoted Saint Cyprien: "Les femmes sont des Démons qui nous font entrer en enfer par la porte du paradis" [Women are demons who lead us to Hell through the gates of Paradise].[26] Eve was believed to have a demonic aspect to her personality because she was a harbinger of death. According to Nehama Aschkenasy, "The three traits of the biblical Eve that were assumed to prefigure the essence of womanhood are a proclivity for evil, a destructive sexuality, and a demonic-deadly power."[27]

Nineteenth-century journal illustrations depict a struggle between the devil and Eve through the snake. In Henri Gerbault's "Eve et son flirt" (figure 97), which appeared in *Le Journal Amusant* in 1900, Eve appears in a barren landscape, watched over by the "eye of God." She is seated on the broken stump of good and evil.[28] Her hair, tightly bound on the left but flowing free on the right, symbolizes released sexuality. The snake whispers in her ear, to which she replies: "Vous n'êtes pas sérieux; vous êtes un serpent à sornettes" [You are not serious; you're a prattlesnake]. In French, there is a pun between *sornettes* [nonsense] and *sonnettes* [rattles], thus creating a "serpent à sonnettes," or rattlesnake. While the caption and title identify the serpent as a flirt, it is clear from Eve's demeanor that the attraction is mutual.

For the nineteenth-century popular illustrator Henri Gray, this "destructive sexuality" was turned back upon the Edenic snake in a work entitled "Eve pendant le péché: Le premier lapin" (figure 98). Here the serpent delivers the apple to Eve, seemingly with a kiss; the coils are her only means of support and her only "clothing." The image here becomes a symbol for the Fall without reference to the rest of the biblical story. Gray evidently borrowed the idea for this work from one of William Blake's illustrations for Milton's *Paradise Lost,* but he made significant alterations.[29] In Blake's version, Eve has a trance-like stare, and the serpent is in complete control of the Fall. Gray's work has a different implication because of the caption "the first rabbit," which suggests that Eve was responsible for the seduction. Rabbits are found in many images from this period, often hunted by women. Such images are metaphors for finding a mate and reproducing. The meaning of Gray's illustration, therefore, is that the first "rabbit" was the biblical snake of Eden.

Eve seducing the snake appears elsewhere in popular imagery, such as in the illustration "A la foire au pain d'épice," by B. Gauthier for *Le Journal Amusant* (1888). This features sideshow attractions, including a scantily clad woman holding a snake, and is captioned: "Le serpent tenté par Eve" [The serpent tempted by Eve].[30] The pornographic text *Satan et Eve ou l'origine de la fouterie et du cocuage* graphically describes a sexual encounter between the serpent and Eve.[31] Rops's frontispiece for F. N. Henry's 1881 book *Le diable dupé par les femmes* contains a

Figure 97. Henri Gerbault, "Eve et son flirt: '—Vous n'êtes pas sérieux; vous êtes un serpent à sornettes.'" *Le Journal Amusant,* July 28, 1900, 16. Bibliothèque Nationale de France.

Figure 98. Henri Gray, "Eve pendant le péché: Le premier lapin." *Le Courrier Français,* Jan. 18, 1885, cover. University of Minnesota Libraries. Author's photograph.

multitude of nearly nude women with fans, frolicking with the devil and several skeletons.[32] Many hold burning objects, indicating that they are more in control than is the emaciated Satan, who, wearing a beret, sits on a giant cauldron. The text describes an affinity between the devil and prostitution, faulting suffragists for this state of affairs.[33]

Louis Leroy, in "Ou Mme Eve tente le serpent" for *Le Charivari* (1883), acerbically described the Parisian park as a paradise in which the Genesis story was refabricated by the New Eve without the serpent.[34] Visual artists used much more direct means to make similar statements. For example, Adolphe Léon Willette's frontispiece for Georges Montorgueil's 1898 *Paris-Dansant* has little to do with the book's content (figure 99).[35] Eve is shown nude, using the serpent to skip rope. Flowers adorn her long hair; in the background is a single apple branch. The artist has rewritten

the narrative, leaving only tangential references to the biblical text. In this representation, the snake has literally become an object to be used, manipulated, and directed by Eve. Similarly, Henri Gerbault, in "Les grandes inventions: L'origine de la musique," shows Eve using the serpent as a musical instrument with the double-entendre caption "Eve s'essayant sur le serpent" [Eve experimenting on the serpent]. In another Gerbault illustration, Eve uses the serpent as a bell cord.[36] In his "Sa toute-puissance la femme," a woman is draped in ermine, wielding a parasol as a scepter (figure 100).[37] She clasps the hand of a blindfolded cupid, who is unable to perform his assigned duties. A large snake wraps around the woman's knees and curls up over her head, suggesting both throne and halo. The caption proclaims the alliance invincible: "Une royauté que les anarchistes n'arriveront jamais à démolir" [A royalty the anarchists will never manage to overthrow].

Woman dominates even more forcefully in José Roy's cover illustration for Josephin Péladan's satirically titled book *Femmes honnêtes* (1888) (figure 101). A

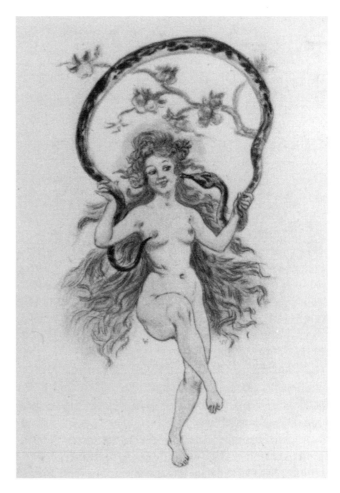

Figure 99. Adolphe Léon Willette, "La première danse." Frontispiece for Georges Montorgueil, *Paris-Dansant* (Paris: Théophile Belin, 1898). Bibliothèque Nationale de France.

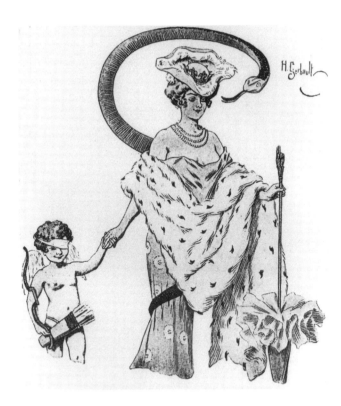

Figure 100. Henri Gerbault, "Sa toute-puissance la femme—Une royauté que les anarchistes n'arriveront jamais à démolir." *Les maîtres humoristes,* 1905. University of Minnesota Libraries. Photographer, Tim Fuller.

commercial book illustrator, Roy was a contributor to the avant-garde Montmartre-based group called the Incohérents. In this image, a daughter of Eve rides a large serpent, a substitute phallus. The snake appears threatening, but the woman shows no fear of it. Jack Spector commented that "for all the menace of the wide-open mouth facing her, she seems in control of the creature, riding it like a witch, and less concerned with dodging it than with flirting with the reader."[38] The book was the second volume of stories by Péladan using this title. The first, dated 1885, was written under the pseudonym Le Marquis de Valognes. Taken together, the two volumes show significant changes in attitudes toward women in the late nineteenth century. The 1885 text contains individual stories about women who are narcissistic and obsessed with material goods, especially fashion. They use their feminine wiles to seduce men (and women, in one story) in a series of perverted sexual adventures. Only some are identified specifically as courtesans; none of them are "honest women." References to works by Emile Zola, and to Flaubert's *Madame Bovary,* link these stories both to the naturalist movement in literature and to the theory that environment plays a large role in women's morality. Biblical references abound in the tales: the department store is described as "paradise," the sexual act, as "forbidden fruit." Péladan suggested that the devil is aware of the perverse activities of the "femmes honnêtes," and he described elements of their appearance as "serpentine."[39]

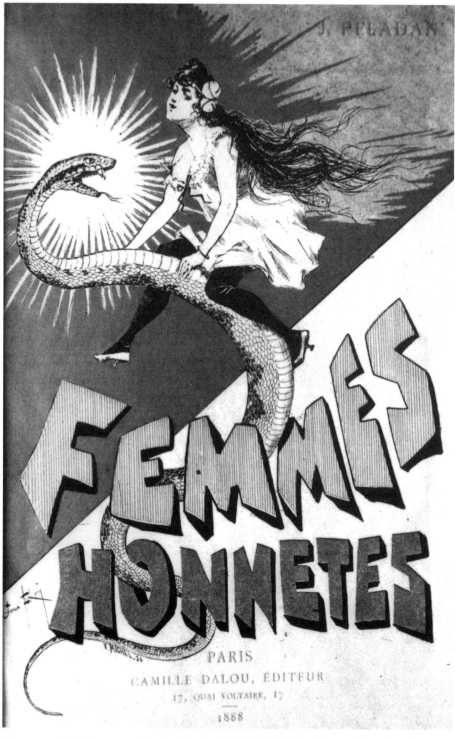

Figure 101. José Roy, cover illustration for Joséphin Péladan, *Femmes honnêtes* (Paris: C. Dalou, 1888). Bibliothèque Historique de la Ville de Paris. Author's photograph.

Péladan's stories in the 1888 collection are complicated in structure, with increased references to current events and literature. Although Satan is alluded to in the first text, he is given a more prominent role in the second, where he is associated directly with the women's rights movement.[40] The women are more openly diabolical in their maneuvers, which the author associates with modern society. From the first volume of stories to the second, there is progressive degeneration. Accidental crimes are replaced with premeditated ones, and chagrin changes to celebration. The women in the second volume are more aware that they control their destinies, which Péladan connected to the women's rights movement: "Le bas-bleuisme forme un demi-monde dans le demi-monde" [Bluestockings have created a demi-monde within the demi-monde].[41]

While many popular illustrators, and eventually painters and sculptors, would couple fashionable women with snakes, no one did so more subtly than Alfred Grévin. A typical example is "A travers Paris," an illustration for *Le Charivari* (1883), in which two women walking in unison have a serpentine sway to their bodies. The depiction of one as white and one as black suggests a dual aspect to the women, as though one were the evil twin of the other. A man watches them pass and comments "P'tites satanées femelles!!!" [Goddamned little bitches!][42] Dozens of Grévin's illustrations for *Le Journal Amusant* show serpent-like costumes, suggested by folds or twists in the fabric (figure 102). In these illustrations, Grévin simultaneously simplifies and exaggerates the lines of contemporary fashionable clothing, such as that in James Tissot's oil painting *Le bal* (1878, Paris, Musée d'Orsay). The refined curves Grévin gave to his women's fashions in the late 1870s would appear in real dresses only later, from 1898 to 1904, in a mode now termed "la ligne sinueuse" [the sinuous look] by fashion historians,[43] and similar stylistically to the forms of Art Nouveau.[44]

In "Le sphinx à la Comédie-Française," drawn by an anonymous artist for *La Vie Parisienne* in 1874, the dress winds around and between blocks of text describing a theatrical performance about a dangerous woman-beast. The caption reinforces the notion of fashion, as well as woman's cold-blooded character.[45] Grévin's women, and the anonymous illustration, recall two of Baudelaire's poems from *Les fleurs du mal* that specifically link feminine costume and/or a woman's physical movement to the sinuous motion of a snake. "Even When She Walks . . ." begins with the lines: "Even when she walks she seems to dance! / Her garments writhe and glisten like long snakes." Elsewhere in the couplets, Baudelaire referred to the woman having "polished eyes."[46] "As If a Serpent Danced" describes iridescent skin and a walk that is timed to "cadences of sinuous nonchalance . . . as if a serpent danced in rhythm to a wand."[47]

Henry Somm employed a more literal approach to the snake-woman motif. Rather than depicting clothing that resembled serpentine coils, he drew a real snake's tail emerging from under women's dresses. An 1874 etching that appeared in *Paris à l'Eau-Forte* may have been his first of many examples (figure 103).[48] This work combines the puppet and snake symbols. The barren mountain landscape

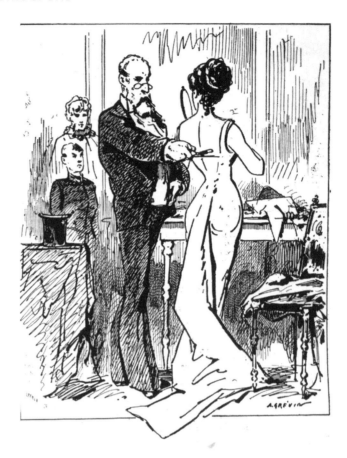

Figure 102. Alfred Grévin, "Fantaisies parisiennes—Avant la fête." *Le Journal Amusant,* 1879. University of Minnesota Libraries. Author's photograph.

reinforces the idea of impending death and further suggests a post-Eden existence for this fille d'Eve. The only vegetation grows near Somm's signature. The image calls to mind the last lines of Baudelaire's poem "As If a Serpent Danced," which expresses the poet's irresistible attraction to the woman despite the inherent danger.

> I seem to drink a devil's brew,
> salt and sovereign,
> as if the sky had liquefied
> and strewn my heart with stars![49]

Somm has strewn his sky with stars, and the accompanying commentary by the artist's friend Richard Lesclide describes the woman as the devil. "La Parisienne, de M. Somm . . . C'est le Diable, si l'on juge par sa queue de dragon et par les victimes qu'elle disperse autour d'elle;—mais c'est le diable en falbalas, expert à dévorer les coeurs et à les promener au bout d'un fil, sur l'air connu: 'Vole, amoureux, vole! . . .'

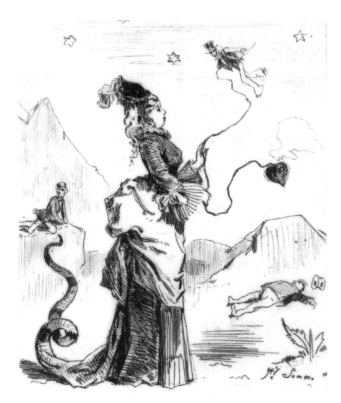

Figure 103. Henry
Somm, "La Parisienne."
Paris à l'Eau-Forte, June
21, 1874, unnumbered
plate between pages 86
and 87. Bibliothèque
Nationale de France.

Dieu vous garde de ses griffes!" [M. Somm's Parisienne . . . is the Devil, to judge by
her dragon's tail and the victims she scatters all around her. But this is the Devil in
skirts, expert at ensnaring hearts and leading them on a leash, to the well-known
tune: "Fly, beloved, fly! . . ." God keep you from her claws!]⁵⁰

Significantly, the same print was used to accompany the final installment of
an article by Lesclide entitled "Sur la Vénus de Milo," ostensibly about how the
Venus de Milo lost her arms and came to be part of the Louvre.⁵¹ The article de-
scribes her as originally named Vénus Anadyomène (a reference to her rising from
the sea, as in the Birth of Venus) and, finally, Venus Victrix, presenting her almost
as a counterpoint to Somm's illustration of the Parisienne. "Il ne pouvait se lasser
d'admirer cette beauté surhumaine, cette majesté douce, cette taille divine, et lui
récitait des vers d'Homère, pendant qu'on l'amarrait soigneusement dans l'entre-
pont" [He never tired of admiring this unearthly beauty, this sweet majesty, this
divine form, and he addressed her with lines of Homer as she was carefully stowed
away in the steerage].⁵²

Somm's motif of the fashionable Parisienne who, on close inspection, has a
snake's tail, spans his mature career, from the 1870s to at least 1902. In his *Pro-
gramme du 16 Mars,* a standing woman at lower left holds a fan (figure 104). From
beneath her dress, a snake tail emerges and seizes a small man, squeezing him in

its coils. The woman's apparent obliviousness to her action suggests that women harbor evil that is not readily apparent, giving them the ability to trick men.[53] In Somm's 1901 illustration of a fashionable snake-woman for the periodical *Le Rire,* he also composed the captions (figure 105). The central image of "Faux sceptique" is a woman wearing a large hat and carrying a muff, fashion staples in 1901. Her eyes and mouth are like those of a snake, and a thick snake tail emerges from her coat and squeezes a man. Somm attributes the caption, "La femme est un serpent" [Woman is a serpent], to "diverse thinkers." The smaller illustrations on the page are numbered, suggesting a sequential narrative. These illustrations progress from a scene showing men pursuing women and discussing their attributes, to an image of a woman cooking hearts in a frying pan, with the caption, "we know too well in which kitchen they sautée our poor hearts." In the next, an old man, a member of

Figure 104. Henry Somm, *Programme du 16 Mars.* Etching, 1870s-1880s. Bibliothèque Nationale de France.

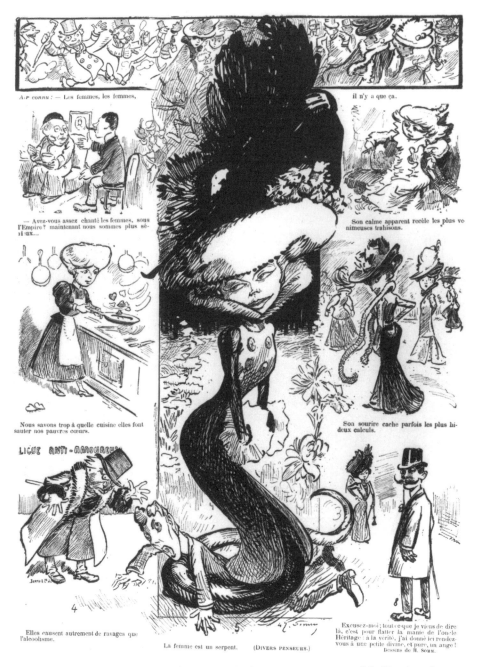

Figure 105. Henry Somm, "Faux sceptique—La femme est un serpent." *Le Rire,* Apr. 6, 1901, 3. University of Minnesota Libraries. Author's photograph.

Figure 106. Henry Somm, *Mermaid,* undated. Jane Voorhees Zimmerli Art Museum, Rutgers, the State University of New Jersey, Ralph Voorhees Purchase Fund, 83.005.027. Photo by Victor's Photography.

the "ligue anti-amoureuse" [anti-mistress league], notices the distress of the man being squeezed by the snake-woman and comments: "elles causent autrement de ravages que l'alcoolisme" [They cause far more damage than alcoholism]. Other vignettes comment on women's calculating smiles and their calm exteriors that mask "venomous treasons." In the final image, a representation of the artist himself addresses the viewer, stating, "Excusez-moi; tout ce que je viens de dire là, c'est pour flatter la manie de l'oncle Héritage: à la vérité, j'ai donné ici rendez-vous à une petite divine, et pur, un ange!" [Forgive me; what I just said then was to play along with my rich uncle's little obsession. To be honest, I've arranged to meet a divine little creature here, innocent too—an angel!] Somm is not really reversing himself so much as he is admitting that, despite his awareness of the danger and heartache these women can cause, he is in fact helpless in their presence.[54]

It is significant that these magazine illustrations showing fashionable feminine snakes first developed in the 1870s, well in advance of the appearance of women with snakes in Salon paintings, sculptures, and decorative arts around the turn of the century. It demonstrates that such motifs in the "fine" arts actually evolved from imagery tested in the popular realms of literature, theater, and journal illustration. The development of this imagery was gradual, not precipitous, as has been claimed by scholars who have studied painting and sculpture of the Belle Epoque and the Symbolist movement but not popular sources. It is now possible to see artists such as Henry Somm, Félicien Rops, or even Alfred Grévin as Symbolists in certain works, although they have no *official* association with the art movement by that name. An evocative undated watercolor by Somm, the so-called *Mermaid* (the title is not Somm's), is fully Symbolist (New Brunswick, New Jersey, Jane Voorhees Zimmerli Art Museum) (figure 106).[55] The woman in the watercolor is embraced by a giant mottled sea snake whose head, mouth open and fangs bared, appears behind her own. The artist went *beyond* the idea that a mermaid or siren was a dangerous woman; in his use of underwater serpents, he could refer to Athena's sea serpents that attacked Laocoön.

Serpentine Accessories

In Somm's watercolor, the serpent wrapped around the woman's shoulders suggests the fashion accessory called, not coincidentally, a boa. Honoré de Balzac stated in his *Traité de la vie élégante* (1830) that fashion was the expression of society and that, simultaneously, it was "une science, un art, une habitude, un sentiment" [a science, an art, a habit, an emotion].[56] This statement remained true throughout the nineteenth century. Georges d'Avenal considered woman's dress to be a provocative envelope, a present to be unwrapped.[57] Fashion was consistently characterized as a temptation in the literature of the period; by 1897 it was recognized that "la toilette est devenue, essentiellement, expressive du sexe" [dress has become, essentially, an expression of sexuality].[58] Octave Uzanne, in his discussion of fashion accessories, called woman a "créature d'enfer qui fait rêver de paradis, est ensorcelante dans la diabolicité de ses grâces" [a creature from hell who makes

men dream of heaven, bewitching in her devilish beauty]. He suggested that the proper attire, in this case, the proper fur, would enhance beauty, "comme si de l'électricité de cette pelleterie il s'épandait dans l'air ambiant de la provocante fille d'Eve une sensualité attirante comme une caresse subtile qui frôlerait nos sens au passage" [as if, from the electricity of this fur, there spread into the air around the provocative daughter of Eve a magnetic sensuality, like a subtle caress, brushing our senses as she passes by].[59] Marguerite d'Aincourt, in discussing women's clothing, made it clear that the fille d'Eve had to be concerned with fashion: "La Parisienne ne s'habille pas seulement avec coquetterie—ce qui est à la portée de toutes les filles d'Eve—elle s'habille avec esprit, avec art. Rien qui choque, rien qui détonne, rien qui soit exagéré; une harmonie parfaite, qui produit le plus séduisant ensemble. Phidias a dit: Le vrai beau séduit par l'ensemble." [The Parisienne doesn't dress only to flirt—all woman can do this—she dresses with good taste and art. Nothing shocking, nothing out of place, nothing exaggerated; a perfect harmony that produces the most seductive overall effect. As Phidias said: "The power of true beauty lies in the whole."][60]

D'Aincourt continued to address her reader as a fille d'Eve, as she described the proper fashion and even the appropriate hairstyles she would need to cultivate herself as a "tentatrice" [temptress]. Violette, author of *L'art de la toilette chez la femme,* was similarly preoccupied with the seductive powers of costume. She wrote, "La femme comme la fleur a besoin pour s'épanouir d'une atmosphère spéciale. Il est d'agrestes filles d'Eve dont les formes plantureuses se détachent en merveilleuses silhouettes. . . . Sa beauté frêle, presque débile à force de civilisation, exige un cadre qui la fasse valoir." [Woman, like a flower, needs the right atmosphere to blossom. Some rustic daughters of Eve have buxom forms that make wonderful silhouettes. . . . Her beauty, frail, almost fragile, as a result of civilisation, needs the right frame to set it off.][61]

Violette's desire was to create a provocative aura around the women of Paris, in an ideal paradise. Among the irresistibly "dangerous sirens" were the courtesans, who, according to Violette, had a desire for luxuries that devoured their own and others' fortunes.[62] She was not alone in declaring prostitutes to be on what today would be called "the cutting edge" of fashion.[63] Furs, boas, and a good relationship with a couturier were absolute necessities. The couturier was charged with more than just the creation of fashions. He was a confidant responsible for expressing the emotions and inner desires of the woman by means of her clothing.[64] The assembly of a woman's toilette was considered a science, and her accessories encompassed everything from hats, shoes, and stockings to appropriate makeup and perfume. A humorous illustration by Somm indicates the degree to which fashion and accessories were believed to reflect the emotional state of the wearer (figure 107). Here, a woman tries on a hat covered with question marks. The saleswoman tells her that this is a hat designed for "before the affair," and she shows her another one, with exclamation points, for "after the affair."

An 1879 cover illustration for *Le Journal Amusant,* by Alfred Grévin, demon-

Figure 107. Henry Somm, "La modiste. —C'est le chapeau de 'l'Affaire' que vous essayez là. Voici ce qu'on portera ensuite: 'le chapeau d'après l'Affaire.'" *Le Rire,* July 15, 1899, 4. University of Minnesota Libraries. Photographer, Tim Fuller.

strates an important iconographical shift in the depiction of the fille d'Eve (figure 108). People are shown swarming around two female figures, which comprise a proposed sculpture for the next Salon, according to the caption: "Mon exposition de sculpture . . . pour le prochain Salon." Both women are dressed in skimpy drapery that has a serpentine appearance. Connected to the devil directly by a serpent bearing an apple in its mouth, the woman standing in the center experiences sensual abandon. The snake's coils encircle her body; woman and serpent share a kiss mediated by the apple of dangerous knowledge. Stripped to the waist, she holds a glass of champagne and a fashionable fan. Below, a second woman, in similar *déshabillé,* seems to have expired, following a similar embrace, while clutching a lifeless, headless snake. It is not clear if the reclining figure has killed the snake or if the snake has killed her. In any event, the demise of the second serpent seems to refer to the crushing of the serpent by Mary as the New Eve. But, here both filles d'Eve triumph over the serpents not to atone for sins, but rather to assume masculine phallic power. The fact that the snake is an accessory of the woman, like the champagne glass and the fan, gives her greater power. In the popular illustration, and in the real world of fashion, snakes began to be increasingly associated with women's accessories; in fact, the concept of the fille d'Eve appeared in the work of illustrators before it was embraced by couturiers. It seems perfectly reasonable to assert that the increased discussion and appearance of this figure in popular journals led to the adoption of snake motifs in fashion.

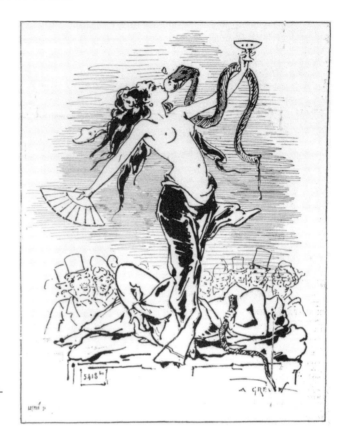

Figure 108. Alfred Grévin, "Filles d'Eve," from the series "Fantaisies parisiennes." *Le Journal Amusant,* June 14, 1879, cover. University of Minnesota Libraries. Photographer, Tim Fuller.

Henri Gray's depiction of bathing suits of yesterday and today appeared in *Le Tout-Paris* in 1882 (figure 109). Eve is in the center oval, modeling the "premier maillot" [earliest bathing-suit], which is no more than the snake wound around her body. The apple has been dropped at her feet. Eve permits the serpent to embrace her as she raises her arms to cover her eyes, allowing the viewer to gaze upon her body. A fan, perfume bottles, opera glasses, and a mirror at the lower edge of the composition link the bathing suit to other symbols of vanity. With Eve are other women: an acrobat, a ballet dancer, a strolling musician, and a circus performer. At lower left and right are men who gaze at the women as if each is on stage, which makes the inclusion of Eve significant. The text below her vignette reads:

> Le voilà tel qu'on le portait avant le péché originel. Tout ce qu'il y a de plus collant et de plus transparent. Rien pour l'art: la vérité pure. Hélas! depuis la séduction du serpent qui a su se glisser dans les bonnes grâces de l'innocente Eve tout est changé.
>
> A présent plus de naturel; de la soie et parfois . . . de coton. La pudeur est sous la sauvegarde du du [*sic*]. Code et le serpent est devenu plus vénimeux que jamais.

[That was how it was worn before original sin. Skin-tight and absolutely transparent. Nothing to do with art: just the naked truth. Alas! Since the serpent managed to worm his way into innocent Eve's good graces and seduce her, everything has changed.

Nothing natural now; silk and sometimes . . . cotton. Modesty is protected by law and the serpent has become more deadly than ever.]

The tongue-in-cheek commentary implies that the Fall will occur as the women leave the stage to meet their admirers, reenacting the seduction of Genesis. The filles d'Eve of the late nineteenth century are described as even more dangerous because their silk and cotton clothing disguises their true nature.

The most prominent fashion accessory related to Eve in this period was the boa. It developed from fur-trimmed clothing and could take the form of a long fur worn around the neck, or a feather "summer version," which became popular in the early 1890s.[65] Fur boas appear in paintings from the early nineteenth century, such as J. D. Ingres's *Mlle Rivière* of 1808 (Paris, Louvre). At midcentury, this snake-shaped fur accessory, which does not appear to have been called a boa at this time, was no longer fashionable.[66] By the 1880s, it was coming back into fashion. An anonymous 1882 illustration for *La Vie Parisienne* showed styles of

Figure 109. Henri Gray, "Le maillot d'autrefois et d'aujourd'hui." *Le Tout-Paris,* Nov. 19, 1881, 156–67. Bibliothèque Nationale de France.

"Femmes et fourrures" that had a snakelike appearance: "Le cygne" had an edg-
ing of swan feathers that had the appearance of a boa but it was not separate from
the garment.[67]

By 1886, the word "boa" was used in an illustration in *La Vie Parisienne,* which
showed the object as the now familiar detached accessory.[68] The woman modeling
the boa is nude and has long, flowing hair; the caption describes various ways that
the accessory can be "coiled" to flatter the wearer. Significantly, the woman holds
a mirror but averts her gaze. Artists associated the snake in Eden with the mirror
and the concept of vanity, since the snake flattered Eve when first approaching
her. For example, Max Klinger's illustration "The Snake," from the cycle *Eve and
the Future* (1880), depicts a snake who has sprouted hands and holds a mirror, as
he wraps around the tree of knowledge.[69]

The snake from Eden was identified as "le premier boa," by the artist known
as Stop, in "Echos du jour" for *Le Journal Amusant* (1888).[70] The popularity of the
feather boa fashion reached its peak in 1890 to 1891, as indicated by a two-page
assessment of the accessory that appeared in early 1891 in the fashion periodical
L'art et la mode (figure 110). The boa became legitimized in portraits such as Henri
Fantin-Latour's 1890 *Portrait of Sonia* (Washington D.C., National Gallery of Art),
yet some artists decried the accessory as being too distracting. For example, Degas
wrote a letter to Mme Dietz-Monin in which he chastised her for "proposing that
I reduce [your portrait] to a boa and a hat."[71]

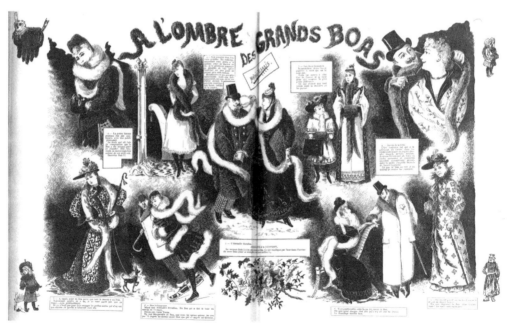

Figure 110. Maurice Marais, "A l'ombre des grands boas." *L'art et la mode,* Jan. 31, 1891. Bib-
liothèque Nationale de France.

The boa appears in posters and print advertisements of the early 1890s, including Chéret's "La diaphane poudre de riz," which shows Sarah Bernhardt using the powder while wearing the accessory, and "Pastilles Géraudel," which appeared as a nearly full-page advertisement in *Le Figaro.*[72] In 1894, Ferdinand Bac demonstrated the use of the boa in an illustration in *La Vie Parisienne* (figure 111).[73] The text accompanying this image explains that a woman could position the boa in order to emphasize her moods or expression. These early representations of the boa as a fashion accessory did not associate it with danger or seduction. This would change as diatribes against women, and women's rights, became increasingly vituperative, and as illustrators realized the iconographical potential of the motif. Toward the

Figure 111. Ferdinand Bac, "Frileuses" (detail). *La Vie Parisienne,* Feb. 17, 1894, 91. University of Notre Dame Libraries. Photographer, Tim Fuller.

end of the century, artists animated the boa-as-snake, so that it signified either the reptile from Eden or the serpent from hell.

Nevertheless, most images remained humorous. In one particularly clever approach, a number of artists utilized the myth of Laocoön as expressed in the famous sculpture by Hagesander, Polydorus, and Athenodurus, discovered in Rome on the Esquiline Hill in 1506 and now housed in the Vatican Museum. In the original story, Athena sent the snakes to attack Laocoön and his sons as revenge for their alerting the Trojans to the wooden horse. Draner used the satiric title "Madame Laocoön" for his version of a portrait by L. Amans, in the 1890 Salon.[74] Carl-Hap (Karl Happel) used the statue to comment on the boa as fashion accessory for *La Caricature* in 1892.[75] His work entitled "Les boas" (figure 112) depicts six different types of boa, including the fur version at left, "Boa . . . titude," and the feather version at right, "Boa . . . teuse." In the center of the upper register is a revised Laocoön, with women replacing father and sons, and the boa standing in for the

Figure 112. Carl-Hap (pseudonym for Karl Happel), "Les boas." *La Caricature,* Dec. 10, 1892, 397. Bibliothèque Historique de la Ville de Paris. Author's photograph.

sea serpents. Underneath this image is a quote attributed to Virgil. "Quand deux affreux boas sortis de . . . chez . . . J'en tremble encore d'horreur etc." [When two terrible boas emerging from the sea . . . I tremble still at the memory, etc.] Two of the images in the lower register suggest the constricting action of the sea serpents. At the left, two women have their feet entrapped in boas. In the lower center, two women are bound so tightly to the taller man that their feet no longer touch the ground. The mouths of the three figures are covered by the boa, effectively silencing their potentially dangerous voices. At right, a nude African figure, known as a "Hottentot," exhibits exaggerated breasts and buttocks.[76] The dual aspects of sexuality and entrapment suggested by the boa was also featured in a work by Sahib entitled "Bibelots, et jouets d'été," for *La Vie Parisienne* (1902). In this image, the boa is referred to as a "boa tentateur" [boa of temptation] and a "Serpent à plumes" [Feathered serpent].[77]

Artists sometimes worked backward from the fashion accessory to the snake of Genesis. A 1904 illustration signed "Spret," for *La Caricature,* depicts a woman wearing an actual serpent as a boa (figure 113). The snake has moved from her shoulders to grasp the pear-shaped head of the fat man next to her. The man's exclamation, "What beautiful apples," comments on her partially revealed breasts. The woman's reply, "What a lovely pear!" indicates the man's stupidity.[78] Gustave

Figure 113. Spret, "Derniers fruits d'hiver." *La Caricature,* Apr. 9, 1904, 114. Bibliothèque Historique de la Ville de Paris. Author's photograph.

Adolphe Mossa took a more serious approach in his watercolor *Adamus et Eva,* of 1907 (Nice, private collection).[79] In this image, the very conspicuous snake mimics the boa, as its scales are rendered with brushstrokes making them resemble feathers. While the couple embrace, a miniature demon drives a stake into Adam's head. The predella-like format of the composition is at odds with the blasphemous subject. Mossa depicted snakes in a number of works, including a "psychological self-portrait" (1905); two representations of *Circe* (1904, 1906); *Cleopatra Finding Moses* (1904); *Paradise Lost* (1905); *Eva-Pandora* (1907) (see figure 2 of the present book); *Salomon* (1908); and *The Devil in Paradise* (1909).

Jewelry has historically featured snakes. The motif was popular in Minoan, Assyrian, and Egyptian societies, while Greek statues of Aphrodite in the Hellenistic period were often adorned with snake bracelets. Snake motifs continued to be used in Roman times.[80] With the advent of Christianity, snake imagery fell out of favor, for it was unthinkable for a Christian woman to adorn herself with a motif associated with Satan.[81] The motif reappeared in periods when Christianity lost power. The snake with its tail in its mouth was rediscovered as a symbol of eternity and became popular early in the nineteenth century; this shape could be easily adapted to bracelets. The sinuous curves of snakes were particularly attractive to artists working in the Art Nouveau style, and by the turn of the century, jewelers were interested in exploiting snake shapes associated with mythological and historical figures, such as Medusa and Cleopatra. An illustration, probably by Sahib, for *La Vie Parisienne* in 1883 featured snake accessories as part of "Intimités—Toilettes d'intérieur offensives et défensives" [Indoor jewelry: offensive and defensive].[82] It is typical in its presentation of different types of women wearing accessories corresponding to their characteristics. One of these is the "Savante" [Wise One], whose serpent accessories contribute to her nature: "Irrésistible. Affole les plus indifférents" [Irresistible: will drive the most indifferent man wild]. Serpent jewelry was also the centerpiece of a short story, "Le serpent," in which the owner of a snake bracelet ascribed to it magical powers.[83] In the realm of fine jewelry design, both Alphonse Mucha and René Lalique produced ornaments of this type, catering to a wealthy clientele. Both men also designed jewelry for the Exposition Universelle (1900) in Paris. A costume jewelry trade also flourished as cheap reproductions of Lalique and Mucha's designs became available to the general public.[84]

René Lalique created several pieces of jewelry and a number of glass pieces that featured snakes. Marie-Odile Briot reports that Lalique designed the first serpent jewelry for Sarah Bernhardt.[85] His showpiece jewel, featured at the 1900 Exposition Universelle, was a "sinister-looking corsage ornament consisting of nine writhing serpents with ropes of pearls hanging from their mouths," according to Marilyn Nissenson and Susan Jones, who note that this piece was reflected in a mirror flanked by two six-foot-tall snakes.[86] Another Lalique piece with the same type of composition was made in 1898 or 1899 (figure 114). In that gold and enamel brooch, eight serpents, with jaws spread, are tied together by a ninth in a similar

Figure 114. René Lalique, serpent brooch, c. 1889–99. Calouste Gulbenkian Museum, Lisbon. © 2005 Artists Rights Society (ARS), New York/ADAGP, Paris.

pose. The gold bands positioned around the snakes create symmetry, as well as a sense of confinement, as if the serpents are under the control of the wearer. Lalique also designed a silk and suede handbag, dated 1901–3, for Bernhardt (figure 115).[87] The silver clasp takes the form of two opposing serpent heads, with fangs bared, while interlaced snake bodies form the symmetrical pattern on the bag. Such a motif on a bag, in which a woman would carry makeup, perfume, and other accoutrements of artifice, presents these objects as temptations for both the owner and her admirers.

Alphonse Mucha, who immortalized Bernhardt in a series of posters, could be considered the actress's protégé. Beginning in 1894, he supervised the production of her sets, costumes, hairstyles, and jewelry.[88] Although Lalique had been Bernhardt's jewelry designer for many years, Mucha began designing tiaras and other items for her as part of a five-year contract. In 1899 he designed a gold-and-enamel combination ring and bracelet (figure 116), which was executed by Georges Fouquet. The piece was based on a detail from his earlier poster of Bernhardt in the role of Medea (figure 117) and was reportedly a thank-you gift for the preface

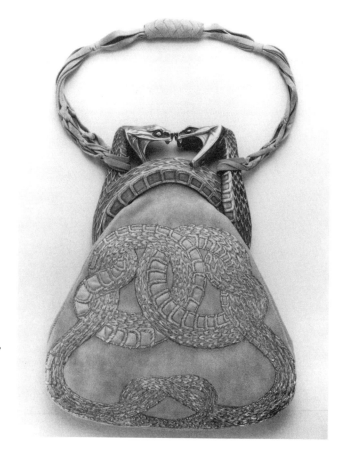

Figure 115. René Lalique, handbag, c. 1901–3. Private collection, New York. © 2005 Artists Rights Society (ARS), New York/ADAGP, Paris.

she wrote for his 1897 exhibition catalogue.[89] Mucha's use of the snake motif for Medea does not seem to be inspired by the play, since there is no prominent reference to snakes in the contemporary script by Catulle Mendès, nor in the original work by Euripides. But the story of Medea in Greek mythology does involve snakes. The princess Medea, granddaughter of the sun god, Helios, helped Jason to obtain the golden fleece by lulling a giant guardian serpent to sleep. Later, she used a snake-drawn chariot to escape Corinth, after wreaking revenge upon the unfaithful Jason by murdering first her female rival, Créuse, and then her own children by him. Medea was sometimes depicted with snakes on ancient Greek vases, theoretically referring to the Great Goddess of earlier periods.

Mucha's poster depicts Bernhardt as Medea with the bodies of her children at her feet; the snake motif of the bracelet alludes to the presence of the serpents in the myth and makes use of "bad mother" symbolism, possibly due to ambiguities in the portrayal of the Great Goddess. While some believed that Catulle Mendès's version of the story made it "impossible to feel sympathy for this queen who is both deficient in maternal love and abounding in sexual jealousy,"[90] the writer's

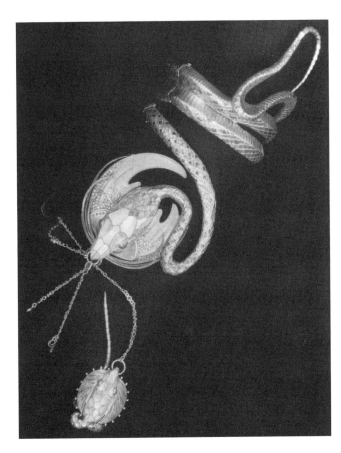

Figure 116. Alphonse Mucha (design) and Georges Fouquet (execution), snake bangle-ring combination, 1899. © 2005 Artists Rights Society (ARS), New York/ADAGP, Paris, and Christie's Images Ltd.

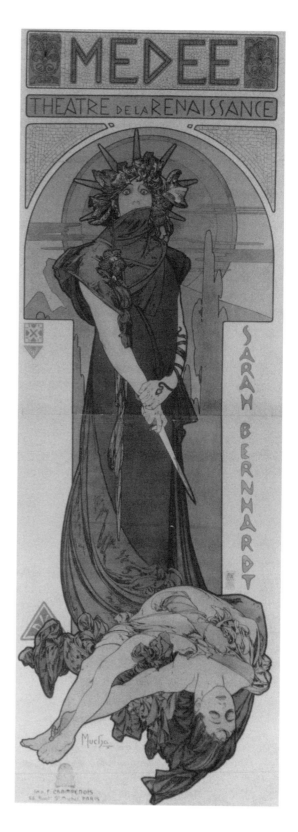

Figure 117. Alphonse Mucha,
Médée, Théâtre de la Renaissance.
Poster, 1898. Bibliothèque des
Arts Décoratifs, Paris. © 2005
Artists Rights Society (ARS), New
York/ADAGP, Paris.

intent was to alter the ancient narrative, making Medea's rage understandable by depicting Jason as unscrupulous and egocentric. When Bernhardt stepped on stage, she was "heralded by a foreboding, disembodied, repeated cry of 'Malheur!'" [Woe!].[91] In an interview for the *Revue d'art dramatique,* Bernhardt described her conception of the character. "Médée, Médée, ah! cher monsieur, C'est un beau rôle, un rôle que j'aime. Ce que j'y ai vu? Mais l'amante, l'amante jalouse, passionnée, la femelle. C'est en cela qu'elle est belle, d'ailleurs, et intéressante. C'est la femelle barbare. Comme mère, elle n'existe pas, puisqu'elle tue ses enfants." [Medea, Medea! Ah, my dear sir, it's a fine role, a role I love. What do I see in it? Why, the lover, the jealous lover, the woman. That's why she's beautiful, by the way, and fascinating. The female barbarian. As a mother, she is nothing, since she kills her children. Medea, Medea!"][92]

Bernhardt did not portray a sympathetic character. Indeed, Medea's caustic laughter at her victims inspired hostility.[93] Elaine Aston has pointed out that "Bernhardt's own image of the sexually independent and morally unorthodox woman would merely serve to heighten the healthy, if not excessive, sexual appetite of Medea comprising a very uncomfortable threat to middle-class theatre audiences."[94] This contributed to the relative failure of Mendès's production—Bernhardt ceased to play the role after just twenty-three performances. Another likely factor was that Mendès changed the characterization of Medea, and of Jason, from that of Ernest Legouvé's 1873 play. While Legouvé emphasized Medea's role as a mother and depicted Jason as her seducer, Mendès made Medea a seductress.

Bernhardt apparently understood the shock value of the reptile, which could simultaneously appeal and repulse. Her use of a real snake in the death scene of *Cleopatra* elicited screams from the audience.[95] Bernhardt was also reported to have worn a live chameleon as an ornament.[96] Whether live or in the form of jewelry, snake accessories enhanced the femme fatale character of the female performer, both onstage and off.

Mucha's snake bracelet and ring echoed the design of ornaments found on representations of Athena, as well as similar nineteenth-century conjoined pieces used in Indian marriage ceremonies. Bernhardt must have paid a steep price for the piece; it has been reported that messengers were sent to the theater to collect installments on the purchase. She owned the bracelet until 1908, when it was sold to settle her son's gambling debts.[97]

Staging the Femme Fatale

The Genesis story was brought to the stage many times during the nineteenth century, including a performance of *Adam et Eve* at the Théâtre des Nouveautés in 1886, which featured the expulsion from Eden as the first act. Successive acts followed descendants of Adam and Eve in Italy (where the rich patrician "Adamus" rejects his fiancée for "Eva" the slave girl), Spain, and finally nineteenth-century France (where Adam is a young painter). The action of the characters was intended to convey the fatalistic nature of the Fall in all societies through time.[98]

While interest in the biblical story continued, secularized versions of the wom-
an-and-snake theme became increasingly popular. Furthermore, the waning of
Catholicism and the emergence of alternative religions, including witchcraft,
stimulated artists and writers increasingly to explore ancient themes from Egyptian
history and Greek mythology. Some, like Gustave Flaubert in *Salammbô* (1862),
invented their own versions of the woman-and-snake theme. Working in an en-
tirely imaginary realm, Flaubert gave his exotic character Salammbô everything
believed typical of a femme fatale. Her snake, a great black python, was described
by Flaubert as "both a national and private fetish" whose origin was "the earth's
depths." It symbolized fertility, and "the circle it describes, as it bites its own tail,
the planetary system." Salammbô is a femme fatale in both senses, for she inter-
prets the snake in its basket as a "spiral in her heart, like another serpent slowly
coming up into her throat to choke her."[99] Flaubert goes on to describe an erotic
encounter between Salammbô and the python, in which the latter becomes a
living "boa." Salammbô removes her earrings, necklace, bracelets, and hair orna-
ments. As she begins her dance, her clothing falls around her. The python appears
and crawls through the scattered garments, before raising up on its tail to stare
fixedly at the dancer. Salammbô at first hesitates, but then moves forward, while
"the python fell back, and putting the middle of its body round her neck, it let
its head and tail dangle, like a broken necklace with its two ends trailing on the
ground. Salammbô wound it round her waist, under her arms, between her knees;
then taking it by the jaw she brought the little triangular mouth to the edge of
her teeth."[100]

Gabriel Ferrier's 1883 painting *Salammbô,* based on Flaubert's narrative, demon-
strates how the theme could be translated into a Salon painting with only minimal
changes from earlier prototypical depictions of the nude (figure 118). Since the
subject matter had a literary, quasi-historical basis, it was deemed appropriate for
the Salon, as were representations of Eve. Considerably more inflammatory were
similarly erotic depictions that lacked the guise of history, mythology, or allegory.
Although Manet's *Olympia,* which updated Titian's *Venus of Urbino* of c. 1558 and
attempted to reveal the hypocrisy of the typical Salon subject, was selected for the
Salon of 1865, this did not immediately make pictures of everyday life in modern
Paris acceptable. Even when painters associated with Symbolism participated in
the Salons, they borrowed subjects from antiquity, rather than focusing on the
contemporary Parisienne.

Salon paintings were frequently satirized in the popular press. Nearly every
year *Le Charivari* and *La Vie Parisienne* published illustrations and text poking
fun at the use of a particular subject matter, painting technique, or both. Illustra-
tors were also intrigued with the fact that certain subjects had moved from the
realm of the journals to that of the stage and Salon, thus legitimizing what once
had been considered vulgar. In a detail from Sahib's "La pudeur moderne," for *La
Vie Parisienne* (1902), Salon paintings and the "imaginary" historical subject of
Salammbô are lampooned.[101]

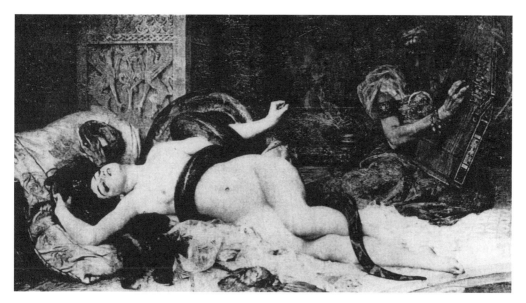

Figure 118. Gabriel Ferrier, *Salammbô*. Oil on canvas, 1883. Location unknown. From Armand Silvestre, *Le nu au Champ de Mars* (Paris, 1889), unnumbered plate. Author's photograph.

Despite its critical failure, Flaubert's *Salammbô* infiltrated popular art forms. The theatrical version premiered in February 1890 in Brussels, and articles in *Le Figaro* immediately questioned why it was not staged in Paris.[102] The story provided the inspiration for numerous variations on the woman-and-snake theme, such as the 1908 performance of *Mlle Isis à Parisiana,* depicted by D. O. Widhopff (1867–1933) in *Le Courrier Français.* In the accompanying article by Henri Galoy, Mlle Isis is described as the incarnation of a goddess, "telle nous apparaît dans l'oeuvre de Flaubert, Salammbô" [like Salammbô in the Flaubert novel].[103]

As the public grew more interested in Flaubert's *Salammbô,* as well as in the story of Cleopatra, the subject of numerous plays and novels of the period, side-show performances featuring snake charmers became more popular. Journal illustrations and photographs depicted women as "charming" and simultaneously as "being charmed" by serpents.[104] The snake charmer was commonly portrayed as innately sexual, such as in the following verses from "Charmeuse de serpents," published in *La Vie Parisienne* in 1876.

> Deux serpents aux bras, la charmeuse,
> Sous leur caresse paresseuse,
> Tressaille et rêve, langoureuse:
>
> Elle tient fermés ses yeux lourds
> Et rêve à de fauves amours,
> A des corps enlacés toujours.

[Two serpents on her arms,
The charmer, under their languid caresses,
Quivers with pleasure
And dreams a listless dream:

[Holding closed her heavy eyes,
She pictures her fierce loves,
Bodies eternally intertwined.][105]

The content of the verse is strikingly similar to Flaubert's description of *Salammbô* and her python. It could also serve to describe a number of female performers who embraced the symbol of the serpent, either through their specific roles on the stage or through their costumes adorned with snake motifs.

Sarah Bernhardt played the part of the femme fatale both on stage and in her celebrated private life. In her portrayal of Medea and Cleopatra in particular, the actress lent her personal allure to the character of the literary or historical snake-woman. By depicting Bernhardt as a snake-woman, artists either expressed Bernhardt's thorough assimilation of these characters or engaged in anti-Semitic typecasting.[106] Bernhardt was arguably the most famous actress of the nineteenth century. Known for her sometimes outlandish behavior, she has been the subject of numerous books, including her own memoirs, *Ma double vie* (1907). She became the epitome of the liberated woman, due largely to her involvement in the theater.[107] As Eric Salmon has noted, "She was not simply an actress, a presenter of plays, and a representer of characters: she was also the founder of a cult and the head of that cult. In fact, she became in a curious way [the] *personification* of the cult itself."[108]

By 1896, Sarah Bernhardt's reputation as a femme fatale was fully established. Not only had men as diverse as the literary giant Pierre Loüys and the popular illustrator Henry Somm recorded their infatuation with her, but a two-page illustration by Sahib, chronicling some of her most memorable roles, appeared in *La Vie Parisienne,* entitled "Demandez! Les crimes du Boulevard Saint-Martin! Horribles détails! Les châtiments de la Meurtrière!" [Read All About It! The Crimes of the Boulevard Saint-Martin! Grisly Details! The Murderess's Fate!][109] The roles that tended to be illustrated were those in which she murdered a man in the course of the action: *Gismonda,* with an axe; *Les bois,* with a revolver; *Iseyl,* with a dagger. But the term "fatal" applied to her character as well. Sahib communicated this by showing performances in which she dies by poison (*Hernani*); ruptured aneurism (*Ruy Blas*); and burning at the stake (*Jeanne d'Arc*). He included productions in which death and love were somehow connected, such as *La dame aux camélias* in which her character dies from excess love, and *Cléopâtre,* in which death is the result of unrequited love.

Not surprisingly, the serpent became an important visual component in the story of the "fatal" Cleopatra, for she was the secular counterpart to the biblical Eve. The deadly and sexual characteristics of snakes were perfectly embodied in

Cleopatra. Léopold Lacour declared, in an 1890 review for *Le Figaro,* that "Cléopâtre renaît sans cesse éternel symbole de la faiblesse de l'homme devant la puissance de la femme" [Cleopatra is ceaselessly reborn, the eternal symbol of man's vulnerability to the power of Woman].[110] While the character of Cleopatra was extremely popular in the late nineteenth century, it was a difficult role for actresses, who had to convey the dangerous power of the Egyptian queen yet attract sympathy because of her ultimate limitations in functioning essentially as a professional courtesan.[111] Sarah Bernhardt approached the role not with fear but with relish, using "serpentine movement" or "pantomimic undulations" in her interpretation of Cleopatra's character, which met with criticism.[112] Audiences and critics alike drew connections between the political power of the queen and that wielded by Bernhardt in her personal life. As has been suggested, "this combination of sexual and political power over men . . . resulted in an overwhelming and antipathetic portrayal of female dominance."[113]

A significant phenomenon in the successive representations of Cleopatra was how the tiny asp with which Cleopatra, distraught over Marc Antony, supposedly committed suicide, became larger and larger. In Sahib's illustration for *La Vie Parisienne,* the snake reaches about an arm's length. But the anonymous representation of an 1891 staging of the death of Cleopatra at the Cirque d'Hiver, published in *L'Illustration,* showed that the tiny asp had been replaced by a huge boa constrictor (figure 119).

Apart from her shocking interpretations of figures such as Cleopatra, Sarah Bernhardt cultivated an eccentric femme fatale persona offstage as well. For example, she made it publicly known that she sometimes slept in a coffin. She painted and she made macabre sculpture, including an inkwell entitled *Self-Portrait as a Sphinx,* which merged her facial likeness with the body of a bat. Victor Hugo gave her a human skull, which she proudly displayed to visitors. Her appearance in male roles onstage, as well as her masculine dress, attitude, and activities offstage, led some to call her "Monsieur Sarah Bernhardt."[114] Caricatures of Bernhardt included a 1910 illustration entitled "Coeur humain, sauce Sarah" [human heart, Sarah sauce], published in *Le Rire,* in which she concocts a brew from unflattering reviews. The caption explains, "Il faudra tout de même que le public ait un rude estomac pour digérer ce coeur!" [All the same, the public will need a strong stomach to digest this heart!][115] Her persona as a femme fatale was exploited in caricatures of her artwork, such as a satirical representation of one of her paintings, *La jeune fille et la mort.* In the caricature, a woman described as "Demoiselle à marier suivie de ses *espérances*" [Woman suitable for marriage, together with her *expectations*] has removed one black glove, which seems to reach out to the shocked male viewer, who also notices a skeleton lurking behind the woman.[116] In the realm of popular journal illustration, the association of Sarah Bernhardt with snakes took on a life of its own. These representations became increasingly negative, reflecting how she was viewed later in the century, as her Jewish background became more and more an issue.

Figure 119. Unknown artist, "Au Cirque d'Hiver," detail, "Mort de Cléopâtre. *L'Illustration,* Feb. 14, 1891, 161. University of Minnesota Libraries. Photographer, Tim Fuller.

Georges Clairin's 1876 portrait of Bernhardt, entitled *L'enchanteresse dans son antre,* showed her reclining on a chaise with a dog lying on the floor near the train of her dress. It was caricatured several times. The version called "Resarah Bernhardt," by an artist known as Brac, played on her pose and that of the dog in the painting. Brac saw a "C" shape, which he believed Clairin used to insinuate himself into the picture, as the support on which Sarah lounged.[117] An illustrator who used the name Zag, on the other hand, saw a snakelike shape in the composition. In his caricature of the portrait, "Sarah belle d'indolence," Bernhardt and the dog are connected, becoming a serpent-like creature with a head at each end, both of which could be dangerous (figure 120). A detail of Sahib's "La rue de Paris," from *La Vie Parisienne,* shows her as a snake-woman, her lower body replaced with a serpentine tail (figure 121). The accompanying text describes her as a man-eater in a freak show. "La baraque de la Femme-Serpent; la grande artiste: dislocations, acrobaties; Sarah dévorera à chaque séance cinq dramaturges (dont un italien), deux enfants grecs en bas âge, quatre commanditaires et des tirades de deux cents alexandrins sans boire" [The Serpent-Woman's tent; the great artiste; contortions, acrobatics. At each performance, Sarah will devour five playwrights (including an

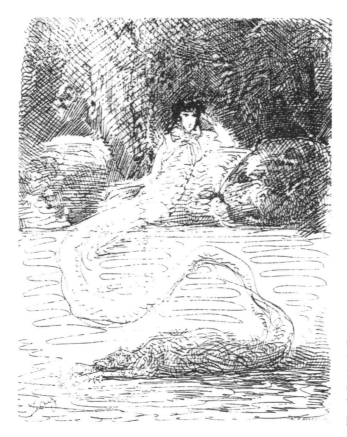

Figure 120. Zag, "Sarah belle d'indolence, par M. Clairin." *Zigzags,* May 7, 1876, 12. Bibliothèque Historique de la Ville de Paris. Author's photograph.

Figure 121. Sahib, "La rue de Paris" (detail). *La Vie Parisienne,* Dec. 31, 1898, 758–59. University of Notre Dame Libraries. Photographer, Tim Fuller.

Italian), two young Greek children, four sponsors and outbursts of two hundred alexandrine verses—without taking a drink].

The snake motif was also used by André Gill, in a caricature of Bernhardt entitled "Hymen-vapeur," for *La Nouvelle Lune* (1882); by Charvic, in an 1894 caricature of Yvette Guilbert, which included Bernhardt as a rival; and by Ferdinand Bac, in a work published in *Tout le théâtre,* that had clearly anti-Semitic overtones.[118] In the latter work, Bernhardt is shown en route during one of her transatlantic tours. She as metamorphosed into a snake in the ship's storage area, in the company of a monkey that has broken out of its cage and an African American entertainer who holds a beastly lap dog. The vituperative nature of nineteenth-century caricatures of Sarah Bernhardt can only be fully understood in the context of the woman-and-snake tradition. Moreover, her ethnicity in the anti-Semitic environment during the height of the Dreyfus affair (1897–98) only exacerbated the condemnation she experienced as an independent woman. This confluence of factors explains why representations of Bernhardt as a snake are dramatically different from those of other female performers of the period.

While Sarah Bernhardt was charged with bringing established characters to life on stage, Loïe Fuller took advantage of the popularity of snakes, and their associations, to develop a completely original production. Serpents were often featured on Fuller's costumes, whose seductive nightclub performances were dubbed "la danse serpentine" [the serpent dance].[119] Fuller, who was born in Illinois in 1862 and settled in Paris in 1892, was never depicted in such universally derogatory terms as Bernhardt. In part, this may have been because she did not draw attention to herself outside her performances, and thus did not generate as much controversy. She became known for her flowing skirts and being illuminated by colored lights.[120] In her act, she sometimes manipulated her skirts with poles, and at other times, with her hands. Through careful staging and lighting, she was able to create a fantasy environment and present herself as an object of desire. The degree to which her smoke-and-mirrors effects enhanced her appearance is evident through a comparison of publicity posters with contemporary photographs.

An 1892 illustration entitled "La danse serpentine," for *L'Illustration,* demonstrates Fuller's various transformations (figure 122). Two images, on the upper and lower left side, show her manipulating her snake-decorated dress, while the middle one shows the dress at rest.[121] *L'Illustration* was a mainstream magazine, and its coverage of her reveals how widely known her performances were. While Fuller had a variety of costumes and corresponding dances, the *danse serpentine* was her most popular act. An anonymous 1893 poster shows her as a snake-woman, with her head and chest joined to the body of a serpent (figure 123). She posed for publicity photographs in the snake costume holding a rubber snake to her lips (figure 124). An article about Fuller published in *Gil Blas* in 1892 focused primarily on her use of serpent motifs, describing the snakes on her dress that "awaken" as she begins the dance. As the spiraling cloth moved about her body, she appeared to be "charming" the serpents.[122] Georges Rodenbach, who commented specifi-

Figure 122. Unknown artist, "La danse serpentine—Mlle Loïe Fuller et ses transformations." *L'Illustration,* Nov. 12, 1892, 392. University of Minnesota Libraries. Photographer, Tim Fuller.

cally upon her appearance during the *danse serpentine,* gives a similar account of Fuller's sensual movements in a long poem, which reads in part:

> Onduleuses, sur elle, en forme de serpents . . .
> O tronc de la Tentation! O charmeresse!
> Arbre du Paradis où nos désirs rampants
> S'enlacent en serpents de couleurs qu'elle tresse!
>
> [Like serpents, the cloths twist about her body . . .
> Oh trunk of Temptation! Oh irresistible charmer!
> Tree of Paradise where our rampant desires
> Intertwine like serpents in the colors she weaves.][123]

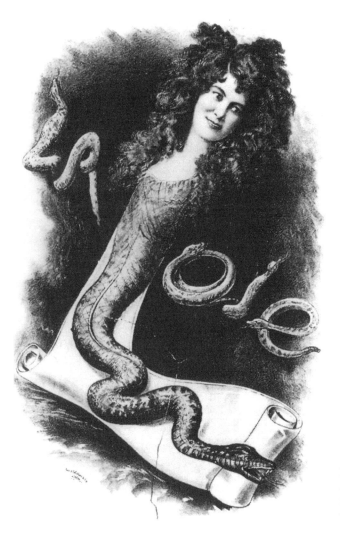

Figure 123. Unknown artist, *La Loïe.* Poster, 1893. Bibliothèque National de France.

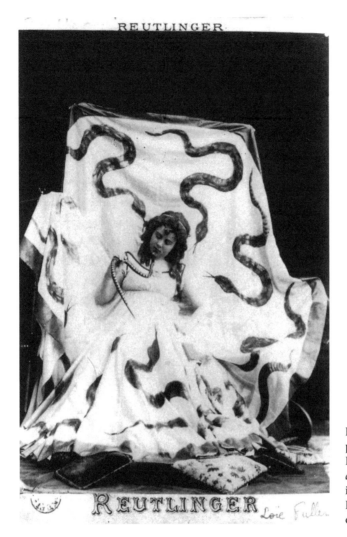

Figure 124. Reutlinger, photograph of Loïe Fuller in costume for *la danse serpentine,* holding a snake prop, 1896. Bibliothèque National de France.

Fuller clearly cultivated the image of the "snake charmer" in her performances, publicity photographs, and poster advertisements, drawing on the popular mythology associated with women in the company of snakes.[124]

Bernhardt and Fuller played to large audiences in a theater setting. Jane Avril (1868–1923), on the other hand, performed in the more intimate environment of the cabaret. Compared to Bernhardt and Fuller, little is known about Avril, although her likeness appears in many of the posters and paintings of Henri de Toulouse-Lautrec (1883–1901), who was one of her most fervent admirers. Avril danced the racy *chahut* and was said to have a split personality—"elegant and discreet" but also "endowed with a ferocious energy that earned her the nickname of 'La Mélinite'" (a type of explosive).[125] The British artist William Rothenstein,

who studied in Paris in 1890, described Avril as "a wild, Botticelli-like creature, perverse but intelligent, [with a] madness for dancing."[126] Avril was said to have been the daughter of an alcoholic prostitute and an Italian nobleman. Because of her difficult childhood, she developed tics and phobias, resulting in at least one stay at the Salpetrière clinic in Paris. According to Claire Frèches-Thory, Avril's first encounter with the "exhilaration of the dance" was at a ball organized by a doctor, "and it was the dance that cured her."[127] The period 1890–94 was the peak of Avril's career as a dancer, and the time when she associated most closely with Lautrec, Arsène Houssaye, Arsène Alexandre, and Arthur Symons. (Symons described her as having "the beauty of a fallen angel.")[128]

Raoul Ponchon dedicated a long verse to Jane Avril in his collection of poems about Paris nightlife, *La muse gaillarde* (1939).

> Elle se glissait mignonne,
> Souple entre les rangs pressés
> Sans jamais gêner personne
> Et sans jamais dire: assez. . . .
>
> Elle est toute charme, harmonie.
> C'est la seule, à mon avis,
> Saltatrice de génie
> Que jusqu'à ce jour je vis,
>
> Elle est à la fois espiègle
> Et mélancholique. Elle a
> Son seul caprice pour règle,
> Et c'est de l'art que voilà.
>
> [All sweet charm, with supple movements,
> She slipped among the close-packed throng,
> Never made their steps once falter,
> Never resting the whole night long. . . .
>
> [She is all grace, all harmony;
> No other like her do I know;
> No dancer of such genius
> Have I beheld before or now.
>
> [She's sad and sprightly both at once;
> Her only constant quality
> Is, to be sure, inconstancy.
> And then that little naughtiness,
> Is really art, you must confess.][129]

Ponchon made clear that the dance Avril performed was the dance of the Moulin Rouge, not one you would see at a presidential ball or learn at the academy. The "art que voilà" [that little naughtiness] refers to the revealing of undergarments during the *chahut*.

While Toulouse-Lautrec created many poster advertisements for Jane Avril, perhaps none is more powerful than his 1899 poster commissioned by Avril herself, who is shown in a costume with a snake writhing about it (figure 125).[130] Lautrec's preliminary drawings show the development of the sinuous line and the placement of the snake on Avril's costume. In the first state of the finished poster (only twenty-five impressions were printed), there is a cobra in the background, suggesting that Avril is either reacting to it or transformed by it.[131] According to Anne Roquebert, the poster was never used and may not have been finished, as was the case with many of Lautrec's late works.[132] Lautrec's financial situation—he was destitute in January 1899, when the poster was printed—and his health difficulties were among the reasons a small number of posters was printed and possibly contributed to their not being displayed.[133]

A woman in a similar snake-encircled costume appears in a nearly contemporaneous drawing by Hyp, published in *La Vie Parisienne* in early 1899 (figure 126).[134] Hyp's two-page illustration entitled "Les statues qu'elles aiment," like Carl-Hap's work described earlier, parodies the classical statue of the Laocoön.[135] The accompanying text suggests that the woman who loves the Laocoön, and visits the copy of the sculpture in the Louvre, is a morphine addict prone to hallucinations, and that consequently she imagines snakes writhing about her dress.

> Après l'éther elle s'est mise à la morphine. Elle est atteinte d'anxiomanie, elle a la maladie de la peur—et en même temps un goût morbide pour les spectacles terrifiants. Toute sa vie elle a eu des serpents une terreur qui, sous l'action ces poisons, est devenue démentielle. Elle verdit lorsqu'elle en parle et ne peut s'empêcher d'en parler sans cesse. Elle va au Louvre se figer devant le Laocoön. Secouée de tremblements affreux, la tête gisante, elle reste, c'est là qu'elle aime le mieux se faire sa piqûre, elle attend l'hallucination d'être elle-même entortillée par les reptiles. Alors elle s'enfuit, son mouchoir aux dents, pour qu'on ne l'entende pas crier.

> [After ether, she has turned to morphine. She has become prey to panic attacks and irrational fears—and at the same time conceives a morbid taste for terrifying spectacles. All her life she has had a deep fear of snakes, which the drugs she is taking have turned into a form of dementia. When she speaks of it, she turns ghastly pale, but she cannot keep the subject from her lips. She frequents the Louvre, standing rooted before the statue of Laocoön. There she remains, shaking fearfully, her eyes fixed. This is her favorite haunt for injecting herself, waiting for the hallucinations in which the snakes twine themselves about her own body. Then she flees, her handkerchief stuffed in her mouth so that people cannot hear her screams.]

Given the resemblance of the woman's dress and her pose to those of Avril in her poster, it seems reasonable to say that Lautrec was implying that Avril was in a hallucinatory state. Arthur Symons's description of Avril supports the notion that Toulouse-Lautrec depicted her in such a way.

> [She had an] unconscious air, as if no one were looking—studying herself before the mirror. . . . [She] had a perverse genius, besides which she was altogether adorable

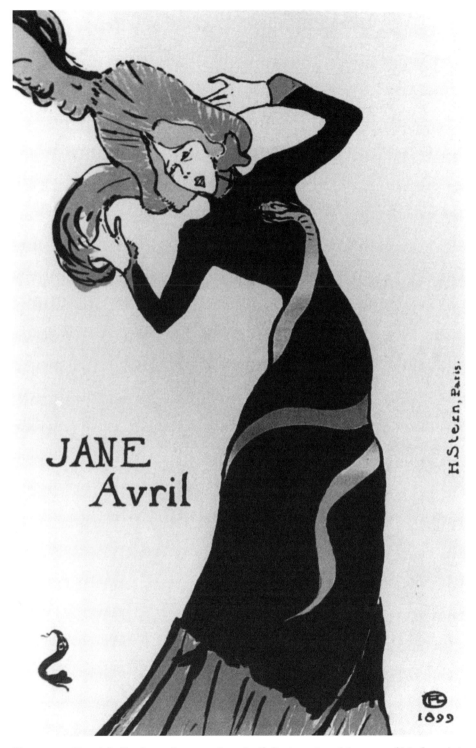

Figure 125. Henri de Toulouse-Lautrec, *Jane Avril*. Poster, 1899. Museum of Modern Art, New York, N.Y., Gift of Abby Aldrich Rockefeller. Digital image © The Museum of Modern Art/Licensed by SCALA/Art Resource, N.Y.

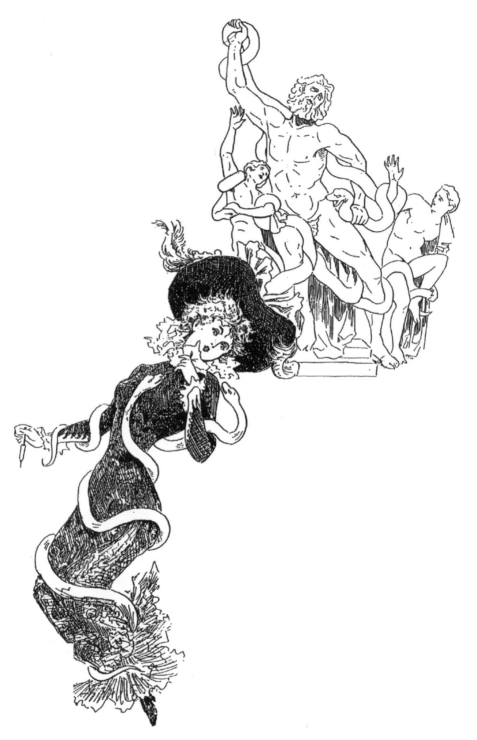

Figure 126. Hyp, "Les Statues qu'elles aiment" (detail). *La Vie Parisienne,* Jan. 7, 1899, 7. University of Notre Dame Libraries. Photographer, Tim Fuller.

and excitable, morbid and *sombre,* biting and stinging; a creature of cruel moods, of cruel passions; she had the reputation of being a Lesbian; and, apart from this and from her fascination, never in my experience of such women have I known anyone who had such an absolute passion for her own beauty. She danced before the mirror under the gallery because she was *folle de son corps.* . . . She was so incredibly thin and supple in body that she could turn over backward—as Salomé when she danced before Herod and Herodias.[136]

Like Avril, Lautrec had experienced psychological disturbances and had to be institutionalized. He was prone to hallucinations and suffered from delirium tremens because of his alcoholism, or perhaps due to tertiary syphilis. In 1899, he suffered a breakdown and was confined to Dr. Sémelaigne's clinic in Neuilly for eleven weeks.[137] It has already been noted that this poster of Avril is "inconsistent with a cheerful publicity poster for a cabaret performer," and that it was probably not used because it was "judged too ambiguous or frightening to attract the public."[138] Moreover, the depiction of a drug-induced hallucination, as implied by the Hyp illustration, was certainly not a common feature of advertisements for nightclub acts during the period. In any event, the dramatic impact of this snake-woman image has contributed to its continued reputation as one of Lautrec's masterpieces.

The fusion of woman and serpent represents the fullest development of the fille d'Eve in the context of original sin. Artists and writers exploited the ambiguity of the Genesis seduction scene, depicting woman as the agent of the devil or alternately as a seductress who was so powerful that Satan himself was overcome. This dual interpretation fueled the continuing denigration of the women of Paris, for the feminist and the prostitute alike could be cast as agents of evil. The prostitute was feared but nonetheless desired by men, making her sexuality seem like a form of black magic. The feminist, on the other hand, bore Eve's responsibility for the fall of mankind. To the contemporary artist or writer with misogynistic leanings, high-profile feminist activists or merely supremely independent women seemed poised to cause the upheaval of the patriarchal structure.

Epilogue

In 1909, Claire Galichon published *Eve réhabilitée* as a sequel to her earlier work, *Amour et maternité* (1907). As a woman of the early twentieth century, she hoped to "réhabiliter la femme et créer autour d'elle, au moyen des lumières spiritualistes, une plus saine atmosphère de justice sociale et de morale logique" [rehabilitate women and surround them, through the power of spiritualism, with a more healthy atmosphere of social justice and logical morality].[1] Her preface explained how and why she became a feminist. Having grown up in a family where her parents appeared to be equal partners, she became, in her words, "convertis au féminisme CONSCIENT" [converted to an ACTIVE form of feminism] at age fourteen. However, when she met her husband, she found herself to be an antifeminist. "Why declare war on men?" she asked. "Do we really want to take their place?"[2]

For Galichon, being a feminist in 1909 meant dressing like a man, and the emancipation of woman seemed a ridiculous pretension. She proposed that the "revised" version of feminism was "l'humanité affirmée dans la femme" [the affirmation of women's humanity] but added that it was necessary to distinguish between the "femme feministe" [feminist woman], who revolts for her sex, and the "femme non-feministe" [non-feminist woman], who revolts only for herself, when she is so inclined. In order to discover the origins of feminism, one had to look for the source of man's abuse of power, that is, to Genesis. In other words, "masculinism" created the response of feminism. The Eve of Genesis, the "guilty, submissive" Eve, had been replaced by the

"revolting" Eve of the radical feminists Maria Deraismes and Maria Martin, who were equally problematic for Galichon at the beginning of the twentieth century. In their place, Galichon called for "the conscientious, rehabilitated Eve," the perfect spouse for the regenerated man, or the "Adam of the future."[3]

Galichon identified early in the twentieth century a conflict that remains within the feminist movement today. No universal definition of feminism exists. Women and men continue to struggle with the legacy of the Genesis story (and similar stories in non-Judeo-Christian traditions), which, despite attempts to ignore it, or rewrite it, is still responsible for stubborn gender stereotypes. The memory of the biblical Eve, and the specter of her contemporary descendants, permeated every facet of French society during the nineteenth century. Analysis of the visual and literary manifestations of the filles d'Eve reveals the uneasy nature of the symbol, subject as it was to the desires of individual users, and allows insight into societal changes of the period. Since these changes were often radical, they were most often broached in the realm of popular culture, following a tradition predating the French Revolution of 1789. Contemporary illustrated journals and other forms of popular literature demonstrate the gradual evolution from the fille d'Eve to the femme fatale, in response to increasing feminism, and the desire by men to halt its spread. Eventually the "dangerous" and "fatal" woman—a product of Eve's "sin"—appeared in all levels of visual culture. Salon paintings of the 1890s depicting historical figures, such as Salomé or Judith, must be understood in the context of the fille d'Eve, and of precedents in popular culture. By the fin de siècle, such historical and biblical figures in art unquestionably contained secular references to contemporary society and carried coded antifeminist messages formed slowly over time.

While antifeminists in France were certainly alarmed by the vocal minority of feminist activists, they were more fearful of the masses to which the "radical" message of these activists might spread. Antifeminist artists and writers were schooled in France's long tradition of caricature, and of the popular press, to mobilize individuals to think and act in unison. Their strategy was to flood the market with messages about "real" women in society, occasionally referring to biblical or allegorical references directly, but more often indirectly. It is only through consideration of the fille d'Eve, and her evil motifs in a wide range of sources, that one can grasp the truly pervasive nature of visual propaganda. These images, both literary and visual in their link to Eve, mapped the difficult territory between the sexes during the last half of the nineteenth century. The story they tell is one of struggle for control and domination. Women wanted equality and independence; men, fearful of depopulation and the dissolution of the family, wanted women to remain domestic and deferential. The complex negotiations between nineteenth-century man and woman are today manifest in this popular imagery, replete with its parallel ambiguities and double-entendres.

Notes

Introduction

1. The subtitle of Grévin's *Filles d'Eve* read: "Mon exposition de sculpture . . . pour le prochain Salon." Unless noted otherwise, all translations from the French are by Ian West of First Editions Translations, Ltd., Cambridge, England.

2. Arsène Alexandre, writing in 1894, commented on the near disappearance of political caricature and what he saw as an "absence of political passion," which was "partly the reason that humorous draughtsmen during the last few years have devoted themselves much more willingly to pure fancy and the study of manners." (Quoted and translated in Robert Justin Goldstein, *Censorship of Political Caricature in Nineteenth-Century France* [Kent, Ohio: Kent State University Press, 1989], 237.) Jacques Lethève provides a list of journals that published caricatures during the period of the Third Republic. He categorizes most of the periodicals considered in the current study (with the exception of *L'Assiette au beurre* and *Le Sifflet,* which both had an understood political undertone) as "essentiellement de moeurs" [essentially to do with manners]. Lethève, *La caricature et la presse sous la IIIè république* (Paris: Colin, 1961), 241–54. Lethève says that these publications participated in "la chasse au plaisir" [the mania for self-gratification]; see pages 138–53.

3. See Elizabeth K. Menon, *The Complete Mayeux: Use and Abuse of a French Icon* (New York: Peter Lang, 1997), in which I trace the proliferation of a particular character in the prints, literature, and decorative arts of the July Monarchy.

4. See Virginia Allen, *The Femme Fatale: Erotic Icon* (New York: Whitston, 1983); Bram Dijkstra, *Idols of Perversity: Fantasies of Feminine Evil in Fin-de-Siècle Culture* (New York: Oxford University Press, 1986). Dijkstra's *Evil Sisters: The Threat of Female Sexuality and the Cult of Manhood* (New York: Knopf, 1996) continues his earlier study into the twentieth century. See also Henk van Os et al., *Femmes Fatales, 1860–1910,* exh. cat. (Antwerp: Koninklijk Museum and Groninger Museum, 2002).

5. John Raymond Miller, in his Ph.D. dissertation, "Dante Gabriel Rossetti from the Grotesque to the Fin de Siècle: Sources, Characteristics, and Influences of the Femme Fatale" (University of Georgia, 1974), divides the femme fatale into conscious and unconscious categories in his thematic assessment of Rossetti's work; see page 89.

6. Mario Praz, *The Romantic Agony,* trans. Angus Davidson (New York: World, 1965), 191. Praz concerns himself with the development of the Fatal Woman in literature, as part of his larger study of the characteristics of the Romantic psyche.

7. Ibid.

8. Marie Lathers, *Bodies of Art: French Literary Realism and the Artist's Model* (Lincoln: University of Nebraska Press, 2001), 39.

9. Octave Uzanne, as quoted in translation by Lathers, ibid., 39.

10. Allen, in *The Femme Fatale,* identifies Georges de Feure as a prototypical artist developing the femme fatale and examines what she calls the "full-blown" version in the work of six individuals: Théophile Gautier, Charles Baudelaire, Gustave Moreau, Dante Gabriel Rossetti, Algeron Swinburne, and Edward Burne-Jones. While she identifies the original source of the femme fatale as the "dark half of the dualistic concept of the Eternal Feminine—the Mary/Eve dichotomy" (vii), she is primarily concerned with the iconography of the figure during the 1890s in painting and literature. She connects the appearance of the figure to fear caused by feminism—noting that the agitation began in the 1860s—but does not show how this idea developed or proved a definitive link to the women's rights movement, which the journal illustrations of the current study provide.

Allen did not believe that the term *femme fatale* had been in use during the nineteenth century (vii); I show that the term was in use in France as early as 1854. I agree with Allen's assessment that the popularity of the femme fatale could not have occurred if real women were not modeling themselves after the figure in some way, as demonstrated below, with regard to the performers Sarah Bernhardt, Loïe Fuller, and Jane Avril.

11. Marsicano divides the images in his study into four broad categories: mythical/classical/biblical; nude women in provocative poses; prostitutes; and famous performers. He locates prostitution as a primary source of the myth of the femme fatale. Marsicano endeavors to study the sources of myths inherent within the images and to elucidate how myths both influenced and were influenced by the behavior of real people, although his consideration of real women is limited to the prostitute and the performer. His study is restricted to the years 1880–1920 and he provides a chronology for the development of the femme fatale only within this period. See Edward Marsicano, "The Femme-Fatale Myth: Sources and Manifestations in Selected Visual Media, 1880–1920" (Ph.D. diss., Emory University, 1983).

12. Dijkstra utilizes an almost overwhelming number of images and connects them with literature, but he frequently uses the literature of one country to explain visual images in another. While compelling, this most likely creates an artificial sense of coherence within European representations of the femme fatale. He is concerned almost exclusively with painting and divides his examination into themes—primarily historical and mythological—although he includes images of women as weak (sleeping or in a state of invalidism) as a source for vampirism imagery. Dijkstra, *Idols of Perversity,* esp. chapters 2 and 3.

13. For more recent works, see, for instance, Sharon L. Hirsch, *Symbolism and Modern Urban Society* (Cambridge: Cambridge University Press, 2004); Peter Nørgaard Larsen, *Symbolism in Danish and European Painting, 1870–1910* (Copenhagen: Statens Museum for Kunst, 2000); Patricia Mathews, *Passionate Discontent: Creativity, Gender, and French Symbolist Art* (Chicago: University of Chicago Press, 1999); Michael Gibson, *Symbolism* (Cologne: Taschen, 1999); Reinhold Heller, *The Earthly Chimera and the Femme-Fatale: Fear of Women in Nineteenth-Century Art,* exh. cat. (Chicago: David and Alfred Smart Gallery, University of Chicago, 1981); and Patrick Bade, *Femme Fatale: Images of Evil and Fascinating Women* (New York: Mayflower, 1979).

14. See H. R. Hays, *The Dangerous Sex: The Myth of Feminine Evil* (New York: Putnam, 1964); Peter Gay, *The Bourgeois Experience: Victoria to Freud,* vol. 1, *Education of the Senses* (Oxford: Oxford University Press, 1984); and Charles Bernheimer, *Decadent Subjects: The Idea of Decadence in Art, Literature, Philosophy, and Culture of the Fin de Siècle in Europe* (Baltimore: Johns Hopkins University Press, 2002).

15. Allen, *Femme Fatale,* 3.

16. See Linda Nochlin, "Why Have There Been No Great Women Artists," *Art News,* Jan. 1971. More recently the essay has been reprinted in Nochlin's *Women, Art, Power, and Other Essays* (New

York: Harper and Row, 1988). Nochlin indicated that there had been women artists, but their existence had been obscured by the discipline of art history. They were not "great" because they did not receive the same training as male artists, and they were most often expected to complete duties of wife and mother while pursuing their art.

17. Griselda Pollock, *Vision and Difference: Femininity, Feminism, and Histories of Art* (London: Routledge, 1988), 15 (quote). Pollock at this point became interested in theories of the "gaze" but focused her investigation on the ideology behind that phenomenon rather than considering the specific historical instances when it was put to use in visual production. Arguing that their relative historical positions (male as superior, female as inferior) have caused women and men to see different things, as well as to see things differently, Pollock sidelined the significance of the influence of Japanese prints on the work of Mary Cassatt, for instance, attributing the cropped, flattened oppressive interiors in her works instead to an expression of women's domestic imprisonment. (For the earlier work, see Griselda Pollock and Rozsika Parker, *Old Mistresses: Women, Art, and Ideology* [New York: Pantheon, 1981].) John Berger's *Ways of Seeing* (New York: Penguin, 1972), reproduced in Melita Schaum and Connie Flanagan, eds., *Gender Images: Readings for Composition,* Boston: Houghton Mifflin, 1992) describes women, as they are pictured in works of art, as objects of the male gaze, the basis for theories of the "gaze" employed by Pollock and others. Within this configuration, the presumed male viewer has control over his female subject. The proximity of the (usually male) artist to the (typically female, from the nineteenth century onward) model begins to describe a second area impacted by the notion of power.

18. Noël Carroll, *A Philosophy of Mass Art* (Oxford: Clarendon, 1998), 185.

19. Patricia Anderson, *The Printed Image and the Transformation of Popular Culture, 1790–1860* (Oxford: Clarendon, 1991), 193. Richard Terdiman identifies the beginning of the mass media in France due to the forty-fold increase of newspaper circulation between 1830 and 1880. (Terdiman, *Discourse/Counter-Discourse: The Theory and Practice of Symbolic Resistance in Nineteenth-Century France* [Ithaca, N.Y.: Cornell University Press, 1985], 129.) Vanessa Schwartz examines mass culture in fin-de-siècle France in popular culture forms including certain aspects of the Parisian press, Alfred Grévin's wax museum, panoramas, and film as visual experiences shared by a modern urban population. See Schwartz, *Spectacular Realities: Early Mass Culture in Fin-de-Siècle Paris* (Berkeley: University of California Press, 1998). Schwartz's examination of the mass press does not consider the illustrated journals from which images are drawn for the current study.

20. Raymond Manevy, *La presse de la IIIè république* (Paris: J. Foret, 1955), 19. On the expansion of the reading public during the period of the Third Republic (considering both class and gender), see James Smith Allen, *In the Public Eye: A History of Reading in Modern France, 1880–1940* (Princeton: Princeton University Press, 1991), 202–23

21. Schwartz, *Spectacular Realities,* 27.

22. John A. Walker and Sarah Chaplin, *Visual Culture: An Introduction* (Manchester, Eng.: Manchester University Press, 1997), 2.

23. Nicholas Mirzoeff, *An Introduction to Visual Culture* (New York: Routledge, 1999), 6. See also Malcolm Barnard, *Approaches to Understanding Visual Culture* (New York: Palgrave, 2001). For theoretical perspectives on visual culture, see the essays in Norman Bryson, Michael Ann Holly, and Keith P. F. Moxey, eds., *Visual Culture: Images and Interpretations* (Hanover, N.H.: University Press of New England, 1994).

24. Claude Bellanger, Jacques Godechot, Pierre Guiral, and Fernand Terrou, eds., *Histoire générale de la presse française,* vol. 3, *De 1871 à 1940* (Paris: Presses Universitaires de France, 1972), 385. Robert Goldstein uses a different set of figures. He points to an increase of caricature journals, from 26 in 1876 to 49 in 1880, with 40 more begun during 1881 alone; from 1881 to 1914 another 130 were added. Goldstein notes that "many of these journals were extremely ephemeral, however, with most of them folding after only a few years due to poor quality, an overly specialized orientation . . . and an over saturated market." Goldstein, *Censorship of Political Caricature,* 232.

25. See Champfleury (pseud. Jules Fleury), *Histoire de la caricature moderne* (Paris: E. Dentu, 1865). A work from the July Monarchy that describes caricature as historical document is "Caricatures et chansons," *Le Figaro,* Mar. 1, 1831, 1.

26. René de Livois, *Histoire de la presse française,* vol. 1, *Des origines à 1881* (Lausanne: Editions Spes, 1965), 279. The 1867 law change resulted in an additional 140 periodicals in a matter of months, bringing the total to 900 by 1869.

27. On the demise of political caricature and the rise of social caricature, see Goldstein, *Censorship of Political Caricature,* 235–37.

28. On the July 29, 1881, law and the character of publications as a result, see Manevy, *La presse,* 9–15, 35–37; Bellanger et al., *Histoire générale,* 3:7–22; and Goldstein, *Censorship of Political Caricature,* 229–38. James Smith Allen publishes numbers from 1880 and 1910 but does not list figures for the *Courrier Français* for either of those years.

29. Translated in Théodore Zeldin, *France, 1848–1945,* vol. 4, *Taste and Corruption* (New York: Oxford University Press, 1980), 369.

30. Goldstein, *Censorship of Political Caricature,* 220.

31. Zeldin, *Taste and Corruption,* 369. Zeldin reports that in 1890 the lawyer for a rival paper, brought to trial for indecency, complained that "the supposedly respectable *La Vie Parisienne,* catering for a well-to-do society, was no better" (ibid.). Unfortunately Zeldin does not identify the rival paper or provide a citation for this statement, but the paper in question was likely *Le Courrier Français.*

32. Claude Bellanger et al., *Histoire générale de la presse français,* vol. 2, *De 1815 à 1871* (Paris: Presses Universitaires de France, 1969), 311. See also 3:386.

33. Ibid., 3:387.

34. Goldstein, *Censorship of Political Caricature,* 244.

35. Ibid.

36. Bellanger, *Histoire générale,* 2:311. The figures are for 1866.

37. The latter publication reappeared from June 1880 until 1891, but illustrations for the current study came from the journal as it appeared in the late 1870s.

38. Goldstein, *Censorship of Political Caricature,* 251.

39. Statistics for *Le Figaro* and *Le Petit Journal* are taken from Roger Bellet, *Presse et journalisme sous le Second Empire* (Paris: Colin, 1967), 312. Zeldin, in *Taste and Corruption,* cites the statistics for the popular dailies (which were not illustrated) as increasing in circulation from 235,000 copies in 1858 to two million in 1880 and five million in 1910 (192). The popularity of many of these publications grew when serial novels were included in them. On this subject see Anne-Marie Thiesse, *Le roman du quotidien: Lecteurs et lectures populaires à la belle époque* (Paris: Le Chemin Vert, 1984).

40. Zeldin, *Taste and Corruption,* 368.

41. On the study of female types in French posters see Anne Marie Springer, "Woman in French Fin-de-Siècle Posters" (Ph.D. diss., Indiana University, 1971). Maria Warner studies female allegorical types in *Monuments and Maidens: The Allegory of the Female Form* (New York: Athenaeum, 1985). The book that bears the closest methodological resemblance to the current study is Lou Charnon-Deutsch's *Fictions of the Feminine in the Nineteenth-Century Spanish Press* (University Park, Pa.: Pennsylvania State University Press, 2000), a study of images of women in the Spanish illustrated press.

42. See the discussion of Febvre's ideas in Peter Burke, ed., *A New Kind of History: From the Writings of Febvre,* trans. K. Folca (London: Routledge and Kegan Paul, 1973).

43. B. E. Maidment, *Reading Popular Prints: 1790–1870* (Manchester, Eng.: Manchester University Press, 1996, 2001), 7.

44. On the study of "types," see Georges Doutrepont, *Les types populaires de la littérature française,* 2 vols. (Brussels: Maurice Lamertin, 1926).

45. A more recent study of female types from this period appears in Jean-Paul Aron, ed., *Misérable et glorieuse: La femme du XIXe siècle* (Paris: Fayard, 1980). Sections address women in positions of servitude (including prostitutes, maids, and common workers), symbolism (woman as fashion plate, for instance), and the relative power of feminist writers.

46. Recent studies include James F. McMillan, *Housewife or Harlot: The Place of Women in French Society, 1870–1940* (New York: St. Martin's, 1988); Charles Bernheimer, *Figures of Ill Repute: Repre-*

senting Prostitution in Nineteenth-Century France (Cambridge, Mass.: Harvard University Press, 1989); Alain Corbin, *Women for Hire: Prostitution and Sexuality in France after 1850,* trans. Alan Sheridan (Cambridge, Mass.: Harvard University Press, 1990); Hollis Clayson, *Painted Love: Prostitution in French Art of the Impressionist Era* (New Haven: Yale University Press, 1991); Jann Matlock, *Scenes of Seduction: Prostitution, Hysteria, and Reading Difference in Nineteenth-Century France* (New York: Columbia University Press, 1994); Mary Spongberg, *Feminizing Venereal Disease: The Body of the Prostitute in Nineteenth-Century Medical Discourse* (London: MacMillan, 1997); and Richard Dellamora, *Victorian Sexual Dissidence* (Chicago: University of Chicago Press, 1999).

47. Stephen Kern has described the pitfalls of examination of art along with literature in a thematic exposition in his *The Culture of Love: Victorias to Moderns* (Cambridge, Mass.: Harvard University Press, 1992), 3–4.

Chapter 1: *Les filles d'Eve*

1. Jeanne-Hélène Roy discusses this issue with reference to Rousseau in "Rousseau's Floral Daydreams: Cultivating an Aesthetics in the *Rêveries*" (Ph.D. diss., Cornell University, 1997), 162 n. 60.

2. For discussion of this concept, see John Phillips, *Eve: The History of an Idea* (San Francisco: Harper and Row, 1984), chapter 9, "The Second Eve"; Susan Ashbrook Harvey, "Eve and Mary: Images of Woman, *Modern Churchman* 24 no. 3–4 (Autumn–Winter 1981): 133–48; and Marina Warner, *Alone of All Her Sex: The Myth and the Cult of the Virgin Mary* (New York: Knopf, 1976), esp. chapter 4, "Second Eve," 50–67.

3. See Tertullian's "De Carne Christi," 17; portions are translated and quoted in Henry Bettenson, ed., *The Early Christian Fathers: A Selection of the writings of the Fathers from St. Clement of Rome to St. Athanasius* (London: Oxford University Press, 1956), 174.

4. Mieke Bal, "Sexuality, Sin, and Sorrow: The Emergence of Female Character (A Reading of Genesis 1–3)," in *The Female Body in Western Culture: Contemporary Perspectives,* ed. Susan Rubin Suleiman (Cambridge, Mass.: Harvard University Press, 1986), 335.

5. For instance, a sculpture by Jean Hughes titled *Tentation* was reproduced in *L'Art Français* on Oct. 2, 1887, and the painting *Les paradis,* by Auguste Germain, was reproduced in *Le Courrier Français* on Aug. 30, 1903. Armand Silvestre features Eve as subject matter for both painting and sculpture in *Le nu au salon de 1893 (Champs-Elysées)* (Paris, 1893). Among the many literary works are *Eve ressuscitée, ou la belle sans chemise,* an 1873 reprinting of a racy 1844 document, and the 1899 novel *Adam et Eve* by Camille Lemonnier. Theatrical productions included L. Gallet's *Eve* at the Cirque d'Hiver, Mar. 28, 1875; E. Blum and R. Toché's *Adam et Eve* at the Théâtre des Nouveautés, Oct. 6, 1886; and G. Pollonnais's *Eve* at the Théâtre d'Application, Mar. 25, 1896.

6. Dee Marie Woellert, "Eve: The Image of Woman" (Ph.D. diss., Northern Illinois University, 1988), 4. Woellert has studied interpretations of Eve by analyzing theological and psychological works from different times, in order to show a shift from discussions of the archetypal Eve to women in general. An overview of the changes made to Eve's meaning also appears in Katharine Rogers, *The Troublesome Helpmate: A History of Misogyny in Literature* (Seattle: University of Washington Press, 1966).

7. *The City of God,* book 2, chapter 27. See the recent translation by R. W. Dyson, *The City of God against the Pagans* (Cambridge: Cambridge University Press, 1998).

8. Quintus Septimius Florens Tertullian, "On the Apparel of Women," in *The Ante-Nicene Fathers: Translations of the Writings of the Fathers down to A.D. 325,* ed. Rev. Alexander Roberts and James Donaldson (Grand Rapids, Mich.: Eerdmans, 1969–73), 2:18–19.

9. Phillips, *Eve,* 39. See also Aviva Cantor Zuckoff, "The Lilith Question," *Lilith* 1 (Fall 1976): 5–38.

10. Margaret Hallissy, *Venomous Woman: Fear of the Woman in Literature* (New York: Greenwood, 1987), 16.

11. Phillips, *Eve,* 41.

12. Milton's *Paradise Lost,* first printed in 1667, was tremendously popular in France during

the nineteenth century, with more than thirty-two editions published between 1808 and 1903. The catalogue of the Bibliothèque Nationale indicates that French translations appeared in 1775, 1778, 1786, 1792, 1804, 1805, 1807, 1808, 1811, 1813, 1820, 1822, 1824, 1832, 1836, 1837, 1850, 1855, 1858, 1861, 1862, 1863, 1866, 1867, 1868, 1870, 1871, 1873, 1874, 1875, 1877, 1881, 1884, 1889, 1896, and 1903. The translations were accomplished by well-known French writers, including the poet Jacques Delille and the literary great Chateaubriand. The first of many theatrical presentations based on *Paradise Lost* was performed in 1763.

13. Larcher writes: "'Oh!' dit ce poëte dans son *Paradis perdu,* 'pourquoi Dieu, créateur sage, qui peuple les cieux d'esprits mâles, créa-t-il ensuite cette nouveauté sur la terre, ce beau défaut de la nature? Pourquoi n'a-t-il pas tout d'un coup rempli le monde d'hommes, comme il a rempli le ciel d'anges, sans femmes? Pourquoi n'a-t-il pas imaginé une autre voie pour perpétuer la race humaine? Ce malheur, ni tous les malheurs qui le suivront, n'auraient pas été produits; ces troubles innombrables, apportés sur la terre par les artifices des femmes et par l'intime union avec ce sexe.'" ["Oh!" exclaims this poet in his *Paradise Lost,* "why did God, the all-wise Creator, who peopled the heavens with male creatures, then create this new being on earth, this beautiful flaw of Nature? Why did he not suddenly people the world with men as he filled Heaven with angels, without women? Why did he not devise another way to perpetuate the human race? This disaster, and all subsequent ones, would never have arisen: these troubles beyond number, brought down upon Earth by the cunning of Woman and intimacy with her sex."] L. J. Larcher, *Satires et diatribes sur les femmes, l'amour, et le mariage* (Paris, 1860), 160.

14. Nehama Aschkenasy, *Eve's Journey: Feminine Images in Hebraic Literary Tradition* (Philadelphia: University of Pennsylvania Press, 1986), 42.

15. Milton, *Paradise Lost,* prefaces by Philip Hofer and John T. Winterich (New York: Heritage Press, 1940), book 10, pp. 235–66.

16. Edmond Perrier et al., eds., *La femme dans la nature, dans les moeurs, dans la légende, dans la société: Tableau de son évolution physique and psychique,* vol. 3, *La femme dans la légende,* by A. Schalck de la Faverie (Paris: Bong, 1908–10), 18.

17. Allen, *Femme Fatale,* vii. Mario Praz, who was the first to study the dangerous woman now commonly called the femme fatale, in his *Romantic Agony* (first published in English in 1933), does not use the term. Bram Dijkstra uses it frequently in *Idols of Perversity* without questioning its origin or nuances in meaning.

18. J. de Marchef-Girard, *Les femmes: leur passé, leur présent, leur avenir* (Paris, 1860), 13.

19. Marchef-Girard writes, "L'Eve de la Genèse, la Pandore des Grecs, la femme fatale dans chaque théogonie, ne se ressemble que par sa fatalité même; lorsque l'histoire s'en est emparée et lui a donné une figure indélébile, elle était déjà si ancienne que le type primitif avait eu le temps de s'altérer profondément." [The Eve of Genesis, the Pandora of Greek mythology, the femme fatale found in every theogony, are linked only by the very fatality of their natures. When history got hold of them and lent them an indelible character, they were already so old that the prototype had had time to alter considerably.] Ibid., 17.

20. Ibid., 28.

21. Edmond-August Texier, *Les femmes et la fin du monde* (Paris: C. Lévy, 1877), 237.

22. Mossa, born in Nice, found inspiration in Parisian women and used contemporary fashion to enhance mythological and historical figures. The 1900 Exposition Universelle in Paris solidified his interest in the curvilinear, natural motifs of Art Nouveau and the role of woman not as a "neutral" muse, but one who inspired evil.

23. See the discussion in H. R. Hays, *The Dangerous Sex: The Myth of Feminine Evil* (New York: Putnam, 1964), chapter 7, "Pandora's Box," 79–87.

24. Rops, *Les muses sataniques Félicien Rops: Oeuvre graphique et lettres choisies par Thierry Zéno* (Brussels: J. Antoine, 1985), 203.

25. These included Octave Uzanne's *La femme à Paris, nos contemporaines: Notes successives sur les Parisiennes de ce temps dans leurs divers milieux, états et conditions* (Paris: Ancien Maison Quantin, 1894), which was reprinted in an expanded edition entitled *Parisiennes de ce temps en leurs divers milieux, états et conditions: Etudes pour servir à l'histoire des femmes, de la société, de la galanterie*

française, des moeurs contemporaines et de l'égoïsme masculine (Paris: Mercure de France, 1910), and Georges Montorgueil's, *La Parisienne peinte par elle-même* (Paris: L. Conquet, 1897). This literature will be examined in chapter 4. Uzanne's 1910 edition will be cited subsequently in the present book, as *Parisiennes de ce temps.*

26. Phillips, *Eve,* 62.

27. Henry Ansgar Kelly, "The Metamorphoses of the Eden Serpent during the Middle Ages and the Renaissance," *Viator* 2 (1971): 303.

28. Margaret Hallissy, *Venomous Woman: Fear of the Female in Literature* (New York: Greenwood, c. 1987), 15.

29. Phyllis Trible, *God and the Rhetoric of Sexuality* (Philadelphia: Fortress Press, 1978), 73. Trible summarizes some of the aspects that have achieved a consensus, including the concept that the creation of man first and woman second means that woman is inferior; that woman is created as a helpmate; and that since woman is made from man's rib, she is dependent upon him for life. She is derivative, and therefore does not have an autonomous existence. Since man named woman, he has power over her and God has given man that right. Since woman tempted man to disobey, she is responsible for sin in the world, as well as being untrustworthy, gullible, and simpleminded.

30. *La Vie Parisienne* promoted tourism by highlighting fashion, sports, and leisure activities undertaken by women. Valerie Steele has termed it the "*Playboy* of its day," which overstates the nature of the illustrations compared to other available "pornography" in the Bibliothèque Nationale's Enfer collection. (Valerie Steele, *Paris Fashion: A Cultural History* [New York: Oxford University Press, 1988], 119.) David Kunzle has more accurately referred to this publication as providing a "rich panorama of Parisian life" and an attempt to provide a *physiologie de la toilette* [analysis and explanation of women's dress]. He reports that men wrote the magazine for women, and for the male "gourmet de la femme" [male who is a gourmet for women]. Kunzle discusses the magazine in part 6 of his essay "The Corset as Erotic Alchemy," in *Woman as Sex Object: Studies in Erotic Art, 1730–1970,* ed. Thomas Hess and Linda Nochlin (New York: Newsweek, 1972), 116–21 (quotes, 116–17).

31. Caron, quoted in L.-J. Larcher, *La femme jugée par l'homme: Documents pour servir à l'histoire morale des femmes et à celle des aberrations de l'esprit des hommes* (Paris: Garnier, 1858), 301, where "curiosity" appears as part of an alphabetical list of uncomplimentary characteristics of women under the collective title of "Petite mosaïque."

32. Maria Deraismes, *Eve dans l'humanité* (1895; Paris: Côté-femmes, 1990,), 166–67.

33. Larcher writes: "Les femmes font-elles partie du genre humain? ont-elles une âme? Telle est la double et puérile question qui, pendant plusieurs siècles, a très-sérieusement préoccupé des philosophes, des savants, des évêques, des prêtres de toutes les religions." ["Are women part of the human race? Have they a soul? Such is the twofold and puerile question that, for several centuries, seriously preoccupied philosopher, scholars, bishops and priests of every religion."] *La femme jugée par l'homme,* 120.

34. Anson Rabinbach, *The Human Motor: Energy, Fatigue, and the Origins of Modernity* (New York: HarperCollins, Basic Books, 1990), 154, 155.

35. Ibid., 153.

36. Neurasthenia is linked to hysteria in the sense of being diagnosed more often in women (who, according to Darwinian thinking, were "weaker" than men in the intellectual, emotional, and physical sense). Jean-Martin Charcot, director of the Salpêtrière, made hundreds of diagnoses of both conditions. On the hereditary theories of French doctors studying neurasthenia, see Robert C. Nye, *Crime, Madness, and Politics in Modern France: The Medical Concept of National Decline* (Princeton: Princeton University Press, 1984).

37. On the proximity of Adam to Eve at that moment, see Jean M. Higgins, "The Myth of Eve: The Temptress," *Journal of the American Academy of Religion* 44 (Dec. 1976), esp. 645–46.

38. Anatole France, "Joséphin Péladan," *La vie littéraire,* Oeuvres complètes illustrée de Anatole France, vol. 7 (Paris: Calmann-Lévy, 1926), 226. See Christophe Beaufils, *Joséphin Péladan (1858–1918): Essai sur une maladie du lyrisme* (Grenoble: J. Millon, 1993), and Jean-Pierre Laurant

and Victor Nguyen, *Les Péladan,* Les dossiers (Lausanne: L'Age d'homme, 1990). Rops provided the frontispiece illustrations for the four volumes in the first septénaire of Péladan's *La Décadence Latine—Le vice suprême,* "diathèse morale et mentale de la décadence latine"; *Curieuse,* "phénoménisme clinique collectif parisien"; *L'initiation sentimentale,* "les manifestations usuelles de l'amour imparfait, expressément par tableaux du non-amour"; and *A coeur perdu,* "réalisation lyrique du dualisme par l'amour; réverbération de deux moi jusqu'à saturation éclatante en jalousie et rupture; restauration de voluptés anciennes et perdues." (Concordance schema published in each volume.)

39. See Maurice Exsteens, *L'oeuvre gravé de Félicien Rops* (Paris: Editions Pellet, 1928), no. 440.

40. Ibid., no. 866.

41. The engraving after the original drawing has foliage on the tree but no flowers and no banner. Ibid., no. 438. The actual frontispiece is no. 520.

42. Ibid., no. 863.

43. Védrine's observation appears in her *Félicien Rops, Joséphin Péladan: Correspondance* (Paris: Seguier, 1997), 20–21. In his letter, Péladan writes, "J'ai vu de vous des eaux-fortes magistrales & d'une perversité si intense, que moi qui prépare le traité de la perversité, je me suis épris de votre extraordinaire talent." [I have seen some of your etchings; they are masterly and so intensely depraved that I, who am preparing a treatise on depravity, fell under the spell of your extraordinary talent.] (Ibid., letter 1, Péladan to Rops, Mar. 22, 1883.) Védrine notes that it appears that the *traité* to which Péladan refers was never written (20–21).

44. Ibid., letters 101 (Rops to Péladan, March or April 1887) and 102 (Péladan to Rops, March or April 1887), 217.

45. Ibid., letter 103, Rops to Péladan, Nov. 24, 1887, 218. In a note on page 218, Védrine explains that an author had already engraved one of Rops's works without his permission—Théodore Hannon, *Rimes de joie* (Brussels: Gay and Doucé, 1881).

46. Rops wrote: "—Si l'on saississait cette planche comme contraire aux moeurs,—ce que arriverait l'auteur du dessin & l'éditeur seraient mis en jeu & traduits, vous, vous resteriez à l'abri. C'est trop facile. *Mais cela ce paraîtra pas je vous l'affirme.* Même en supposant, ce que je ne crois pas, que vous ne fassiez rien pour vous opposer à sa publication." [If this plate was seized on as being prejudicial to public morals, what would happen is the publisher and the artist would be the ones to be targeted and prosecuted, while you would be in the clear. That's far too convenient. *But I tell you, it will never be published.* Even supposing—which I don't believe—that you are doing nothing to oppose publication.] Ibid., letter 103, 219. Letters 104, 105, and 107 continue the discussion, with Rops's explanation of how he reoriented the serpent's head.

47. See "F. Rops jugé par les Catholiques," an extract from the *Journal de Bruxelles* dated June 22, 1890, reprinted in a special volume of *La Plume* completely dedicated to Rops, *La Plume* 172 (June 15, 1896): 453–54. On the appearance of Rops before tribunals in Brussels, see Henry Detouche, *Les peintres de la femme intégrale: Félicien Rops et A. Willette* (Paris: A. Blaizot, 1906), appendix, 159.

48. This work is no. 342 in *Félicien Rops: 1833–1898,* exh. cat. (Brussels: Centre culturel de la Communauté française/Les Musées Royaux des Beaux-Arts de Belgique, 1985).

49. Emile Verhaeren, in a tribute section entitled "A Félicien Rops," in Pierre Caume, *Les Ropsiaques* (Paris, 1890), unpaginated.

50. Joséphin Péladan, "Félicien Rops, L'oeuvre et l'homme," *La Revue de Paris,* July–Aug. 1904, 333.

51. In the series "Leurs péchés véniels" published in *La Vie Parisienne* were "Le mensonge," July 18, 1896, 414–15; "La jalousie," Oct. 3, 1896, 572–73; and "L'hypocrisie," May 22, 1897, 298–99. The series "Leurs péchés capitaux" as originally published in *La Vie Parisienne* included "Orgueil," Oct. 5, 1895, 572–73; "L'avarice," Nov. 30, 1895, 684–5; "La luxure," Jan. 1896; "L'envie," Feb. 22, 1896, 103–4; "La colère," Mar. 21, 1896, 160–61; "La gourmandise," Apr. 1896; and "La paresse," May 16, 1896, 280–81. The advertisement for the album appeared Dec. 4, 1897, 700.

52. Edouard de Pompéry, *La femme dans l'humanité: Sa nature, son rôle, et sa valeur sociale* (Paris: Hachette, 1864), 14.

53. On the medical implications of the "corps de la pécheresse," see Yvonne Knibiehler and Catherine Fouquet, *La femme et les médecins: Analyse historique* (Paris: Hachette, 1983), 47–62.

54. Pol de Saint-Merry, *Petite bibliothèque du coeur* (Paris: H. Geffroy, c. 1898). The twelve volumes were: 1. *La femme;* 2. *L'amour;* 3. *La jalousie;* 4. *Les baisers;* 5. *La beauté;* 6. *Le coeur;* 7. *Le péché;* 8. *L'amante;* 9. *L'épouse;* 10. *Pécheresses;* 11. *L'adultère;* and 12. *Le Divorce.* Saint-Merry mentions Zola's *La terre* (1887) in *Pécheresses,* which suggests that the date c. 1898, determined by the Bibliothèque Nationale, is fairly accurate.

55. Pol de Saint-Merry, "Le péché," *Pécheresses,* 6.

56. Ibid., 10.

57. Honoré de Balzac, *Une fille d'Eve,* trans. Clara Bell and R. S. Scott (Philadelphia: John D. Morris, 1897), xii.

58. Ibid., 32.

59. Ibid., 27.

60. Ibid., 42.

61. The polarization of masculinity and femininity in Balzac's *La comédie humaine* is discussed by Martha Niess Moss in "Balzac's Villains: The Origins of Destructiveness in *La Comédie Humaine,*" *Nineteenth-Century French Studies* 6, nos. 1, 2 (Fall–Winter 1977–78): 36–51. However, *Une fille d'Eve* is not among the Balzac stories discussed.

62. P. J. Martin and L. J. Larcher, *Anthologie satirique: Le mal que les poètes ont dit des femmes* (Paris: Hetzel, 1858).

63. Ibid., 8 (first quote), 18 (second quote).

64. Ibid., 22.

65. Ibid., 32.

66. Charles Valette, *Les filles d'Eve* (Paris: G.-A. Pinard, 1863). Valette's use of rhyming verse was satirized in a review that appeared in *Le Hanneton,* Jan. 4, 1863, 3. The author of the review (identified only as "Puck") also pointed out the apparent contradiction between Valette's title and his intended audience.

67. The latter edition appeared without the explicatory preface, suggesting that Houssaye's intentions were already clear to later audiences.

68. Bois's oeuvre includes the "études sociales" *Les petites religions de Paris* (1894), *Le satanisme et la magie* (1896), and *L'Eve nouvelle* (c. 1896), and the novels *L'éternelle poupée* (1894), *La douleur d'aimer* (1896), *La femme inquiète* (1897), and *Une nouvelle douleur* (1900). Karen Offen has incorrectly characterized *L'Eve nouvelle* as "a mystico-romantic" novel, in "Depopulation, Nationalism, and Feminism in Fin-de-Siècle France," *American Historical Review* 89 (1984): 648–76.

69. Jules Bois, "La guerre des sexes," *La Revue Blanche* 9, no. 81 (Oct. 15, 1896): 363–68; Jules Bois, "La femme nouvelle," *La Revue Encyclopédique* 6 (1896): 832–40.

70. Bois, *L'Eve nouvelle,* 1.

71. Ibid., 3.

72. Ibid., 4.

73. Much of the proceedings was published as *Congrès français et international du droit des femmes* (Paris: Dentu, 1889).

74. Bois, *L'Eve nouvelle,* 7.

75. Ibid., 23; see also 358n.

76. Ibid., 77.

77. Ibid., 90.

78. Ibid., 91.

79. Ibid., 103.

80. Bois, *La femme inquiète,* v. Bois titled the second part of this text "Genèse de la femme-nouvelle."

81. The novel was reviewed by François Coppée (*Le Journal*), Maurice Guillemot (*Gil Blas*), Claude Frollo (*Petit Parisien*), Albert Monniot (*Libre Parole*), and Adolphe Brisson (*Annales politiques et littéraires*).

82. *Le couple futur* attacked the double standard and the inequality inherent in contemporary notions of love and marriage.

83. Jules Bois, *Le couple futur* (1912), notations on the "ouvrages de Jules Bois," inside cover.

84. "L'Eve future," *La Vogue,* May 13, 1886, 170–75. For a modern translation of the novel, see

Auguste Villiers de l'Isle-Adam, *Tomorrow's Eve,* trans. Robert Martin Adams (Urbana: University of Illinois Press, 1982, 2001).

85. "Les livres—L'Eve future," *La Vogue,* June 28–July 5, 1886, 357–60.

86. Émile Pierre, "L'Eve future par Villiers de l'Isle-Adam," *Le Chat Noir,* May 29, 1886, 712.

87. Villiers de l'Isle-Adam, "Fragments inédits de L'Eve future," *Mercure de France,* Jan. 1891, 1–16.

88. See Marie Hope Lathers, "Villiers de l'Isle-Adam's *L'Eve future:* Sculpture, Photography, and the Feminine" (Ph.D. diss., Brown University, 1990). Lathers recounts recent reevaluations of the meaning and significance of the text, which have turned to a consideration of the gendering of the robot Hadaly. Lathers sees Hadaly as having a more complex heritage than Eve, being fashioned with the participation of four male and four female characters: "Edison, who builds her; Ewald, whose belief allows her to exist; Edward Anderson, whose tragic affair with a femme-fatale induced Edison to begin constructing a race of gynecoids[,] and Martin, Edison's assistant (largely absent from the text); Alica, whose positivism pairs her (although uncomfortably) with Edison; Hadaly, Ewald's new love; Evelyn Habal, Anderson's poisonous courtesan[,] and Any Sowana (formerly Annie Anderson), like Martin an assistant to the scientist" (42–43).

89. Esther Rashkin, "The Phantom's Voice," in *A New History of French Literature,* ed. Denis Hollier (Cambridge, Mass.: Harvard University Press, 1989), 805. The idea of the body's being a type of "machine" was not new, and was likely stimulated by anatomical studies. Julien Offroy de la Mettrie's *L'homme-machine* had already put forth this type of argument in 1748.

90. Villiers de l'Isle-Adam, *Tomorrow's Eve,* 36 ("living hybrid"); the puppet-like quality of the profession of singing is discussed on page 41; Ewald's predicament is described on page 43.

91. See Henri Demarest, *La femme future* (Paris: V. Havard, 1890).

92. Jean Floux, "Les filles d'Eve," *Gil Blas Illustré,* Dec. 20, 1891, 2–3.

93. Marie Krysinska, "I. Eve, II. Hélène, III. Magdelaine," *Revue Indépendante,* Jan. 1890, 442–47.

94. Reviews of the play included those by Jacques de Tillet, "Théâtres," *Revue Bleue,* Mar. 23, 1895, 379–82, and Jacques des Gachons, "Autour des Théâtres," *L'Ermitage,* Apr. 1895, 240. The play was published in *La Revue des Deux-Mondes,* June 1, 1899.

95. See Willa Z. Silverman, *The Notorious Life of Gyp: Right-Wing Anarchist in Fin-de-Siècle France* (New York: Oxford University Press, 1995), and Patricia Ferlin, *Gyp: Portrait fin-de-siècle* (Paris: Indigo/Côté-femmes, 1999). Gyp polarized society with her personality and writings. People loved her or despised her. At her death, the American journalist Janet Flanner credited her with detailing the "rise of the impolite modern generation with its uncorseted jeunes filles and its divorcing duchesses" (Silverman, *Notorious Life,* 222). "Gyp's case exemplifies the new nationalist formula of the late nineteenth century—authoritarian, populist, anti-Semitic, drawing strength from both Right and Left. . . . It was Gyp's class and eclectic political background that partly conditioned her reaction against the grounding of a liberal and democratic bourgeois republic, lead to her defense of traditional institutions as bulwarks against social decay, and explained her attraction to ambiguous populism—all features of this revolutionary Right. And it was her complex relation to her gender that channeled itself, to a certain extent, into both a call for a strong, male authority, and, at the same time, a vindication of the rights of the oppressed against such authority—again features of the Right" (ibid., 223).

96. Gyp, "La femme de 1885," reprinted in *Le Figaro,* July 16, 1932, from a manuscript in a private collection.

97. "L'Eve Future," *Journal des Femmes* 33–34 (1894): 1.

98. Marcelle Tinayre, "La révolte d'Eve," *La Fronde,* Sept. 5, 1898, 2; Sept. 6, 1898, 2; Sept. 7, 1898, 2.

99. Maria Martin, "Eve dans l'humanité," *Journal des Femmes* 104 (1900): 3.

100. J. Beauduin, "Eves parisiennes," *Paris s'Amuse,* Apr. 14, 1883, 376–77.

101. The loss of grace and charm suffered by women who wore masculine clothing is described in many journal articles. See, for instance, Jack, "Les femmes en hommes," *Le Charivari,* July 26, 1880, 2; Arsène Alexandre, "Les déféminisées," *Le Figaro,* Mar. 12, 1897, 1; the anonymous "Les

pantalons réhabilités et le manifeste féminin," *La Revue des Revues* 7 (1893): 635; and Victor Jozé, "Le féminisme et le bon sens," *La Plume,* Sept. 15, 1895, 1–2.

102. "Nos Dessinateurs: Henri Gray," *Le Courrier Français,* Dec. 7, 1884, 3. The article also states: "Henri Gray a pris le genre Grévin. De là un atroce jeu de mots. On craignait que Grévin meure sans élève. Mais heureusement Henri *Gray vint.*" [Henri Gray has followed in the footsteps of Grévin. This has led to an atrocious pun. There was a fear Grévin would die leaving no pupil and heir, but, happily, Henri Gray arrived on the scene.] The pun linked the name "Grévin" and the phrase "Gray vint" [Gray arrived], both pronounced similarly in French; Gray was a pseudonym of Henri Boulanger.

103. "Nos dessinateurs par eux-mêmes," signed "Parisiana, pour copie conforme: H. Gray" [*Parisiana,* certified as accurate: H. Gray]. *Le Courrier Français,* July 19, 1885, 2.

Chapter 2: Artificial Paradise

1. The image belongs to a series called "Fantaisies parisiennes."

2. G.-A. de Caillavet and Robert de Flers, quoted in Georges Gillard, *Le livre de la femme et de l'amour: Aphorismes et réflexions des plus notoires écrivains contemporains* (Paris: Flammarion, 1924), 51.

3. Jean Delumeau, *History of Paradise: The Garden of Eden in Myth and Tradition* (New York: Continuum, 1995), 134–37. Delumeau is concerned with texts to 1800 that attempt to locate Paradise. There was continued interest in this during the nineteenth century; see "L'emplacement du paradis terrestre," *La Revue des Revues* 1 (1890): 99.

4. On the implications of the body of Eve before and after the Fall, see Margaret R. Miles, *Carnal Knowing: Female Nakedness and Religious Meaning in the Christian West* (Boston: Beacon, 1999), esp. chapter 3.

5. George H. Tavard, *Woman in Christian Tradition* (South Bend, Ind.: University of Notre Dame Press, 1973), 130.

6. Alphonse Karr, *Encore les femmes* (Paris, 1858), 312.

7. Ibid., 312–13.

8. The text is not dated but has been determined to be earlier than 1870; see Jean-Pierre Fontaine, *La vie tumultueuse d'Alfred Grévin* (Paris: Zélie, 1993), 176. I agree with his estimation. It must be dated after 1862, since Flaubert's *Salammbô* is mentioned. The sequencing of the costumes ends with Second Empire representations, hence the estimated date of 1870.

9. The success of Grévin's costumes is recorded by Arnold Mortier, in his series *Les soirées parisiennes,* which appeared each year as a diary of theatrical performances and various events. A description of the play *Les hannetons* states that the costumes "sont de Grévin—c'est tout dire" [are by Grévin—which says it all] (*Les soirées parisiennes,* Apr. 23, 1875, 269).

10. "Nouvelles," *L'entr'acte,* June 30, 1876, 2. The charge was that the type was an outrage to societal morals.

11. Achille Denis, review of *Les jolies filles de Grévin,* in the column "Théâtre des Variétés," *L'Entr'acte,* July 6, 1876, 2. Pierre Véron reviewed the play in *Le Charivari,* where it didn't inspire a discussion of the women themselves; the review focused on the popularity of Grévin.

12. Denis, review of *Les jolies filles de Grévin,* 2.

13. Ibid.

14. Victor Hugo's thoughts about the artist are recorded in Félicien Champsaur, *Le massacre* (Paris, 1885), 312.

15. John Grand-Carteret, "Grévin et le genre Grévin," *Revue Encyclopédique* 2 (1892), col. 857.

16. Flaubert's *Salammbô* is an exotic woman who performs erotic dances with the help of a large snake she loves. See Gustave Flaubert, *Salammbô* (Paris, 1862). This text is discussed further in chapter 8.

17. Quoted in Sima Godfrey, "Haute Couture and Haute Culture," in Hollier, *New History of French Literature,* 764.

18. Ibid., 765.

19. Ibid.

20. See, for example, Uzanne's *La femme et la mode: métamorphoses de la Parisienne de 1792 à 1892: Tableau des moeurs et usages aux principales époques de notre ère républicaine* (1892) and *Les ornements de la femme: L'éventail, l'ombrelle, le gant, le manchon* (1892).

21. As noted earlier, the book, which I refer to as *Parisiennes de ce temps,* appeared first in 1894 and again, in an expanded edition, in 1910. The later edition contains an expanded discussion of fashion.

22. Uzanne, *Parisiennes de ce temps,* 13–14.

23. Ibid., 23.

24. Ibid., 28–29.

25. Ibid., 30.

26. Ibid., 346.

27. Ibid., 348.

28. Max Nordau, *Degeneration* (Lincoln: University of Nebraska Press, 1993), 8.

29. Georg Simmel, "Fashion," *International Quarterly* 10 (Oct. 1904): 133. The essay appeared in German as *Philosophie der mode* (Berlin: Pan, 1905).

30. Simmel, "Fashion," 133.

31. Ibid., 135.

32. Ibid., 139.

33. Ibid., 145.

34. Ibid., 146.

35. Ibid., 151.

36. Guillaume Ferrero, "La psychologie du vêtement," *La Nouvelle Revue* 86 (1894): 776.

37. Ibid., 776–77.

38. Ibid., 778.

39. Ibid., 785.

40. Gomez Carrillo, "Psychologie de la mode," *Revue Bleue,* Feb. 19, 1910, 241–44.

41. Ibid., 242.

42. De Banville wrote, "Donc, cher lecteur, regarde passer, au bruit du satin qu'on froisse et au bruit de l'or, pudiques et amoureuses, et insolentes et souverainement maîtresses des élégances, les Parisiennes de Paris, ces femmes mystérieuses dont les toutes petites mains déplacent des montagnes" [And so, dear reader, watch them go by in a rustle of satin and a clinking of gold, modest and amorous, the insolent, tyrannical arbiters of elegance, the *Parisiennes* of Paris, these mysterious women whose cute little hand can move mountains]. Théodore de Banville, *Esquisses parisiennes* (Paris: Charpentier, 1876), 2.

43. Ibid., 5.

44. M. Le Vicomte de Marennes, *Manuel de l'homme et de la femme comme il faut* (Paris, 1855), 6 (comments about love and elegance), 27 (four characteristics given).

45. Ibid., 50.

46. Ibid., 58–59. There De Marenne wrote, "La première et la plus impérieuse est ce besoin d'égalité qui dévore tous les orgueils et dont la susceptibilité ridicule commence à dégénérer en monomanie; la seconde, et la plus dangereuse, parce qu'elle explique l'autre misérablement, est ce besoin de luxe qui bouleverse toutes les classes, luxe risible, d'un anachronisme monstrueux, qui ne s'accorde avec rien dans notre siècle et qui semble n'avoir d'autre but que de faire ressortir la mesquinerie de nos fortunes, la bourgeoisie de nos moeurs, la grossièreté de nos manières et l'inconséquence de nos institutions. Voulez-vous savoir ce qu'il font, nos parvenus, aussitôt qu'ils ont gagné de l'argent?" [The first and most imperious is this passion for equality which swallows all pride and whose ridiculous susceptibility begins to degenerate into monomania. The second, and the more dangerous because it explains the other in such wretched terms, is the quest for luxury that is disrupting every class-a risible luxury, monstrously anachronistic, completely incongruous in this century and seemingly with no other aim than to emphasize the meanness of our fortunes, the bourgeois nature of our moral, the grossness of our manners and the insignificance of our institutions. Would you like to know what these parvenus of ours do as soon as they've made their money?]

47. Emmeline Raymond, *Le secret des Parisiennes, suivi de mélanges* (Paris: Firmin Didot, 1866), 4.

48. Charles Baudelaire, "The Painter of Modern Life," reprinted in *The Painter of Modern Life and Other Essays,* ed. and trans. Jonathan Mayne (London: Phaidon: 1964), 1–40.

49. Rosalind Williams, *Dream Worlds: Mass Consumption in Late Nineteenth-Century France* (Berkeley: University of California Press, 1982), 67.

50. See Emile Zola, *Au bonheur des dames* (Paris, 1883). I cite in subsequent notes the 1992 English translation; see Emile Zola, *The Ladies' Paradise,* introduction by Kristin Ross (Berkeley: University of California Press, 1992). Zola's original notes on the appearance and activity of Le Bon Marché are found in the Bibliothèque Nationale, Départment des manuscrits, NAF 10277, 10278.

51. Rachel Bowlby, *Just Looking: Consumer Culture in Dreiser, Gissing, and Zola* (New York: Methuen, 1985), 66.

52. Philippe Perrot, *Fashioning the Bourgeoisie: A History of Clothing in the Nineteenth Century* (Princeton: Princeton University Press, 1994), 63.

53. Zola, *Ladies' Paradise,* 70.

54. Ibid. Zola wrote, "All difference of sex disappeared" (100), and, further, "They were all nothing but the wheels, turned round by the immense machine, abdicating their personalities, simply contributing their strength to this commonplace, powerful total. It was only outside that they resumed their individual lives, with the abrupt flame of awakening passions" (119).

55. Zola's *Ladies' Paradise* describes these strategies (8).

56. Rémy G. Saisselin, *The Bourgeois and the Bibelot* (New Brunswick, N.J.: Rutgers University Press, 1984), 39.

57. Alexandre Weill, *Un fléau national: Les grands magasins de Paris* (Paris, 1888).

58. Jean-Paul Nayrac, *Grandeur et misère de la femme: Etudes de psychologie normale* (Paris: A. Michalon, 1905), 107.

59. Zola, *Ladies' Paradise,* 234. This is but one of many similar references.

60. "Le mécanisme de la vie moderne" was the collective title of the articles, which appeared during 1894–1905. They were also published in book form in several editions. The department stores were the subject of the July 1894 article (329–69).

61. Pierre Giffard, *Les grands bazars* (Paris, 1882), 6, translated and reprinted in Perrot, *Fashioning the Bourgeoisie,* 63.

62. Sahib's "Leur enfer sur la terre" appeared in *La Vie Parisienne,* Feb. 5, 1898, 76–77.

63. The females typically depicted by Robida were dubbed *épinglées*—compared to the *cocottes* drawn by Grévin. Champsaur explained that the épinglée "croit un peu à l'argent, beaucoup aux louis, passionnément aux billets de banque. . . . la cocotte de Grévin a des tendresses soudaines et des béguins impromptus, tandis que l'épinglée de Robida est une femme menant bient son affaire sans se laisser distraire, malgré des sentimentalités niaises" [believes a little in money, a lot in gold *louis,* and passionately in banknotes. . . . Grévin's *cocotte* has sudden crushes and passions, whilst Robida's *épinglée* runs her business efficiently without letting herself be distracted, despite certain silly sentimentalities]. Félicien Champsaur, "Albert Robida," *Les Contemporains* 24, p. 1; the same article is reprinted in Champsaur's *Le Cerveau de Paris* (Pairs: E. Dentu, 1886), 250–55.

64. Gomez Carrillo, "Psychologie de la mode," *Revue Bleue,* Mar. 12, 1910, 343. Articles in the same series appeared on Feb. 19, Mar. 5, Mar. 19, and Mar. 26 of the same year.

65. Zola, *Ladies' Paradise,* 68.

66. Ibid., 69.

67. Ibid., 17.

68. Bowlby, *Just Looking,* 66.

69. *La Vie Parisienne,* Oct. 4, 1879, 584–85.

70. Ross, introduction to Zola, *Ladies' Paradise,* xii.

71. Brada, "Flânerie de femme," *La Vie Parisienne,* June 21, 1879, 362.

72. Giffard, *Les grands bazars,* 108–13.

73. Zola, *Ladies' Paradise,* 279.

74. The Jacobins made the original decree regarding groups on Oct. 20, 1793. This was followed by a decree in May 1795 that effectively excluded women from all aspects of public life. See Claire

Moses, *French Feminism in the Nineteenth Century* (Albany: State University of New York Press, 1984), 13–14.

75. "Scènes de Paris.—Une séance du club des femmes dans l'église Saint-Germain-l'Auxerrois (D'après nature, par M. Lix)," *Le Monde Illustré,* May 20, 1871, 312.

76. Juliette Adam, in a letter to Alphonse Karr, then editor of *Le Siècle,* complained that "la mode d'aujourd'hui, quand on la verra dans les receuils, sera une des premières entre les plus ridicules et entre les plus cocasses qui aient jamais enlaidi les femmes. . . . Ceux que nous portons aujourd'hui, il ne faut pas qu'ils rendent difformes et grotesques" [today's fashions, when viewed in retrospect, will be seen as in the first rank of the most ridiculous and comical ever to have disfigured women. . . . Those we wear today must not make us look ugly and misshapen] (Feb. 20, 1856, 1–2). While Adam was complaining at this particular date about crinolines that made sitting and moving about nearly impossible, the corset, bustle, and tight-fitting skirts that would subsequently come into fashion were also decried by feminists, who chose simple, functional, comfortable clothing.

77. Baron Marc de Villiers, *Histoire des clubs de femmes et des légions d'amazones, 1793-1848-1871* (Paris: Plon-Nourrit, 1910).

78. "Les clubs de femmes," *L'Etoile,* May 10, 1871, 2.

79. "Le club des femmes (Projet)," *La Vie Parisienne,* Mar. 15, 1879, 141–44.

80. "Le club des femmes, quelques lettres" appeared in *La Vie Parisienne,* Apr. 5, 1879, 183–87.

81. Ibid.

82. "La dernière séance du club des femmes" appeared in *La Vie Parisienne,* Apr. 3, 1880, 185–89.

83. See, for example, Zed, "Femmes du monde," *La Vie Parisienne,* Dec. 17, 1887, 703–5; Modica, "Femme du monde," *La Vie Parisienne,* Sept. 19, 1891, 523-424.

84. Draner, "Mon ladies club," *Le Charivari,* 1896, Sept. 24, 3. For additional descriptions of these organizations, see Chamillac, "Les Clubs Parisiens et le suffrage universel," *Le Figaro,* Jan. 7, 1896, 1, and Courtavont, "Au Ladies' Club," *Le Figaro,* Jan. 23, 1897, 1.

Chapter 3: Decadent Addictions

1. This description includes works like Edouard Manet's *Absinthe Drinker,* which was rejected at the 1859 Salon for (as the official story goes) awkward handling of the paint. However, given Manet's ability to point out social ills in advance of the consuming public's wish to be confronted by them, perhaps the subject matter itself played a part in the decision to reject it. While well accustomed to pictures of peasants (even drunk ones) from Dutch and Spanish seventeenth-century painters like Frans Hals and Diego Velasquez, the French public was ill prepared for a modern indigent figure drawn from their own midst. A good example of a work focused on removing alcoholism as a threat to men and their families is Juste Baudrillard's *Histoire d'un bouteille: Livre de lecture sur l'enseignement anti-alcoolique: à l'usage des cours moyen et supérieur des écoles primaires* (Paris, 1898). Illustrated by Jean-Jules Geoffroy (1853–94), this work recorded the downward spiral of individuals (men), families, and society as they came into contact with "the bottle." This book was intended as a teaching tool to prevent alcohol abuse by young children. Baudrillard was Inspecteur de l'enseignement primaire for Paris.

2. On the history of absinthe and the images associated with it, see Marie-Claude Delahaye, *L'absinthe: Histoire de la fée verte* (Paris: Berger-Levrault, 1983); Delahaye, *L'absinthe: Art et histoire* (Paris: Editions Trame Way, 1990); and Barnaby Conrad III, *Absinthe: History in a Bottle* (San Francisco: Chronicle, 1988). Each of these contains many images and much valuable information but little contextual analysis and documentation. See also Doris Lanier's brief study *Absinthe: The Cocaine of the Nineteenth Century* (Jefferson, N.C.: McFarland, 1995). On the representation of women in tobacco advertisements, see three articles written by Dolores Mitchell: "The Iconology of Smoking in Turn-of-the-Century Art," *Source* 6, no. 3 (Spring 1987): 28–33; "Images of Exotic Women in Turn-of-the-Century Tobacco Art," *Feminist Studies* 18, no. 2 (Summer 1992): 327–50; and "Power and Pleasure in Nineteenth-century Tobacco Art," in *Tobacco and Health,* ed. Karen Slama (New York: Plenum, 1995), 921–24.

3. Conrad summarizes the fight to abolish absinthe consumption on pages 4–7 of his *Absinthe*.

4. On the fear generated by a preponderance of alcoholics and by gatherings of groups of women, see Susanna Barrows, *Distorting Mirrors: Visions of the Crowd in Late Nineteenth-Century France* (New Haven: Yale University Press, 1981), esp. chapter 2, "Metaphors of Fear: Women and Alcoholics," 43–72.

5. Quoted in Patricia E. Prestwich, *Drink and the Politics of Social Reform: Antialcoholism in France since 1870* (Palo Alto, Calif.: Society for the Promotion of Science and Scholarship, 1988), 20.

6. See Dr. Bénédict A. Morel, *Traité des dégénérescences physiques, intellectuelles, et morales de l'espèce humaine* (Paris, 1857). Morel counted among his credentials being Médicin en chef de l'Asile de Saint-Yon, Ancien médecin en chef de l'Asile de Maréville, and Lauréat de l'Institut (Académie des sciences). See also Allan Mitchell, "The Unsung Villain: Alcoholism and the Emergence of the Public Welfare in France, 1870–1914," *Contemporary Drug Problems* (Fall 1986): 450–51.

7. Louis-François-Etienne Bergeret, *De l'abus des boissons alcooliques; dangers et inconvénients pour les individus, la famille et la société; Moyens de modérer les ravages de l'ivrognerie* (Paris, 1870), ii–iii. See also Dr. Etienne Lancereaux, "De l'alcoolisme et de ses conséquences au point de vue de l'état physique, intellectuel, et moral des populations," *La Tempérance* 6 (1878): 270–308; and Mathieu-Jules Gaufres, "L'alcoolisme," *Conférences pour les adultes* (1899): 49–58, where definitions of psychological, moral, and social effects of alcohol are given. Alcohol here is also declared "a poison" and deemed responsible for the degeneration of the race.

8. Bergeret, *De l'abus des boissons*, 51. See also Maurice Yvernès, "Documents statistiques relatifs à l'influence de l'alcoolisme sur la criminalité," *La Tempérance* 1, 2nd ser. (1880): 259–67; and Dr. de Vaucleroy, *Des boissons spiritueuses et de leurs dangers* (Brusssels, 1888). On the connection of alcoholism and crime, see Nye, *Crime, Madness, and Politics*, esp. ch. 5, "Metaphors of Pathology in the *Belle Epoque*: The Rise of a Medical Model of Cultural Crisis," 132–70.

9. Bergeret, *De l'abus des boissons*, 156.

10. A. Mitchell, "Unsung Villain," 452.

11. René Lavollée, *Les fléaux nationaux: Dépopulation, pornographie, alcoolisme, affaissement moral* (Paris: F. Alcan, 1909), 13 (statistics), 45. See also Jacques Roubinovitch, "Alcoolisme et morphinisme en pathologie mentale," *Le Bulletin Médical* 57 (July 21, 1900): 664.

12. Dr. Henry Cazalis, *La science et le mariage: Etude médicale* (Paris: Doin, 1900), 97.

13. Ibid., 99. On hysteria during this period and its connection to the politics (historical and gender-related) of the Third Republic, see Jan Goldstein, "The Hysteria Diagnosis and the Politics of Anticlericalism in Late Nineteenth-Century France," *Journal of Modern History* 54 (June 1982): 209–39; and Elaine Showalter, "Hysteria, Feminism, and Gender," in *Hysteria beyond Freud*, ed. Sander Gilman (Berkeley: University of California Press, 1993), 286–344.

14. "L'alcoolisme," *Cravache Parisienne*, Nov. 12, 1887, 2.

15. "L'alcoolisme à Paris" (in Variétés column), *L'Alcool*, Oct. 1896, 157. Dr. Paul Maurice LeGrain, the driving force behind the magazine and the author of this piece, claimed that by this time the number of women alcoholics was very nearly equal to the number of men who were alcoholics.

16. A. Mitchell, "Unsung Villain," 449.

17. Raymond de Ryckère, *La femme en prison et devant la mort; L'alcoolisme féminin; Etudes de criminologie* (Lyon: A. Storck, 1898), 361.

18. Emile Duclaux, *L'hygiène sociale* (Paris: F. Alcan, 1902), 192.

19. Ibid., 193.

20. Ibid.

21. Dr. Paul Maurice LeGrain, "A la femme française!" *L'Alcool*, Apr. 1896, 50–52.

22. Dr. Paul Maurice LeGrain, "Notre profession de foi," *L'Alcool*, Sept. 20, 1896, 129. LeGrain's declaration begins: "Réjouissez-vous, cabaretiers, et vous de même, beuveurs [*sic*] très illustres! Le temps n'est pas encore venu où vous pourrez nous craindre. La discorde est au camp des tempérants." [Rejoice, innkeepers, and you too, most illustrious drinkers! The time has not yet come to fear us! There is discord in the camp of the temperate.]

23. Alcohol consumption had also increased by an alarming rate: to 4.5 liters per week, per capita, in 1892, from 1.5 liters in 1830. Mme J. Hudry-Ménos, "L'alcool," parts 1, 2, 3, *La Fronde,* Jan. 2, 3, 4, 1898, 2. See also Savioz, "Les femmes et l'alcoolisme," *La Fronde,* Apr. 11, 1899, 2–3, for more information about the temperance movement and women's organizations' roles in it.

24. LeGrain, quoted in Hudry-Ménos, "L'alcool," Jan. 4, 1898.

25. Caen's poem read in part:

Et c'est toi ce poison, absinthe généreuse,
Toi la liqueur de feu, couleur d'espoir divin,
Toi qui a su adoucir ma plainte douloureuse
D'un baume qu'ignora la caresse du vin!

[You, that poison, noble absinthe,
You, O fiery liquor, color of hope divine,
You who were able to lighten my sad complaint
With a balm unknown to the gentler touch of wine!]

 Henri Caen, "A l'absinthe," *Le Courrier Français,* 1893, reprinted in Delahaye, *L'absinthe: Art et histoire,* 72.

26. Vicomte G. D'Avenel, *Le mécanisme de la vie moderne* (Paris: A. Colin, 1906), 153.

27. Dr. Motet, *Considérations générales sur l'alcoolisme et plus particulièrement des effects toxiques produits sur l'homme par la liqueur d'absinthe* (Paris, 1859).

28. Yves-Guyot, *La question de l'alcool: Allégations et réalités* (Paris: F. Alcan, 1917). See esp. chapter 8.

29. Dr. Paul Maurice LeGrain, "Un poison bien français," *L'Alcool,* Jan.–Feb. 1897, 4.

30. Ibid. See also Dr. Paul Maurice LeGrain, "Les homicides commis par les absinthiques," *L'Alcool,* May 1897, 62–63.

31. LeGrain, "Un poison bien français," 5.

32. For instance, see Spire Blondel, *Le livre des fumeurs et des priseurs* (Paris, 1891). Blondel links the popularity of smoking to the Romantic movement, interest in Spain, and especially to Hugo's drama *Hernani* (170). He also discusses details such as how cigarettes are rolled and smoked in Spain.

33. Ibid., 187.

34. Ibid., 287.

35. See Dr. A. Blatin, *Recherches physiologiques et cliniques sur la nicotine et le tabac* (Paris, 1870); D. E. Laurent, *Le nicotinisme* (Paris, 1893).

36. Louis-François-Etienne Bergeret, *Les passions, dangers, et inconvénients pour les individus, la famille et la société: Hygiène morale et sociale* (Paris, 1878), 203.

37. Dr. Paul Jolly, *Le tabac et l'absinthe* (Paris, 1887), 22. On the link between tobacco consumption and crime, see Dr. Hippolyte-Adéon Dépierris, *Le tabac, qui contient le plus violent des poisons: La nicotine. Abrége-t-il l'existence? Est-il cause de la dégénérescence physique et morale des sociétés modernes?* (Paris, 1876), 337, and Dr. E. Vallin, "Sur quelques accidents causés par le tabac," *Revue d'Hygiène* (1883): 223–37.

38. Dépierris, *Le tabac,* 209–11.

39. E. Decroix, "Le tabac et la dépopulation de la France," *Journal de la société de statistique de France* 32 (1891): 95–97.

40. Dépierris, *Le tabac,* 238.

41. Jolly, *Le tabac et l'absinthe,* 20. On smoking and memory loss, see also Blatin, *Recherches physiologiques,* 184.

42. Literature discussing the problem of smoking by women includes "Société de Médecine publique et d'hygiène professionnelle: Séance du 24 décembre 1879," *Revue d'Hygiène* (1880), vol. 1, 914; vol. 2, 35–38, 216–29. (This is a discussion of Dr. Decaisne's *Les femmes qui fument.*) Dépierris introduces the problem of smoking by children on pages 198–99 of *Le tabac.* See also Dr. G. Lecaisne, "Les enfants qui fument," *Revue d'Hygiène* (1883): 422–33.

43. Dépierris, *Le tabac*, 164.

44. See Hippolyte-Adéon Dépierris, *La prise de tabac: Son origine et ses effects; extrait de la physiologie sociale* (Paris: E. Dentu, 1882).

45. Jolly, *Le tabac et l'absinthe*, 22.

46. Dépierris, *Le tabac*, 297.

47. Villiers de l'Isle-Adam, *L'Eve future* (first quote), and Barbey d'Aurévilly, *Les diaboliques* (second quote), both quoted in Blondel, *Livre des fumeurs*, 264. Similar remarks appear in "Vive ou à bas le tabac?" *Le Charivari,* Apr. 18–19, 1892, 2–3. See also Louis Damaré, "Permettez-nous donc de fumer!" *L'Action Artistique,* May 1, 1897, 2.

48. Montjoy's poem reads in part:

Et pour que la voix du passé
Par une autre voix fût couverte,
L'impuissant avait épousé
Ce qu'il nommait la *Muse Verte*
Paradis artificiel!

[And so that the voice of the past
By another voice be drowned,
The powerless wretch espoused at last
His *Green Muse,* and thus he downed
An Artificial Paradise!]
 Quoted in Delahaye, *L'absinthe: Art et histoire,* 73.

49. Lanier, *Absinthe,* 1.

50. Dr. LeGrain, "Chansons a boire," *L'Alcool,* Jan. 20, 1896, 26. LeGrain added, "Les vers sont beaux, surprenants surtout, et si les pâleurs exquises du couchant ne gagnent rien à être comparées à l'absinthe, il est certain que l'absinthe y gagne beaucoup. Mais tout en goûtant cette poésie ne nous laissons pas bercer à son rhythme puissant. [The verses are beautiful, and, in particular, surprising, and if the delicate and exquisite hues of the sunset gain nothing from comparison with absinthe, it is certain that absinthe gains a lot. But while savoring this poetry, we must not let ourselves be lulled asleep by its powerful rhythm.]

51. Ibid., 25.

52. Jan Thompson, "The Role of Women in the Iconography of Art Nouveau," *Art Journal* 31, no. 2 (Winter 1971–72): 158.

53. Pamela Langlois, "The Feminine Press in England and France: 1875–1900" (Ph.D. diss., University of Massachusetts, 1979), 339. Subscription prices for *Le Moniteur de la Mode* ranged from sixteen francs to fifty-two francs. The price range can be explained in part by the fact that the color plates were optional and, since they were hand-colored, added substantially to the price. For subscribers who opted not to purchase the plates, there were black-and-white drawings and pattern details in the front of each issue.

54. For the medical interpretation, see Dr. J. V. Laborde, "Rapport au nom de la commission de l'alcoolisme sur les boissons spiritueuses, apértifs et leurs essences et produits composant les plus dangereux," *Bulletin de l'Académie de Médecine* 48 (1902): 685–712.

55. Blatin, *Recherches physiologiques,* 203.

56. Dépierris, *Le tabac,* 334, 493 (quote).

57. Dépierris wrote, "Mais si cette floraison de l'homme, comme la floraison des plantes (j'insiste sur cette comparaison, car dans la nature tout se ressemble), si cette floraison, dis-je, rencontre, tant qu'elle dure, un élément qui la stérilise, comme le brouillard des nuits stérilise la fleur; de même que la fleur stérilisée s'étiole sans parfum, l'homme à la floraison perturbée s'étiole sans amour. Eh bien! la floraison de l'homme, dans ses habitudes actuelles, s'étiole dans les fumées narcotiques du tabac. Voilà la cause de son indifférence sexuelle, de son égoïsme, de son manque d'amour." [But if this flowering of Man, like the flowering of plants (I insist on this comparison, for everything in Nature bears a mutual resemblance), if this flowering, I say, should at any time

be stricken by something which blights it—as night fogs blight a flower—just as the affected flower will open without scent, so a man whose flowering has been blighted will bloom without love. Alas! Man blossoms, given his present habits, amid the narcotic fumes of tobacco. Here is the cause of his sexual indifference, his egoism, his lack of love.] Ibid., 227–28.

58. Ibid., 229.

59. Ibid., 20.

60. See, for example, the illustration in Jack Rennert and Alain Weill, *Alphonse Mucha: The Complete Posters and Panels* (Boston: G. K. Hall, 1984), plate 15, 83.

61. Patricia G. Berman, "Edvard Munch's Self-Portrait with Cigarette: Smoking and the Bohemian Persona," *Art Bulletin* 75, no. 4 (Dec. 1993): 638–39.

62. Figuier quoted in Blondel, *Livre des fumeurs,* 243.

63. D. Mitchell, "Iconology of Smoking," 28.

64. Laurent, *Le nicotinisme,* 133. "'On dit que le tabac est un anaphrodisiaque,' ont écrit les frères de Goncourt; 'la matérialité d'une femme est bien peu de chose près de la spiritualité d'une pipe.' Ce n'est là qu'un élégant paradoxe, et je croirais volontiers que le tabac, comme la morphine, l'alcool et le café, a une action stupéfiante sur le sens génital, qu'il paralyse ou au moins diminue singulièrement." ["It is said that tobacco is an anaphrodisiac," write the brothers Goncourt. "The material nature of a woman is a small thing compared with the spirituality of a pipe." This is but an elegant paradox, and I would willingly believe that tobacco, like morphine, alcohol and coffee, has a stupefying effect on the sexual instincts, which it paralyses, or at least diminishes considerably.]

65. Dr. A. Penoyée, "Le tabac," *Cravache Parisienne,* Sept. 29, 1887, 2.

66. Delores Mitchell interpreted Mucha's images further, suggesting that "the act of smoking was associated with male virility, with the expulsion of smoke and heat compared to sexual ejaculation" ("Iconology of Smoking," 28). While this is a valuable suggestion, it is supported by neither medical literature nor poetry sources. It is later Freudian assertions of the cigarette as phallic symbol that lead to speculation about ejaculatory smoke.

67. Illustrated in Lucy Broido, *The Posters of Jules Chéret* (New York: Dover, 1992), no. 868, 47.

68. Bergeret, *Les passions,* 260.

69. Ibid., 202.

70. J. Denis, "Cabaretisme et alcoolisme," *Les Annales antialcooliques* 1, no. 1 (June 1903): 16.

71. Quoted in Berman, "Edvard Munch's Self-Portrait," 630.

72. Bergeret, *De l'abus des boissons,* 233.

73. Jolly, *Le tabac et l'absinthe,* 170–78. Among his statistics are the following dramatic increases in cases of alcoholism in Paris: 1856 = 99, 1860 = 207, 1864 = 300, 1870 = 377. See also D. Mitchell, "Iconology of Smoking," 32.

74. Laurent, *Le nicotinisme,* 125.

75. Ibid., 272–73. Bergeret's opinion appears in his *De l'abus des boissons,* 233.

76. The *inviteuse* was mentioned in A. Delvau, *Dictionnaire de la langue verte* (Paris, 1867), as noted in Theresa Ann Gronberg, "Femmes de Brasserie," *Art History* 7, no. 3 (Sept. 1984): 336. The journal *La France Médicale* commented on the significance of Barthélemy's connection of alcohol to syphilis: "La stimulation, que reçoit la syphilis de l'alcool, se caractérise par plusieurs ordres de faits: marche accélérée de la maladie" [The encouragement that alcohol lends to syphilis exhibits itself in several ways: first, acceleration of its progress]. Review article, Barthélemy and Devillez, "Syphilis et l'alcool: Les inviteuses," *La France Médicale,* Feb. 28, 1882, 289.

77. T. Barthélemy, *Syphilis et la santé publique* (Paris: 1882), 19.

78. Didier Nourrisson, *Le buveur du XIXe siècle* (Paris: Albin Michel, 1990), 152. See also Nourrisson's doctoral thesis, "Alcoolisme et antialcoolisme en France sous la Troisième République: l'exemple de la Seine inférieure" (University of Caen, 1986).

79. Alfred Carel, in *Les brasseries à femmes de Paris* (Paris, 1884), 16. See also G. Macé, "Brasseries de femmes," *Le Charivari,* May 21–22, 1888, 2–3.

80. Léon Richer, "Les filles de brasseries," *Le Droit des Femmes,* Nov. 2, 1884, 166–68. See also Henry-Melchior de Langle, *Le petit monde des cafés et débits parisiens au XIXe siècle* (Paris: Presses Universitaires, 1990), and Gronberg's "Femmes de Brasserie," 329–44. Gronberg identifies a new

level of unlicensed prostitute, called an *apéritive* (she gets the definition from Delvau's *Dictionnaire de la langue verte*), who is the social butterfly of prostitution. Delvau calls her the caterpillar to the brilliant butterfly of the demi-monde. This type of social mobility was not possible within the regulated houses of prostitution (Gronberg, "Femmes de Brasseries," 334.) Gronberg talks about how a deposit was eventually required from customers in case they decided to leave with one of the waitresses. In addition, she notes that the women sometimes had to drink to fill their quota of drinks, as well as to get the men to drink more. (Some of the women would drink colored water.) But she has no sources for these facts (336).

81. Coville, article in *Le Triboulet,* Nov. 24, 1881, quoted in De Langle, *Le petit monde des cafés,* 144.

82. This statement is made based upon the breadth of written and visual resources I examined during my research for the current study.

83. For recent contributions to this debate, see Bradford R. Collins, ed., *Twelve Views of Manet's Bar* (Princeton: Princeton University Press, 1996). See also Novolene Ross, *Manet's Bar at the Folies-Bergère and the Myths of Popular Illustration* (Ann Arbor, Mich.: UMI, 1982).

84. See Ronald Pickvance, "L'Absinthe in England," *Apollo* 77 (May 1963): 395–98.

85. Ironically, Andrée rarely drank absinthe in her private life. In a 1921 interview with Félix Fénéon, she expressed her feelings about Degas's picture: "My glass was filled with absinthe. Desboutin had something quite innocuous in his . . . and we look like two idiots. I didn't look bad at the time, I can say that today; I had an air about me that your Impressionists thought 'quite modern,' I had chic and I could hold the pose as they wanted me to . . . But Degas—didn't he slaughter me!" Translated and quoted in Conrad, *Absinthe,* 53.

86. Dr. L. Martineau, *La prostitution clandestine* (Paris, 1885), 75, quoted in Gronberg, "Femmes de Brasserie," 333. Gronberg adds that woman is seen as a spider because of spiders' predatory nature, and the fact that some species kill the males after mating. But she overlooks the more specific connection of Hadol's image with the deadly nature of absinthe as a substance, despite the fact that she compares that image to Degas's *Au café.* She points out that Degas's portrayal of the woman drinking absinthe is in marked contrast to the bright, overdressed woman depicted in the satirical press.

87. Delahaye, *L'absinthe: Art et histoire,* 37.

88. André Gill, "L'heure de l'absinthe," reprinted in Delahaye, *L'absinthe: Art et histoire,* 43.

89. Reprinted in Delahaye, *L'absinthe: Art et histoire,* 44.

90. Gustave Geoffroy, "La bonne absinthe," *L'Alcool,* Sept. 1897, 129–30.

91. René Asse, "Absinthe," in column "Variété Littéraire," *L'esprit gaulois,* Dec. 22, 1881, 3, and Dec. 29, 1881, 4.

92. Henri Balesta, *Absinthe et absintheurs* (Paris, 1860), 49, reprinted in Delahaye, *L'absinthe: Histoire de la fée verte,* 81.

93. See Ronald Siegel and Ada Hirshman, "Absinthe and the Socialization of Abuse: A Historical Note and Translation," *Social Pharmacology* 1, no. 1 (1987): 1–12.

94. Apoux, "Absinthe," illustrated in Delahaye, *L'absinthe: Art et histoire,* 122.

95. Lanier, *Absinthe,* 1.

Chapter 4: Dangerous Beauty

1. There has been a persistent interest in prostitution as it existed in French society. Documents from the period include A. J. B. Parent-Duchatelet, *De la prostitution dans la ville de Paris* (Paris, 1837); Ferrero Lombroso, *Femme criminelle et prostituée* (Paris, 1896); and E. Dolléans, *La police des moeurs* (Paris, 1903). Many original documents are summarized in Dominique Dallayrac, *Dossier prostitution* (Paris: R. Laffont, 1966). Contemporary studies include Bernheimer's *Figures of Ill Repute* and Corbin's *Women for Hire.* The presence of prostitutes in Montmartre cafés was reported in "Les cafés des boulevards," *La Patrie en Danger,* Sept. 22, 1870, 1.

2. Charles Bernheimer, "Prostitution in the Novel," in Hollier, *New History of French Literature,* 780.

3. Ibid.

4. Ibid.

5. Ibid., 782–84. Bernheimer is speaking of *Madame Bovary* (1857), *Nana* (1880), and *Au rebours* (1884), respectively.

6. Camille Mauclair, *Etudes de filles: Quarante eaux-fortes originales et une couverture du peintre-graveur Lobel-Riche* (Paris: L. Michaud, 1910), 8.

7. Ibid., 12.

8. Ibid., 13.

9. Ibid., 13–14.

10. Ibid., 24–25.

11. Ibid., 30.

12. Pol de Saint-Merry, *Pécheresses,* 41.

13. Ibid., 47.

14. Ibid., 49.

15. Paul Bourget, *Physiologie de l'amour moderne* (Paris, 1890), 103.

16. Pol de Saint-Merry, *Pécheresses,* 61.

17. Ibid., 64–66.

18. Ibid., 90, 98.

19. Ibid., 110–11.

20. Catulle Mendès, "Antithèse ou nuance," *Gil Blas Illustré,* Mar. 5, 1897, 4–5.

21. Ibid.

22. While clearly related to the use of descriptive terms based on regional attributes to refer to various women (e.g., *Alsacienne* or even the common *Parisienne*), the use of *Montmartroise* was linked less to the appearance of women than to the characteristic pleasures, even vice, associated with Montmartre. Henry d'Erville preferred the term *montmartraise* to describe "des fillettes à l'air étique" [young, skinny-looking girls], and he concluded, "Sans doute, en veine d'épigrammes, / L'architecte, sur ta hauteur, / Montmartre! rêvait à tes femmes / Quand il bâtit le . . . Sacré-Coeur!" [Your architect, hill of Montmartre, / To forge an epigram, dear sir, / Was dreaming, I think, of your women / When he built . . . the Sacré Coeur!] "Montmartraise," *Le Chat Noir,* June 10, 1893, 2.

23. Homodel, "Les marges de l'histoire: Du cabaret à la brasserie," *La Vie Parisienne,* July 13, 1895, 404.

24. Happel's illustration appeared in the Sept. 1, 1894, issue. Happel was German-born but contributed illustrations to many French journals, including *Le Rire* and *Le Chat Noir.*

25. "Une soirée au Chat-Noir," *La Vie Parisienne,* Jan. 15, 1887, 36–37.

26. Gerbault's "Ah! les demi-vierges" appeared in *Gil Blas* on Feb. 9, 1896, 8. See also the special issue of *Le Courrier Français* titled *La revue des demi-vierges,* Aug. 11, 1895.

27. Début de La Forest, "Les vierges contemporaines," *Le Chat Noir,* Aug. 5, 1882.

28. Gautier's work appeared on Oct. 7, 1893, 3.

29. Lihou, "Léda," *Le Chat Noir,* June 2, 1894.

30. The popularity of Guilbert, and her characterization of various Montmartre venues, was a topic of Widhopff's "Au concert des ambassadeurs—Yvette Guilbert dans ses chansons," *Le Courrier Français,* July 3, 1898. See also Hugues Delorme's article "Pour un camarade," which places Guilbert in the role of "la divette," who is hailed after her performance by a personification of *Le Courrier Français,* with an illustration by Willette (*Le Courrier Français,* Apr. 24, 1898, 3).

31. Henri Rivière, "L'ancien Chat Noir," *Le Chat Noir,* June 13, 1885, 3.

32. See Raymond Verd'hurt, "Modernité," *Le Chat Noir,* Dec. 23, 1893; Despailles, "Le monsieur qui connaît les femmes," *Le Chat Noir,* May 27, 1882. See also Léon Maillard, "I. Femme du monde II. Bourgeoisie III. Femme du peuple IV. La balance," *La Plume,* May 1, 1892, 151.

33. Jean Lorrain, "Modernité," *Le Chat Noir,* Nov. 10, 1883, 2. "Modernité modernité! / A travers les cris, les huées / L'impudeur des prostituées / Resplendit dans l'éternité."

34. This illustration was one of three with commentary that appeared in *La Vie Parisienne* on Aug. 28, 1897.

35. For an example of how such a person was viewed by Montmartre writers, see Raymondo de Cazba, "Les Trotins [*sic*]," *Le Chat Noir,* Mar. 11, 1882, 2; M. Irlande, "P'tit Trottin," *Le Chat Noir,* May 5, 1894, 2; and Ferdinand Loviot, "Trottins," *Le Chat Noir,* Mar. 9, 1895, 4.

36. The first series appeared on June 3, 1893; the second series was published on Oct. 14, 1893.

37. The *fille de brasserie* appears in the second series (Oct. 14, 1893). "Pronostics: La joie des potaches; énorme dans sa robe de soie noire décolletée audacieusement en pointe. Abondantes promesses. Résultats: Tient plus encore qu'elle ne promet,—au point de vue de la quantité, mais non de la qualité,—le corset comprimant et servant également . . . d'ascenseur. Mais les très jeunes gens ne détestent pas ça." [Forecast: students' delight; enormous in her black silk robe, with its audaciously plunging V-neck. Abundant promises. Results: Produces even more than she promises—from the point of view of quantity, but not quality—her corset constraining her and also serving as . . . an elevator. But that's okay with the kids.]

38. Each of these provided an extensive investigation of types based on professions and class level, both masculine and feminine. See Nicolas-Edme Restif de la Bretonne, *Les contemporaines du commun, ou aventures des belles marchandes, ouvrières, &c. de l'âge présent* (1782); Sébastien Mercier, *Tableau de Paris* (1782); and *Les Français peints par eux-mêmes* (Paris: Philippart, 1861), 2 vols.

39. Uzanne, *Parisiennes de ce temps,* 6.

40. Ibid., 6–7 (emphasis his).

41. Ibid., 12.

42. Ibid., 31–32.

43. Ibid., 34–35.

44. Ibid., 35.

45. Ibid., 36–37.

46. Ibid., 37.

47. Ibid., 38–39.

48. Ibid., 108.

49. Ibid., 110.

50. Ibid., 113–14.

51. Ibid., 115.

52. Ibid., 163.

53. Ibid., 334–35.

54. Montorgueil, *La Parisienne peinte par elle-même,* frontispiece. The letter is dated Nov. 1, 1896.

55. Ibid., 35

56. Ibid., 157.

57. Ibid., 163, 170. This illustration has been published in Weisberg, *Montmartre and the Making of Mass Culture,* 54.

58. Ibid., 164–66.

59. Ibid., 173–74.

60. Ibid., 183. The most complete condemnation of the costume is likely that found in John Grand Carteret, *La femme en culotte* (Paris: Flammarion, c. 1910). See esp. chapter 10.

61. Montorgueil, *La Parisienne peint part elle-même,* 187–89.

62. Ibid., 186.

63. Ibid., 190.

64. See Camille Mauclair, "La femme devant les peintures modernes," *La Nouvelle Revue* 1 (1899): 190–213; and Marius Ary-Leblond, "Les peintures de la femme nouvelle," *La Revue* 39 (1901): 275–76, 289–90. For a discussion of these writers' views, see Debora L. Silverman, *Art Nouveau in Fin-de-Siècle France: Politics, Psychology, and Style* (Berkeley: University of California Press, 1989), chapter 4.

65. See Carl-Hap, "Veuve fin-de-siècle," *Le Chat Noir,* Nov. 10, 1894, 3, and "Sous le manteau de ma cheminée," *Le Chat Noir,* Dec. 29, 1894, 3.

66. Montorgueil, *La Parisienne peinte par elle-même* 191–93.

67. Ibid., 192.

68. Ibid., 194–95.

69. Ibid., 192.

70. Jean Floux, "Les Eves," *Le Chat Noir,* Mar. 22, 1890.

71. Victor Jozé (pseud. Comtesse de la Vigne), *Les usages du demi-monde* (Paris, 1909), 4.

72. Ibid., chapters 2 and 3.

73. Ibid., chapter 4.

74. Ibid., 61.

75. Ibid., 67.

76. Ibid., 110.

77. Ibid., 216–17.

78. Ibid., 224.

79. Ibid., 84–85.

80. Ibid., 218.

81. Ibid., 241.

82. Ibid., 70.

83. Ibid., 174.

84. Ibid., 228.

85. Ibid., 255.

86. Ibid., 321.

87. See, for instance, Henry Somm's "Droits de la femme," which is discussed in chapter 6 (see figure 73) of the present book.

88. Sahib, "Nouvelle géographie du pays du tendre. 2me carte. Province du High-Life," *La Vie Parisienne,* Dec. 10, 1881, 712–13.

89. Sahib, "Nouvelle géographie du pays du tendre. 3me carte. La Province du Théâtre," *La Vie Parisienne,* Dec. 17, 1881, 731.

90. Eric Kenneway, *Complete Origami* (New York: St. Martin's, 1987). See also Bernard Lopez, "L'Espagne à l'exposition universelle de 1867," *L'exposition universelle de 1867 illustrée,* v. 1, 455, 458. Lopez does not specifically talk about the pajarita or paper, but he does highlight aspects of their history and industries, and he demonstrates the Spanish presence at the exposition. There were also exhibits of paper products at the exposition. See, for instance, Prosper Poitevin, "Les papiers peints et la papeterie," *L'exposition universelle de 1867 illustrée,* v. 2, 438–39.

91. There is a significant amount of literature dedicated to this type (spelled variously as *cocotte* or *coquette*), including the song "Hue! Cocotte" (lyrics by Sémiane; music by Paul Hucks), *Gil Blas,* Mar. 25, 1898, 5; the short story by Jean-Louis Renaud, "Hue Cocotte!" *Gil Blas,* July 6, 1900, 1–2; the poem by Jean Picard, "Pour la Coquette," *Gil Blas,* Oct. 6, 1895, 3; Aristide Bruant's "Coquette," *Gil Blas,* June 9, 1895, 5; Mario Prax, "Cherchez la cocotte," *Le Charivari,* Oct. 17, 1890, 2–3; and "Coquette, paroles & musique d'André Crémieux," *Gil Blas,* Jan. 17, 1902, 5. Guy de Maupassant wrote two stories about the cocotte. The first was published in *Le Gaulois* in June 1881, under the title "Histoire d'un chien"; a second story appeared as "Mademoiselle Cocotte," in *Gil Blas* in March 1883 and was included in the 1884 collection *Clair de lune.* In the first story, "Cocotte" is a dog adopted by a coachman, but the animal is a nuisance (she attracts male dogs who ruin the garden, she keeps having litters of puppies, etc.). He is finally forced to drown her but is then haunted and dares never touch another dog. Disgust for the dog, but also affection, was related to the way prostitutes were regarded, as was the emphasis on Cocotte's fertility.

92. *Les cocottes!!!!!* (Paris, 1864), 7–8. A short-lived periodical entitled *La Cocotte* appeared in 1877; its masthead pictured a woman reclining on the folded-paper bird as one would on a divan. In 1890, a cheaply produced *Almanach des Cocottes,* with amateurish illustrations, appeared.

93. *Les cocottes!!!!!* 124 (emphasis in original).

94. Edouard Siebecker, *Physionomies parisiennes: Cocottes et petits crevés* (Paris, 1867), 77. Pierre Véron, in *Le carnaval du dictionnaire* (Paris, 1874), gave the following definition: "Cocotte—D'où vient cette métaphore du genre *gallinacée?* Est-ce de ce que les poules se nourrissent dans le fumier?" [Cocotte—why this metaphor, which comes from fowls? From the fact that hens feed on the dung-heap?] (79).

95. Charles Virmaître, *Paris-galant* (Paris, 1890). A similar hierarchy appears in *Ces dames du grand monde par une femme qui n'en est pas* (Paris: P. Lebigre-Duquesne, 1868).

96. Virmaître, *Paris-galant,* 25.

97. Ibid., 40.

98. Siebecker, *Physionomies parisiennes,* 120

99. Ibid., 113.

100. Sahib, "Nouvelle géographie du pays du tendre. 4me carte. Province du Basse-Bicherie," *La Vie Parisienne,* Dec. 24, 1881, 751.

Chapter 5: *Les fleurs du mal*

1. One author linked woman and flower by writing, "De même que la femme est le plus parfait chef-d'oeuvre des êtres animés, la fleur est le chef-d'oeuvre le plus gracieux des êtres inanimés" [Just as woman is the most perfect masterpiece of all living creatures, the flower is the most perfect of inanimate things]. Sirius de Massilie, *L'oracle des fleurs: Véritable langage des fleurs* (Paris: Furne, 1902), 8.

2. Carolyn Merchant, in *Earthcare: Women and the Environment* (New York: Routledge, 1995), discusses the male/female and technology/nature dichotomy and distinguishes three distinct forms of nature associated specifically with Eve: virgin land with the potential for development is associated with "original Eve"; chaotic wilderness or wasteland is connected to "fallen Eve"; and nature as a nurturing garden is representative of "mother Eve" (32). Julien Offroy de la Mettrie had a theory of a uniformity of nature, leading to a startling correspondence between the "systems" of humans and plants: "L'homme n'est donc point un arbre renversé, dont le cerveau serait la racine, puisqu'elle résulte du seul concours des vaisseaux abdominaux qui sont les premiers formés; du moins le sont-ils avant les téguments qui les couvrent et forment l'écorce de l'homme." [Man, therefore, is by no means a tree in reverse, with root and brain interchanged, since the brain develops solely from the aggregation of the abdominal vessels, which are the first to be formed; at least, they are so before the teguments that cover them and form man's "bark."] Julien Offroy de la Mettrie, *L'homme-plante* (1748; New York: Institute of French Studies, 1936), 118. Mettrie also described the "ejaculations" of plants as being similar to those of man; while more feminine traits included the "même ovaires, mêmes oeufs, même faculté fécondante" [same ovaries, same eggs, same ability to bear fruit] (130). While Mettrie chose to connect plant life to "mankind" in general, other scientists, including Johann Casper Lavater in his *Essays on Physiognomy* (1775–78), separated male and female on the bases of dichotomous characteristics: "Man is more solid; woman is softer / Man is straighter; woman is more supple / Man walks with a firm step; woman with a soft and light one / Man contemplates and observes; woman looks and feels." Lavater, quoted in L. J. Jordanova, "Naturalizing the Family: Literature and the Bio-Medical Sciences in the Late Eighteenth Century," in *Languages of Nature: Critical Essays on Science and Literature,* ed. Jordanova (New Brunswick, N.J.: Rutgers University Press, 1986), 92. Lavater was Swiss, and the original language of his text was German, but his book was quickly translated into both English and French, becoming a standard reference in most of Europe.

3. Angelo de Gubernatis, *La mythologie des plantes ou les légendes du règne végétal* (Paris, 1878), 3–4.

4. See Susan Warrener Smith, "Cistercian Aesthetics as an Affirmation of Creation, Moderation, and Contemplation: A Study of Images of Nature in the Writings of Bernard of Clairvaux" (Ph.D. diss., Drew University, 1991). Clairvaux's descriptions focus on the garden and flowers, especially the lily and the rose, as symbolic of the Virgin Mary, while Christ is likened to trees and fruit.

5. Milton writes:

Beyond his hope, Eve separate he spies,
Veil'd in a Cloud of Fragrance, where she stood,
Half spi'd, so thick the Roses bushing round
About her glow'd, oft stooping to support
Each Flow'r of slender stalk, whose head though gay

Carnation, Purple, Azure, or speckt with Gold,
Hung drooping unsustain'd, them she upstays
Gently with Myrtle band, mindless the while,
Herself, though fairest unsupported Flow'r,
From her best prop so far, and storm so nigh.
 Milton, *Paradise Lost,* 9.424–33 (Hofer and Winterich edition, pp. 212–13).

An article in the *Journal des Demoiselles* credited Milton with the association of Eve with both flowers and perfume: "Milton place Eve voilée d'un nuage de parfum, au milieu des roses à peine écloses et rougissantes du Paradis terrestre" [Milton portrays Eve swathed in a cloud of perfume amidst the newly opened, blushing roses of the Earthly Paradise]. Fulbert-Dumonteil, "Les fleurs à la mode: La rose," *Journal des Demoiselles* 61, no. 4 (Apr. 1893): 86.

6. Herman Rapaport, *Milton and the Postmodern* (Lincoln: University of Nebraska Press, 1983), 60.

7. Texier, *Les femmes et la fin du monde,* 204–5.

8. F. Maréchal, ornamented letter "E" with Eve, flowers, serpent, and apple, *Le Courrier Français,* Sept. 13, 1896, 4; F. Maréchal, ornamented letter "M" with Eve, flowers, and skeletons. *Le Courrier Français,* Oct. 4, 1896, 6.

9. De Pompéry, *La femme dans l'humanité,* 37.

10. Eugénie Niboyet, *Le vrai livre des femmes* (Paris: Dentu, 1863), 1. Niboyet, a member of the Société de la Morale Chrétienne, became a Saint-Simonian in the 1830s after hearing a lecture about the group's vision of equality, but she left in protest to changes to the "rules of sexual experience" proposed by Enfantin. In 1848, she led the feminist suffrage campaign with Jeanne Deroin. By 1852, under government repression of feminist causes, she moved to Geneva. At the writing of *Le vrai livre des femmes,* she returned to France, but she was "elderly now and had long since disavowed the more revolutionary aspects of her past." Moses, *French Feminism,* 174. Nevertheless, Niboyet remained active in feminist causes, even attending the 1878 International Congrès du Droit des Femmes—at the age of seventy-eight.

11. Ibid., 3 (emphasis hers).

12. Ibid., 3–4 (emphasis hers). These comments were written in response to a Mme Saint-Mars, who, using the name La Comtesse Dash, was known for what Niboyet deemed "charming novels," but who had embraced the traditional inferiority of women in *Le livre des femmes.* In this text, Saint-Mars proposed marriage and family as a method for women to accomplish restitution for original sin. These prevalent notions were exaggerated by authors who claimed that women who moved outside of their relegated domestic sphere would bring a new downfall to mankind through harm to the family unit, or even more directly, through depopulation.

13. See Lisa Gasbaronne, "'Innocent Deceptions': Botany in the Writings of Jean-Jacques Rousseau" (Ph.D. diss., Princeton University, 1984), 11. Gasbaronne proved that Rousseau's "Lettres sur la botanique" (1835), written to Madeleine Delessert, constituted a seduction in which "disrobing of the flower in the letters is emblematic" (154). Vaillant described flowers' petals as "colorful protection devised by a modest nature to shield the regenerative parts of the plant" (quoted, 11). According to François Delaporte, "controversies over sexuality in plants and over the ways and means of fertilization were not entirely innocent of fantasies concerning amorous behavior." *Nature's Second Kingdom: Explorations of Vegetality in the Eighteenth Century,* trans. Arthur Goldhammer (Cambridge, Mass.: MIT Press, 1982), x.

14. A. K. Pilkington, "'Nature' as Ethical Norm in the Enlightenment," in Jordanova, *Languages of Nature,* 55.

15. See, for instance, Patrick Geddes and Arthur Thomson, "L'evolution du sexe: Quelques probabilités biologiques," *Revue de Morale sociale* (1899): 95–111. Some plants have flowers that are either male or female, but in many plants the same flower may be both. "Plants are qualified as androgynous when they bear both female and male flowers on the same individual; hermaphrodites when both stamen and pistil are present on the same flower." Gasbaronne, "'Innocent Deceptions,'" 157.

16. L. J. Jordanova considers both French medical writings and literature in "Naturalizing the Family," 86–117. The most complete study of floral poetry and prose of the nineteenth-century to date is Philip Knight, *Flower Poetics in Nineteenth-Century France* (Oxford: Clarendon, 1986).

17. There were nine editions of *L'oiseau* over an eleven-year period, eventually selling 33,000 copies. *L'insecte* reached 28,000 copies in eleven years. *L'amour* sold 30,000 in just two months. See Stephen A. Kippur, *Jules Michelet: A Study of Mind and Sensibility* (Albany: State University of New York Press, 1981), 201, 210. Kippur's source for the publication numbers for *L'oiseau* and *L'insecte* is Hachette's publication record preserved at the Bibliothèque Historique de la Ville de Paris, MS. Fonds Baudoüin-Dumesnil, Michelet et ses éditeurs, cote 5716. The numbers for *L'amour* are reported by Michelet himself in his *Lettres inédites*. Later Michelet added *La mer* (1861) and *La montagne* (1868).

18. Jules Michelet, *Woman*, trans. J. W. Palmer (New York: Carleton, 1868), 85. Similar arguments regarding woman's role as expressed by nature are found in each of the "natural" texts. For a thorough analysis of Michelet's writings involving women, see Jeanne Calo, *La création de la femme chez Michelet* (Paris: Librairie Nizet, 1975). On Michelet's works in the "nature" cycle, see Linda Orr, *Jules Michelet: Nature, History, and Language* (Ithaca, N.Y.: Cornell University Press, 1976), and Roger Huss, "Michelet and the Uses of Natural Reference," in Jordanova, *Languages of Nature*, 289–321.

19. Michelet, *Woman*, 86.

20. Ibid. Michelet, who was himself a student of natural history, no doubt was aware of botanical studies that discussed flower parts as "sexual" and related them to women. See Delaporte, *Nature's Second Kingdom*, esp. 92–99.

21. Michelet, *Woman*, 87.

22. Pol de Saint-Merry, *La femme*, 20.

23. "Nos belles jardinières," *La Vie Parisienne*, Dec. 18, 1897, 724–25.

24. L. J. Jordanova stated that "nature may be a virgin, to be raped or more gently penetrated, a goddess to be worshipped, a woman whose full nakedness should be revealed, a mother who is above all fecund, and so on." See Jordanova's introduction to Gillian Beer's essay "'The Face of Nature': Anthropomorphic Elements in the Language of The Origin of the Species," in *Languages of Nature*, 208.

25. Pierre-Joseph Proudhon, *Notes et pensées: Oeuvre posthume* (1875), quoted in Nicole Priollaud, ed., *La femme au 19e siècle*, Les reporters de l'histoire 2 (Paris: Liana Levi/Sylvie Messinger, 1983), 149–50. Larcher, in Martin and Larcher, *Anthologie satirique*, reprinted a more specific estimation of woman as animal, attributed to Ghérardi: "Voulez-vous bien connaître une femme? Figurez-vous un joli petit monstre qui charme les yeux et qui choque la raison . . . qui est ange au dehors et harpie au dedans. . . . Mettez ensemble la tête d'une linotte, la langue d'un serpent, les yeux d'un basilic, l'humeur d'un chat, l'adresse d'un singe, les inclinations nocturnes d'un hibou, le brillant du soleil et l'inégalité de la lune; enveloppez tout cela d'une peau bien blanche, ajoutez-y des bras, des jambes et caetera . . . vous aurez une femme complète" [Do want to know what a woman is like? Imagine a pretty little monster who bewitches your eyes and shocks your reason . . . an angel on the outside and a harpy inside. . . . Combine a linnet's head, a serpent's tongue, the eyes of a basilisk, a cat's temper, a monkey's craftiness, the nocturnal inclinations of an owl, the brilliance of the sun and the moon's fickleness; wrap all this up in a nice white skin, add arms, legs, etc. . . . and there you have the complete woman] (79–80).

26. For a comparison of this genre of literature in France, England, and America, see Beverly Seaton, *The Language of Flowers: A History* (Charlottesville: University Press of Virginia, 1995). While hundreds of examples exist, Seaton chooses one primary text each from France, England, and America to represent the genre. She lists many other titles in her bibliography. Color symbolism and the symbols for the hours, days, and months are found in Pierre Zaccone, *Nouveau langage des fleurs avec leur valeur symbolique et leur emploi pour l'expression des pensées* (Paris, 1858). For a discussion of the religious tradition as well as the scientific tradition in conjunction with the poetic descriptions in Europe, see Jack Goody, "The Secret Language of Flowers," *Yale Journal of Art Criticism* 3, no. 2 (1990): 133–52.

27. J. J. Grandville, Taxile Delord, Alphonse Karr, et al., *Les fleurs animées* (Paris: Gabriel de Gonet, 1847), 229

28. Abbé Thiébaud, *Marie dans les fleurs; ou, Reflet symbolique des priviléges de la Sainte Vierge dans les beautés de la nature* (Paris: L. Lecoffre, 1867), 1 (first quote); Henri Lecoq, *Le monde des fleurs: Botanique pittoresque* (Paris: Rothschild, 1870), 493–94 (second quote). Lecoq continues, "Et si dans cette esquisse, j'ai pour ainsi dire évité les gracieuses comparaisons indiquées par mon sujet, j'avais un motif puissant pour le faire; plaidant pour les fleurs, exaltant leur mérite, je devais éloigner de mes clientes tout ce qui pouvait affaiblir leur éclat. Ce n'est point par oubli, Mesdames, c'est par habileté que je vous ai écartées de mes tableaux. Reconnaître votre supériorité sur les seules rivales que vous puissiez avoir, c'est les placer sous votre protection." [And if, in this sketch, I have, so to speak, avoided the gracious comparisons my subject indicates, I had a powerful motive for so doing. Pleading the cause of flowers, exalting their merit, I had to distance from my clients anything that might diminish their attractions. It is not, Mesdames, through forgetfulness, but through skill that I have excluded you from my pictures. To recognize your superiority over your only possible rivals is to place them under your protection.] (ibid.).

29. Similarly Albert Maumené, in his 1897 *L'art du fleuriste,* claimed that "la plus jolie toilette serait incomplète si les leurs n'en formaient pas l'accompagnement et la plus fraîche des parures" [the prettiest *toilette* would be incomplete if theirs (i.e., flowers) did not form its accompaniment and a matching set of the brightest jewels] (92).

30. The "regular" illustrators for popular satirical journals were overwhelmingly male, although on occasion a work by a woman might be included (Louise Abbéma provided at least one illustration for *La Vie Parisienne*); but these were not satirical illustrations, which seems to be a male phenomenon. Women were employed drawing fashion plates for journals such as *La Mode Illustrée*. See Valerie Steele, *Paris Fashion: A Cultural History* (New York: Oxford University Press, 1988), chapter 6, for a description of fashion plates by two sisters, Héloïse Colin Leloir and Anaïs Colin Toudouze.

31. Advertisement for the volume published in the *Petit Journal Pour Rire,* no. 56 (undated).

32. Ibid.

33. Rousseau's *Seventh Promenade,* quoted in Jeanne-Hélène Roy, "Rousseau's Floral Daydreams: Cultivating an Aesthetics in the Rêveries" (Ph.D. diss., Cornell University, 1997), 160.

34. In addition to the publication of New York editions in the late 1840s, and Belgian editions in the early 1850s, there were French editions that appeared in 1857, 1866, and 1867—well after Grandville's death. The first edition was published posthumously the year of his death, 1844. The 1857 reprinting is particularly significant, for that was the year that Charles Baudelaire was tried for indecency for *Les fleurs du mal. Les fleurs animées* involved the efforts of not only Grandville as illustrator, but also Alphonse Karr, who wrote the introduction to the first volume and an introduction to the quasi-scientific sections in the second volume. Taxile Delord authored the majority of the text, while L. F. Raban contributed the "more scientific" essays "Botanique moderne des dames" and "Culture des fleurs, horticulture des dames" in the second volume, using the pseudonym Comte Foelix. Each of these authors has been characterized as "challenged by the tone of the drawings to produce a prosaic equivalent" and "unanimous in their attempt to humanize the pursuit of science, dwelling at length upon the simple yet fulfilling pleasures afforded by nature." See Grandville, Delord, Karr, et al., *Fleurs animées,* "Introduction," unpaginated.

35. Seaton, *Language of Flowers,* 92. Philip Knight, on the other hand, sees this text as the culmination of "keepsake variety" of the genre, because of the integration of flower language with illustrations where the flowers personify women. Knight, *Flower Poetics,* 59.

36. Grandville, Delord, Karr, et al., *Les fleurs animées,* as translated and quoted in N. Cleaveland, *The Flowers Personified* (New York, 1847), 18.

37. Ibid., 70.

38. "Eglantine" appeared in *Les fleurs animées* (1844), vol. 1, 238.

39. In fact, the author dares the reader to guess the name by which Eglantine was known at the book's first printing—likely Sand. See *Les fleurs animées,* trans. Cleaveland, *Flowers Personified,* 258.

40. Ibid., 217.

41. Gasbarrone, "'Innocent Deceptions.'" Gasbaronne believes that Rousseau's letters indicated a careful courtship of the woman, under the pretense of the discussion of the nature of flowers. See esp., 154. Rousseau's *Lettres inédites* was published in 1911 (Paris: Plon).

42. *La Vie Parisienne,* Feb. 26, 1876, 122–23.

43. *La Vie Parisienne,* Nov. 11, 1876, 644–45.

44. Unknown artist, "Leurs caprices.—II. Les fleurs naturelles à la ville," *La Vie Parisienne,* Mar. 27, 1880, 176–77.

45. *La Vie Parisienne,* Dec. 8, 1900, 691; Dec. 15, 1900, 703–5; Dec. 22, 1900, 719–20; Jan. 12, 1901, 24–25; Jan. 26, 1901, 52–53.

46. "C'est une coutume répandue par toute l'humanité, depuis le temps où, ainsi que raconte Milton, Eve occupait ses matinées à rattacher les rosiers grimpants aux arbres du Paradis, d'assimiler les femmes aux fleurs" [It is a custom among all races since the time when—as Milton relates—Eve spent her mornings training climbing roses up the trees of Eden, to portray women as flowers].

47. Grévin's "La Demoiselle" was reproduced in *Le Journal Amusant* in 1874.

48. There are numerous studies that provide an overview of the Art Nouveau phenomenon. The best contextualization of the style with the history of the period is contained in D. Silverman, *Art Nouveau in Fin-de-Siècle France.* A brief but valuable consideration of the appearance of women within works of this type is found in Thompson, "Role of Women," 158–67.

49. Alphonse Mucha, "Les fleurs" (decorative panels: la rose, le lys, l'oeillet and l'iris), advertised in *Revue Illustrée,* May 15, 1898, and *Cocorico,* Mar. 5, 1899. The advertisement in *Cocorico* lists the price of the deluxe edition as one hundred francs. Mucha used flowers in most of his calenders and posters. See Rennert and Weill, *Alphonse Mucha.* Mucha also completed a series of lithographs for *Documents Décoratifs,* an encyclopedia of decorative designs, which featured flowers. See plates 123c and 123e in Victor Arwas et al., *Alphonse Mucha: The Spirit of Art Nouveau* (New Haven: Yale University Press, 1998). A drawing for one of the plates (123b) is clearly a straightforward botanical study, demonstrating that Mucha worked directly from the flowers, not from memory or imagination, only stylizing them into patterns once he thoroughly understood their structure.

50. Camille Pert reported in 1908 that the average man's salary in Paris was six francs per day; in the provinces, four francs. A woman's average salary was three francs and two francs, respectively. "Le travail de la femme," in Perrier et al., *La femme dans la nature, dans les moeurs, dans la légende, dans la société,* vol. 4, *Le rôle social et mondain de la femme,* by Victor du Bled et al., 257.

51. *Revue Illustrée,* May 15, 1898, unpaginated insert.

52. These meanings were taken from Anaïs de Neuville, *Le véritable langage des fleurs* (Paris, 1868). Meanings vary slightly from text to text, especially in the case of different colors and varieties of a flower.

53. On the relationship between literary symbolism and De Feure's representations of women, see Gabriel P. Weisberg, "Georges de Feure's Mysterious Women: A Study of Symbolist Sources in the Writings of Charles Baudelaire and Georges Rodenbach," *Gazette des Beaux-Arts* 84, ser. 6 (1974): 223–30. The most complete study of de Feure to date remains Ian Millman, *Georges de Feure: Maître du symbolisme et de l'art nouveau* (Paris: ACR, 1992).

54. A study of the use of specific flowers by de Feure has not been undertaken; the flowers have been called simply "erotic" by Weisberg ("Georges de Feure's Mysterious Women," 225), for instance.

55. The most comprehensive analysis of all of the themes within *Les fleurs du mal* remains the staggering four volumes by Léon Bopp, *Psychologie des Fleurs du mal* (Geneva: Droz, 1964). See also James R. Lawler, *Poetry and Moral Dialectic: Baudelaire's "Secret Architecture"* (Madison, N.J.: Fairleigh Dickinson University Press, 1997).

56. Originally published as an edition of thirteen hundred copies in 1857 (and subjected to a censorship trial that same year), the work appeared in a new, expanded edition of fifteen hundred copies in 1861. Individual poems also appeared in newspapers: three poems were found in *Le Messager de l'Assemblée;* eighteen poems appeared under the borrowed title *Fleurs du mal* in advance of the appearance of the text, in the June 1, 1855, issue of *Revue des Deux Mondes.* The

critic and short-story writer Hippolyte Babou suggested the title to Baudelaire after considerable discussion. See Joanna Richardson, *Baudelaire* (New York: St. Martin's, 1994), 145. See also Alfred Engstrom, "Baudelaire's Title for 'Les Fleurs du mal,'" *Orbis Litterarum* 12 (1957): 193–202. At the 1857 trial, the public prosecutor had the edition seized and filed suit against Baudelaire and his publisher. Baudelaire was fined and ordered to remove six poems: "Lethe," "Jewels," "Lesbos," "Damned Women," "Against Her Levity," and "Metamorphosis of the Vampire." The overriding issue centered on lesbianism. See F. W. Leakey, *Baudelaire: Collected Essays, 1953–1988* (New York: Cambridge University Press, 1990), esp. *"Les Lesbiennes:* A verse novel?" 29–47. Baudelaire was defended by Victor Hugo, who praised the *Fleurs du mal*. By 1862, Swinburne (another major advocate) published a defense of *Fleurs du mal* in *The Spectator*. See Anne Walder, *Swinburne's Flowers of Evil: Baudelaire's Influence on the Poems and Ballads, First Series* (Stockholm: Uppsala, 1976). In 1866, sixteen poems, written after the second edition appeared, were published as "Nouvelles fleurs du mal" in Catulle Mendès's publication *Parnasse Contemporain*. The third edition of *Fleurs du mal* appeared in 1868, the year following Baudelaire's death. Between 1869 and 1903, at least nineteen editions appeared, with never more than three years passing without a new reprinting. There were several editions of the "pieces condamnées," or the censored original poems. By 1891, a new illustrated edition appeared with works by Odilon Redon, then a leading Symbolist image maker. Thus, the continued popularity of Baudelaire's works cannot be questioned.

57. Knight, *Flower Poetics,* 95.

58. Letter quoted, ibid., 117.

59. Ibid., 119.

60. Quoted in Richardson, *Baudelaire,* 75.

61. Baudelaire scholars debate the significance of the original intended order, versus that of the "revised" version of 1861. Some scholars, notably Lawler, suggest that *Les fleurs du mal* must be read together, in intended order, if one is to understand the full impact of the text. (Lawler provides a concordance of the 1857 and 1861 editions in an appendix. See his *Poetry and Moral Dialectic.*) More recently individual poems have been analyzed, as in William J. Thompson, ed., *Understanding "Les fleurs du mal": Critical Readings* (Nashville: Vanderbilt University Press, 1997). J.-D. Hubert (*L'esthétique des "Fleurs du mal"* [Geneva: P. Cailler, 1953]) says that what distinguishes Baudelaire from Milton is the sense of "self" that he invokes in the poetry (220). See also Tamara Bassim, *La femme dans l'oeuvre de Baudelaire* (Neuchâtel, Switz.: Baconnière, 1974), 86–88.

62. As contained in the Lévy edition of Baudelaire's *Oeuvres complètes* (1868). See Claude-Marie Senninger, *Baudelaire par Théophile Gautier* (Paris: Klincksieck, 1986), for details on the relationship and reproductions of the original French texts.

63. Lévy, *Oeuvres complètes,* 43–44.

64. Ibid., 45.

65. Ibid., 61.

66. Ibid., 66–67.

67. Bourget published a series of articles about contemporary literature under the title "Essais de psychologie contemporaine" in the *Revue Bleue*. These can be found together in the *Oeuvres complètes de Paul Bourget,* vol. 1, *Critique-essais de psychologie contemporaine* (Paris: Plon, 1899).

68. Duval's mother was a former slave turned prostitute, and it is likely that Jeanne was also a prostitute. See F. W. J. Hemmings, *Baudelaire the Damned: A Biography* (New York: Scribner, 1982), 50. Much has been written about the influence of Duval on the content of certain poems in *Les fleurs du mal,* but practically nothing has been said of the influence of the syphilis itself, save a brief allusion by Patrick Wald Lasowski in his *Syphilis: Essai sur la littérature française du XIXe siècle* (Paris: Gallimard, 1982). Duval was not the only woman who had an impact on the poems. See Pierre Sauvage, "Figures féminines dans Les Fleurs du mal," in Paul-Laurent Assoun et al., *Analyses et réflexions sur—Baudelaire: Spleen et idéal: ouvrage collectif* (Paris: Ellipses, 1984), 113–15.

69. Quoted in Richardson, *Baudelaire,* 74.

70. Ruff, de Reynold, and Aupick quoted in Richardson, *Baudelaire,* 75.

71. George Heard Hamilton, *Manet and His Critics* (New Haven: Yale University Press, 1986), 79.

72. Knight, in his *Flower Poetics,* traces the history of the use of flowers in prose from classical texts and also considers the "flower language" manuals described above. He establishes that the reason that the title of *Les fleurs du mal* had such a great impact was because of its subversion of that tradition. See esp., chapter 3, "Baudelaire's Flower Poetics," 62–130.

73. Charles Baudelaire, *Les fleurs du mal,* trans. Richard Howard (Boston: Godine, 1997), 35–36. The poem has been interpreted by William Olmsted in terms of the moral significance of the corpse, misogynism, and the destruction of narcissism on Baudelaire's part. He does not consider venereal disease to be a possible source of decay. See Olmsted, "Immortal Rot: A Reading of 'Une Charogne,'" in W. Thompson, *Understanding "Les Fleurs du mal,"* 60–71.

74. Hemmings, *Baudelaire the Damned,* 56. The image of a woman literally rotting from the progression of veneral disease was nowhere made more graphic than in the last lines of Emile Zola's *Nana*—a description that seems not far removed from the decomposing flower of Baudelaire's "Carrion": "a shovelful of putrid flesh," a "shapeless pulp" resembling some "mould from the grave," complete with "bubbling purulence" and a "reddish crust starting on one of the cheeks." One of Zola's last lines is a brief but telling indication of the fate of the former performer turned prostitute, Nana: "Venus was decomposing." Emile Zola, *Nana,* trans. George Holden (New York: Penguin 1972), 470.

75. Elisabeth Kashey, *Félicien Rops, 1833–1898: Drawings for Prints,* exh. cat. (New York: Shepherd Gallery, 1998), "Introduction." The fear of syphilis was palpable in the nineteenth century, as evidenced by its frequent mention, not only in medical journals, but also in prose and poetry. See Lasowski, *Syphilis.*

76. Rops, translated and quoted in Victor Arwas, "Félicien Rops," essay in *Audacious Eroticism: The Unconventional Art of Félicien Rops (1833–1898),* exh. cat. (New York: Theodore B. Donson, 1983), n.p.

77. Portions of the letter, which is located in the Bibliothèque Royale Albert 1er in Brussels, are quoted in Edith Hoffman, "Notes on the Iconography of Félicien Rops," *Burlington Magazine* 123, no. 1 (Jan.–June 1981): 206–18.

78. Rops, quoted, ibid., 214.

79. Maurice Kunel, *Félicien Rops: Sa vie—son oeuvre* (Brussels, J. Lebegue, 1943), 6.

80. According to Ramiro, "Il possède en cette matière une science inouïe, connaissant les noms, les moeurs et l'histoire de toutes les fleurs présentes et passées" [He possesses an unheard-of knowledge of this subject, knowing the names, habits and history of every flower past and present]. Erastène Ramiro, *Catalogue descriptif et analytique de l'oeuvre gravé de Félicien Rops* (Paris, 1887), iii.

81. The full title was *La fleur lascive orientale: Contes libres inédits, traduit du mongol, de l'arabe, du japonais, de l'indien, du chinois, du persan, du malais, du tamoul, etc.*

82. Rops was credited with the "invention" of the woman made "naked" by the addition of stockings, which removed allusions to the "classical" nude and instead suggested a strip tease. See Camille Mauclair, "Félicien Rops," *Revue Encyclopédique* 8 (1898): 978.

83. A member of this family of plants is described by Henry Chastrey in "Fleurs et plantes bizarres," *Magasin Pittoresque,* Mar. 15, 1905, 134–36. Fear of exotic plants, and the implication that Satan had created some of them, was a factor in Dora d'Istria's "Le surnaturel dans le monde végétal," *Revue des Deux-Mondes* 32, 3rd ser. (1879): 481–508.

84. *La fleur lascive orientale,* 125. A note makes clear the meaning of "kumil fleuri." I have used Freud's term, which was coined later but nevertheless communicates the same meaning.

85. See Gabriel P. Weisberg, "Louis Legrand's Battle over Prostitution: The Uneasy Censoring of *Le Courrier Français,*" *Art Journal* 51, no. 1 (Spring 1992): 45–50.

86. In the Nov. 1895 issue of *Le Courrier Français,* Rocher contributed an illustration with a poem, "Les Chevelures," likely in imitation of the well-known Baudelaire poem "La Chevelure" from *Fleurs du mal.*

87. Massilie, *L'oracle des fleurs,* 101.

88. Constance Classen, David Howes, and Anthony Synnott, *Aroma: The Cultural History of Smell* (London: Routledge, 1994), 70.

89. A. Delacoux, *Hygiène des femmes* (Paris, 1829), 223–24.

90. Reported in Classen et al., *Aroma,* 71.

91. Ibid., 83.

92. Scientists did not neglect the olfactory aspect as they sought to classify all aspects of human existence. See Classen et al., *Aroma,* 88–92.

93. Rostan, "Odeur," in *Dictionnaire de médecine,* quoted in Alain Corbin, *The Foul and Fragrant* (Cambridge, Mass.: Harvard University Press, 1986), 55.

94. Corbin, *Foul and Fragrant,* 176. Corbin discusses the use of olfaction in the works of Baudelaire, Flaubert, and especially Huysmans in chapter 12.

95. "Femmes et parfums," *La Vie Parisienne,* Mar. 8, 1879, 132–33.

96. "Etudes sur la toilette: nouvelle série—II. Les parfums," *La Vie Parisienne,* Oct. 28, 1882, 620–21. The manner of dispensing perfumes in liquids, powders, and solid concentrated crayons was treated in 1890 in the illustration spread entitled "Nouvelles études sur la toilette—Les Parfums et la manière de s'en servir," *La Vie Parisienne,* Jan. 18, 1890, 34–35. Floral perfumes were memorialized in a long, rhymed verse by a well-known Montmartre cabaret-goer and *chansonnier,* Maurice Donnay; see Donnay, "Parfums," *La Revue Illustrée,* July 15, 1890, 25–26.

97. India, "Chronique de la mode," *La Libre Parole,* Feb. 12, 1900, 2.

98. Alain Corbin, "Commercial Sexuality in Nineteenth-Century France: A System of Images and Regulations," *Representations* 14 (Spring 1986): 210–12. Corbin cites a fifth assumption that is true but not truly olfactory: "5. The final image . . . integrates the prostitute with that chain of resigned female bodies, originating in the lower classes and bound to the instinctive physical needs of upper-class males" (ibid.). Corbin elaborates on each of these points, while summarizing the principles that structured official French policy toward prostitution, including tolerence of prostitution, its isolation in certain areas, enforced concealment, and the examination of sanitary conditions.

99. See, for instance, Montorgueil, *La Parisienne peinte par elle-même,* and Jozé, *Les usages du demi-monde.* Illustrations include Henri Gerbault's "Comment elles retroussent leur robe," *La Vie Parisienne,* Aug. 28, 1897, 494–95; Ferdinand Bac's "Femmes automatiques," *La Vie Parisienne,* Mar. 19, 1892, 160–61; and Job's "Prognostics et results," *La Vie Parisienne,* June 3, 1893, and in a second series that appeared on Oct. 14, 1893.

100. Lucien Rigaud, "Femme de trottoir," *Dictionnaire du jargon parisien* (Paris, 1878), 335.

101. Emile Goudeau, *Fleurs du bitume, petits poèmes parisiens* (Paris: P. Ollendorf, 1882), 86. Goudeau's *Fleurs de bitume* is discussed in the context of his membership in the Hydropathes in Jorgelina Orfila's essay "*Blague,* Nationalism, and *Incohérence,*" in *Nationalism and French Visual Culture, 1870–1914,* ed. June Hargrove and Neil McWilliam (Washington, D.C.: National Gallery of Art, 2005), 173–94.

102. Robert Hyenne, "Fleurs de vice," *Le Charivari,* July 11, 1891, 2–3.

103. Hyp, "Des fleurs," *Gil Blas,* May 26, 1899, 4.

104. Georges Pioch, "A une femme," *La Nouvelle Revue,* n.s. 14 (1902): 224–26.

105. Corbin, *Foul and Fragrant,* 194.

106. Marcus Osterwalder, *Dictionnaire des illustrateurs, 1890–1941* (Paris: Hubschmid and Bouret, 1992), vol. 2, 929.

107. Vallet was born in 1856. We might do well to recall that Michelet titled one of his four "natural" books *L'insecte* and in it made many comparisons between the societal organizations of specific insects, like ants and spiders, and the industriousness of women.

108. Each of these works is illustrated in J. R. Soubiran, *Gustave Adolphe Mossa: L'oeuvre symboliste, 1903–1918* (Paris: Editions Paris-Musées, 1992).

109. St. Francis de Sales (1567–1622), who was known for his use of plant and flower references in his sermons, asserted that the lily also represented Mary Magdalen after her conversion; thus the lily was given an identity that contained the idea of both chastity and its polar opposite. See "Sermon for the Feast of St. Mary Magdalen," *The Mystical Flora of St. Francis de Sales or, The Christian Life under the Emblem of Plants,* trans. Clara Mulholland (Dublin: M. H. Gill, 1877), 20.

110. Merlet's poem reads:

Le sourire d'enfant qui pardonne ton âme
O Salomé te reste ineffaçable et sûr;
Il te suivra jusqu'en tes ivresses de femme
Tes lèvres garderont les traces d'un sang pur
Que tu goûtas . . .

Ainsi te rappelant le glaive
Par lequel tu connus et la haine et l'horreur
Oublieuse, et le coeur prêt pour un autre rêve
Tu sauras en dansant offrir ta bouche en fleur

O Salomé pour effacer les rouges larmes
Qui sur toi glisseront au couchant d'un beau jour
Les esclaves, le front courbé, fous de tes charmes,
Voudront manger ton coeur fait de mort et d'amour!

[Your child's smile that secures your soul's pardon,
O Salome, remains indelible and secure;
It will never leave you,
Even in your woman's drunken debaucheries
Your lips will retain the traces
Of the pure blood you tasted . . .

[Thus reminding you of the sword
That taught you love and hate and horror.
Forgetting the past, your heart ready for another dream,
As you dance you will somehow tender
A mouth like a flower in bloom.

[O Salome, to efface the red tears
That will bathe your face in the sunset of a glorious day,
Your slaves, forehead bowed, maddened by your charms,
Will crave to devour your heart,
A heart fashioned of love and hate!]

111. St. Francis de Sales, "Sermon for the Eve of the Epiphany," in *Mystical Flora,* 78–79.

Chapter 6: *La femme au pantin*

1. For detailed discussion of this work, see Elizabeth K. Menon, "Henry Somm: Impressionist, Japoniste, or Symbolist?" *Master Drawings* 33, no. 1 (Spring 1995): 3–29. The work can now be dated solidly to the last three months of 1879 because the particular cuffed sleeves and the interest in pockets were fads in September 1879.

2. Ann Marie Porot, Jacques Porot, and François Theimer, *S.F.B.J. Captivating Character Children* (Cumberland, Md.: Hobby House Press, 1986), 236.

3. François Theimer, *The Bru Book: A History and Study of the Dolls of Léon Casimir Bru and his Successors* (Annapolis, Md.: Gold Horse, 1991), 9.

4. Henry d'Allemagne described the distinction between dolls and puppets: "En étudiant les poupées, nous avons vu qu'elles étaient simplement articulées de façon à conserver la position qui leur est imposée par l'enfant; le pantin au contraire est une petite figure peinte, généralement en bois ou en carton, à laquelle on imprime différents mouvements au moyen de fils de fer ou de cuivre que l'on tire par derrière." [From our study of dolls, we have seen that they were simply constructed, with joints that preserved the pose in which the child left them. The puppet, on the contrary, is a small, painted figure, usually of wood or cardboard, and which can be made to move in different ways by means of iron or copper wires activated from behind.] d'Allemagne, *Histoire des jouets* (Paris, 1902), 206.

5. Ibid. Here d'Allemagne quotes the unnamed author of *Dictionnaire des origines*.

6. Michelet, *Woman*, 85–92.

7. Antonin Rondelet, "Les poupées," *Journal des Demoiselles*, May 1, 1880, 141. "Du temps de nos mères et de nos grand'mères, suivant une recommandation expresse qu'on trouve soigneusement consignée dans les livres d'éducation, il était de règle que les poupées n'étaient sujettes à aucun de ces besoins inférieurs qui proclament périodiquement l'infirmité de la nature humaine. On faisait défense aux enfants de mentionner jamais rien de semblable dans leurs jeux. C'était, comme on le voit, une application très sage de la grande métaphysique d'Aristote: Il est des choses qu'il vaut mieux ignorer!" [In our mothers' and grandmothers' times, following an express recommendation scrupulously included in educational manuals, it was held that dolls were not subject to those baser needs which periodically proclaim the infirmity of human nature. Children were forbidden to mention anything of the sort in their play. It was, as we can see, a very wise application of Aristotle's tenet: "There are some things of which it is best to remain ignorant."]

8. Léo Clarétie, "Les jouets," *Magasin Pittoresque*, 1897, 395–99; Marie-Louise Néron, "L'esprit des poupées," *La Fronde*, Jan. 1, 1899, 2.

9. d'Allemagne, *Histoire des jouets*, 8.

10. François Theimer, *Les jouets* (Paris: Presses Universitaires de France, 1996), 9. In 1897, Léo Clarétie estimated that Paris employed five thousand workers in making dolls and their dresses. Clarétie, "Les jouets," 395. In 1899, doll commerce was estimated at close to five million francs annually. Néron, "L'esprit des poupées," 2.

11. François Theimer and Florence Thériault, *The Jumeau Book* (Annapolis, Md.: Gold Horse, 1994), 51.

12. Jumeau, quoted in Florence Thériault, *The Beautiful Jumeau* (Annapolis, Md.: Gold Horse, 1997), 4.

13. In 1867, Henri Nicolle estimated that twelve hundred to fifteen hundred of the Huret dolls were produced per year, creating "a whole new industry in the field of luxury dolls." Reported in François Thériault, *The Trousseau of Blondinette Davranche* (Annapolis, Md.: Gold Horse, 1994), 6. Nicolle's comments came within the context of the 1867 Universal Exposition.

14. Henri Nicolle, a jurist for the 1867 Universal Exposition, stated that "they are dressed in the most up-to-date of little girls' fashions: short, low-cut dresses, their legs bare with open-cut flat shoes; or in pelisses, muffs, and Hungarian-style boots, depending on the season. Carnival time and they are found wearing a cotillion gown and flat shoes. In an everyday situation, our young ladies are 'at home' surrounded by beautiful furniture of exactly the right size, receiving visits from their friends, offering them tea from miniature services. And then it's bedtime and they are ready in their long night gowns. . . . From hats, gloves, jewels, dresses and underwear to armchairs, beds and bedclothes, there is nothing more to be desired for the Huret doll's world. I even noticed a chest equipped with separate compartments and a hand-bag, should they wish to take a trip." Translated and quoted in Thériault, *Trousseau*, 6.

15. Clarétie, "Les jouets," 395.

16. Thériault, *Trousseau*, 7.

17. Florence Thériault, *In Their Fashion: Doll Costumes and Accessories, 1850–1925* (Annapolis, Md.: Gold Horse, 1994), 3. See also Thériault's *The Way They Wore: Doll Costumes and Accessories, 1850–1925* (Annapolis, Md.: Gold Horse, 1993).

18. Néron, "L'esprit des poupées," 2.

19. Ibid.

20. Georges Sala, *Notes and Sketches of the Paris Exhibition* (1868), 141.

21. Ibid., 143.

22. Ibid., 149.

23. Ibid., 146–47.

24. Ibid., 147, 149.

25. Rigaud, "Cocotte," *Dictionnaire du jargon parisien*, 91. Rigaud calls the *cocotte* "le centre de ce monde" [the center of this world].

26. "Les jouets et les poupées," *L'Exposition Universelle de 1867 illustrée*, no. 14, 210–11.

27. Ibid., 211.

28. "Courrier de Paris," *L'Illustration, Journal Universel,* May 4, 1867, 275.

29. Ibid.

30. Vicomtesse de Renneville, "Courrier de la mode et des étrennes," *Le Monde Illustré,* Dec. 29, 1866, 431.

31. This practice had begun in the seventeenth century, when Henri IV sent the Grand Pandora, who was dressed lavishly, and the Petite Pandora, in simple day dress, to Marie de' Medici. See Florence Thériault, *A Fully Perfected Grace* (Annapolis, Md.: Gold Horse, 1996), 1. In the eighteenth century, M. Dubois, the French ambassador to London under the Regency, ordered a doll in contemporary dress and hairstyle from Mlle Fillon, a famous dressmaker, for a price of three hundred francs. The poet Jacques Delille described the practice in 1786: "The 'despot' mannequin enslaves the universe, carrying our taste to the far corners of the world" (translated and quoted in Thériault, *Fully Perfected Grace,* 1). Marcelle Tinayre described the continuation of this practice in "Au pays des jouets," *La Revue de Paris,* Jan.–Feb. 1902, 209. See also Max von Boehn, *Dolls,* trans. Josephine Nicoll (New York: Dover, 1972), 134.

32. d'Allemagne, *Histoire des jouets,* 112 n. 1.

33. Translated and quoted in Thériault, *Fully Perfected Grace,* 1.

34. Rondelet, "Les poupées," 141. A "lighter" interpretation of the adult nature of dolls is reported in "Les joujoux de cette année," *La Vie Parisienne,* Dec. 25, 1880, 764–65, 768–70. Here, a grandfather who has come into Paris from the provinces is said to be stunned by the doll displays in the windows of the department stores. He ultimately decides that the dolls are too grown-up for his children, and too specifically modeled on actual individuals, including the feminist Madame Adam, who introduces herself as a "daughter of the ideas of Georges Sand" and then proceeds to deliver a lecture to the man. He ultimately decides that he cannot, in good conscience, buy these dolls for his grandchildren. Instead, he decides to buy the set of dolls representing the theater, including Sarah Bernhardt, for himself.

35. Rondelet, "Les poupees," 141.

36. These and other stores are listed in an appendix to Thériault, *Fully Perfected Grace,* as is a record of doll and doll-accessory firms that were listed in *L'Annuaire du commerce, 1850–1880.* The names of the latter two stores are similar to Emile Zola's fictional store in *Au bonheur des dames,* and both were in existence at the time he wrote the novel of the same title in 1882.

37. Porot, Porot, and Theimer, *S.F.B.J. Captivating Character Children,* 166. See also Theimer, *Bru Book,* 136.

38. Jeanne Sizon proposed that fashion dolls should not be given to girls, and *polichinelles* should not be given to boys, in "Poupée et Polichinelle," *Bulletin de l'union universelle des femmes,* Nov. 15, 1890, 7. Jeanne Peyrat described the influx of dolls on the market during the Christmas season, and focused on the nature of the workers who produced the dolls, in "La naissance d'une poupée," *Libre Parole Illustrée,* Dec. 30, 1893, 3.

39. "Joujoux de l'année," *La Vie Parisienne,* Dec. 28, 1901, 720–21.

40. Texier, *Les femmes et la fin du monde,* 40.

41. "Divine poupée," *La Vie Parisienne,* May 11, 1901, 258–59; May 18, 272–73; June 1, 1901, 300–301; July 6, 1901, 370–71; July 20, 398–99; Sept. 14, 1901, 510–22.

42. "Divine Poupée," *La Vie Parisienne,* Sept. 14, 1901, 511.

43. Alfred Grévin, "Fantaisies parisiennes," *Le Charivari,* Jan. 13, 1883, 3.

44. An advertisement published in *Le Courrier Français* combines the poupée and the pantin, showing a scantily dressed showgirl, in the tradition of the "chérette" of Jules Chéret, who manipulates mainly female stock characters on strings. "Ambassadeurs Revue Blanche," *Le Courrier Français,* Aug. 2, 1896, 11.

45. Sahib, "Les poupées de Paris," *La Vie Parisienne,* Nov. 14, 1896, 656–57.

46. Eugène Lami, "Nos visites à l'exposition—Voyez poupées!" second series, *La Vie Parisienne,* Oct. 27, 1900, 602–3.

47. Moumoute, "Maison de poupées," *La Vie Parisienne,* Nov. 5, 626–27; Nov. 26, 666–67; and Dec. 17, 1892, 711–12. Marcel Schwab's story "Les marionnettes de l'amour" appears in Octave

Uzanne's *Féminies: Huit chapitres inédits dévoués à la femme, à l'amour, à la beauté* (Paris: Académie des beaux livres, 1896).

48. Gustave Coquiot, *Poupées de Paris: Bibelots de luxe* (Paris: Librairie de la collection des dix, 1912), 7.

49. Théodore de Banville, *Les belles poupées* (Paris: Charpentier, 1888), 3–4. Comparison with an earlier, similar document, Pierre Véron's *Les marionnettes de Paris* (Paris: Dentu, 1861), demonstrates a significant shift in the ratio of women to men, from nearly equal in the 1860s to almost completely women, as revealed in de Banville's text. The technique is imitated again by Camille Lemonnier, in *Poupées d'amour* (Paris: Société d'éditions littéraires et artistiques, 1903), which features exotically named dolls in search of primarily female children to "educate."

50. The Bibliothèque Nationale *exemplaire* is handwritten. The cover credits Baladier with the calligraphy, and it indicates that the watercolors are by Henry Sommier—at this date, he had not yet shortened his name to Somm. This work would appear to be something of a collector's edition, or a one-of-a-kind gift for a friend of Droz or Somm. While artists' proofs for several illustrated books exist, attesting to Somm's working process on these commissions, *Oscar* is one of three known examples of connoisseur books with original watercolors. (For example, there are proofs for *Le harem d'Hervilly* in the Print Room of New York Public Library that were also never used in a final printed version.) One of the others is in the Enfer Collection of the Bibliothèque Nationale, a version of R. P. Lacayorne's *Les joyeusetés* with pornographic illustrations. The other, *La Marguerite,* is also pornographic, and is in a private collection.

51. The lettering on the print is identical to that used on the cover of *Oscar,* but the woman's dress suggests that the date of this work is a bit later, perhaps 1881 or 1882.

52. Edith Hamilton, *Mythology* (New York: Penguin/Mentor, 1969), 103–5.

53. The first documented use of the motif of a woman controlling a puppet man occurs in an illustration for *Paris à l'Eau-Forte* in 1874. See chapter 8, figure 103, of the present book.

54. Ferdinand Bac, "De quel bois elles se chauffent," *La Vie Parisienne,* Jan. 14, 1888, 20–21.

55. Lucien Métivet, "Pluie d'or," *La Vie Parisienne,* Apr. 22, 1899, 216–17.

56. P.C., "Le magnétisme et le somnambulisme," *L'Illustration,* Dec. 21, 1878, 391, Dec. 28, 1878, 407.

57. Paul Janet, "Psychologie, de la suggestion dans l'état d'hypnotisme," *Revue Bleue,* July 26, 1884, 100–104; Aug. 2, 1884, 129–32; Aug. 9, 1884, 179–85; Aug. 16, 1884, 198–203. Janet studied under the prominent director of the Salpêtrière, Jean-Martin Charcot, an expert on hysteria.

58. See, for example, E. Pillon, "Philosophie: Le merveilleux scientifique," *Revue Encyclopédique* 4 (1894): 392–94. This was a review of a recent book entitled *Le merveilleux scientifique* by J. P. Durand, which proposed that term to comprise everything that was related to the then-current popular term, hypnosis. Dr. Bernheim, Professeur à la Faculté de médecine de Nancy, contributed "La suggestion et l'hypnotisme par le docteur Bernheim," *Revue Encyclopédique* 7 (1897): 929–931. Bernheim claimed that there was no such thing as hypnotism, but rather several diverse phenomena that were called hypnotism.

59. The case is the subject of Ruth Harris's "Murder under Hypnosis in the Case of Gabrielle Bompard: Psychiatry in the Courtroom in Belle Epoque Paris," in *The Anatomy of Madness: Essays in the History of Psychiatry,* ed. W. F. Bynum, Roy Porter, and Michael Shepherd (London/New York: Tavistock, 1985), 197–241. Harris's primary source is a series of articles that ran in *La Revue de l'hypnotisme* from 1889 to 1890, detailing the arguments of Charcot, Liégois, and the others involved in the case, as well as the arguments surrounding the public performances of *magnétiseurs.* Bompard's defense was orchestrated by Jules Liégois, whose theory on hypnosis held that anyone with a "sufficiently impressionable nature could be prevailed upon to act unconsciously under the influence and power of external suggestion" (ibid., 198). The prosecution responded with its experts drawn from the school of Charcot, who held that posthypnotic suggestion was a tendency in hysterics, thus requiring more than just a "fairly impressionable nature" (ibid.).

The overarching importance of this case was that public discussion of it demonstrated bourgeois anxieties about sexuality, that is, that women "might be raped in a state of complete un-

consciousness, and hypnotism was accordingly perceived as a threat not only to decent family life but also to the stability of society in general." The 1878 trial of a dentist accused of raping a female patient, after hypnotizing her, seemed to justify these fears. The case took place in Rouen and was investigated by Paul Brouardel. See Harris, "Murder under Hypnosis," 217. In 1892, Liégois proposed what he called a "moral vaccination" for nervous (i.e., suggestible) women, who would "be hypnotized by a trustworthy practitioner who would insert permanent suggestion to thwart the aims of any nefarious magnetizer" (ibid.). See also Gilles de la Tourette, *L'hypnotisme et les états analogues* (Paris: 1887).

60. Harris, "Murder under Hypnosis," 220.

61. Potonié-Pierre, "L'amour guéri par l'hypnotisme," *Le Droit des Femmes,* Nov. 16, 1890, 258–59.

62. See J. Grasset, "Le roman d'une hystérique: Histoire vraie pouvant servir à l'étude médico-légale de l'hystérie et de l'hypnotisme," *Revue de l'hypnotisme* 4 (1889–90): 270–77. Grasset alluded to the recent, sensational Bompard case and then gave several of his own examples of characteristics of hysteria, from "crises convulsives" [convulsions], including the "pose de sirène" [siren pose], and the "sommeil spontané" [spontaneous sleep]. Following these medical examples, he relates a hypothetical series of events, beginning with the accusation of a fourteen-year-old who claimed to have been raped and impregnated by a colporteur, who she said had hypnotized her. When the baby arrived, it was discovered that the girl's claim had been a hoax—the real father of the baby was the girl's boyfriend. But by this time, the colporteur has already been tried, convicted, and sentenced—all on the word of a girl who had learned enough about magnetism and hypnotism from public performances to describe the events surrounding the supposed rape. Harris did not cite this particular article in her essay on the Bompard case. On the legalities of the defense of hypnotism, see "De la suggestion hypnotique dans ses rapports avec le droit civil et le droit criminel," *Séances et travaux de l'académie des sciences morales et politiques* 120, n.s. 22 (Paris: Picard, 1884): 156–240.

63. Ferdinand Bac, "Hypnotisme, hypnotisées, et Hypnotiseurs," *La Vie Parisienne,* Mar. 3, 1888, 118–19.

64. Paul Laur, "Le Bébé Jumeau et le magnétisme," likely from *La Gazette de la Poupée,* Dec. 3, 1887, reproduced in Theimer and Thériault, *Jumeau Book,* 110. For a reasonably objective description of the fabrication of dolls at the Jumeau factory in Montreuil, see Gaston Tissandier, "Les industries parisiennes, une fabrique de poupées," *La Nature,* 1887, 231–34.

65. See "L'hypnotisme et la psychologie physiologique," *Revue de l'hypnotisme* 4 (1889–90): 7, where it is reported that a woman was compelled by an "irrésistible désir" [irresistible desire] to continue returning to the *magnétiseur* five times in three weeks, seemingly at his command.

66. Von Boehn, *Dolls,* 51.

67. See Sandra L. Hampson, "The Decadent Decades: A Phenomenology of Fetishism in the Turn-of-the-Century French Novel: The Case of Huysmans" (Ph.D. diss., Cornell University, 1996).

68. "Il était passé en coutume chez elles de placer dans le berceau vide une représentation grossière de l'enfant ravi par la mort, c-à-d, une poupée véritable. . . . N'est-ce pas là, sous sa forme la plus sincère, le jeu de la poupée, et ici, comme chez la petite fille, n'a-t-il pas pour but et pour effet de donner une satisfaction aux effusions féminines?" [The custom had arisen amongst them to place in the empty cradle a rough effigy of the child being snatched away by death-to all intents and purposes, a doll. . . . This was surely, in its truest sense, an example of doll play; and here, as with the little girl, is the object and the result not to satisfy women's emotional needs?] Chateaubriand, quoted by Rondelet, "Les poupées," 141.

69. Theimer and Thériault, *Jumeau Book,* 42, 83.

70. See H. P. Clive, *Pierre Louÿs (1870–1925): A Biography* (Oxford: Clarendon, 1978), 132, 147. Louÿs's original title was *La mozita.* In Cairo he changed the title to *La sévillane.* The title *La femme et le pantin* first appeared with the serialization in *Le Journal* and became the official title with the story's publication by the Société du Mercure de France in June 1898. Scholars have isolated certain recurrent themes, such as the choice of eighteen-year-old female protagonists, and an

almost obsessive focus on brunette hair, that connected them to Louÿs's relationship with Marie de Régnier, who (as Marie de Hérédia) was eighteen in 1893.

71. Jean-Paul Goujon, *Pierre Louÿs: Un vie secrète, 1870–1925* (Paris: Seghers/J. J. Pauvret, 1988), 205.

72. Pierre Louÿs, "Woman and Puppet," in *The Collected Works* (New York: Livewright, 1939), 165.

73. The pastel, from a private collection, is illustrated in *Félicien Rops: La modernità scandalosa, 1833–1898,* exh. cat. (Rome: Museo Nazionale del Palazzo di Venezia, 1996), no. 19, 111. While the pastel has been dated to 1864, that date seems too early for the appearance of the particular fashion the woman wears. A woman similarly dressed appears in a signed, dated pencil drawing in the Cabinet des Estampes, Bibliothèque royale Albert 1er, Brussels, inv. sv 91872; reproduced in *Félicien Rops, 1883–1898,* exh. cat. (Brussels: Centre culturel de la Communauté française Wallonie-Bruxelles, 1985), no. 83. A second drawing, identified as "le modèle," shows a woman leaning on a similar object. Always attentive to women's fashion, Rops became most interested during the period 1875 to 1885, with the completion of a number of fashion illustrations popularizing the designs of the two women he was then living with—the Duluc sisters. *Félicien Rops* (Brussels catalogue), 110–15.

74. The image appeared as a full page in *Le Courrier Français.*

75. It is tempting to relate this action to Louÿs's story, since money was clearly one aspect of Concha's domination over Mateo. Similarly, the oval shape of the *pantin* suggests Loüys use of hollowed-out eggs filled with confetti as a motif by which Concha and André first meet.

76. The Goncourt brothers spoke of "the bewilderment aroused in him" by the "transvestitism" and "near fantastic clothing of the Parisian woman, who appeared to him like a woman from another planet." Edmond and Jules de Goncourt, *Journal,* Dec. 1866, translated and quoted in Arwas, "Félicien Rops," 3.

77. Octave Uzanne, *Son altesse la femme* (Paris, 1885). The image is in the section entitled "Mulieriana," 279–312. Rops's image appears between pages 202 and 203.

78. The passage specifically referring to Rops's images reads: "Homme! pour dogmatique que tu sois, si engoncé dans l'indifférence et mort aux sensations que tu puisses être, quelque astuce que tu montres, quelque dédain que tu affiches, dans les doigts souples, ingénieux, mignons, magiques, nerveux et enveloppants de la femme, tu m'apparaîtras longtemps comme un faible pantin dont elle joue à son plaisir; qu'elle te séduise par la vanité, par la gloriole, par sa soumission, par sa beauté rayonnante ou sa bonté caressante, qu'elle te prenne par l'esprit, par le cerveau, par les sens ou par le coeur, je verrai toujours cette grande prêtresse te dressant comme un hochet au bout de son bras levé, semblant porter écrit sur son front de sphinx: UBI MULIER, ECCE HOMO." [Man! However dogmatic you may be, however armored with indifference and dead to human feelings; whatever cunning, whatever disdain you evince; under the supple, ingenious, delicious, magical, restless caressing hands of woman, you will always appear to me as a feeble puppet she plays with at leisure. Whether she seduces you through vanity, conceit, by her submissiveness, by her brilliant beauty or her tender attentions; whether she ensnares your mind, your spirit, your senses or your heart, I shall ever picture this high priestess raising her arm and rearing you up like a puppet, wearing, as it were, on her sphinx-like brow, the inscription: UBI MULIER, ECCE HOMO.] Uzanne, *Son altesse,* 281–82.

79. Ibid., 302.

80. Ramiro, *Catalogue descriptif,* xxi. Ramiro wrote of "Nymphes, Dryades, Bacchantes, Déesses d'une mythologie contemporaine, dont l'artiste aurait, par une secrète initiation, découvert le culte . . . spirituel, les cérémonies troublantes, les saturnales échevelées et les autels dorés, où les demi-dieux d'un Olympe terrestre et chimérique déposent leurs riches offrandes aux pieds de l'implacable Amour!" [Nymphs, Dryads, Bacchantes, Goddesses of a contemporary mythology . . . of whom the artist has discovered, through a secret initiation, the spiritual . . . cult, hideous ceremonies, drunken saturnalia, and golden altars where the demigods of an earthly and fantastical Olympus lay their rich offerings at the feet of implacable Love!] Ibid.

81. Mauclair, "Félicien Rops," 978–79.

82. Kunel, *Félicien Rops,* 62–63.

83. Baudelaire, *Fleurs du mal,* 40–41.

84. This is the standard interpretation. See Lawler, *Poetry and Moral Dialectic,* 71.

85. J. R. Soubiran has interpreted the skeletons in the background as the "call to the chase" that initiates a fox hunt, in the catalogue entry for the work in Soubiran, *Gustav Adolf Mossa,* 161. The writers of the catalogue entry did not realize that the poem "Duellum" was a quote from Baudelaire.

86. The last installment of "Grammaire grelotteuse—Auprès d'une femme" utilized the motif to illustrate "un parfait grelotteux." See Jean Alesson, "Grammaire grelotteuse," *Le Courrier Français,* Dec. 21, 1884, 6–7.

87. Translations of the phrase "C'est le Diable qui tient les fils qui nous remuent!" [literally "The devil holds the strings that work us"] vary. Richard Howard's translation is "the Devil's hand directs our every move" (Baudelaire, *Fleurs du mal,* 5), which doesn't precisely capture the puppet aspect of the original French.

88. Péladan to Rops, end of May 1883, quoted by Péladan in his 1904 article "Félician Rops." The remark was first made in the context of a discussion of Rops's *Dame au pantin,* in slightly different form: "Si vous étiez constant dans votre retour à la palette vous devriez faire pour le Salon de 1884 non seulement un Envoûtement moderne; mais la Dame au pantin, avec cette formule que j'ai mise dans mon salon & qui est de vous je crois: l'homme, pantin de la femme; la femme, pantin du diable." [If you were really serious about taking up your brushes again, you ought to paint not only *A Modern Bewitchment* for the 1884 Salon, but also *Woman with Puppet.* The legend could be the one I have in my drawing room, and which I believe was your invention: "Man, woman's puppet; woman, the Devil's."] The full letter is reprinted in Védrine, *Félicien Rops,* 46.

89. Péladan, "Félicien Rops," 321. Péladan reported that Rops had once said to him "C'est le Diable qui est venu. Je ne pensais pas à lui; il est venu sur mon cuivre, je l'ai gravé. Mais vous ne croyez pas au Diable?" [It was the Devil who turned up. I wasn't thinking of him; he appeared on the copper I was working, and I engraved him. But don't you believe in the Devil?] Laughing in what the writer described was "a vulgar way," Rops continued, "Le Diable forme par lui-même l'âme de la femme" [The Devil shapes women's souls all on his own]. In the same article, Péladan explained how he connected the devil, woman, and puppet with the works of Rops: "Il considérait que dans chaque destinée le rôle de la sexualité prédomine comme élément recteur et qu' Eve n'était pas plus libre de résister au démon que nous ne le sommes de lui résister, à elle!" [He considered that in each person's fate the determining role is played by sexuality, and that Eve was no more able to resist the Tempter than we are to resist her!] (ibid.).

90. J. Olivier, *A Discourse of Women, Shewing Their Imperfections Alphabetically* (London: Brome, 1662), 21.

91. Ibid., 158. A section titled "A la plus mauvaise du monde" in the 1876 French edition uses similar juxtapositions, calling woman "la plus imparfaite créature de l'univers, l'écume de nature, le séminaire de malheurs, la source de querelles, le jouet des insensés, le fléau de sagesse, le tison d'enfer, l'allumette du vice, la sentine d'ordure, un monstre en nature, un mal nécessaire, une chimère multiforme, un plaisir dommageable, l'hameçon du diable, l'ennemi des anges et le momon de la divinité" [the most imperfect creature in the universe, the scum of Nature, the breeding-ground of misfortune, the source of disputes, the plaything of madmen, the scourge of wisdom, a brand of hellfire, the tinder of vice, a cesspool of filth, a monster in the flesh, an unavoidable evil, a hybrid chimera, a deadly pleasure, the Devil's lure, the enemy of the angels and a mocker of everything divine] (1–2).

92. Olivier, *A Discourse of Women,* 125.

93. Ibid., 159.

94. Soubiran, *Gustave Adolphe Mossa,* 66.

95. Jules Bois, *L'eternelle poupée* (Paris, 1894), viii–ix. Jacques Tellier, who reviewed the text in *La Plume* (1894), didn't particularly care for the overwrought nature of Bois's writing, and indicated his belief that Bois had a different story in his heart that didn't appear in the book. Tellier

also states correctly that the idea of a woman's appearing as a "doll" to men was not a new one (364–65).

Chapter 7: Depopulation Demons

1. See Janis Bergman-Carton, *The Woman of Ideas in French Art, 1830–1848* (New Haven: Yale University Press, 1995), esp. 153–65.

2. Annelise Maugue, "The New Eve and the Old Adam," in *A History of Women*, vol. 4, *Emerging Feminism from Revolution to World War*, ed. Geneviève Fraisse and Michelle Perrot (Cambridge, Mass.: Harvard University Press, 1993), 528.

3. Anonymous image, "Les droits de la Femme," *Paris-Caprice*, Oct. 10, 1868, 330–31.

4. La Palférine, "Les droits de la femme," *Paris-Caprice*, Oct. 10, 1868, 329.

5. Translated and quoted in Moses, *French Feminism*, 213. See Jehan des Etrivières, *Les amazones du siècle* (Paris, 1882). Auclerc was also ridiculed in "A Mlle Hubertine Auclerc et Cie.," a long poem that appeared on the first page of *Le Figaro*, Feb. 14, 1880.

6. Documents describing the "guerre des sexes" [war of the sexes] are plentiful in the late nineteenth century. Jules Bois's article "La guerre des sexes" is one example. Satirical articles include Gustave Rivet's "Vengeance des femmes," *Le Charivari*, Aug. 12, 1890, 2–3; and Quivala, "La femme, voilà l'ennemi," *Le Charivari*, July 30, 1891. Among articles in the mainstream, serious-minded *Le Figaro* were "Le calvaire des femmes" by Maurice Talmeyr (Feb. 24, 1894, 1); "L'invasion des femmes" by A. Claveau (Sept. 24, 1897, 1); and "Guerre aux femmes" by Charles Chincholle (Jan. 1, 1897, 2). Albert Pajol changed the title of his 1891 "Fantaisie-bouffe" in two acts, destined for performance at *La Cigale*, from "La guerre des femmes" to "La guerre aux hommes" (MS, Archives Nationales de France, F18 1426).

7. Maugue, "New Eve," 529. See also Maugue's longer study, *L'identité masculine en crise au tournant du siècle, 1871–1914* (Paris: Rivages, 1987).

8. Maria Martin, "Couturières et tailleurs," *Journal des Femmes* 108 (1901): 1.

9. Quoted in Uzanne, *Parisiennes de ce temps*, 259.

10. Translated and quoted in Maugue, "New Eve," 529.

11. See Bergman-Carton, *Woman of Ideas*, chapter 3, "Ménagère ou courtisane: Daumier's Vision of Female Intellect," 65–102. The term "bluestocking" was developed in England as a commentary on a particular aspect of women's clothing—bloomers—which, while not particularly form-fitting, appeared to the average man as a type of trouser.

12. See, for example, "Bas-bleu," *La Revue des Revues* 6 (1893): 144; "Les bas-bleus en France," *La Revue des Revues* 6 (1893): 143; and Henry Fouquier, "Les bas-bleus," *Le Figaro*, July 5, 1896, 1.

13. Lombroso, quoted in Uzanne, *Parisiennes de ce temps*, 260. The biological basis for women's inferiority is propagated in a great deal of period literature, including Alfred Fouillée, "La psychologie des sexes et ses fondements physiologiques," *La Revue des Deux-Mondes*, Sept. 15, 1893, 397–429; "Les femmes et le Darwinisme," *La Revue des Revues* 7 (1894): 325–30; and M. Poirier, *L'infériorité sociale de la femme et le féminisme*, a doctoral thesis published in 1900. See also Fernand Mazade, "La femme devant la science," *Documents du progrès* (Oct. 1912): 245–49; and Geddes and Thomson, "L'evolution du sexe," 95–111. Feminists refuted this evidence. See, for example, Dr. L. Manouvrier, "Indications anatomiques et physiologiques relatives aux attributions de la femme," *Bulletin de l'union universelle des femmes*, Dec. 15, 1890, 9–12, and Jan. 15, 1891, 12–14, and Jeanne E. Schmahl, "La question de la femme, son infériorité," *La Nouvelle Revue* 83 (1893): 614–17.

14. Uzanne, *Parisiennes de ce temps*, 290.

15. According to Barbey d'Aurévilly, "Les femmes qui écrivent ne sont plus des femmes, . . . ce sont des hommes,—du moins de prétention,—et manqués! Ce sont des Bas-bleus. *Bas-bleu* est masculin. Les Bas-bleus ont, plus ou moins, donné la démission de leur sexe. Même leur vanité, très souvent jolie, de la femme, il leur en a poussé une autre qui a dévoré la première, et qui est affreuse comme l'orgueil impuissant." [Women who write are no longer women . . . they are men. At least they try to be—and fail! They are bluestockings. *Bluestocking* [*bas-bleu*] is a masculine noun in French. The bluestockings have more or less resigned their sex. Even their woman's

vanity, often a very pretty thing, has been swallowed up by a new sort, a sort of ghastly, impotent pride.] Quoted in Uzanne, *Parisiennes de ce temps,* 274. Barbey d'Aurévilly was following in literary tradition of the July Monarchy, including Frédéric Soulié's *Physiologie du bas-bleu* (Paris, c. 1844), discussed below.

16. John Grand-Careret, *La femme en culotte* (Paris: 1900), iv.

17. See Laura S. Strumingher, "The Vésuviennes: Images of Women Warriors in 1848 and Their Significance for French History," *History of European Ideas* 8, nos. 4/5 (1987): 451–88; and Edith Thomas, *Les pétroleuses* (Paris: Gallimard, 1980).

18. Draner, "La femme-homme," *Le Charivari,* Nov. 27, 1890, 3.

19. Alexandre Dumas fils, *Man-Woman; or, The Temple, The Hearth, The Street,* trans. George Vandenhoff (Philadelphia, 1873); originally *L'homme-femme.*

20. Ibid., 7.

21. Ibid., 65.

22. Ibid., 77.

23. Ibid., 79.

24. Ibid., 80.

25. Ibid., 82.

26. Ibid., 83.

27. Ibid., 104–6. The Bible has been interpreted as justifying this type of domestic violence. See Charles Ess, "Reading Adam and Eve: Re-Visions of the Myth of Woman's Subordination to Man," in *Violence against Women and Children: A Christian Theological Sourcebook,* ed. Carol J. Adams and Marie M. Fortune (New York: Continuum, 1995), 92–120.

28. Jules Hoche, "Tue-la," *Le Charivari,* June 19, 1886, 1–2. For a summary of the debate, and a reprinting of original documents, see André Lebois, *Alexandre Dumas Fils: Le dossier "Tue-La!"* (Avignon: Edouard Aubanel, 1969).

29. Maria Deraismes, *Eve contre M. Dumas fils* (Paris: E. Dentu, 1872), 26.

30. Albert Wolff published a summary of the document. See Albert Wolff, "Alexandre Dumas Fils, *Les femmes qui tuent et les femmes qui votent,*" *Le Figaro,* Sept. 24, 1880, 1. Jules Clarétie's article was titled "La vie à Paris" and appeared Aug. 24, 1880, 3. The Tilly affair also inspired controversy in the press about the trial itself, and renewed the debate over divorce that had been rampant in *Le Figaro* throughout 1879 and early 1880, when Dumas's *La Question du Divorce,* was summarized by Albert Wolff (Jan. 31, 1880). See Janus, "Paris au jour le jour," *Le Figaro,* Aug. 19, 1880 2; and A.R., "A propos de l'affaire de Tilly," *Le Figaro,* Aug. 22, 1880, 2.

31. Dumas's *Les femmes qui tuent* was popular enough to warrant a new edition in 1885. See Alexandre Dumas, *Les femmes qui tuent et les femmes qui votent* (Paris: C. Lévy, 1885), esp. 175 and 195 for a discussion of Eve. Dumas also promoted the appearance of biblical references and characters in French theater. See his "La Bible au théâtre," *La Revue des Revues* 6 (1893): 184–86. Dumas's *Les femmes qui tuent* also inspired copycat titles, such as René Marcil's *Les femmes qui pensent et les femmes qui écrivent* (Paris, 1889).

32. See also Alfred Barbou, "Alexandre Dumas *Fils,*" *L'éclipse,* July 19, 1883, which also featured an illustration by Moloch. In this case, Dumas was shown dwarfing a woman, to whom he hands a "bulletin de vote" [voting form]. Between the two are stacked three books, labeled "Tue-Le" [Kill him!], on the bottom; "Tue-La!" [Kill her!], in the middle; and "Entre-tuez-vous les uns les autres" [Kill each other!], on top.

33. André Laroche, "La femme-homme," *Le Charivari,* Aug. 2, 1887, 1–2.

34. Alphonse Lafitte, "Les femmes-garçons" *Le Sifflet,* Sept. 22, 1872, 3.

35. For a summary of the statistical evidence of depopulation, and the attempts to reverse the trend, see *Histoire de la population française,* vol. 3 (Paris: Presses Universitaires de France, 1988), chapter 7, "La chute de la fécondité," 351–402. For an interpretation of that evidence as it relates to the perceived "health of the nation," see Robert Nye, *Masculinity and Male Codes of Honor in Modern France* (New York: Oxford University Press, 1993), chapter 5, "Population, Degeneration and Reproduction."

36. Draner, "Enquête charivarique sur la dépopulation," *Le Charivari,* Jan. 11, 1900, 5.

37. Angus McLaren, *Sexuality and Social Order* (London: Holmes and Meier, 1983), 154. See also Karen Offen, "Depopulation, Nationalism and Feminism in Fin-de-Siècle France," *American Historical Review* 89 (1984): 648–76.

38. Translated and quoted in Moses, *French Feminism,* 195.

39. McLaren, *Sexuality and Social Order,* 163.

40. A.G., "Dépopulation," *Journal des Femmes* 29 (1894): 1.

41. Maria Martin, "Dépopulation," *Journal des Femmes* 9 (1892): 1. A summary of Maria Deraismes's lecture on the subject is contained in Maria Martin, "Dépopulation," *Journal des Femmes* 14 (1893): 1–2. Deraismes's "Dépopulation" was included in her text *Les droits de l'enfant,* in 1887. See also her article "La régénération de la France," *L'Avenir des femmes,* Nov. 5, 1871, 1–2. The most comprehensive article to appear in the journal on the subject was Camille Bélilon and Hyacinthe Bélilon, "Rapport sur qualité prime quantité," *Journal des Femmes,* two-page supplement to the Dec. 1903 issue. On the statistics of illegitimate children and social implications, see Catherine Rollet-Echalier, *La politique à l'égard de la petite enfance sous la IIIe république* (Paris: Institut National d'Etudes Démographiques, Presses Universitaires de France, 1990), esp. chapter 2.

42. "La stérilité des mariages en France," *La Revue des Revues* 9 (1894): 261.

43. McLaren, *Sexuality and Social Order,* 140.

44. Ibid., 142.

45. Ibid., 148.

46. See Frédéric Soulié, *Physiologie du bas-bleu,* vignettes by Jules Vernier (Paris: n.d.). The Bibliothèque Nationale has given this text an approximate date of 1800, but the proliferation of studies of this type during the July Monarchy makes the 1840s a more likely approximation.

47. Ibid., 31.

48. The specimen jar was commonly used for the preservation of medical specimens. A similar piece of scientific equipment, the bell jar, was exported by the Dutch to other countries, including Japan. See Timothy Benjamin Mark Screech, "The Western Scientific Gaze and Popular Culture in Late Edo, Japan" (Ph.D. diss., Harvard University, 1991), esp. 206–14. Aubrey Beardsley's representation of a fetus in a bell jar (figure 93 in the present book) is discussed below.

49. See Robert Fath, *L'influence de la science sur la littérature française dans la seconde moitié du XIXe siècle: Le roman, la poèsie, le théâtre, la critique* (Lausanne: Payot, 1901), and Louis Figuier, *La science au théâtre* (Paris: Tresse et Stock, 1889). The popularizing of science has been studied more recently by Nadine Felton George, "Popular Science and Philosophy in France, 1850–1975" (Ph.D. diss., Cornell University, 1974), and Bruno Béguet, ed., *La science pour tous: Sur la vulgarisation scientifique en France de 1850 à 1914* (Paris: Bibliothèque du Conservatoire national des arts et métiers, 1990).

50. Jean Beauduin, "L'émancipation de la femme," *Paris s'Amuse,* Jan. 27, 1883, 200.

51. Jacques Gélis, *The History of Childbirth,* trans. Rosemary Morris (Cambridge: Polity Press, 1991), 219.

52. Achille Valenciennes, "Catalogues des préparations anatomiques laissées dans le cabinet d'anatomie comparée du Museum d'Histoire Naturelle, par G. Cuvier," *Nouvelles Annales du Muséum d'Histoire Naturelle* 2 (1833): 429. I thank Cédric Crémière, who was kind enough to discuss with me the collection of the Muséum National d'Histoire naturelle and provide photographs and a copy of a portion of his thesis, "Mettre en scène l'esprit scientifique"—La Galerie d'anatomie comparée—Mémoire de DEA, Muséologie, Muséum National d'Histoire naturelle, 1998.

53. See Béguet, *La science pour tous,* 136–38. The public could view these collections on Tuesdays, Thursdays, and Sundays. See Adolphe Joanne, *Le Guide Parisien* (Paris: Hachette, 1863) 350. In 1874, the attendance numbers for the Jardin approached six hundred thousand, although numbers are not available for the specific galleries in the museum. Statistics from 1861 to 1874 are summarized in Michael Osborne, "The Société Zoologique d'acclimatation and the New French Empire: The Science and Political Economy of Economic Zoology during the Second Empire" (Ph.D. diss., University of Wisconsin–Madison, 1987), 182. A register conserved at the Archives Nationales (AJ15*145) lists a number of academic artists, including Camille Claudel and Henri Matisse, who

received permission to study in the collection between 1832 and 1896 ("visiteurs et étudiants du cabinet d'anatomie, 1832–1896").

54. Today this collection exists as part of the Musée Dupuytren. I thank Paul Prudhomme de Saint-Maur, Professeur d'Anatomie Pathologique à l'U.F.R. Saint-Antoine and Conservateur du Musée Dupuytren, for correspondence that clarified the history of the collection of the Ecole de Médecine, which debuted in the 1830s and existed without change until 1937. In 1967, it was re-opened in its current location as the Musée Dupuytren. Because the catalogue of the collection is incomplete, it is not possible to document when the "malformations" entered the collection, but M. Saint-Maur says that most certainly they had entered the collection before the end of the nineteenth century. Unlike the Natural History Museum at the Jardin des Plantes, the Ecole de Médecine did not keep a register of visitors, but visitation by artists and the general public was possible, even through bribery of the museum's employees. M. Saint-Maur also confirms that the collection was known to the public at large, and that it "suscitait bien des fantasmes" [gave rise to all sorts of fantasies] (e-mail, Nov. 8, 2000). The public also would have been enticed by the original installation of the collection in a Gothic convent refectory and the immersion of the specimens in a "secret sauce." Paul P. de Saint-Maur, "Le Musée Dupuytren et le Musée Déjerine, *Les musées de la Médecine* (Paris: Privat, 1999), unpaginated, copy provided by the author.

55. The anecdote is repeated in Joanna Richardson, *Verlaine* (London: Weidenfeld and Nicolson, 1971), 6.

56. Mac-Nab, "Les foetus," originally published in *Poèmes mobiles,* reprinted in Bertrand Millanvoye, *Anthologie des poètes de Montmartre* (Paris: Société d'éditions littéraires et artistiques, n.d.), 241–43. Mac-Nab was, like Henry Somm, a member of both the Hydropathes and the Ancien Chat Noir in Montmartre.

57. G. Lion, "Récompenses," *Le Charivari,* Sept. 11, 1900, 3. On the subject of artists' interest in evolution in terms of nature versus nurture, and women's culpability, see Barbara Larson, "La génération symboliste et la révolution darwinienne," in *L'âme au corps: Arts et sciences, 1793–1993* (Paris: Réunion des Musées Nationaux, Gallimard/Electa, 1993), 322–41.

58. Henri Somm, "Psychologues," *Le Rire,* Aug. 8, 1903, 15.

59. Examples of "sirènes" are depicted in Jean-Louis Fischer, *Monstres: Histoire du corps et de ses défauts* (Paris: Editions Syros-Alternatives, 1991), 40–41.

60. The literature in this area of science is vast, including the works of J. F. Meckel, E. Geoffroy Saint-Hilaire, and E. R. Serres in France. Also significant were the theories of Darwin, which were increasingly accepted in the nineteenth century. See, for instance, Georges Canguilhem et al., *Du développement à l'évolution au XIXe siècle* (Paris: Presses Universitaires de France, 1962); Robert Ernest Stebbins, "French Reactions to Darwin, 1859–1882" (Ph.D. diss., University of Minnesota, 1965); Yvette Conry, *L'introduction du Darwinisme en France au XIXe siècle* (Paris: Librairie Philosophique, 1974); Toby Appel, *The Cuvier-Geoffroy Debate: French Biology in the Decades before Darwin* (New York: Oxford University Press, 1987); and Bernard Balan, *L'ordre et le temps: L'anatomie comparée et l'histoire des vivants au XIXe siècle* (Paris: Librairie Philosophique, 1979).

61. Ambroise Paré, *On Monsters and Marvels,* trans. Janis Pallister (Chicago: University of Chicago Press, 1982), xv. The earliest version of the treatise, *Des monstres et prodiges,* appeared in 1573.

62. Marie-Hélène Huet, *Monstrous Imagination* (Cambridge, Mass.: Harvard University Press, 1993), 17.

63. Ibid., 57.

64. Dr. Karl du Prel discussed these beliefs in his "La maternité et la suggestion," *Revue Bleue* 15 (1895), 428–35. Ernest Legouvé's oft-reprinted *Histoire morale des femmes* (Paris: Didier, 1849, 1854, 1856, 1864, 1869, 1870, 1874, 1882, 1896) also repeats these ideas; see esp. 245–61. On the progression of medical theories of monstrosity, see Jean Borie, *Mythologies de l'hérédité au XIXe siècle* (Paris: Editions Galilée, 1981), esp. 83–100.

65. In the story, a character asks, "Have you given any thought to these human monstrosities[,] . . . horrible errors of nature, all issued from a sensation, a whim, a sight, an IDEA that occurred during the mother's pregnancy?" Quoted in Huet, *Monstrous Imagination,* 103.

66. Nye, *Masculinity and Male Codes of Honor,* 86.

67. Maugue, *L'identité masculine,* 84.

68. Linda Zatlin, "Félicien Rops and Aubrey Beardsley: The Naked and the Nude," in *Reconsidering Aubrey Beardsley,* ed. Robert Langenfeld (Ann Arbor, Mich.: UMI, 1989), 167–205.

69. Jane Haville Desmarais, *The Beardsley Industry: The Critical Reception in England and France, 1893–1914* (Brookfield, Vt.: Ashgate, 1998), esp. chapter 6, "Beardsley and the Symbolists," 104–16. Desmarais has compiled data related to the availability of Beardsley's illustrated books (see page 109) and compared the critical response in England and France side-by-side; see appendix 1.

70. Ruding's novel is discussed by Linda Zatlin, *Aubrey Beardsley and Victorian Sexual Politics* (Oxford: Clarendon, 1990), 27. In subsequent pages, Zatlin details three other novels illustrated by Beardsley that make similar claims.

71. Milly Heyd, *Aubrey Beardsley: Symbol, Mask, and Self-Irony* (New York: Peter Lang, 1986), 56. Heyd believes that the symbol in Beardsley's work is complex, and she assigns to it a "trifold nature," symbolizing the artist's life, a desire for procreation (termed "pregnancy envy" by Heyd), and the act of artistic creation. While these interpretations may be valid, I don't believe they represent the true scope of possibilities for the motif. Hyde concentrates on the scientific aspect of the motif at the expense of the possibilities inherent within the Symbolist/decadent circles in which Beardsley was involved. More disturbing is her sacrificing of the content and meaning of the texts in which the motif appears.

72. The arguments of Haldane MacFall, Brian Reade, and Malcolm Easton are summarized by Heyd, *Aubrey Beardsley,* 56–58.

73. Henry Maas, J. L. Duncan, and W. G. Good, eds., *The Letters of Aubrey Beardsley* (Rutherford, N.J.: Fairleigh Dickinson University Press, 1970), 120. Beardsley was describing a specific example of an embryo merged with a dwarf's body in a cover illustration for *The Savoy,* Apr. 1896.

74. Zatlin, paraphrasing John Rothenstein, in the introduction to her *Aubrey Beardsley and Victorian Sexual Politics,* 8.

75. Maas, Duncan, and Good, *Letters of Aubrey Beardsley,* 34.

76. Sydney Smith and R. Brinsley Sheridan, *Bon-mots of Sydney Smith and R. Brinsley Sheridan* (London: J. M. Dent, 1898), 88.

77. Ibid., 89.

78. Zatlin, *Aubrey Beardsley and Victorian Sexual Politics,* 113.

79. Aubrey Beardsley, "Lucian's Strange Creatures" (designed for *Lucian's True History* but unused), c. 1893, illustrated in Zatlin, *Aubrey Beardsley and Victorian Sexual Politics,* 33.

80. Aubrey Beardsley, *Incipit Vita Nova,* c. 1893, Victoria and Albert Museum, London, illustrated, in Chris Snodgrass, *Aubrey Beardsley: Dandy of the Grotesque* (New York: Oxford University Press, 1995), 180.

81. The relationship between Munch and French artists, especially the Symbolists, is detailed in Rodolphe Rapetti and Arne Eggum, *Munch et la France,* exh. cat. (Paris: Réunion des Musées Nationaux, 1992).

82. At least one of the prints is signed "E. Munch 1896 Paris." See Robert Rosenblum et al., *Edvard Munch: Symbols and Images,* exh. cat. (Washington D.C.: National Gallery of Art, 1978) 217. On Munch's exhibitions in Paris, and his relationship with Siegfried Bing's gallery L'Art Nouveau, see Arne Eggum, "Munch tente de conquérir Paris (1896–1900)," in *Munch et la France,* 188–201.

83. An additional mummified specimen, originally thought to be that of a monkey, which an Italian archaeologist sold to Etienne Geoffroy Saint-Hilaire, is illustrated in Fischer, *Monstres,* 27. This latter example is curled up in a position closer to the position of Munch's *Madonna* fetus.

84. Rosenblum, "Introduction," *Edvard Munch: Symbols and Images,* 8.

85. Ruth A. Rynn, "The Eve Motif: A Comparative Study of the Artwork of Paul Gauguin and Edvard Munch" (M.A. thesis, Hunter College, 1992). Rynn interprets Munch's *The Voice* as "Eve before the Fall" (113), and *The Kiss* as the beginning of the love affair. *Jealousy* is the first work to refer explicitly to Adam and Eve (114).

86. These failed relationships include his affair with the married, and very liberated, Milly Ihlen Thaulow (identified by Munch in his letters through the pseudonym "Mrs. Heiberg"). See Patricia G. Berman and Jane Van Nimmen, *Munch and Women: Image and Myth* (Alexandria, Va.: Art Services International, 1997), 29.

87. Quoted in Bente Torjusen, *Words and Images of Edvard Munch* (Chelsea, Vt.: Chelsea Green, 1986), 117.

88. Review in *Revue Blanche,* 1896, quoted in J. P. Hodin, *Edvard Munch* (New York: Praeger, 1972), 76. In the same article, Strindberg published a diagram of a new triad of womanhood as found in Munch's work: *hommesse, pécheresse, maîtresse.* See Berman and Van Nimmen, *Munch and Women,* 25.

89. Carla Lathe, "Edvard Munch and Modernism in the Berlin Art World 1892-1903," in *Facets of European Modernism. Essays in Honour of James McFarlane,* ed. Janet Garton (Norwich, Eng.: University of East Anglia, 1985), 99-129.

90. Arne Eggum, "The Theme of Death," in Rosenblum et al., *Edvard Munch: Symbols and Images,* 164. The equation of pregnancy and death appears in a subheading entitled "Madonna: Pregnancy Means Death," 165.

91. Berman and Van Nimmen, *Munch and Women,* 28. The fact that the fetus is infected with syphilis is explained through a notice posted on the back wall, in the painting and the print.

92. *The Issue,* Oct. 4, 1902, consisted only of Léandre's series of images. Léandre, a student of Alexandre Cabanel, was a well-published caricaturist and cofounder of the Société des Humoristes. Among the journals in which he published were *Le Chat Noir, Le Figaro, Le Journal Amusant,* and *Le Rire.*

Chapter 8: Serpent Culture

1. See Balaji Mundkur, *The Cult of the Serpent: An Interdisciplinary Survey of Its Manifestations and Origins* (Albany: State University of New York Press, 1983), and Buffie Johnson, *Lady of the Beasts: Ancient Images of the Goddess and Her Sacred Animals* (San Francisco: Harper and Row, 1988), esp. part 4, "The Serpent," 121-92. A useful list of artifacts containing snakes (though there is little analysis of the examples) is found in Elpis Mitropoulu, *Deities and Heroes in the Form of Snakes* (Athens: Pyli, 1977).

2. The most thorough study of the different manifestations of the Great Goddess remains Erich Neumann's *The Great Mother: An Analysis of the Archetype* (New York: Bollingen, 1955).

3. Ibid., 21.

4. Ibid., 149.

5. Merlin Stone, *When God Was a Woman* (New York: Harcourt Brace Jovanovich, 1976), 199. This work was originally published in Great Britain under the title *The Paradise Papers.*

6. The term "python" can be traced to Delphi. It was the name of the snake associated with Gaia, the mother goddess. On the process by which the Great Goddess figure was replaced with male deities, see Stone, *When God Was a Woman,* 203. See also Marilyn Nissenson and Susan Jones, *Snake Charm* (New York: Abrams, 1995), 32.

7. On the phallic quality associated with serpents, see Balaji Mundkur, *The Cult of the Serpent: An Interdisciplinary Survey of Its Manifestations and Origins,* chapter 4, "The Serpent as Sexual Symbol," and M. Oldfield Howey, *The Encircled Serpent: A Study of Serpent Symbolism in All Countries and Ages* (London: Rider, [c. 1963]), chapter 12, "The Serpent as Phallic Emblem." A similar masculine/feminine dichotomy occurs with symbolism surrounding trees, which have a phallic character to their trunks. Trees were once understood as a combination of masculine and feminine but eventually became (like much of nature) considered feminine. See Neumann, *The Great Mother,* 49-51.

8. Nissenson and Jones, *Snake Charm,* 15.

9. Eva C. Hangen, *Symbols: Our Universal Language* (Wichita, Kans.: McCormick-Armstrong, 1962), 226. Hangen writes, "The underlying purpose of this serpent is to deceive and to destroy mankind; consequently, it basically symbolizes chaos. However, it uses its association with life and wisdom to attempt the realization of this objective" (ibid.).

10. On the phenomenon of motherhood inherent within the great goddess in various cultures, see Lotte Motz, *The Faces of the Goddess* (New York: Oxford University Press, 1997).

11. Nissenson and Jones, *Snake Charm,* 19.

12. Karen Randolph Joines, *Serpent Symbolism in the Old Testament: A Linguistic, Archaeological, and Literary Study* (Haddonfield, N.J.: Haddonfield House, 1974), 30.

13. Nissenson and Jones, *Snake Charm,* 23.

14. See Kelly, "The Metamorphoses of the Eden Serpent," 302–3. Sculptures on the cathedral of Laon include a woman whose waist is encircled by a snake (c. 1210–30); the portals at the cathedral at Moissac (1115–35) include a relief representation of lust depicting serpents biting the breasts and genitals of women, the parts that contain sin.

15. John K. Bonnell, "The Serpent with a Human Head in Art and in the Mystery Play," *American Journal of Archaeology* 21, ser. 2 (1917): 255. Bonnell cites other early sources, such as Beda Venerabilis, *Dubia et spuria in Migne,* but he believes that Beda's source was Comester. Alice Kemp-Welch primarily considers the appearance of the motif in Michelangelo's "Fall and Expulsion" on the Sistine Chapel ceiling, in "The Woman-Headed Serpent in Art," *The Nineteenth Century and After* 52 (Dec. 1902): 983–91. Some of the implications that the female-faced snake had for later art (especially British paintings) have been studied by Nancy Weston, in "The Strange Career of the English Snake Woman" (master's thesis, University of Southern California, 1988). I thank Professor Weston for sharing her thoughts on this subject with me, and for pointing me in the direction of important literature on the subject that I may not have otherwise found.

16. Bonnell, "Serpent with a Human Head," 279.

17. Ibid., 257. According to Margaret Hallissy, "The serpent with a woman's face becomes the serpentine woman, the woman whose special relationship with a venomous animal makes her more fearful than either serpent or woman would be alone" (*Venomous Woman,* 89). Hallissy is concerned with women as poisoners and thus sees the woman/snake as the fusion of two symbols of evil; she writes, "the woman is the poison" (ibid.).

18. Larcher, *Satires et diatribes,* 13 and 57, respectively.

19. Ibid., 87.

20. Ibid., 186.

21. De Pompéry, *La femme dans l'humanité,* 133.

22. Ibid., 174.

23. Milton, *Paradise Lost,* 9.463–64 (Hofer and Winterich edition, p. 213), quoted in Rapaport, *Milton and the Postmodern,* 64–65.

24. Women are cited as accomplices to the devil in the poem "Satan semant l'ivraie," in L. Lefèvre, *Les Ropsiaques* (1890)—poetry inspired by the artist's illustrations of women. On Rops and his "organiste du diable" [devil's organist], see J. Pradelle, "Rops naturien et Féministe," *La Plume,* June 15, 1896 (an issue dedicated exclusively to Rops), 401–12.

25. Other examples include Arsène Houssaye's *Les femmes du diable* (Paris, 1867, 1878), and Pierre Véron's *Paris à tous les diables* (1882).

26. *Maximes et pensées sur la femme* (Paris, 1880), 23.

27. Aschkenasy, *Eve's Journey,* 40.

28. The eye motif appears in an illustration by Lami, called "Le décolletage à travers le siècles: Celui de notre mère Eve," *Le Courrier Français,* Jan. 13, 1901, 10. Gerbault used the motif in a cover illustration for *Le Charivari* (July 6, 1899), where the eye wears a monocle and watches over "Mademoiselle Phryné se rendant à Trouville."

29. See William Blake, *Temptation of Eve,* watercolor (1808, Boston, Museum of Fine Arts). Blake created his own version of biblical stories. He is not "illustrating" Milton but trying to reconcile/reconsider the story in terms of his own beliefs. As David Bindman has noted, "By absorbing Milton's experience into his own, Blake becomes the prophetic saviour necessary for the Apocalypse." Bindman, *William Blake: His Art and Times* (New Haven: Yale Center for British Art, 1982), 149.

30. B. Gauthier, "A la foire au pain d'épice," *Le Journal Amusant,* Apr. 7, 1888, 3.

31. Tracking the origin of the book is impossible due to its satiric publication information ("A Damnopolis, chez Diabolino, Librarie-Editeur, rue d'Enfer"). Pascal Pia believes that the book dates in its original version to the 1830s; he has documented that the courts condemned it in 1845. See Pia, *Les livres de l'enfer* (Paris: C. Coulet and A. Faure, 1978), vol. 2, col. 1209.

32. See F. N. Henry, *Le diable dupé par les femmes* (Brussels: Gay and Doucé, 1881).

33. Ibid., 5.

34. Louis Leroy, "Ou Mme Eve tente le serpent," *Le Charivari*, Oct. 23, 1883, 2–3. Leroy notes, "Oubliait le serpent, ou plutôt elle en jouait le rôle auprès du paysagiste qui, peu à peu, se sentait de terribles envies de mordre dans les fruits savoureux qu'on semblait mettre à sa portée; mais la crainte de les trouver pleins de cendre, de fair un four, pour parler moins bibliquement, le rete-nait." [(She) forgot the serpent, or, rather, she played its part with the artist who, little by little, began to experience a terrible desire to taste the appetizing fruit that appeared to have been placed within his reach. But the fear of finding it full of ashes—of falling on his face, to put things less biblically—restrained him.]

35. A slightly different version (with a more defined background) was reproduced in *Le Courrier Français*, May 25, 1902.

36. The illustration is in the Bibliothèque Nationale, Cabinet des Estampes, "Oeuvres de Ger-bault," G175651, G175695.

37. The work was also reproduced in the album *Bonjour m'sieurs dames* (1903).

38. Jack Spector, "A Symbolist Antecedent of the Androgynous Q in Duchamp's L.H.O.O.Q.," *Source: Notes in the History of Art* 18 no. 4 (Summer 1999): 44. Spector's main concern in the article is to discuss the implications of the phallic cedilla of the "Q" in other works by Roy; in the case of *Femmes honnêtes* he argues that the penetration of the snake through the "O" in the word "hon-nêtes" is similar to the cedilla.

39. For instance, in the story "Bibiane" her walk is described as "à la fois serpentine et contenue" [at the same time serpent-like and restrained]. Joséphin Péladan, *Femmes honnêtes* (Paris: C. Dalou, 1888), 23.

40. Ibid., 18.

41. From the story "Edelburge-Nina" (1888), ibid., 33.

42. Alfred Grévin, "A travers Paris," *Le Charivari,* Jan. 13, 1883, 3; the work later appeared in *Petit Journal Pour Rire* 450, 3rd ser., cover.

43. Jacques Ruppert et al., *Le costume français* (Paris: Flammarion, 1996), 287.

44. A side-by-side comparison of clothing and Art Nouveau forms is found in Comte d'Aumale, "Génétique du Costume," *L'Amour de l'art* (1st trimester, 1952): 67. Alison Gernsheim describes Art Nouveau gowns in terms of "long convolvulus-like curves, trailing boas and trains." Gernsheim, *Fashion and Reality* (London: Faber and Faber, 1963), 82.

45. The caption reads: "La Toilette du Sphinx.—Effrayante! Rien qu'une immense tunique de dentelle noire garnie de tessons de bouteilles et de pointes d'acier! . . . Serrez donc cette femme-là sur votre coeur? Brrrr . . . il y a trop de pièges à loups dans son enceinte!" [The toilette of the Sphinx.—Ghastly! Nothing but a huge tunic made of black lace decorated with bottle shards and steel points! . . . Embrace that woman tight? Brrrr . . . too many mantraps in her fortifications!] Artist unknown, "Le sphinx à la Comédie-Française," *La Vie Parisienne*, Apr. 4, 1874, 193.

46. Baudelaire, *Les fleurs du mal*, 33.

47. Ibid., 34.

48. The Bibliothèque Nationale Cabinet des Estampes owns a prepatory sketch page. The sketch page has Japanese-inspired designs on it, leading to the question of whether or not Somm incor-porated the idea of the Japanese dragon into his representations. See Richard Lesclide's articles "Sur la Vénus de Milo," part 1, *Paris à l'Eau-Forte*, June 7, 1874, 71; part 2, June 14, 1874, 79–80; part 3, June 21, 1874, 86–87.

49. Baudelaire, *Les fleurs du mal*, 35.

50. Lesclide, "La Parisienne," *Paris à l'Eau-Forte*, June 21, 1874, 83.

51. Somm completed illustrations for Lesclide's *Maison des fous* in 1874.

52. Lesclide, "Sur la Vénus de Milo," part 3, 87. Here, Lesclide has quoted the words of a Mon-sieur de Marcellus, who made the statement because he was practically in love with the statue.

53. Like the "Pupazzi" program (figure 68) described in chapter 6, this work seems to be not a specific program, but a symbolic representation in which Somm has utilized real works (from literature, music, and theater) to comment on contemporary events. Mentioned are *Le codicille,* a "real" one-act play by Paul Ferrier; the musical pieces *Ave Maria* and *Cavatine du barbier;* a scene from a play by Henri Meilhac (*Fanny Lear*); a "scène de Louis XI" by Casimir Delavigne; unidenti-

fied poetry by Victor Hugo; *Les adieux à Suzon* by Alfred de Musset; and something termed "panorama vivant et imitations d'artistes" [living panorama and imitations of artists], supposedly performed by a Monsieur H. Plessis.

54. Women were described as snakes in French literature. The poem "Collection de Serpents," by Jules Vernier, describes a cold woman called a "fille de marbre" [daughter of marble] as the "monstre" missing from his vision of fourteen pythons, thirty-six boas, and a variety of other snakes. *L'Artiste* 4 (1875): 361–62. The antifeminist writer Victor Jozé titled one of his books in the series *La ménagerie sociale* (many volumes of which focused on prostitution) as *L'éternel serpent* (1906). The book followed the affairs of two women, Georgette and Léontine. Jozé used the term "serpent" ambiguously to refer simultaneously to women and to sexual temptation. This is implied by the title as compared to the content, for there is no direct mention of serpents in the text. Paul Mathiex's article "La Femme-Serpent" was concerned with describing the contortionist abilities of a circus performer: "Elle, si souple dans ses exercices de dislocation, quand elle s'allonge, se tord, se contourne comme une couleuvre, tandis que son collant, bordé de pailletttes d'or, scintille, telle une armure de reptile" [So lithe in her contortionist act when she stretched, twisted or curled herself up like a snake, while her gold-sequined leotard glittered, just like a reptile's scales] *Gil Blas Illustré,* July 5, 1901, 2–3. George Tis published a poem titled "La femme serpent" (also about a circus performer) in *Le Courrier Français,* Jan.–Apr. 1908, 45.

55. For further discussion of Somm's *Mermaid* and of Somm as a Symbolist, see Menon, "Henry Somm."

56. Honoré de Balzac, *Traité de la vie élégante,* reprinted with *Les parisiens comme ils sont, 1830–1846* (Geneva: La Palatine, 1947), 213.

57. D'Avenal called dresses "des boîtes à surprises pour le plaisir de les ouvrir, des joujoux compliqués pour en pénétrer les ressorts" [surprise boxes for the pleasure of opening them, complicated toys with mechanisms designed to be explored]. George d'Avenel, *Le mécanisme de la vie moderne* (Paris: Collin, 1902), 3.

58. Jules Lemaître, "Philosophie du costume," *Le Figaro,* Feb. 11, 1897, 1–2.

59. Uzanne, *Les ornements de la femme,* 241.

60. Marguerite d'Aincourt, *Etudes sur le costume féminin* (Paris, 1883), 4.

61. Violette, *L'art de la toilette chez la femme* (1885), 4.

62. Ibid., 26.

63. According to Robert Devleeshouwer, "L'évolution de la mode contribue non à la libération de la femme, mais à l'illustration de celle-ci dans l'outrance (culs de Paris, poitrines galbées, coiffures extravagantes et chapeaux amples et amphigouriques). Grand monde et demi-monde joignent en leurs arabesques démesurées une volonté de s'imposer, sinon à la consideration du moins à l'étonnement de tous." [The way fashion is developing doesn't help liberate women; it simply shows them at their worst: the "Paris bottom," bulging breasts, extravagant hair styles, and big, overblown hats. High society and the demi-monde alike hope these outlandish curves will turn heads—that people will admire them, or at least be astonished.] Devleeshouwer, "Costume et société," *Revue de l'Institut de Sociologie* 2 (1977): 172.

64. This concept was mocked by Ferdinand Bac in "Le couturier de l'âme," Bibliotèque Nationale Cabinet de l'estampes, G191350–54 (microfilm; location of original article is unknown).

65. To date, the history and development of the boa has not been studied carefully. A "Morning Dress" from 1804, showing a fur that is shaped like a snake, is illustrated in James Laver, *Costume Illustration: The Nineteenth Century* (London: His Majesty's Stationery Office, 1947), figure 5. Maurice Leloir's *Dictionnaire du costume* (Paris: Gründ, 1951) gives the following definition of boa: "Fourrure de forme très allongée faite de brins de plumes d'autruche que les femmes portaient autour du cou (fin XIXe et début XXe siècle)" [Long, thin fur stole made of ostrich feathers, worn around the neck by women (late nineteenth, early twentieth century)] (37). The weather had a significant effect on the popularity of furs from year to year. The winter of 1879–80, for example, was extremely cold, prompting an increased desire for fur products. See M. A. Challamel, *Histoire de la mode en France: La toilette des femmes depuis l'époque gallo-romaine jusqu'à nos jours* (Paris: Hennuyer, 1881), 298. W. Macqueen-Pope, in *Goodbye Piccadilly,* mentioned the replacement of

the winter furs with feather boas for the summer; quoted in Norah Waugh, *The Cut of Women's Clothes* (New York: Theatre Arts Books, 1968), 293.

66. However, writers of the 1890s would use the term to describe furs of earlier periods. See Uzanne, *Les ornements de la femme,* 257, as an example.

67. H-Y, "Femmes et fourrures," *La Vie Parisienne,* Mar. 25, 1882, 174–75.

68. "Les fourrures," *La Vie Parisienne,* Feb. 6, 1886, 78–79.

69. Klinger was German but his works were well known in France. The series appeared in July 1880 and went through five documented editions. The plates in the series are "Eve," "First Future," "The Snake," "Second Future," "Adam," and "Third Future." The plate involving the snake has been interpreted as depicting the quest for self-knowledge, which is an overly simplistic interpretation. The "future" predicted by Eve's fall in Klinger's series has been interpreted as the fear of death unfolding in three progressive stages. "First Future" presents a deadly tiger; "Second Future" pits the viewer against a devil-like figure who rides on a leech in a sea of blood. In the "Third Future," a skeleton crushes individuals arriving in hell. See Hans Wolfgand Singer, *Max Klinger: Etchings Engravings and Lithographs, 1878–1903* (San Francisco: Alan Wofsy Fine Arts, 1991), 178–81. The illustration also appears in J. Kirk T. Varnedoe, *Graphic Works of Max Klinger* (New York: Dover, 1977), plate 7.

70. Stop, "Echos du jour," *Le Journal Amusant,* Dec. 1, 1888, 5.

71. Translated and quoted in Marie Simon, *Fashion in Art: The Second Empire and Impressionism* (London: Zwemmer, 1995), 71. The original source is *Lettres de Degas recueillies et annotées par Marcel Guérin* (Paris: Grasset, 1945), letter no. 28. Guérin states that the letter was never sent. Simon notes that there are two pastels of Mme Dietz-Monnin with her boa and a pink hat (243, n. 2 to chapter 2).

72. The latter advertisement featured a *chérette* holding a bottle of the pastilles; she wears a feather boa that trails from her neck to her feet, a clever device that directs the viewer's eye to the product's name. These two designs were used both as posters and as print advertisements. Both are reproduced in Broido, *Posters of Jules Chéret.*

73. Bac was known for his images of fashionable women and published several albums, including *Femme intime* (1894), *Nos femmes* (1895), *Nos amoureuses* (1896), *Les maîtresses* (1897), and *La comédie féminine* (1899), each of which contained one hundred of his works. In his preface to *Nos femmes,* Maurice Donnay described Bac's woman as "très élégante, très fine, très troublante, un peu bibelot" [very elegant, very graceful, highly disturbing, and rather futile]. Marcel Prévost called his work for *La Vie Parisienne* evidence of his being a "boulevardier expert," in the preface to *La femme intime.* And, in the preface to *Les maîtresses,* Félicien Champsaur said that there were "les maîtresses de vous, de lui, de moi peut-être, de nous. Fidèles aujourd'hui, infidèles demain, mais fidèles à un ou à d'autres" [your mistresses, his, mine perhaps, ours. Faithful today, faithless tomorrow, but faithful to someone or other], thus accomplishing "natural law" (vii).

74. Draner, "A travers le Salon," *Le Charivari,* May 8, 1890, 3.

75. Happel was German-born but nevertheless contributed illustrations to many French journals, including *Le Rire* and *Le Chat Noir.*

76. See Partha Mitter, "The Hottentot Venus and Western Man: Reflections of Constructions of Beauty in the West," in *Cultural Encounters: Representing "Otherness,"* ed. Elizabeth Hallam and Brian V. Street (London: Routledge, 2000), 35–50.

77. *La Vie Parisienne,* Sept. 13, 1902, 510–11.

78. The earliest imagery using the *poire* as a visual symbol for stupidity comes from the period of the First Empire under Napoleon, but the most developed campaign was initiated during the period of the July Monarchy, when Louis-Philippe and the symbol of the pear became inseparable. See Sandy Petrey, "Pears in History," *Representations* 35 (Summer 1990): 52–71.

79. See Gustave Adolphe Mossa, *Adamus et Eva,* 1907, watercolor, private collection, Nice, illustrated in Soubiran, *Gustave Adolphe Mossa,* plate 96, 175.

80. Nissenson and Jones, *Snake Charm,* 113. On the use of snake jewelry by ancient societies, see M. Oldfield Howey, *The Encircled Serpent: A Study of Serpent Symbolism in all Countries and Ages* (London: Rider, 1926), chapter 21, "The Serpent as Amulet and Charm."

81. Nissenson and Jones, *Snake Charm*, 113.

82. "Intimités—Toilettes d'intérieur offensives et défensives," *La Vie Parisienne,* June 2, 1883, 308–9.

83. De. V., "Le serpent," *La Vie Parisienne,* May 12, 1877, 253–54.

84. Advertisements published in *La Mode Illustrée* in 1900 described a "Theodora brooch" for ten francs, a Byzantine tiara, and other pieces titled "Cleopatra" or "Joan of Arc," which also referred to Sarah Bernhardt without using her name directly. See Georges Bernier, *Sarah Bernhardt and Her Times,* exh. cat. (New York: Wildenstein), 49.

85. Marie-Odile Briot, "Lalique fin de siècle: Physique et métaphysique du bijou," in *Les bijoux de Lalique,* ed. Yvonne Brunhammer et al. (Paris: Flammarion, 1998), 58.

86. Nissenson and Jones, *Snake Charm*, 114–15.

87. Florence Müller, "Lalique et la mode," in Brunhammer et al., *Bijoux de Lalique,* 108.

88. Nissenson and Jones, *Snake Charm,* 115. For an English translation of Mucha's recollections of his first assignment for Sarah Bernhardt, see Victor Arwas, "Mucha and Sarah Bernhardt," in his *Alphonse Mucha,* 68–70.

89. See Bernier, *Sarah Bernhardt and Her Times,* 54.

90. Elaine Aston, "Outside the Doll's House: A Study in Images of Women in English and French Theatre, 1848–1914" (Ph.D. diss., University of Warwick, 1987), 91.

91. Ibid.

92. Quoted, ibid., 92.

93. As Arsène Houssaye described: "ce rire de Madame Sarah Bernhardt, nous l'entendrons longtemps résonner à nos oreilles, rire affolé et haletant, lorsque les nouvelles lui arrivaient de la mort de Créuse et de la réussite de ses enchantements! Rire fauve et de femme outragée qui s'est vengée à souhait." [We shall always hear Sarah Bernhardt's laughter ringing in our ears. It was a mad, convulsive laugh, when she hears the news about the success of her spells and Creusa's death! The ferocious laughter of the outraged woman who has drunk her fill of vengeance.] Quoted, ibid., 93. On the history of the story of Medea for the stage, see James L. Sanderson, comp., *Medea: Myth and Dramatic Form* (Boston: Houghton Mifflin, 1967), and James J. Clauss and Sarah Iles Johnston, eds., *Medea: Essays on Medea in Myth, Literature, Philosophy, and Art* (Princeton: Princeton University Press, 1997).

94. Aston, "Outside the Doll's House," 93

95. Ibid., 99. An illustration of Sarah Bernhardt holding snakes ("ses aspics") at her dressing mirror was reproduced in Gilbert Augustin-Thierry, "Le théâtre, Cléopâtre," *Revue Illustrée,* Nov. 1, 1890, 315.

96. Nissenson and Jones, *Snake Charm*, 115.

97. Ibid.

98. A performance at the Alcazar d'Hiver in 1887 featured Mademoiselle Gilberte in the role of Eve. The description of the production is accompanied by an illustration of Eve and the serpent by Ferdinand Bac. Toché, *Les premières illustrées,* vol. 6 (1886), 205.

99. Gustave Flaubert, *Salammbô* (London: Penguin Classics, 1977), 166.

100. Ibid., 174.

101. Sahib, "La pudeur moderne I," *La Vie Parisienne,* Dec. 27, 1902, 720–21

102. See Henry Fouquier, "Salammbô," *Le Figaro,* Feb. 10, 1890, 1; Parisia, "Salammbô," *Le Figaro,* Feb. 11, 1890, 1–2. The latter article was dispatched from Brussels following the premiere of the show and contained a careful description of the staging of the performance.

103. Henri Galoy, "Mlle Isis à Parisiana," *Le Courrier Français,* Dec. 24, 1908, 7.

104. While journal illustrations usually showed the snake charmers clothed, photographs published in periodicals "meant for artists" showed them nude. For example, Chantron's "Charmeuse," published in the *Panorama Salon* of 1899, depicts a bare-breasted woman, with drapery covering her lower body, holding a snake in one hand and a palm frond in the other. On the subject of public performances featuring snake charmers, see G. Labadie-Lagrave, "Les serpents au théâtre," *Magasin Pittoresque* 63 (1895): 218–19.

105. "Charmeuse de serpents," *La Vie Parisienne,* Aug. 5, 1876, 450.

106. See Carol Ockman, "When Is a Jewish Star Just a Star? Interpreting Images of Sarah Bernhardt," in *The Jew in the Text: Modernity and the Construction of Identity,* ed. Linda Nochlin and Tamar Garb (London: Thames and Hudson, 1995), 121–39.

107. Jeanne Marcya, "La femme au théâtre," *Revue de Morale Sociale* (1901), 236.

108. Eric Salmon, ed., *Bernhardt and the Theatre of Her Time* (Westport, Conn.: Greenwood, 1984), 9.

109. Sahib, "Demandez: Les crimes du boulevard Saint-Martin. Horribles détails! Les châtiments de la meurtrière," *La Vie Parisienne,* Dec. 5, 1896, 698–99. The timing of this spoof was clever; just ten days later the *Revue Illustrée* published "La carrière de Mme Sarah Bernhardt," an extensive article appeared summarizing her performances in each of her successive roles.

110. Léopold Lacour, "Cléopâtre," *Le Figaro,* Oct. 21, 1890, 1. Lacour takes the quote from a historical novel of the period.

111. Aston, "Outside the Doll's House," 94.

112. Aston quotes Gerda Taranow's estimation of critics' responses, ibid., 97.

113. Ibid.

114. Georges Lorin, "Monsieur Sarah Bernhardt," *Les Hydropathes,* Apr. 5, 1879, 2. Maurice Rollinat, author of *Névroses,* became Bernhardt's protégé and the two frequented the Cabaret des Hydropathes. See Bernier, *Sarah Bernhardt and Her Times,* 38. Sander Gilman has connected the masculine appearance of Bernhardt with her Jewish heritage, in his "Salome, Syphilis, Sarah Bernhardt, and the Modern Jewess," in Nochlin and Garb, *The Jew in the Text,* 97–120.

115. G.B., "Coeur humain, sauce Sarah," *Le Rire,* Jan. 8, 1910.

116. Paf, "Le salon pour Rire," *Le Charivari,* May 1, 1880, 3.

117. Brac, "Resarah Bernhardt," *Zigzags,* May 21, 1876, 5.

118. André Gill, "Hymen-vapeur," *La Nouvelle Lune,* Apr. 16, 1882 (cover); Charvic, "Profils de cafés-concerts, les étoiles, Mlle Yvette Guilbert," *L'éclipse,* July 19, 1894, 228–29. The Bac illustration is reprinted in Osterwalder, *Dictionnaire des illustrateurs,* vol. 1, 69, entry for Bac.

119. See "La danse serpentine—Mlle Loïe Fuller et ses transformations," *L'Illustration,* Nov. 12, 1892, 392. The most complete study of the dancer is Giovanni Lista's *Loïe Fuller: Danseuse de la Belle Epoque* (Paris: Somogy, 1994). Lista is very concerned with the mechanics of the productions, especially with regards to patents on the machinery and the implications for the development of both dance and film.

120. Frank Kermode, "Loïe Fuller and the Dance before Diaghilev," *Theatre Arts* (Sept. 1962): 9.

121. Fashion was also of considerable importance to Fuller's performances, and her costuming was well-enough known to be commented upon by Gaston Worth, the famous couturier, in his text *La couture et la confection des vêtements de femme* (1895). Worth mentions Fuller within the context of a discussion on how different elements, some you might not expect, can influence fashion: "On peut citer l'exemple récent de la mode à laquelle la Loïe Fuller a attaché son nom, et qui a eu, ces derniers temps, un succès des plus vifs. Ce n'est pas cette fameuse danseuse qui a inspiré, par les effets de lumière dont elle s'est servie, l'idée des étoffes multicolores" [One could cite the recent example of the fashion to which Loïe Fuller lent her name, and which has enjoyed the most tremendous success of late. But it was most definitely not this famous dancer and her tricks with light who inspired the use of multicolored materials] (35).

122. René Tardivaux wrote: "Les serpents se redressent éperdus à l'écart. Du dépit de l'arrachement trop dur, les serpents, furieux et domptés, s'exaltent; s'exaspèrent; s'érigent; s'affaissent; bondissent; défaillent; se gonflent; vont crever; s'effilent, multipliés; s'avalent et se rejettent; girations ivres d'unique boa, gorgonesque grouillement de serpentins sans nombre; affluence et colère de tout ce qui rampe et glisse, s'allonge et coule immembré, ondule et brille, comme les eaux, de ses flascuosités et de ses squames; révolte affolée jusqu'au possible, sous la main tranquille, puissante et gracieuse qui, à menus gestes, contient, dominatrice." [The snakes rear apart frantically. In their resentment at being pulled too hard, they seethe with impotent fury; their passion rises, and they dart up in exasperation; sink back down, shoot up once more, collapse; swell, seem on the point of bursting, deflate into long, thin spirals, multiply, swallow and vomit out each other

in the intoxicated gyrations of now a single boa, now a Gorgon-like, living labyrinth of number-less coils. The maddened swarming of every creeping, crawling thing extends itself and flows limblessly, undulating and glistening like water, a scaly spineless mass, rebelling to the utmost of its wild rage against the gentle, strong and elegant hand which, with the barest of gestures, dominates and contains it.] Tardivaux, "La Loïe Fuller," *Gil Blas,* Dec. 18, 1892, 2–3.

123. Georges Rodenbach, "La Loïe Fuller," *Revue Illustrée,* May 1, 1893, 335–36.

124. Fuller was not alone in this. In 1886, women could construct the "Indian snake charmer" costume from the pattern provided in *La Mode Illustrée;* large undulating snakes decorated the bodice and skirt, and a snake bracelet completed the look. Anais Toudouze, "Fancy Dress Costumes," *La Mode Illustrée,* Jan. 31, 1886, reproduced in Florence Leniston, ed., *La Mode Illustrée: Fashion Plates in Full Color* (New York: Dover, 1997), plate 5.

125. Claire Frèches-Thory, *Toulouse-Lautrec* (New Haven: Yale University Press, 1991), 290.

126. Translated and quoted in Julia Frey, *Toulouse-Lautrec: A Life* (New York: Penguin/Viking, 1994), 272.

127. Frèches-Thory, *Toulouse-Lautrec,* 291.

128. Sophie Monneret, *L'Impressionisme et son époque: Dictionnaire international* (Paris: Laffont, 1987), vol. 1, 22–23. The Symons quote is translated and quoted in Frey, *Toulouse-Lautrec: A Life,* 272.

129. Raoul Ponchon, *La muse gaillarde* (Paris: Rieder, 1939), 100–104.

130. See Russell Ash, *Toulouse-Lautrec: The Complete Posters* (London: Pavilion, 1991), commentary on plate 30.

131. See Jean Adhémar, *Toulouse-Lautrec: His Complete Lithographs and Drypoints* (New York: Abrams, 1964), commentary on plate 323.

132. Anne Roquebert, "Late Work," in *Henri de Toulouse-Lautrec,* ed. Joanna Skipwith, Julia Peyton-Jones, Marianne Ryan, et al., exh. cat. (London: Southbank Centre, 1991), 468.

133. Lautrec's financial situation is detailed in Herbert Schimmel, ed., *The Letters of Henri de Toulouse-Lautrec* (New York: Oxford University Press, 1991), 345–47.

134. Which work came first cannot be definitively documented. According to Julia Frey, Lautrec designed his poster in the fall of 1898, but it was not printed until January 19, 1899, which would raise the issue of how Hyp could have become aware of the design in order to produce his work, which was published on January 7. While Frey provided documentation for the printing of the poster, citing a sale catalogue (*Collection M.L.: Ensemble exceptionnel d'estampes originales, livres illustrés, importants dessins aux crayons de couleur de Henri de Toulouse-Lautrec: vente à Paris, Galerie Charpentier le mardi 2 juin 1959* [Paris: Galerie Charpentier, 1959], 449–50), she gives none for the dates of the design itself. Toulouse-Lautrec must have read *La Vie Parisienne.* He certainly had a general interest in popular illustration. In addition, *La Vie Parisienne* published a report on an open house that Toulouse-Lautrec held at his apartment on May 15, 1897; the report appeared on May 22. See Frey, *Toulouse-Lautrec: A Life,* 432–33.

135. Hyp, "Les statues qu'elles aiment," *La Vie Parisienne,* Jan. 7, 1899, 6–7.

136. Quoted in Frey, *Toulouse-Lautrec: A Life,* 273.

137. Anne Roquebert, "Chronology," in Skipwith et al., *Toulouse-Lautrec,* 541.

138. Frey, *Toulouse-Lautrec: A Life,* 450.

Epilogue

1. Claire Galichon, *Eve réhabilitée: Plaidoyer "pro femina": Ouvrage complétant "Amour et maternité"* (Paris: Librairie Générale des Sciences Occultes, 1909), 11.

2. Ibid., 25.

3. Ibid., 26.

Index

ELIZABETH K. MENON is a professor of art history at Purdue University. She is the author of *The Complete Mayeux: Use and Abuse of a French Icon* and (with Gabriel Weisberg) *Art Nouveau: A Research Guide for Design Reform in France, Belgium, England, and the United States.*

The University of Illinois Press
is a founding member of the
Association of American University Presses.

———————————————————————

Composed in 9.5/13 ITC Stone Serif
with ITC Stone Sans and Poplar display
by Jim Proefrock
at the University of Illinois Press
Designed by Paula Newcomb
Manufactured by Sheridan Books, Inc.

University of Illinois Press
1325 South Oak Street
Champaign, IL 61820-6903
www.press.uillinois.edu